PLANET EARTH

Dear Nate—
My, these four years have passed quickly! It's been delightful— and rewarding— to watch your growth as a scholar and citizen through these years. Please remember us as your exciting career unfolds.
All best,
Maureen Hays-Mitchell.

Dear Nate,
Congratulations! It has been a pure delight seeing your Colgate career unfold over these past four years. Your work in and on behalf of the department has been superb— and we thank you! I will miss you. All the best!
Glenn Kranly

Congratulations + best wishes Nate. I've very much enjoyed working with you—especially this semester.
Bob Elgie

Nate,
Congratulations on a wonderful career at Colgate. I've enjoyed observing your work from afar. Best of luck in the future.
regards,
Peter Klepein

NATE,
WELL DONE! IT'S BEEN A PLEASURE — YOU ARE A GREAT STUDENT. I WISH YOU THE BEST OF LUCK IN THE FUTURE
Adam Burnett

Nate—
Congratulations and best wishes to you! I've enjoyed our hallway conversations over the past years.
Deanna McCay

PLANET EARTH

INTRODUCTION BY ROBERT HUGHES

GERMAN AEROSPACE CENTER

ALFRED A. KNOPF NEW YORK 2002

THIS IS A BORZOI BOOK
PUBLISHED BY ALFRED A. KNOPF

Introduction copyright © 2002 by Robert Hughes

All rights reserved under International and Pan-American Copyright Conventions. Published in the United States by
Alfred A. Knopf, a division of Random House, Inc., New York, and simultaneously in Canada by Random House of
Canada Limited, Toronto. Distributed by Random House, Inc., New York.

www.aaknopf.com

First published as *Kunstwerk Erde* in Germany in 2001 by Frederking & Thaler Verlag GmbH, München.
Copyright © 2001 by Frederking & Thaler Verlag GmbH, München.

Editor: DLR—German Aerospace Center
Project Team at DLR: Robert Meisner; Franz Pätzold and Nils Sparwasser, Oberpfaffenhofen
Satellite Pictures: Copyright © see photo references (pages 200–31)

Text by Dr. Stefan Dech, DFD, Oberpfaffenhofen, and Dr. Robert Meisner, DFD, Oberpfaffenhofen

This translation published simultaneously in Great Britain by Jonathan Cape, London.

Knopf, Borzoi Books, and the colophon are registered trademarks of Random House, Inc.

ISBN: 0-375-41530-0
LCCN: 2002104432

English language edition designed by Mark Holborn and Friederike Huber

Printed in Italy
First American Edition

CONTENTS

INTRODUCTION

ROBERT HUGHES

One looks at them with a degree of bewilderment. They are images, sometimes quite recognizable ones, of the Earth, our Earth, our eternal home (for certainly we have no other) – but an Earth we have never seen and never will, one that is very strange and yet incontestably real. It is hard to imagine being anywhere on it, and yet we know we are on it somewhere, but only as motes, specks, unimaginably small particles of a pixel. These pictures have been taken from satellites in fixed orbit, far out in space. The images, since satellites cannot land to offload film, are then radioed back to Earth and reassembled electronically.

There is no one up there making choices. What is recorded is part of a purely indifferent mosaic of information. But looking at the images I think of that remark of Leonardo's: *Il mondo è pieno d'infinite ragioni che no furono mai in isperienza* – 'The world is full of an infinity of causes that were never before set forth in experience.'

It is mesmerising to see those landforms, those streaks and smears of ocean and reef, and those intrusions of man's presence into a once perfect world. To know that these details of land and sea were always there, changing by microtemporal increments, but never recorded or perceived by the human eye until now. To see that the enormously large (though still spatially measurable) has the same kind of mystery and capacity to completely surprise

as the microscopically small. Is this lovely, translucent leaf of substance an assembly of tiny cells, amoebic matter perhaps, glimpsed in a microscope? Not at all; it is a huge ice island in Antarctica, miles long and wide, in the process of calving off from the main ice mass and, as it does so, testifying to the irrefutable reality of global warming, a phenomenon that can now only be denied by an imbecile or the CEO of an oil company. Images like those in this book have their value as objects of scientific interpretation: that is the reason for their existence. Radar images make it possible to determine how thick pack ice is. A floe only a few centimetres thick shows red; ice six feet thick registers as blue-green. The colours have nothing to do with aesthetics or the desire to create gorgeous configurations. But these are real by-products, and even if you are not a geologist or an oceanographer, you can be transfixed by the images' sometimes ominous and sometimes lyrical beauty.

The Middle Ages and the Renaissance had ways of imagining and representing the world in which human presence was everything. Human emotions defined and coloured the look of every feature of the globe, real or imaginary. Here were dragons. Here was a puffy cherub supplying the North Wind. Here were frizzy black men with feathers or a crocodile pouring Nile water on its shining scales. Here were the four rivers of the world, the Pison, the Gehon, the Tigris, and the Euphrates, trickling from a central fountain somewhere in the near East,

the fount of Paradise. The images that make up this book are at the furthest remove from that. They contain no imagination. They are nothing but information–climate and landforms, but also substance, temperature, humidity, the moisture of the ground, the kind of crops it supports, the decay and creation of material, and the millions of other matters that affect the actual existence of the Earth's envelope on which our lives, so frail and brief and yet environmentally so consequential, are lived. Some pictures look like modern art – their meetings of colour and form seem arbitrary, 'expressive.' But there is nothing at all expressive about them. There is no personality to express. Everything in them is the result of objective variation and nothing more. The blue is not there because a person making the image feels blue – nobody is in the satellite, only a machine registering forms and colours in a completely impersonal way. There are photos that resemble paintings. I think of one in particular, which looks just like a Paul Klee. It is a false-colour image that looks down on the surface of rural Kansas – a surface farmed with incredible intensity. It is a grid of squares with perfectly round discs set in them. If you scrutinize the pattern carefully you can see that some of these discs are the size of small townships, but the image otherwise lacks spatial clues. The discs are the traces of giant irrigation arms, which swing round and round their central pivot. Their colours, ranging from pale flesh tones through browns and greens to deep, sharp dots of vermilion, are not the

optical colours of nature: they record information. At the simplest level (though it has other uses, too) such an image tells you which of the irrigated circles needs more water, and which less. The circles vary quite widely in diameter, and this gives the surface of the Earth a beautifully jazzy rhythm, almost exactly like some of Klee's grid-based watercolours. Such an image makes you realize how limited and feeble in scale most 'Earth art' tends to be.

These photographs do not depend on visible light, which makes up only a short part of the electromagnetic spectrum. It is possible to compose images of Mother Earth, to survey her from orbit in space, with gamma, X, and ultraviolet rays; with infrared rays, microwaves, and radio waves, all of which can then be transmitted from satellite to Earth and reconstructed as visual imagery. This means that satellite photography can yield information that regular-light photography cannot record. This point is made by an interesting pairing of two images of exactly the same scene, recorded by different means. The landscape is one of the most sinister on Earth (not that either photo makes you aware of it): the enormous Escondida mine in Chile, which is the largest copper, gold, and silver mine in the world. It produces more than 127,000 tons of ore a day, which is then transported to the coast for export along an enormous conveyor belt cut through the heart of the Chilean mainland. In the right-hand photograph, shot by waves in the visible part of the

spectrum (which lies between infrared and ultraviolet), we see the apocalyptic, forever poisoned landscape of Escondida in its natural colours: the lunar grey and purplish mountains of waste and spoil, the blue leaching tanks each the size of a township, the hairline-thin tracery of access roads. This landscape becomes ghastly and dreamlike on the left-hand page, a shortwave, infrared image of the same scene, with enormous plumes of crimson and magenta runoff and mudslide, and miles of excavated spoil coloured an evil sort of phosphorescent, viridian green. However, in the altered and unfamiliar world revealed by constructing it in terms of nonvisible radiation, very weird colours can be thrown up by quite benign or at least neutral sites. Here is an image of a very 'pure' landform, an island that seems to be covered by some obscenely sulphurous green pollutant. Actually, the green crust is not green to the human eye; it's just lava of different ages and densities, spewed out long ago by the volcano that created the island itself – the peak of Tiede on the island of Tenerife in the Canaries, whose caldera is the centre of the image. It has an archaic, almost dreadful grandeur, recalling the old Spanish belief that Tenerife was the last relic left by the mythical Atlantis as it sank beneath the sea: *restant-li sols lo Tiede*, wrote the great nineteenth-century Catalan poet Jacint Verdaguer, *dit de sa ma de ferre / Que sembla dir als homes, L'Atlantida era aci!* 'Only Tiede remains, finger of that iron hand / That seems to say to men, "Atlantis was here!"'

The beauty of these photos is, however, only an accident. They are meant to be useful, to be evidence. This is so even when they look completely lyrical and dreamy, as in the extraordinarily evocative but (if correctly interpreted) equally informative panorama of the Earth at night, where the relative zones of energy use stand out as brilliant white speckles against the black oceans and the blue-velvet surfaces of the continents. New York, for instance, has a much smaller population than Calcutta, but it shows up larger and brighter because its energy consumption is so much greater.

Often it is this sense of twist, great or small, in the expected flow of information that gives certain images their peculiar magic. Here is the curve of the northern hemisphere. At least, that is what you think it might be. Landforms are pinnacles of glossy grey. Around them creeps a sort of sluggish blue icing, with deep indented canyons, holes, cliffs, valleys. Then you realize: this blue gunk is the Atlantic Ocean and its offshoots, seen not optically but in terms of temperature gradients. You recognize the flat grey plate of the British Isles on the right, and the coast of northern Europe just right of them, then the indented, jagged coast of Norway. Then other things you knew in your childhood geography classes fall into recognisability – the Skaggerak, the Kattegat, the Baltic stretching away to a St Petersburg that doesn't show up, and so on. It is all so harsh, preconscious, and almost unbelievably inhospitable:

a world before it became the matrix of even the simplest forms of life.

Sometimes it's the strange solidity of the airforms that fires one's imagination. We all know that air forms vortices when it passes an object – that's high school physics. But to see how solid these vortices can be is a different matter, and to view a cloud passing – with the reluctance of treacle or of mutton-fat while an oceanic wind blows it across the peak of Juan Fernández, the island on which Alexander Selkirk, the seventeenth-century Scottish castaway on whose adventures in survival Daniel Defoe based the classic English survival narrative *Robinson Crusoe*, was stranded – is a truly extraordinary moment. Larded with wrinkled cloud, the very air has congealed; it forms heavy, fatty commas, and then fully rounded vortices, a string of them carried outward in the airstream like the diminishing vortices left behind the blade of a paddle in water, obeying exactly the same laws of fluid motion as water does.

One of the most beautiful of the photographs is a view of the coral atolls of the Maldive Islands in the Indian Ocean. Seen from outer space, these are of a most exquisite and fragile beauty: wavering rings, floating white necklaces, which one can imagine pulsating in their blue salt water like delicate forms of protoplasm. But some of them are miles across, and all of them are dying. Year by year, month by month in some parts of the world, the coral reefs

are perishing. They are inexorably being done to death by ignorant fish-killers, desperately poor natives who depend for their meagre living on large fish-marketing companies who issue them primitive diving gear and plastic squirt bottles of a deadly soluble poison, potassium cyanide. The natives dive on the coral and inject the cyanide solution into its crevices. This stuns, disorients, or kills the reef fish, which, being coral dwellers, cannot be netted. The resulting overkill is enormous, but just as bad is the ruination of the fishes' habitat: the coral organisms themselves, the polyps by which the reefs are built, whose exoskeletons make up the coral. The white lines and curlicues we see in this photograph mark the irreversible destruction of the atolls. One can infer death as well as life, and in no metaphorical sense, from these remote views of our fragile world.

FOREWORD

STEFAN DECH, Director, German Remote Sensing Data Centre of the DLR
ROBERT MEISNER, Head of Marketing and Media, German Remote Sensing Data Centre of the DLR

In 1962, John Glenn persuaded NASA to let him take a camera along with him on board the Mercury Atlas 6 space capsule on America's first manned space flight. Since that time, no NASA mission has gone into orbit without cameras on board. The fascinating and inspiring pictures that the astronauts brought back from orbit went around the world and have appeared in numerous books and magazines since then. They show a vulnerable and complex planet which is changing rapidly as a result of human intervention, protected only by a wafer-thin mantle shimmering with a bluish hue – the atmosphere, without which no life could exist on Earth.

Almost 2,500 years ago, Socrates already recognized the profound significance of a view onto the Earth from above: 'Man must raise himself above the Earth as far as the outer edge of the atmosphere and beyond if he is to understand the world in which he dwells.' This insight has proved to be eminently well founded: modern photographs from space have led to the Earth as a whole becoming an object of research; they have also shown that human interventions in limited locations have a widespread impact and may lead to global changes.

For all their aesthetic appeal, however, there is one thing that these pictures from space cannot do: they cannot make any significant contribution to the observation and analysis of the complex system that the Earth represents. Photographs show only fragments of the Earth. To observe the never-ending changes under way on land, in the oceans and in the atmosphere, we need permanent watchers in space, artificial satellites packed with state-of-the-art sensors that supply geoscientists continuously with data from every corner of the Earth at all times.

The phenomena measured by the sensors placed on board numerous satellites today far exceed what can be seen in the pictures taken by astronauts. This is mainly because these geo-surveillance sensors can 'see' far more than the human eye, for instance infrared and heat radiation, ultraviolet light and microwave emissions. Moreover, their gaze can penetrate cloud cover and is undaunted by night.

A combination of specialist know-how and state-of-the-art technology allows us to measure the ozone layer, to map the spread of the deserts and to monitor the destruction of the rainforests. It also allows us to measure the height of the waves and the pollution levels in the oceans, and to provide data for planning agricultural and telecommunications projects. Satellites are faithful servants: they cover the entire planetary surface with regularity and objectivity, and supply data that can be reproduced by anyone.

The German Aerospace Centre (DLR) acts as both Germany's research facility for aerospace activities and as its national space agency. The German Remote Sensing Data Centre (DFD), one of the DLR's many institutes, receives, processes and archives the data from about thirty international geo-surveillance sensors and makes it available to the public as well as to users from industry, science and the government. Our digital remote sensing data library is accommodated in one of the largest archives for satellite data anywhere in the world, in Oberpfaffenhofen near Munich. All this data, unless subject to commercial restrictions, is available via the Internet.

The complex systems orbiting in space do not actually supply pictures of the kind seen in this book, they merely transmit electronic data. The 'works of art' shown in this book have been pieced together from this data by the time-intensive, multifaceted and creative work of numerous scientists from diverse disciplines throughout the world. These images far exceed the photographs taken by astronauts in their ability to reveal the Earth's surface, and present us with a view of our planet of extraordinary visual impact and fascination.

It has been our endeavour to compile the world's best satellite images made available by the largest geo-surveillance centres for this unique book. We hope that these new perspectives will provide our readers with fresh insights.

Oberpfaffenhofen, July 2001

WATCHERS FROM SPACE

ROBERT MEISNER

Man has always endeavoured to broaden his understanding of the world around him by creating pictorial representations of the Earth, most obviously through maps. Early cartography is probably even older than the transmission of information by means of written characters. The Babylonian world maps originating from the fifth century BC reflect the philosophical outlook of their age, but they show with equal clarity man's need to create a pictorial representation of his world.

However, the most modern form of mapping the Earth, namely by using high-resolution images from orbiting satellites, only became available on a regular basis in July 1972. It was then that the Earth Resources Technology Satellite (ERTS-1) was launched into polar orbit on a mission in the interests of US national security. This series of satellites, later renamed Landsat, has been developed continuously since then. Today, these satellites represent one of the most important sources of high-resolution data for documenting global change.

It soon became apparent that satellite-borne instruments on permanent-observation missions could be used to detect more than objects of military interest on the Earth's surface. By utilizing the entire electromagnetic spectrum, the Earth's natural resources could also be monitored. Information could thus be obtained about the condition and vitality of vegetation – key parameters for forecasting crop yields. The acquisition of Earth data from a distance, a technique known as remote sensing, has an obvious advantage: only from space can information be obtained continuously from large areas of the planetary surface. Quite irrespective of the political circumstances prevailing on the Earth, global data became available on various scales for applications ranging from climate research to local concerns such as urban and regional planning. New observation instruments, customized for specific purposes, have been continuously developed, constructed and placed into orbit since the beginning of the Landsat-1 series. They are used to monitor vegetation; to map temperatures on ocean surfaces or patterns of cloud distribution around the globe; to measure and accurately observe the atmosphere, and to survey the Earth from space with high precision. Satellites have been developed which see far more than any eye.

The diagram on the following page shows the complete electromagnetic spectrum which can be used for remote sensing. The range of light visible to the human eye is shown in the primary colours: it represents only a small section of the usable spectrum. Sensors operating towards the shorter wavelengths – especially in the ultraviolet region at wavelengths below 0.4 µm – can measure concentrations of trace gases in the Earth's atmosphere. The region of reflected infrared begins beyond the visible red (above 0.7 µm) spectrum and that of thermal infrared from wavelengths of about 10 centimetres. These wavelengths are used particularly for examining vegetation, for geological surveys and for measuring temperatures. Radar sensors use very much longer wavelengths in the range from 3 to 25 centimetres.

Radar data can be used to map rainforests, monitor sea conditions or create elevation models. Its great advantage is that its availability is unaffected by continuous cloud cover or darkness, which render other systems blind.

Combined recordings from various wavelength regions yield multi-spectral images which can be optimized to focus on specific issues. Some of these images appear in this book: in addition to conveying something of their fascination, they give us an idea of the power of this technology.

New techniques and processes of remote sensing have been developed continuously since the 1980s: the information derived from satellite data is now available on a regular basis in a number of sectors. It is currently utilized regularly for the following applications:

• Meteorology and climate research: satellite data supplies global information from large contiguous areas about cloud cover, trace gases, vegetation,

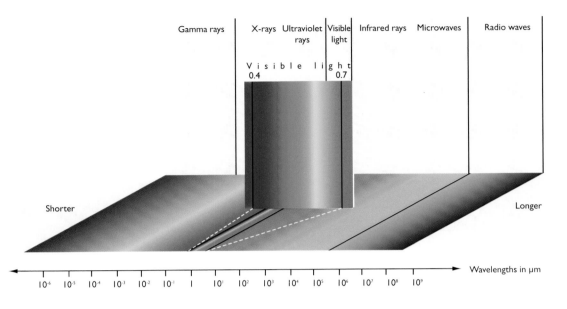

Visible light
0.4 0.7

Shorter

Longer

Wavelengths in µm

10^{-6} 10^{-5} 10^{-4} 10^{-3} 10^{-2} 10^{-1} 1 10^{1} 10^{2} 10^{3} 10^{4} 10^{5} 10^{6} 10^{7} 10^{8} 10^{9}

**The electromagnetic spectrum
used to survey the Earth from space**

precipitation and water vapour. It thus forms the basis for weather forecasting and for developing models of climate change.

- Satellite data is indispensable for detecting tropical cyclones and forecasting their future paths – thus making a significant contribution to protecting human life and giving early warning of natural catastrophes.
- The detection and observation of icebergs and the resulting deployment of icebreakers in northern latitudes are an aid to shipping.
- The optimization of shipping routes with respect to wind and sea conditions saves fuel and thus resources.
- The detection and forecasting of temperature anomalies on ocean surfaces (e.g. El Niño).
- The regular analysis and quantification of worldwide deforestation.
- The use of satellites to monitor farmland use in connection with the EU's agricultural subsidies.

These applications make contrasting demands on the watchers from space. When monitoring clouds, for instance, it is important to collect images of large areas at short intervals (such as every thirty minutes), as the distribution and structure of clouds change quickly over a large area. The detection of small objects on the ground, such as fields, is of secondary importance. On the other hand, monitoring logging in tropical rainforests requires highly detailed spatial information – as the extent

of the deforested areas must be surveyed with great accuracy. However, because of the relatively slow changes involved, it is usually sufficient for this information to be available once or twice annually.

Such diverse applications require the development of customized satellites. The limiting factors are the technologies used and the rate at which the data can be transmitted from the satellite to the ground. These limitations imply a choice between acquiring a large area with poor spatial resolution or a smaller area with good spatial resolution. Images offering great sharpness of detail are consequently available less frequently, as the satellite's narrower swath maps the same region less often.

This trade-off is illustrated by the series of images on the facing page showing the region south of Munich as seen by different satellites at various resolutions. Although the image produced by a

geo-stationary weather satellite (Meteosat-7) is very coarse, with a pixel size of about 5 x 5 kilometres, its data is transmitted every thirty minutes. The image below it comes from a weather and ocean sensor whose significantly higher resolution of about 1 x 1 kilometres (NOAA-AVHRR) is available several times during the day and night. MODIS is a relatively new sensor which takes measurements in 36 different spectral ranges: it records the Earth's surface with even greater sharpness – with a spatial resolution of about 250 x 250 metres – and provides this information once or twice daily. Only from a resolution of about 30 x 30 metres, of the order supplied by Landsat, can finer structures on the ground be detected. However, this high spatial resolution can be made available only about every fourteen days. During its fly-past, the satellite simultaneously transmits what it sees below it to a receiving station on the ground. Because the receiving stations have a limited visibility horizon,

worldwide network is needed to record all a satellite's fly-pasts.

The German remote sensing data centre of the DLR operates one of the largest networks of receiving stations around the world and can collect satellite data from such remote regions as the Antarctic, Mongolia and Siberia as well as central Africa. It subsequently processes this data to produce useful information which is finally archived. This information is then freely available on the Internet.

In autumn 2001, the European Space Agency placed a satellite into orbit jointly with Europe's national space organizations. Equipped with the latest technology, its principal mission is to observe the atmosphere. However, this project also offers an enhanced quality of monitoring the Earth's oceans and land surface. ENVISAT is the largest satellite used so far to observe the Earth. With a launch weight of around eight tonnes and ten different instruments on board, it sets new standards in Earth observation. Will it be possible in future to quantify and monitor international conventions such as the Kyoto Protocol on the reduction of carbon dioxide emissions? The research planned with ENVISAT will provide the answer.

Despite the range of possibilities already offered by remote sensing, one thing should be kept clearly in mind: the epoch of commercial utilization of satellite data has only just begun. The fleet of remote sensing satellites has so far been developed primarily for scientific and government missions and is available for commercial purposes only in certain sub-sectors. The market has hitherto been limited essentially to enhancing this data and integrating information from various data sources: advanced data utilization requires the combination of various remote sensing data and the integration of geographical information systems.

It remains to be seen whether the new ultra-high-resolution systems such as IKONOS, EarlyBird, TerraSAR and RapidEye with their primarily commercial orientation will succeed in opening this market up further. The images presented in this volume are the fruit of these pioneering technologies, which offer resolutions of a metre and less from space for the first time.

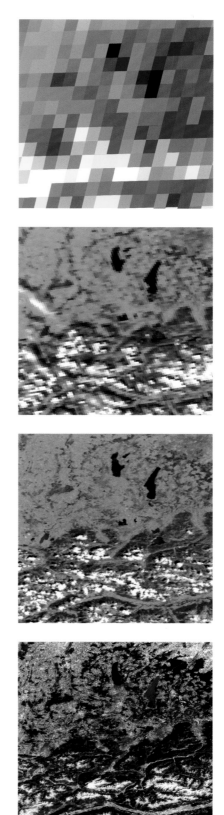

ACKNOWLEDGMENTS

We would like to take this opportunity to thank
our many colleagues from the following institutions
and companies without whose help this book could
never have been produced:
Earth Resources Observation Systems (EROS)
Data Centre of the United States Geological
Survey (USGS, Sioux Falls, South Dakota); National
Aeronautics and Space Administration (NASA);
Goddard Space Flight Center (GSFC, Greenbelt,
Maryland); NASA Jet Propulsion Laboratory (JPL,
Pasadena, California); Chinese Remote Sensing
Ground Station (CRSGS, Beijing, China); Space
Imaging Co., Thornton, Colorado; National Remote
Sensing Agency of India (NRSA, Hyderabad, India)/
Department of Space; Asian Center for Research
on Remote Sensing (ACRoRS, Bangkok, Thailand);
Radarsat International, Richmond, Canada; Canadian
Centre of Remote Sensing (CCRS); European
Space Agency (ESA, Paris/Frascati); National Space
Development Agency of Japan (NASDA, Tokyo);
Applied Remote Sensing Corporation (GAF,
Munich); National Oceanographic and Atmospheric
Administration (NOAA, Washington DC);
and many others.

STEFAN DECH and ROBERT MEISNER

WHO IS WHO

Deutsches Zentrum für Luft- und Raumfahrt e.V. (DLR – German Aerospace Centre), Germany

www.dlr.de

The DLR is Germany's research centre for aerospace and its national space agency.

It runs the **Deutsche Fernerkundungsdatenzentrum (DFD)** – the German Remote Sensing Data Centre – the country's national archive for remote sensing data. The DFD operates the world's largest network of receiving stations as well as systems for processing and distributing data and also manages extensive archives. It is the largest partner within the network of the European Space Agency ESA.

www.dfd.dlr.de

National Aeronautics and Space Administration (NASA), USA

NASA is the USA's national space agency. It includes the following institutes:

- The **Jet Propulsion Laboratory (JPL)**, Pasadena, California, the world's leading facility for exploring space with robot probes. It is also responsible for carrying out the radar missions on the Space Shuttles.

www.jpl.nasa.gov

- The **Goddard Space Flight Center (GSFC)**, Greenbelt, Maryland, is the USA's largest scientific facility for investigating the Earth, the solar system and the wider universe.

www.gsfc.nasa.gov

- **Orbital Imaging Corp. (Orbimage)**, USA, produces low-cost remote sensing images. In cooperation with NASA's GFSC, it distributes the images collected by several satellites, including SeaWiFS.

www.orbimage.com

US Geological Survey, EROS Data Center, USA

Earthexplorer.usgs.gov

The EROS Data Center is the USA's national archive for remote sensing data of the Earth's land surface. The archive contains aerial images of the USA, elevation data, released satellite images and global Landsat data going back almost thirty years.

Space Imaging Co., USA

www.spaceimaging.com

Space Imaging (founded in 1994) has been operating IKONOS, the world's first commercial satellite with 1-m resolution, since 24 September 1999. The products derived from this data are available in the CARTERRA™ archive.

National Remote Sensing Agency (NRSA), India

NRSA (founded in 1974) is an organization of India's Department of Space. It operates a ground segment whose facilities include data reception, product generation, extensive archives, development, fly-pasts and the support of applications.

China Remote Sensing Ground Station (China RSGS), PR China

China RSGS (founded in 1979 within the scope of the scientific-technical cooperation between the USA and China) receives data from Landsat-5/-7, ERS -1/-2, SPOT 1/2/4, RADARSAT 1 and CBERS which it makes available to Chinese users.

Gesellschaft für Angewandte Fernerkundung mbH (GAF – Applied Remote Sensing Corporation), Germany

www.gaf.de

GAF is a private-sector enterprise (founded in 1985) concerned with the value-added processing of remote sensing data, geo-information and GIS applications.

Radarsat International Inc. (RSI), Canada

www.rsi.ca

RSI (founded in 1989) is a distributor of information based on radar data. It has a global scope of operations and has been operating Radarsat-1 since 1996. It is currently preparing to launch its successor Radarsat-2 (2003).

Asian Center for Research on Remote Sensing (ACRoRS), Thailand

www.acrors.ait.ac.th

ACRoRS is a joint venture of the Asian Institute of Technology (AIT) and the Asian Association on Remote Sensing (AARS) designed to promote remote sensing in the Asia-Pacific region.

Australian Centre for Remote Sensing (ACRES), Australia

www.auslig.gov.au/acres

ACRES is Australia's most important ground station for terrestrial observation satellites. It also offers facilities for processing satellite data.

National Space Development Agency of Japan (NASDA), Japan

www.nasda.go.jp

NASDA (founded in 1969) is the nucleus of Japan's activities for the peaceful investigation and utilization of space. NASDA develops satellites, experiments (also for the International Space Station) and launcher rockets as well as the associated methods, equipment and installations, and also carries out launch campaigns.

National Oceanic and Atmospheric Administration (NOAA), USA

www.noaa.gov

NOAA is the USA's national weather service. It operates a system of polar-orbiting and geo-stationary weather satellites.

Canadian Centre for Remote Sensing (CCRS), Canada

ccrs.nrcan.gc.ca

CCRS is the centre for Earth observation in Canada. It is responsible for receiving, processing, archiving and distributing remote sensing data in Canada.

Planetary Visions, England

www.planetaryvisions.com

Planetary Visions produces computer animations and graphics from remote sensing data. Its products are designed primarily for TV, print and multimedia applications.

HUGIN AG, Germany

www.huginag.de

HUGIN is concerned with the production, analysis and visualization of information derived from satellite images and offers GIS and mapping services.

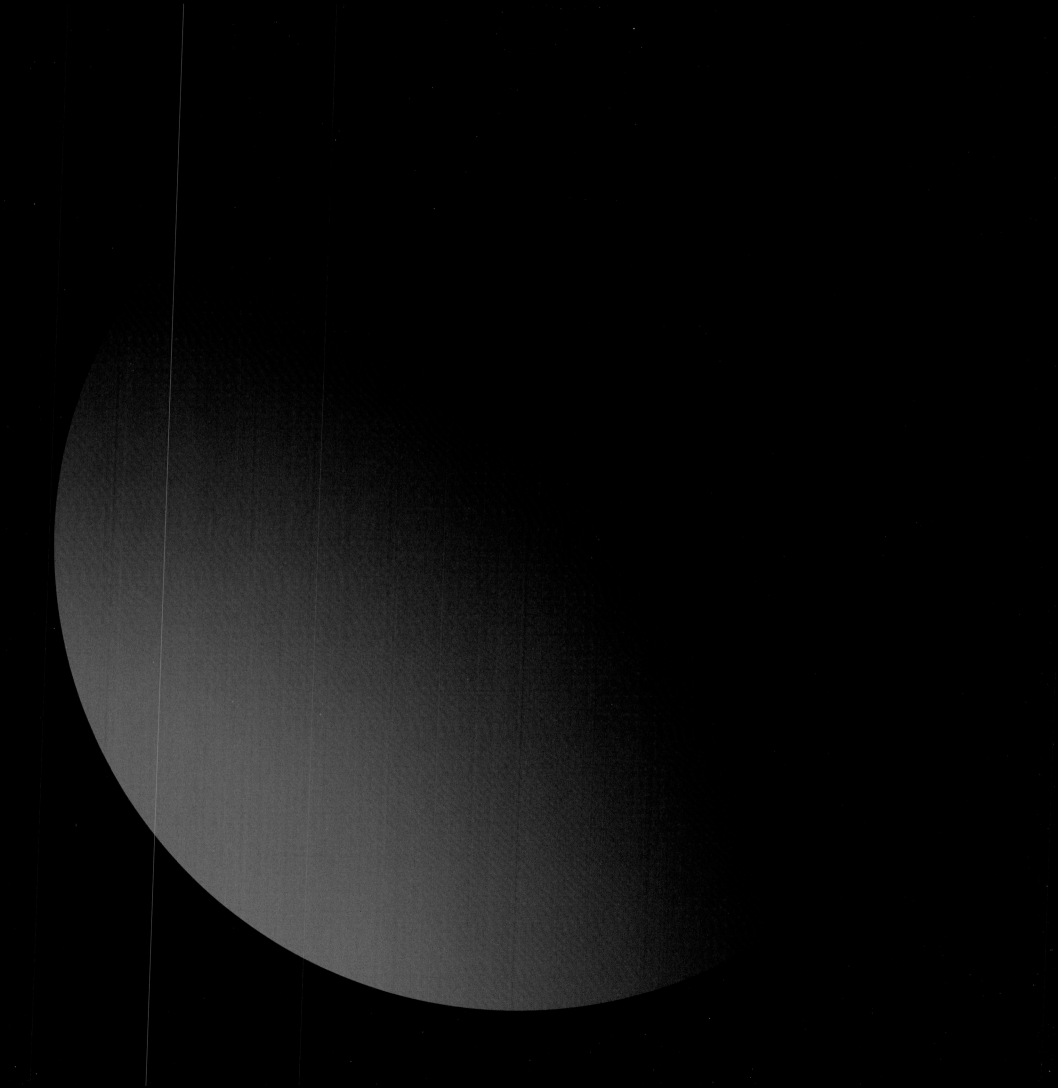

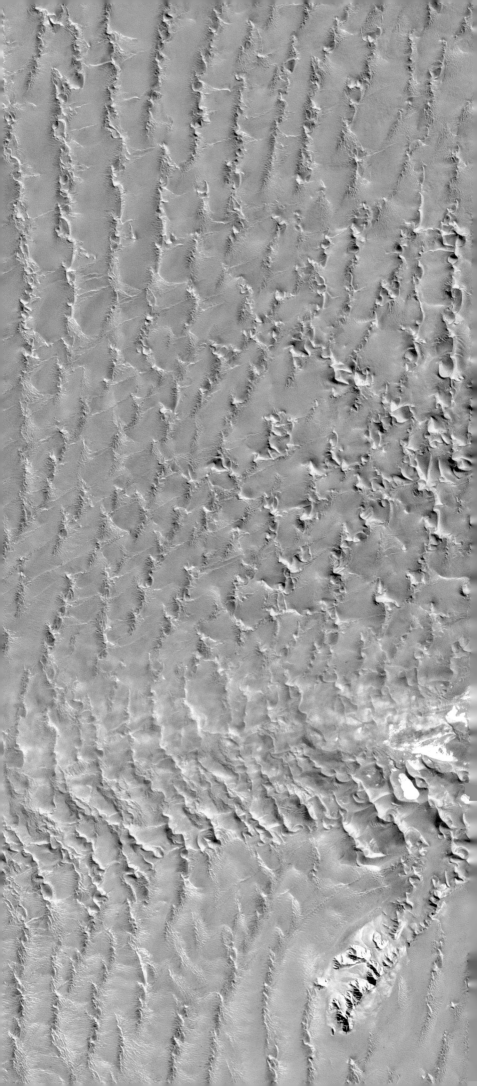

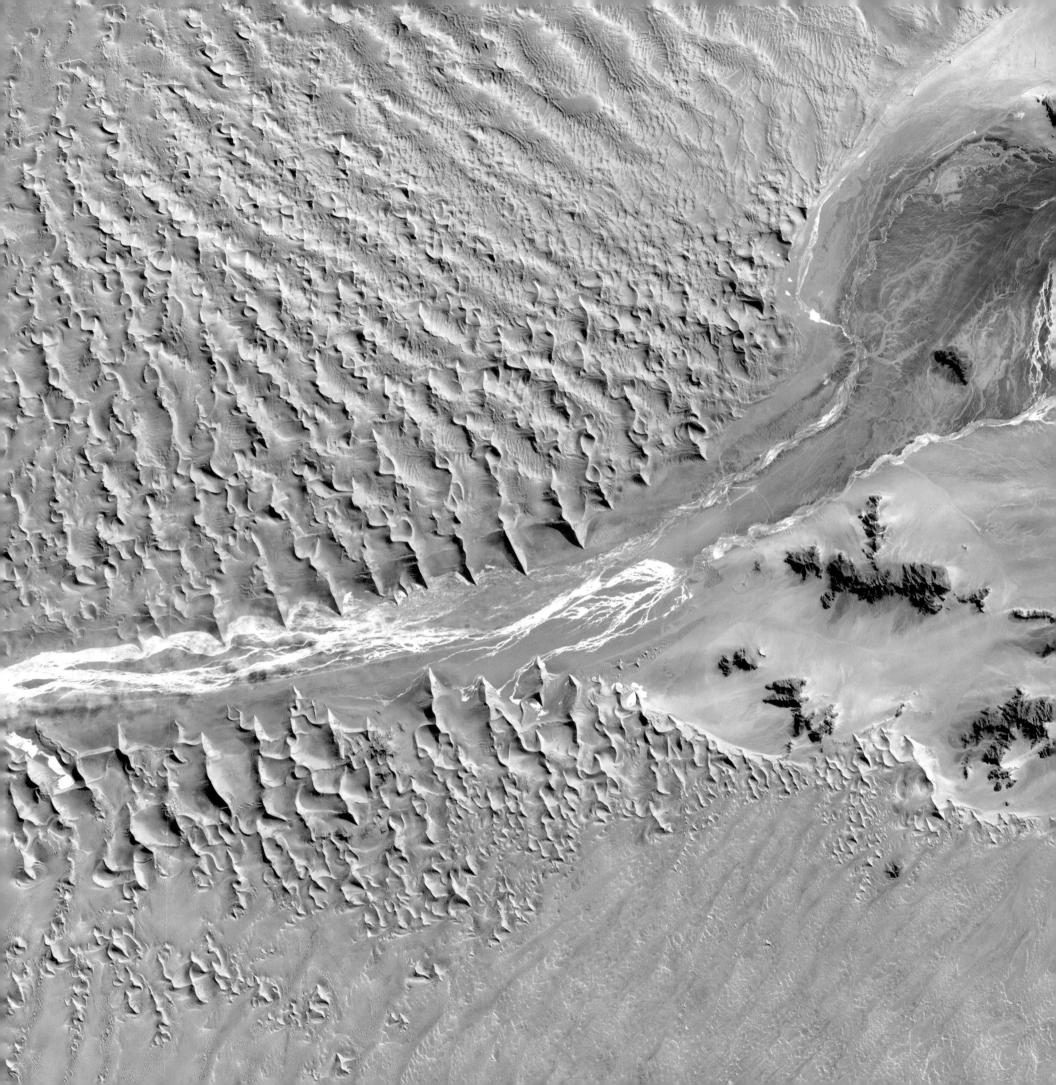

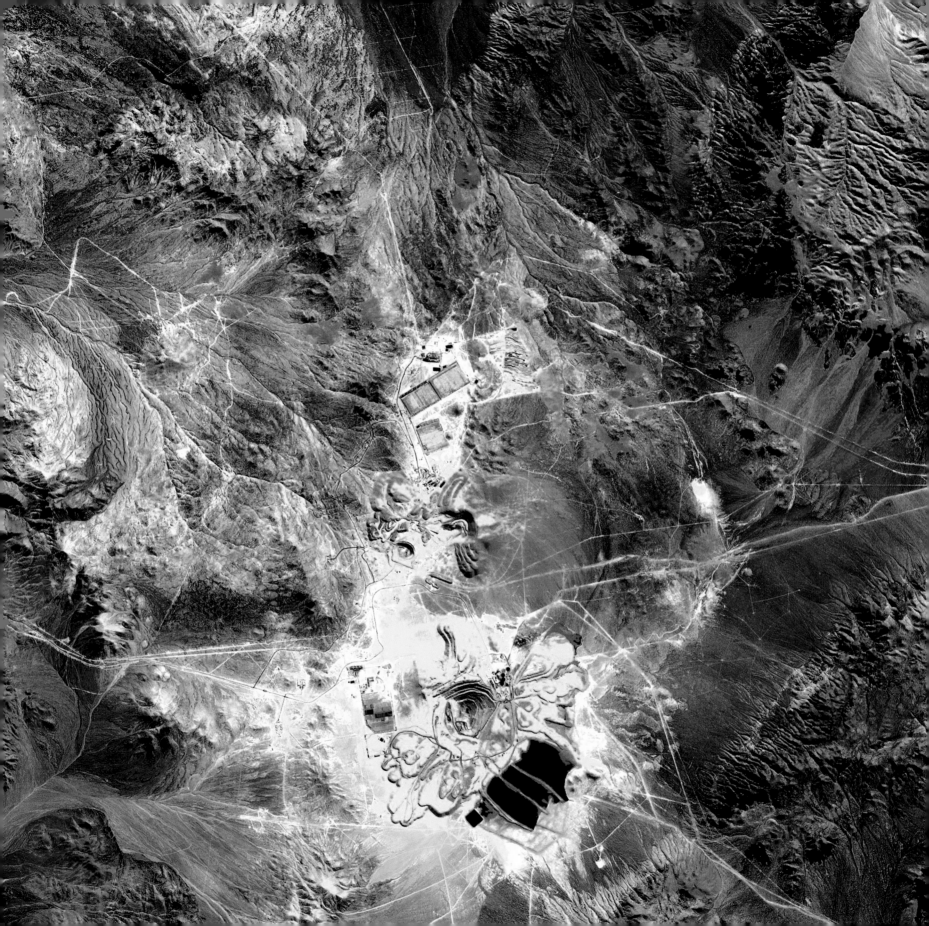

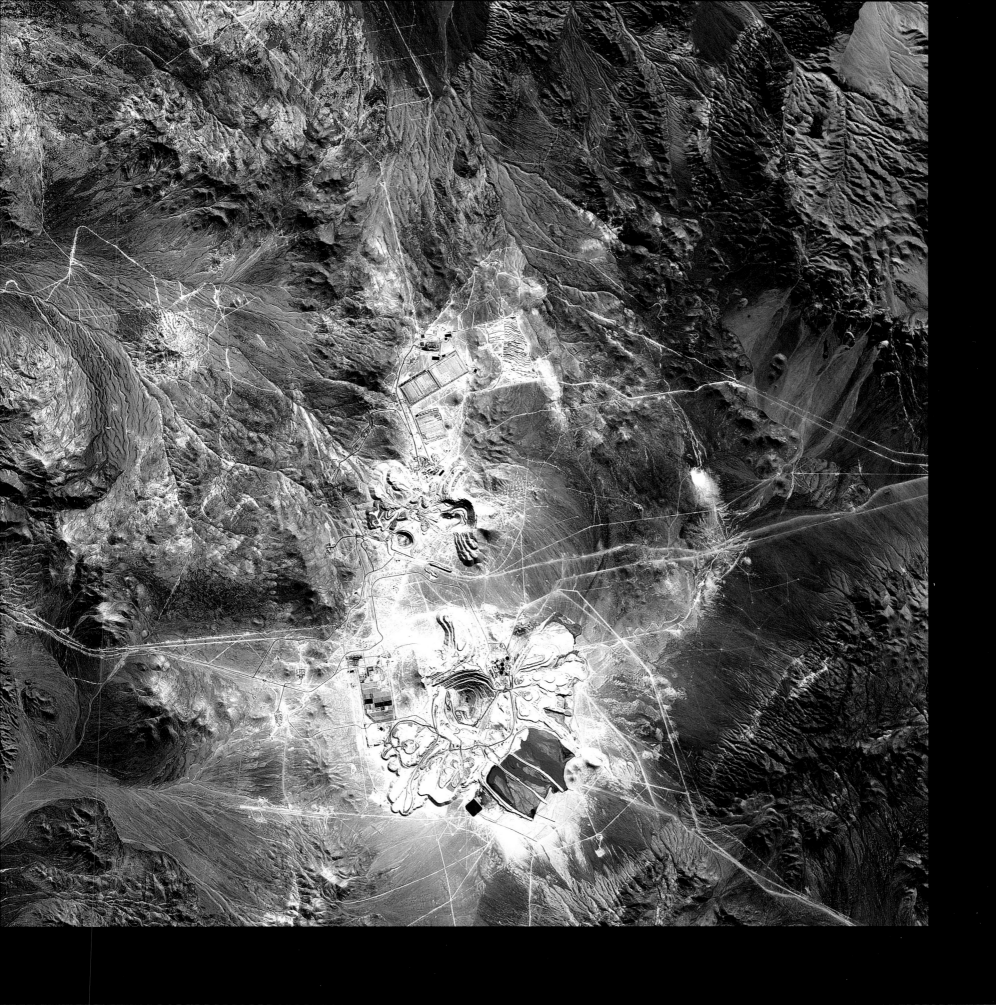

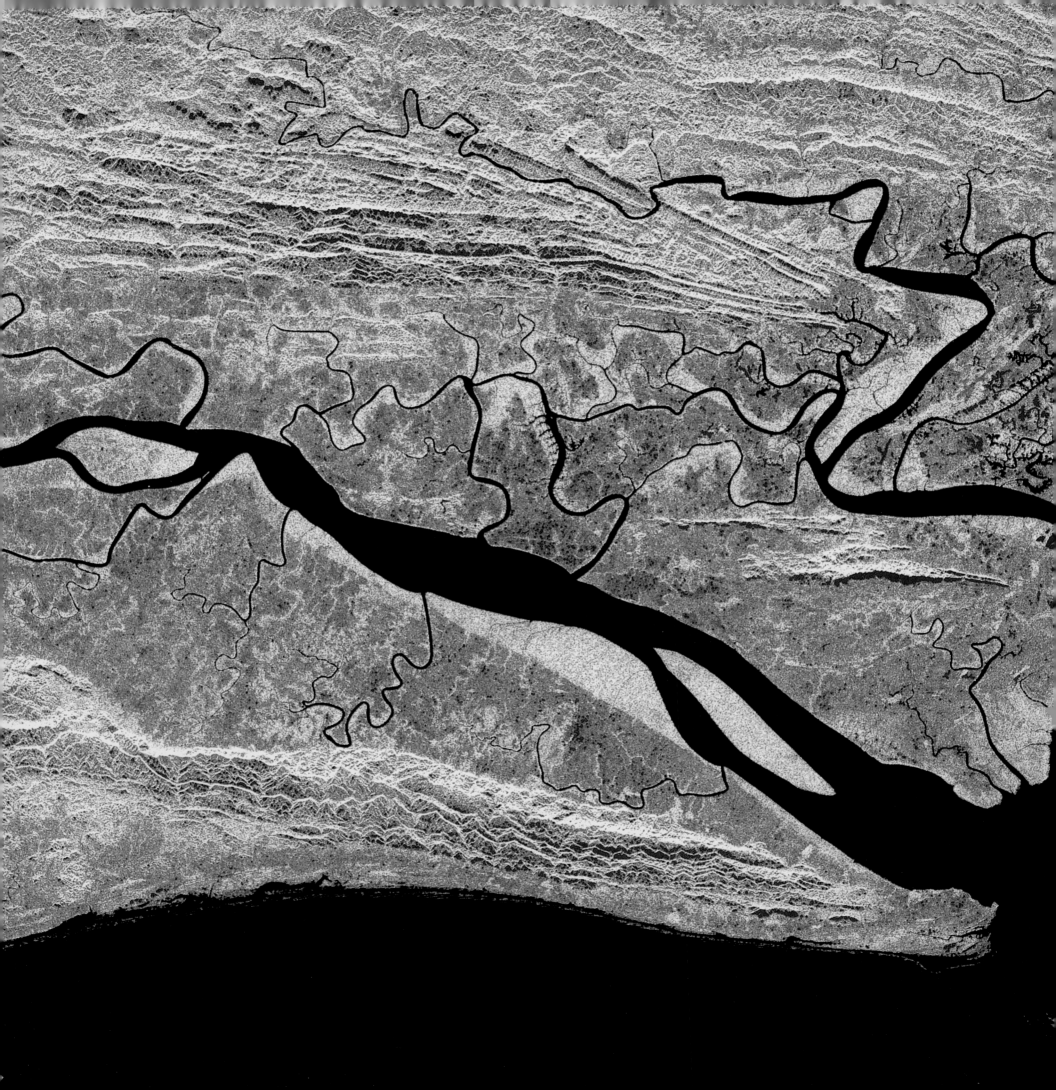

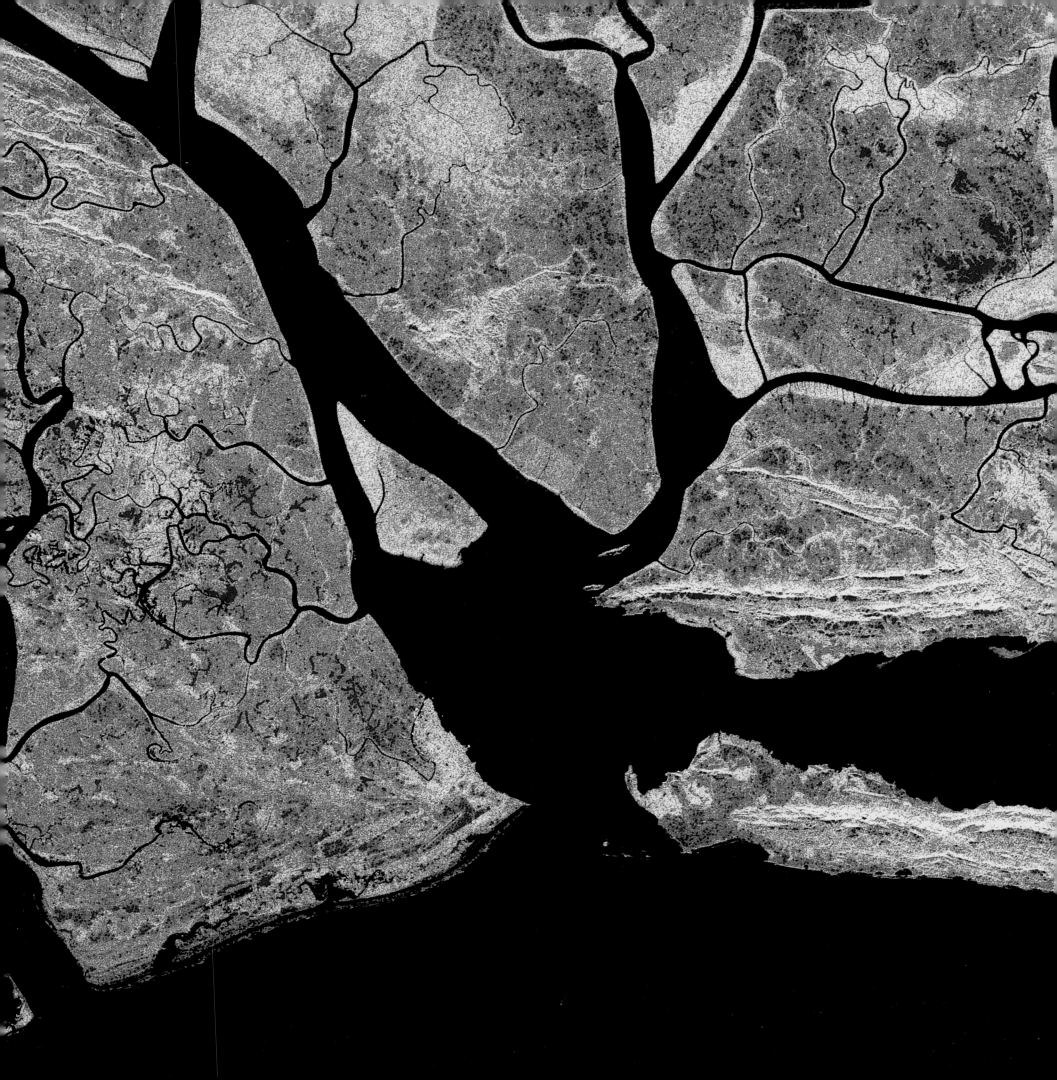

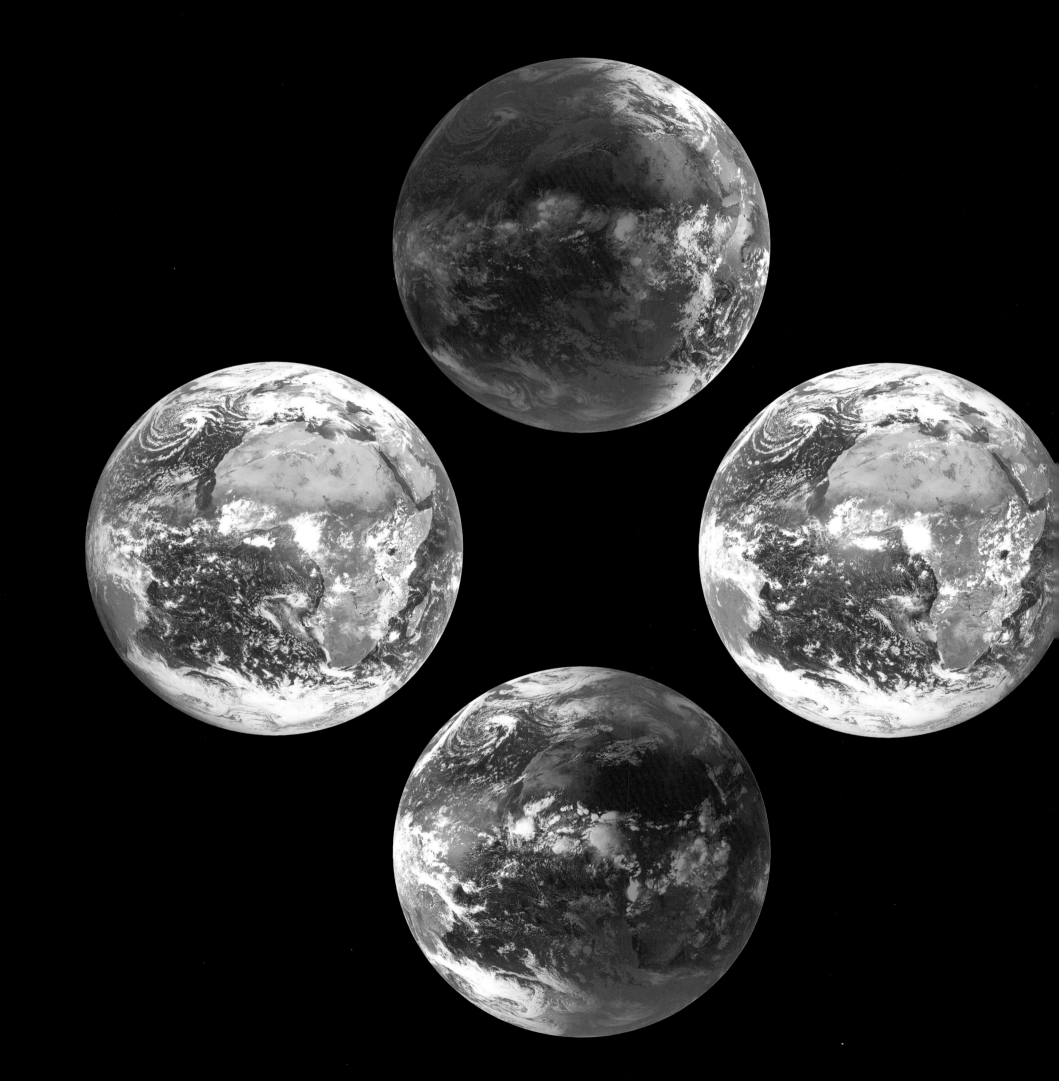

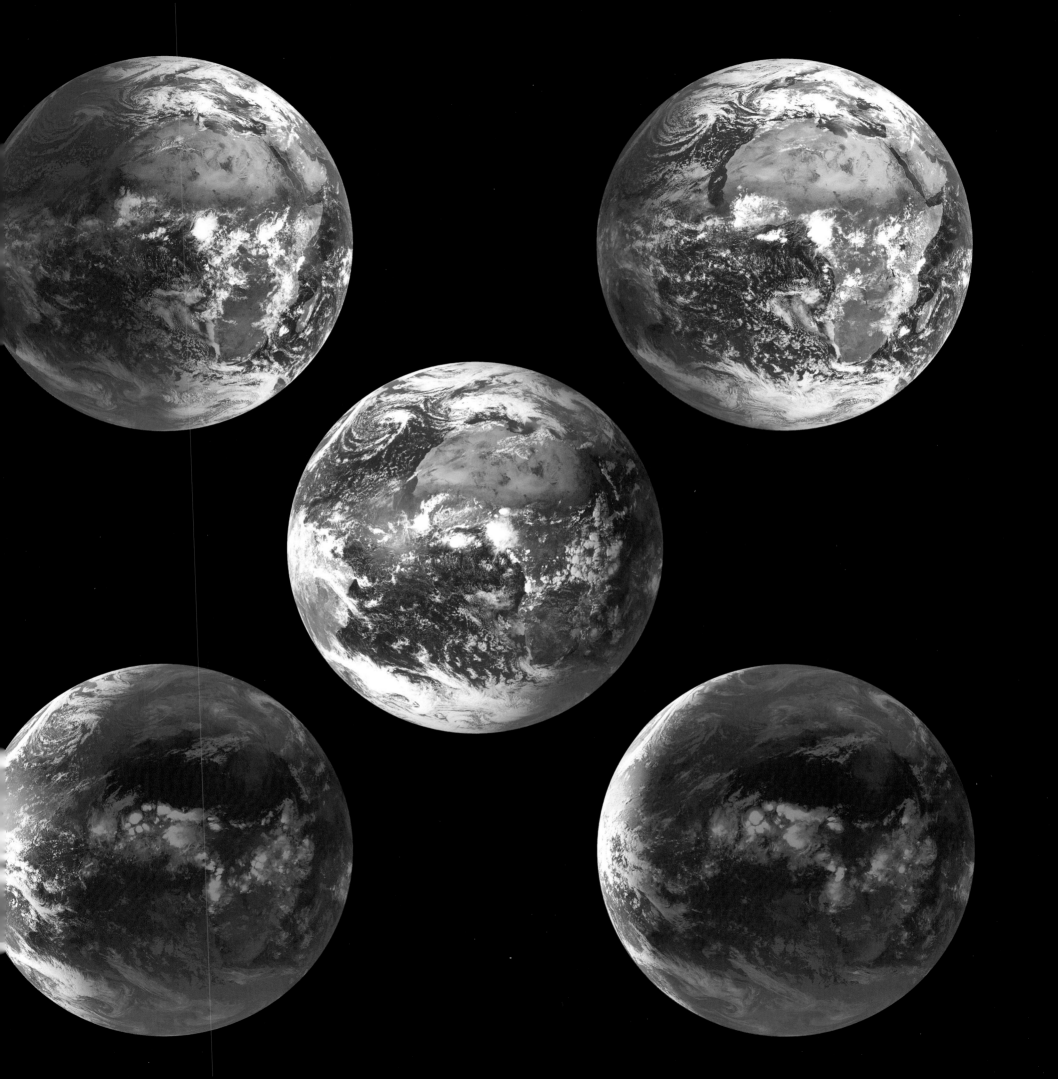

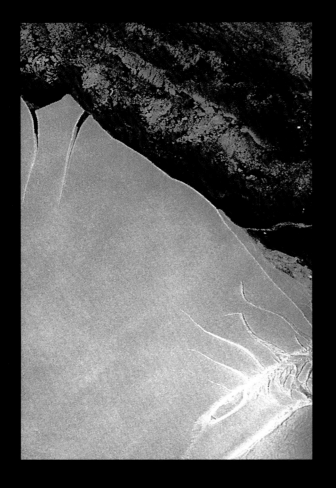
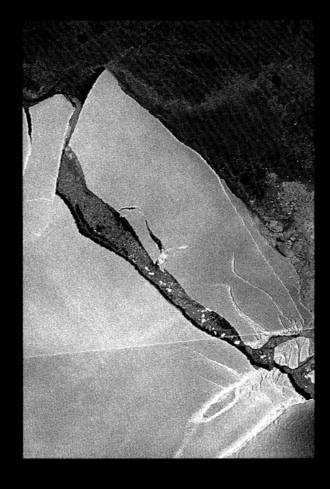
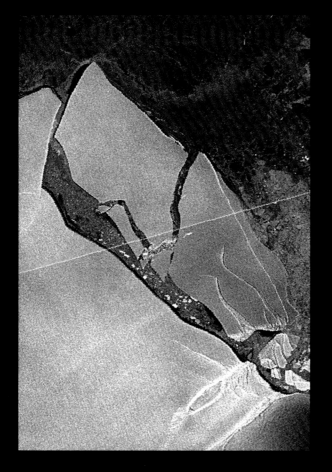
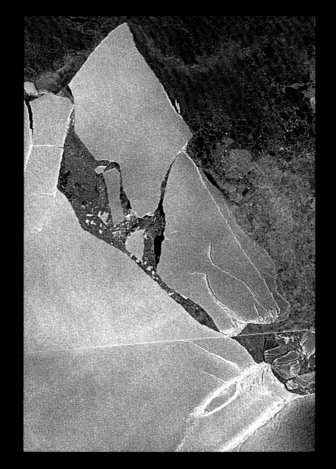
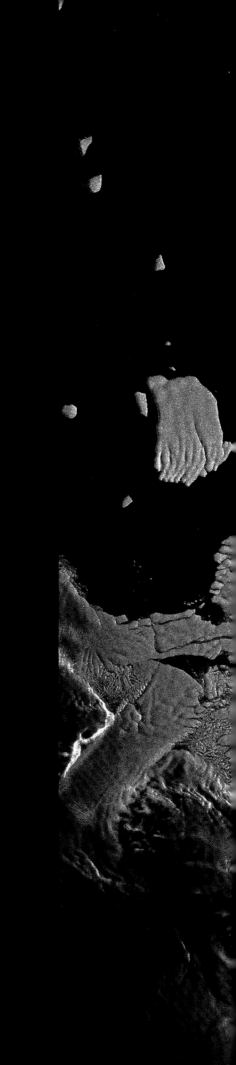

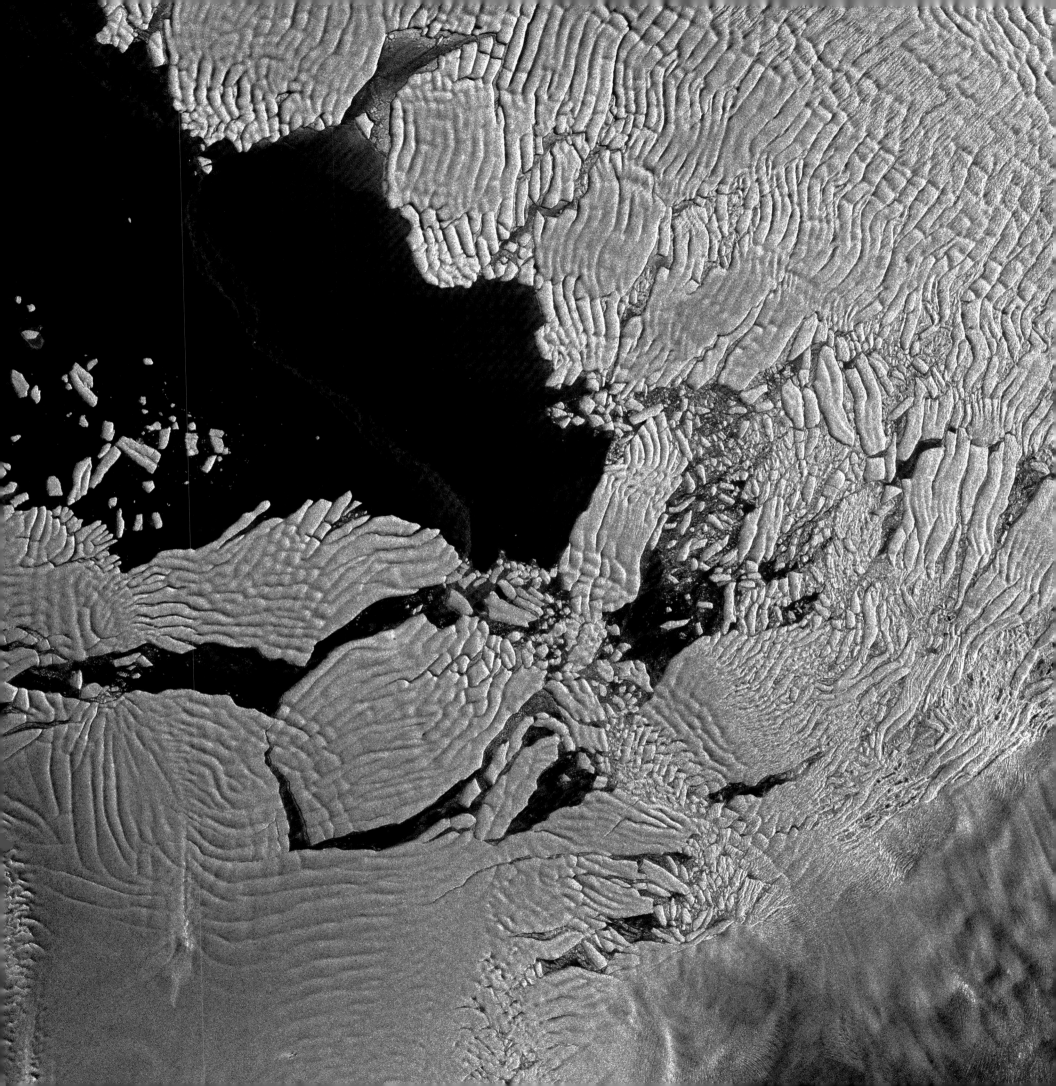

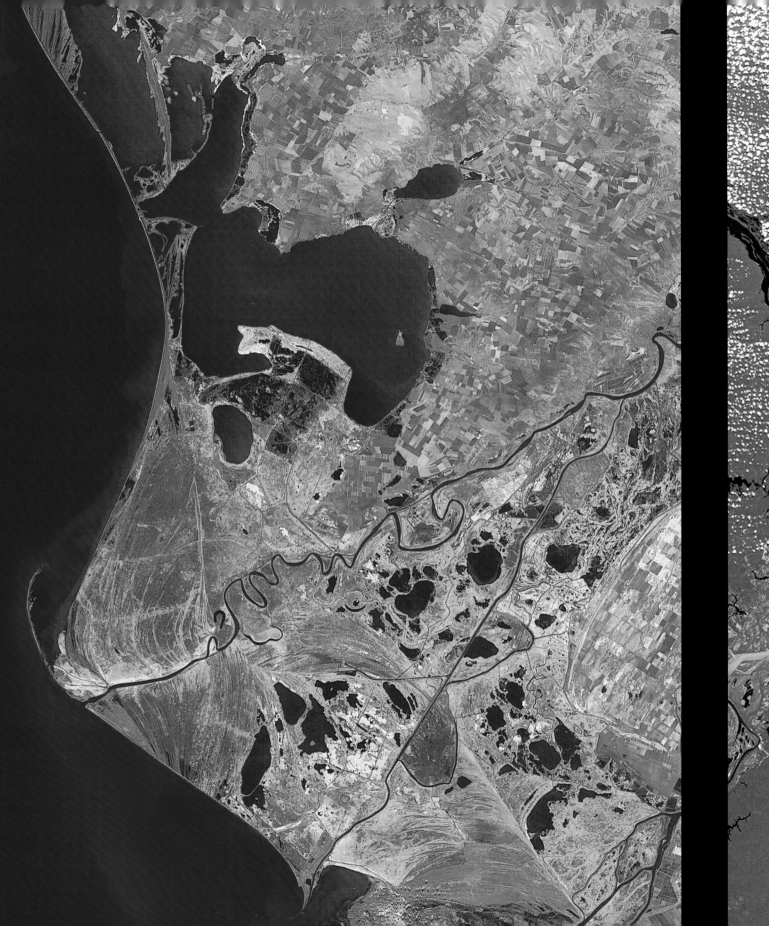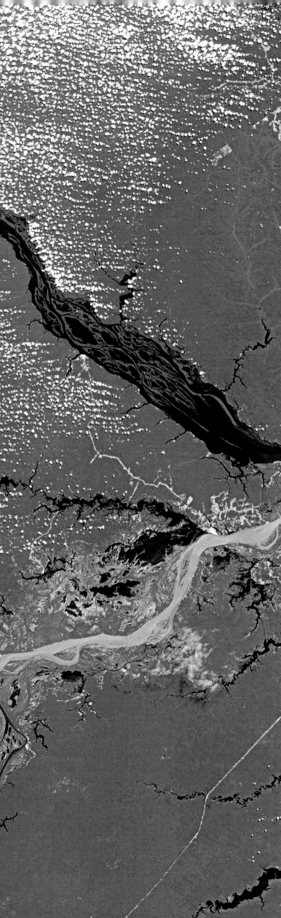

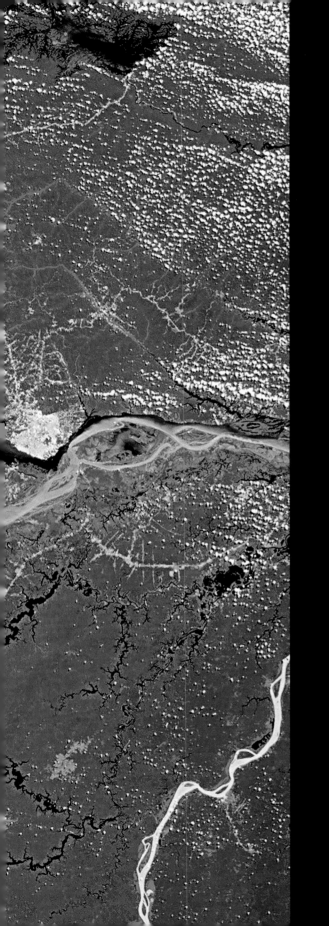
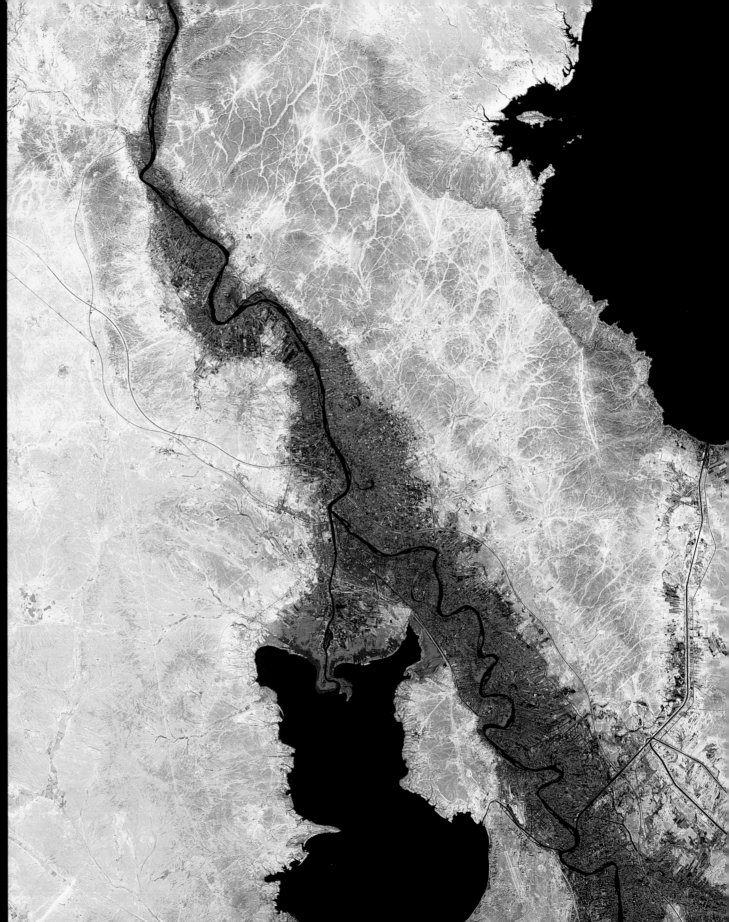

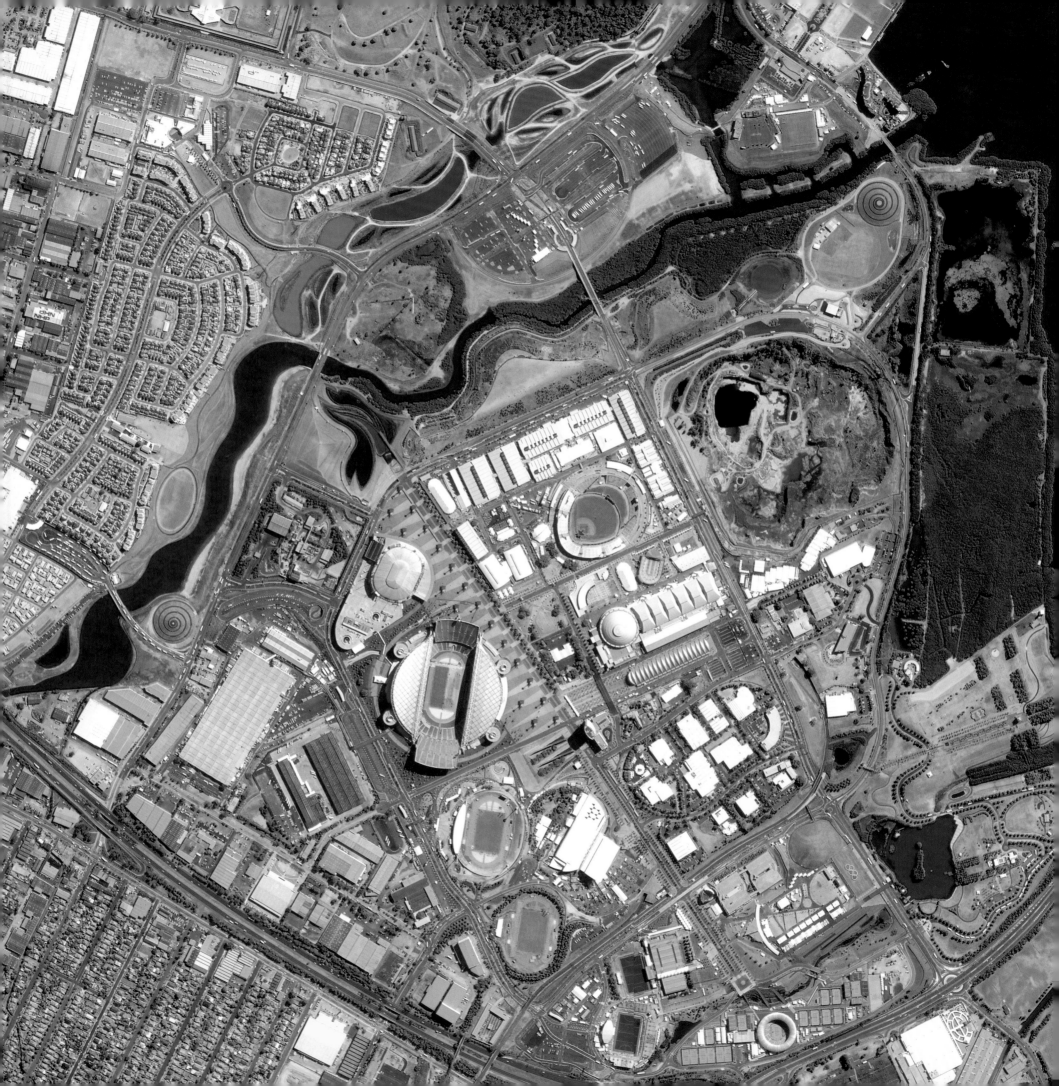

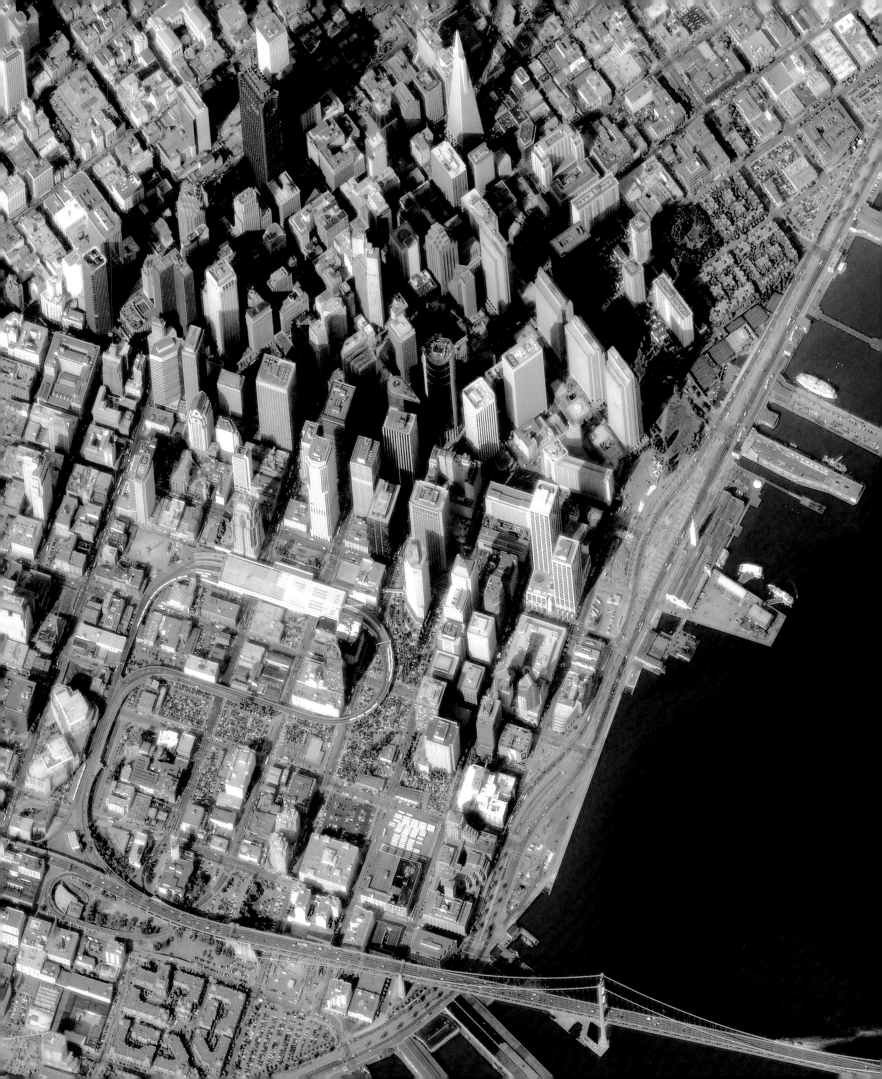

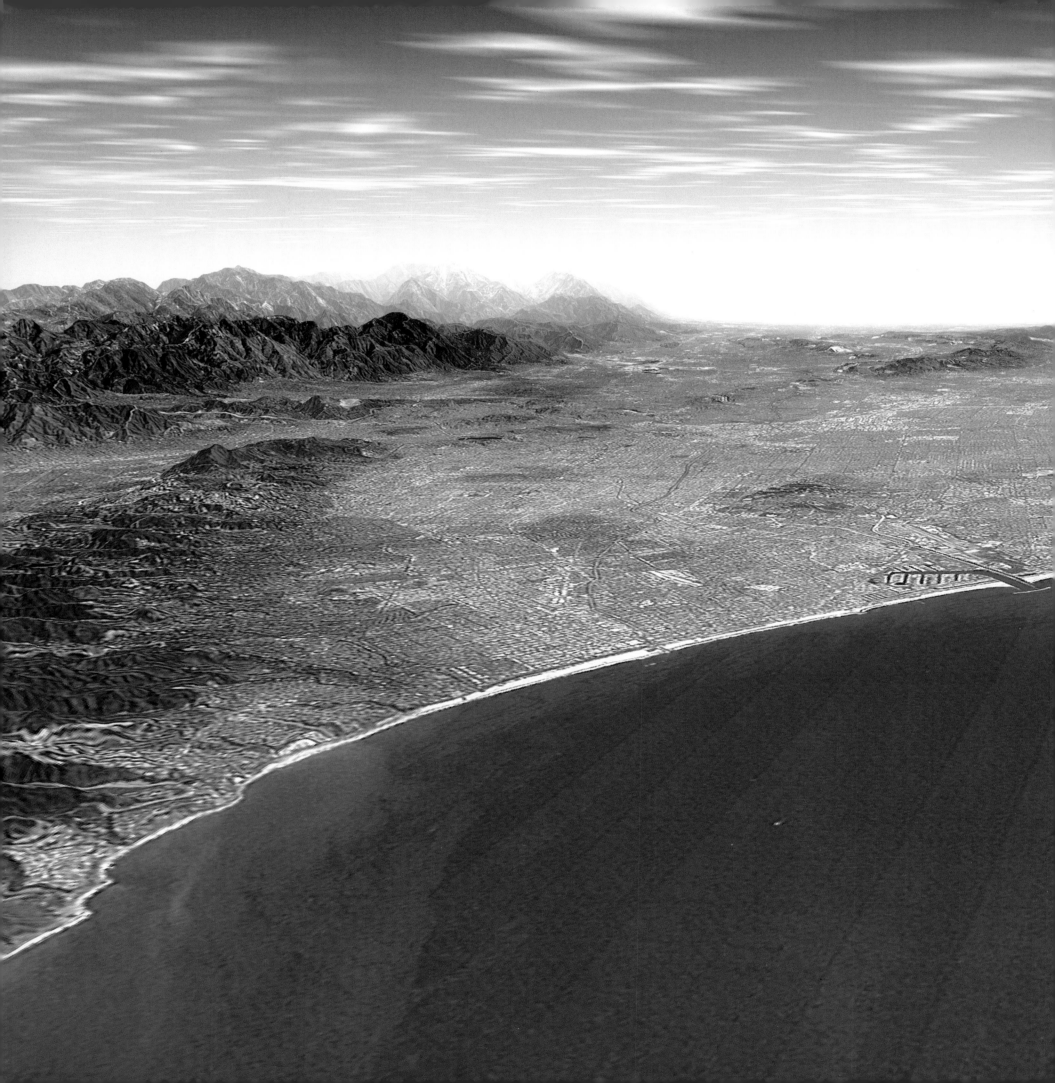

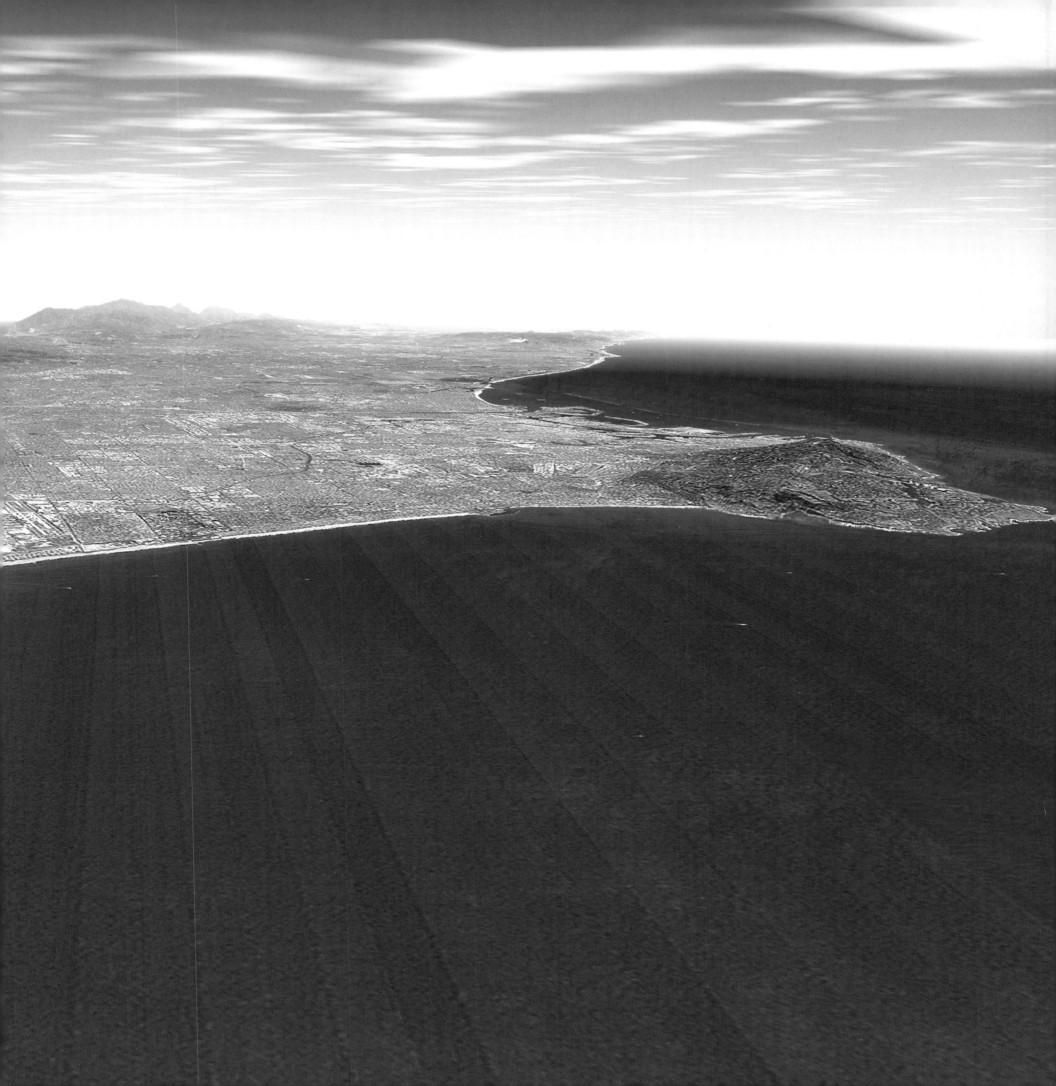

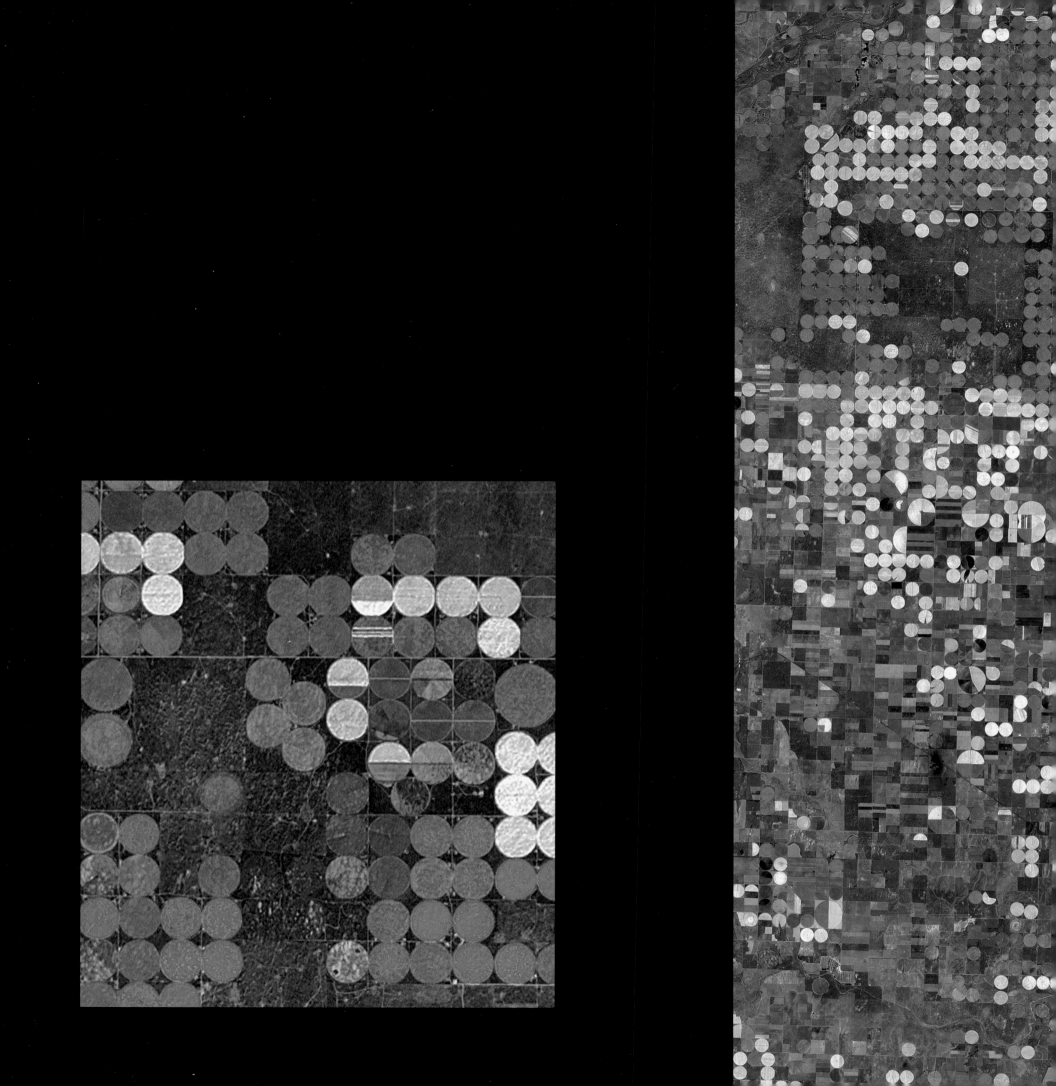

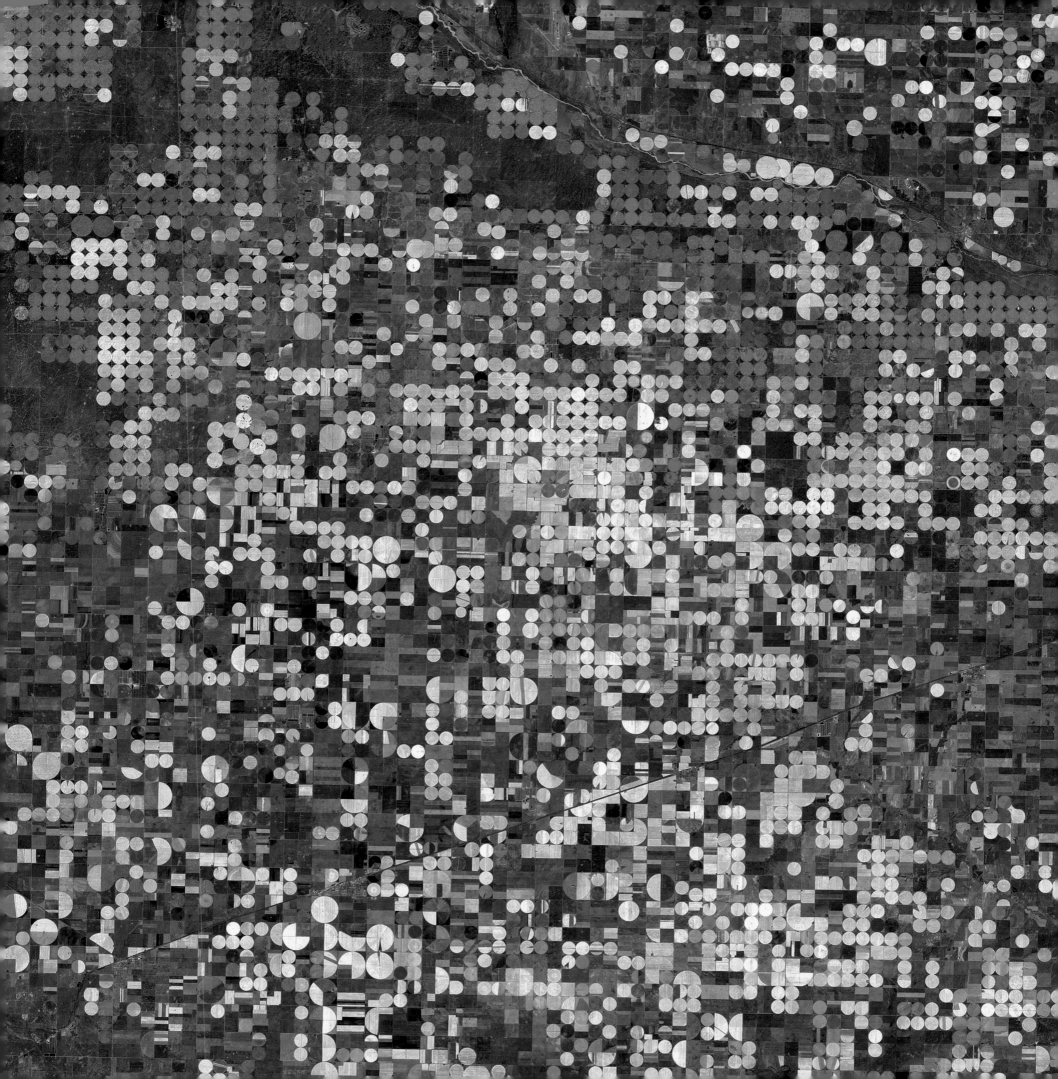

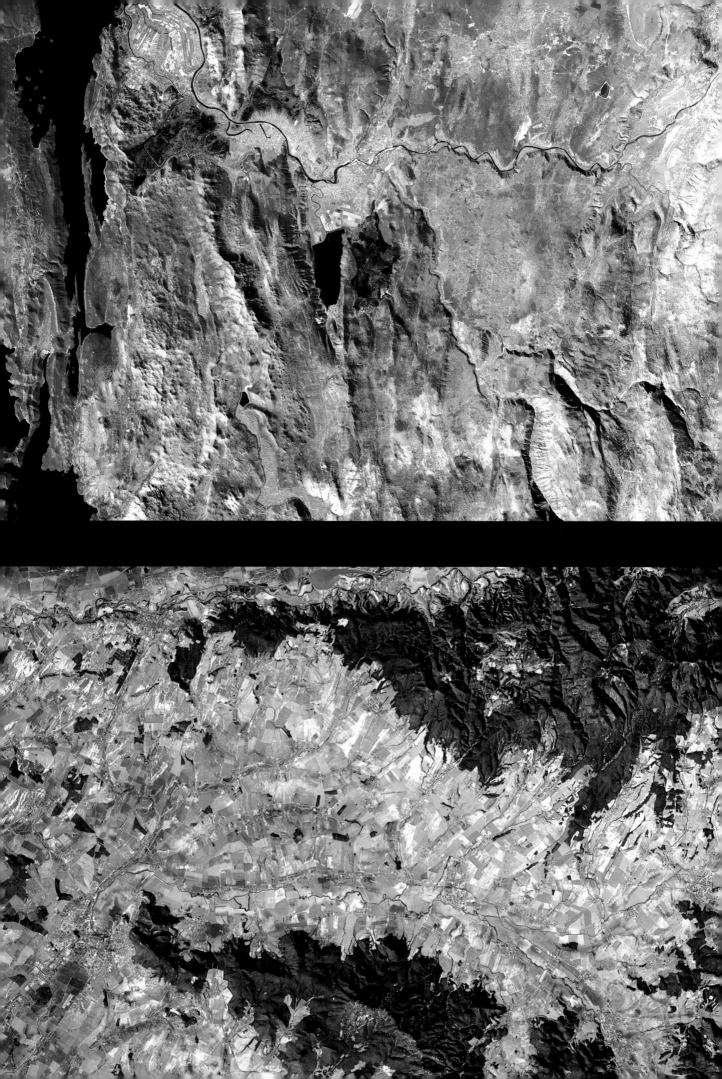

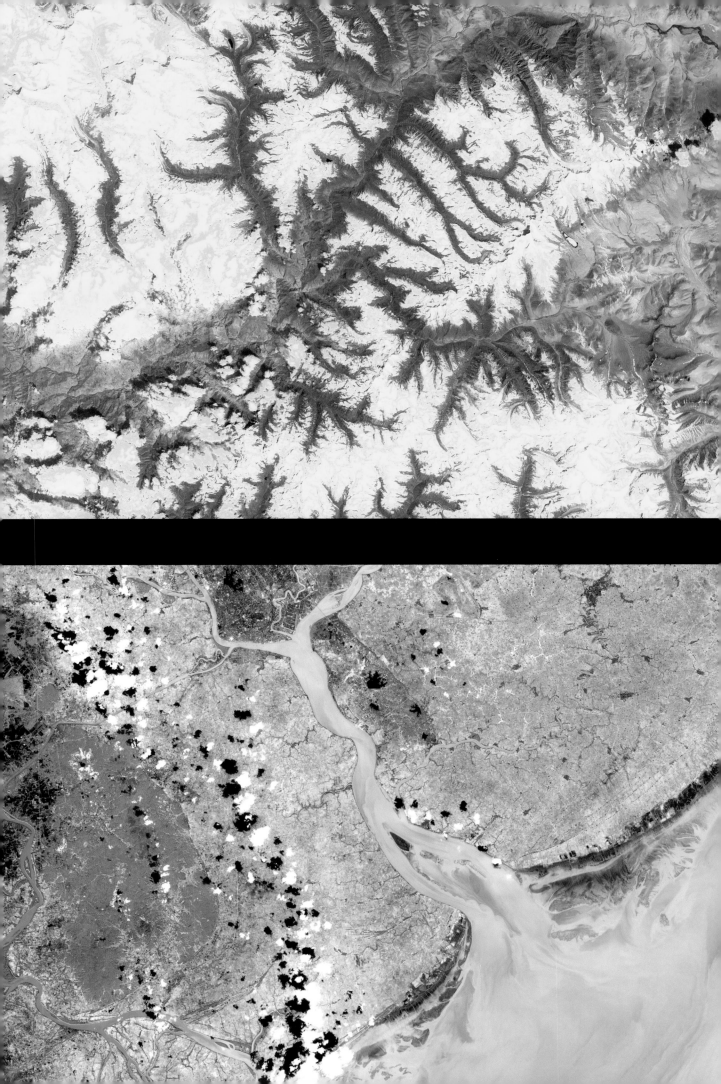

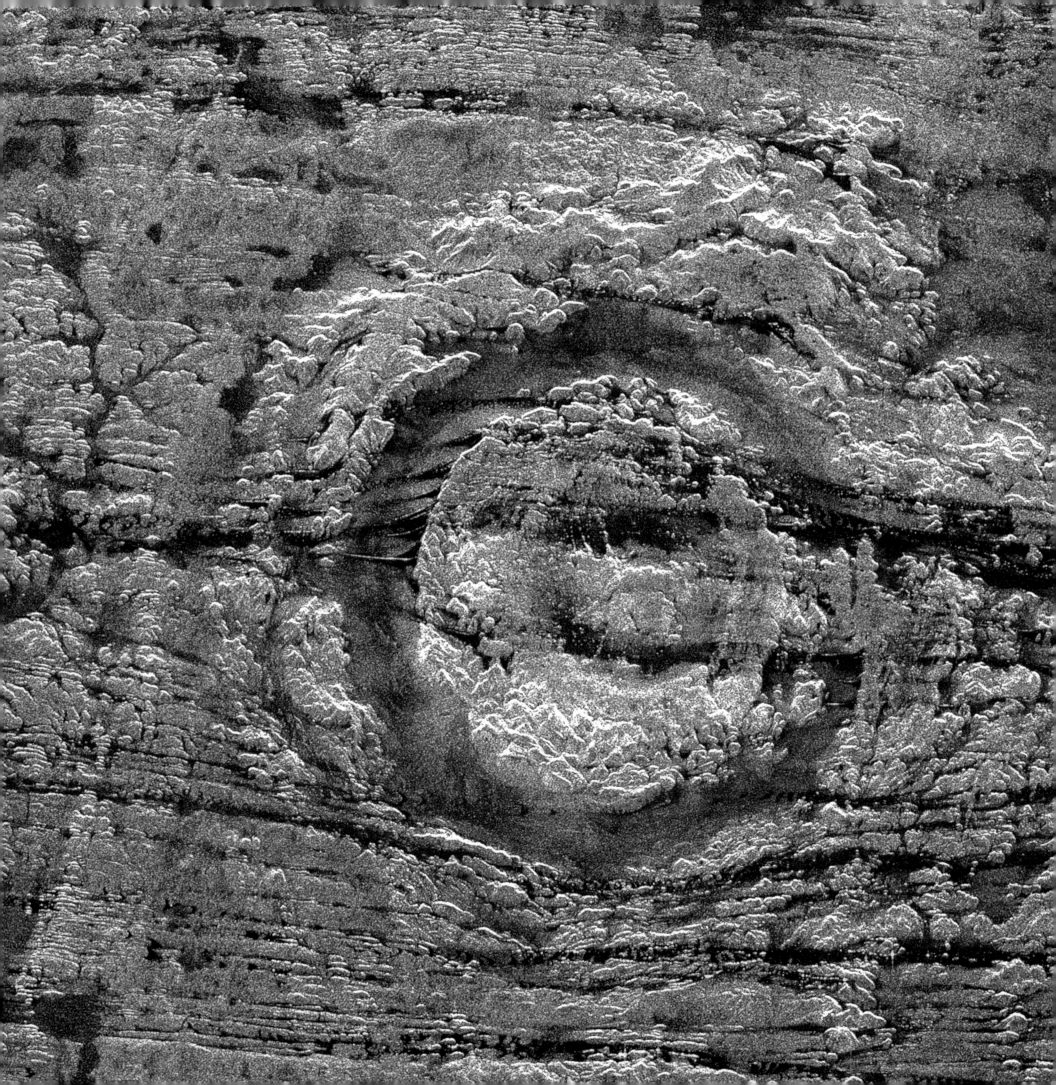

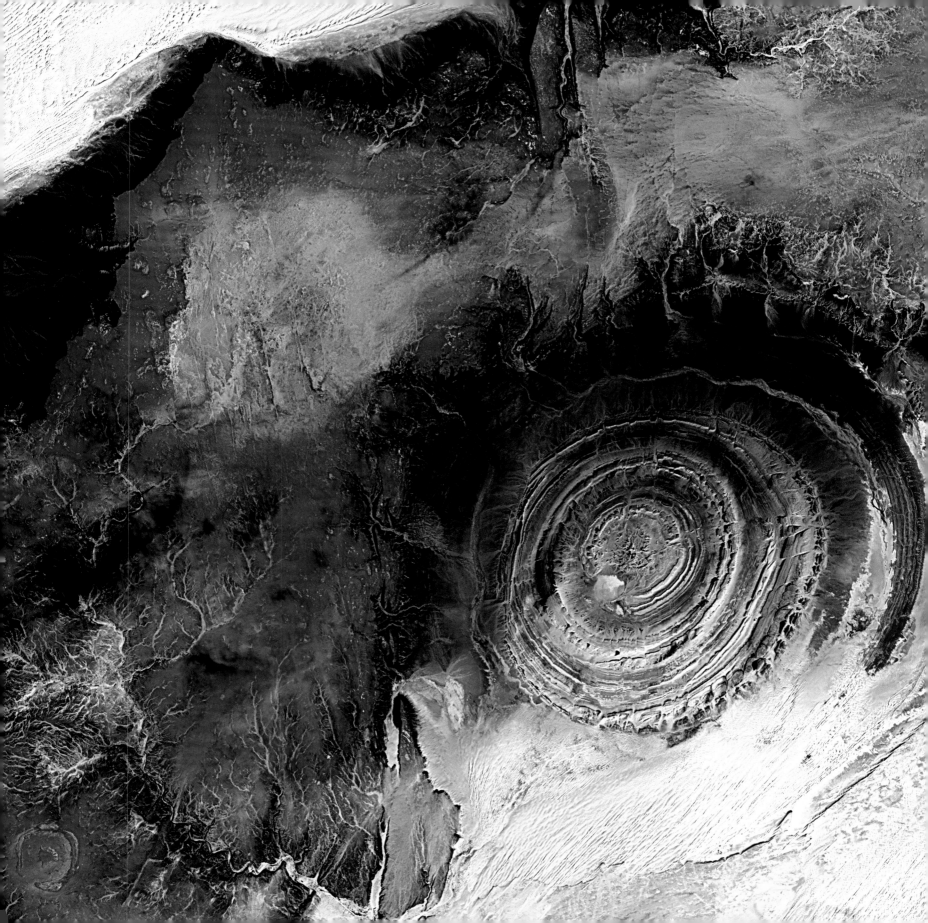

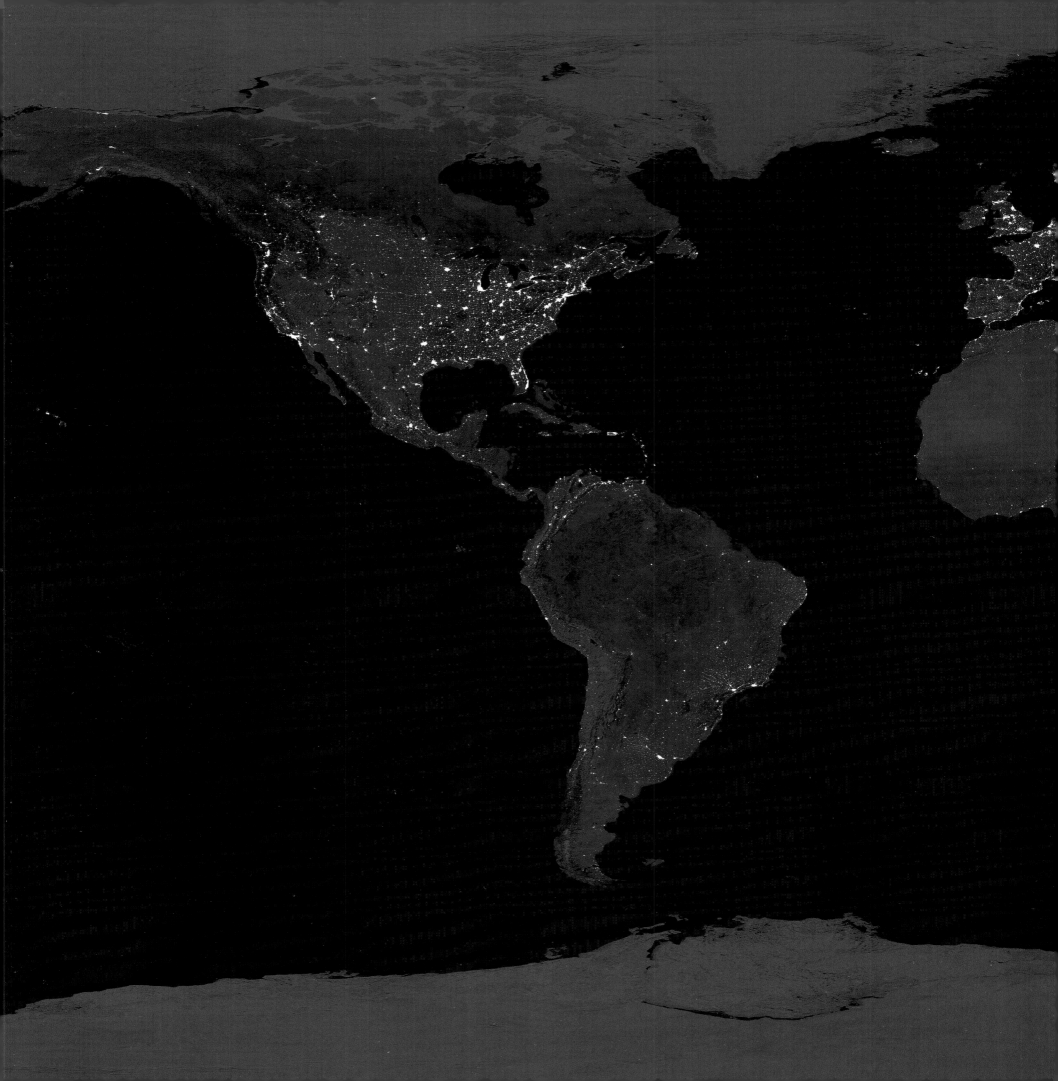

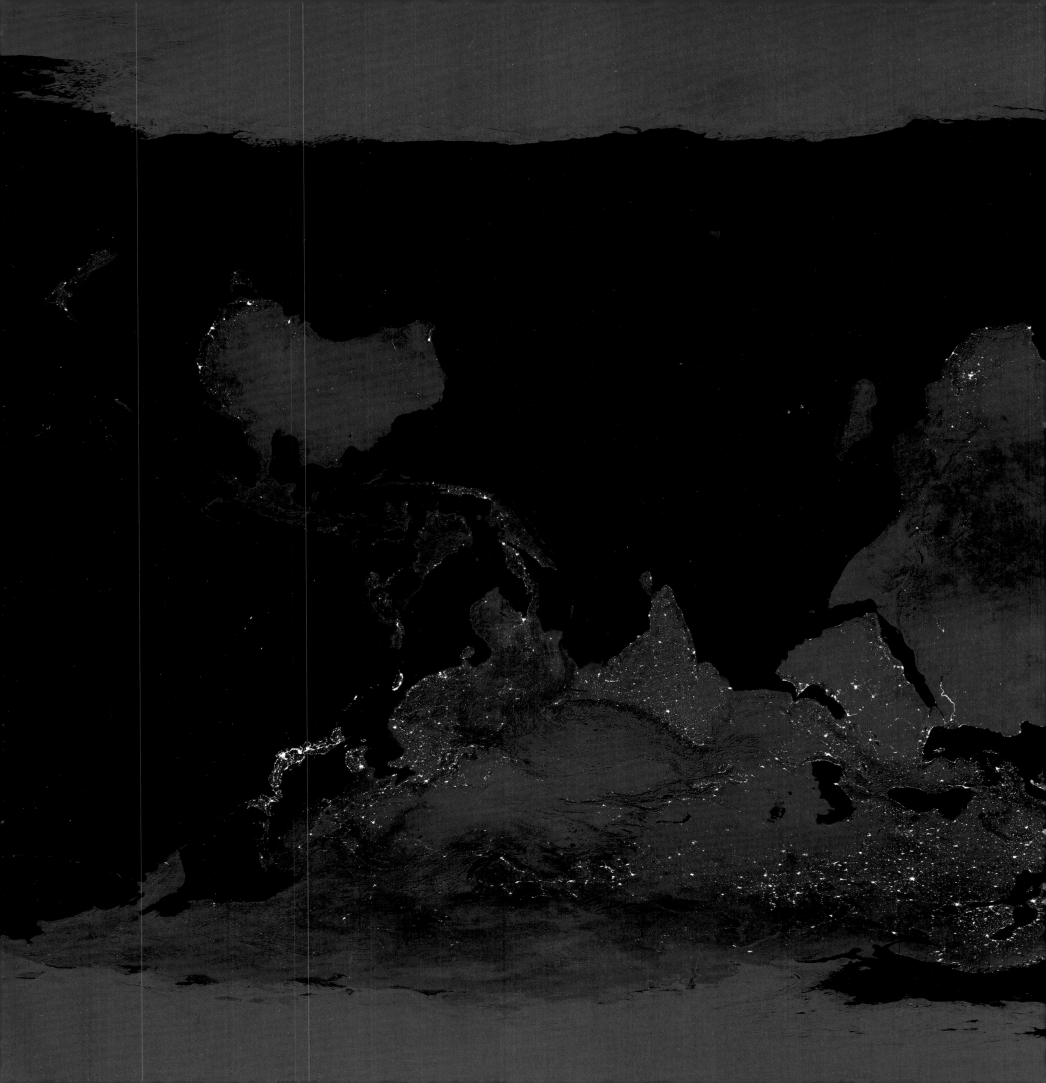

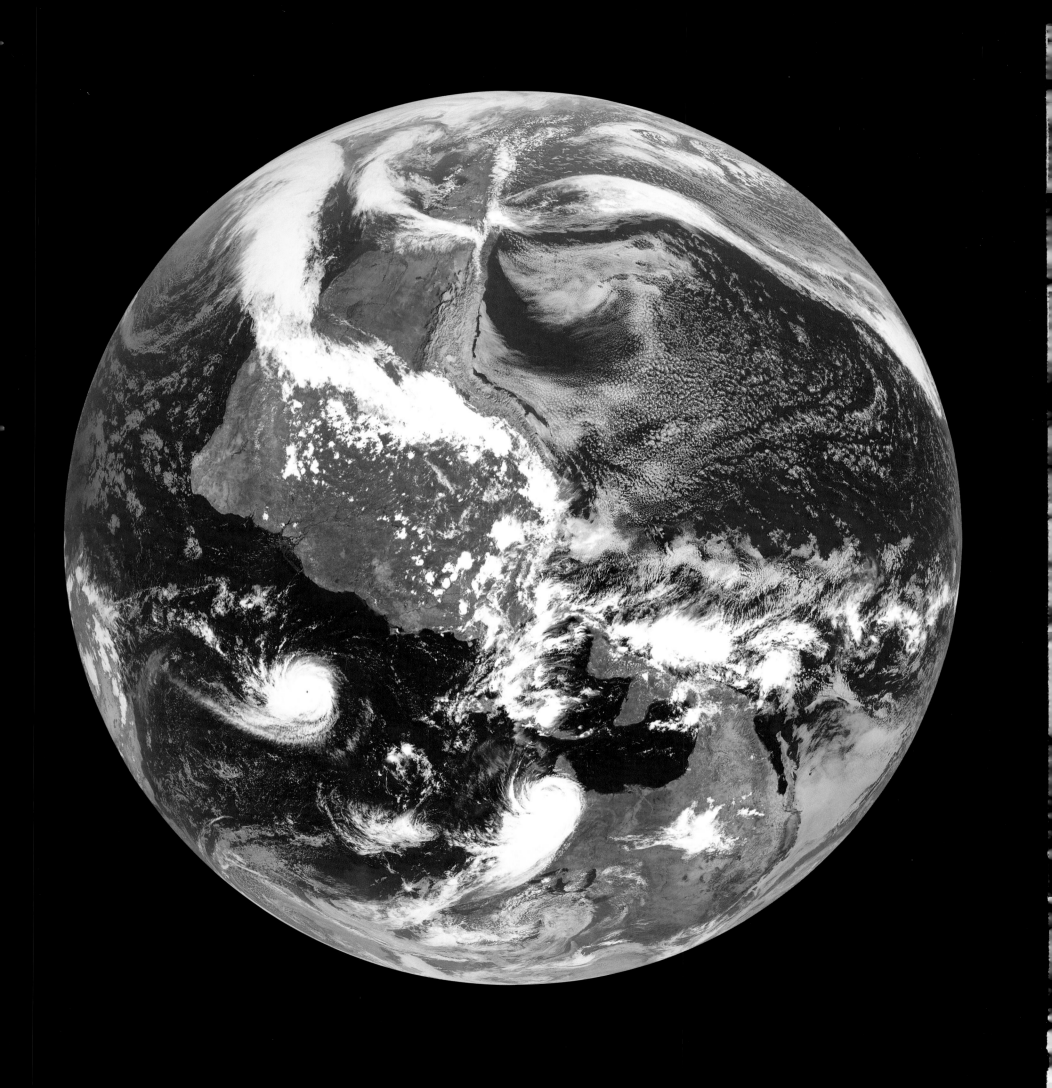

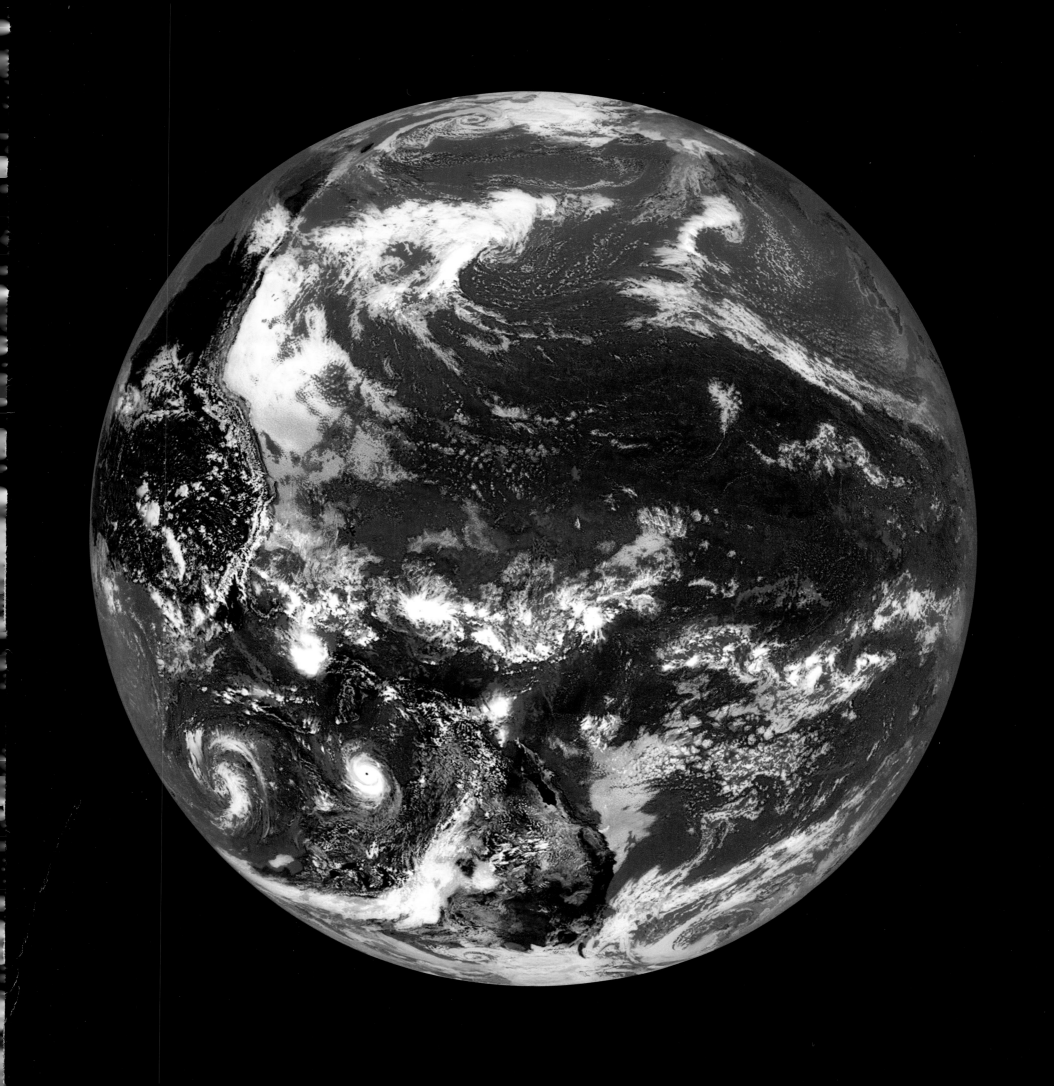

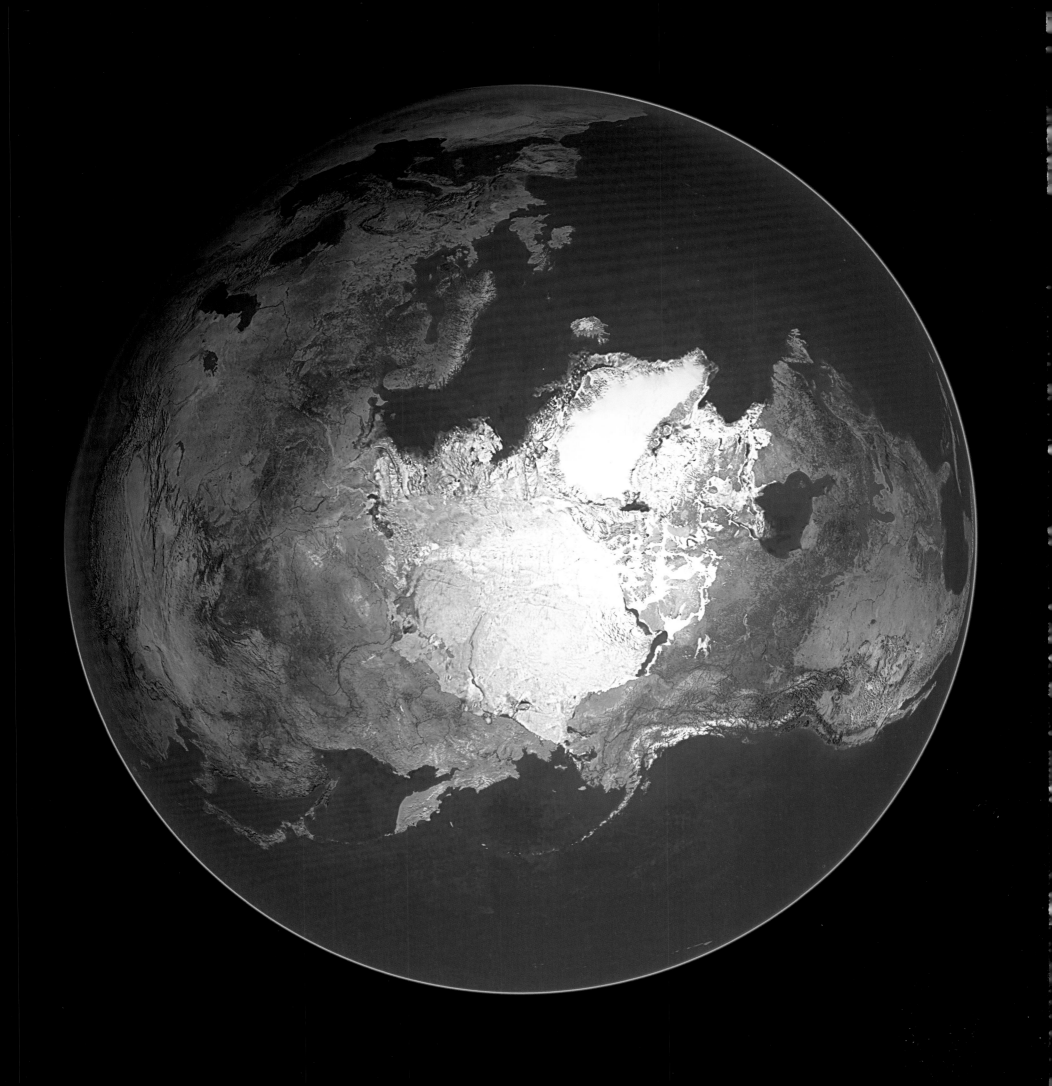

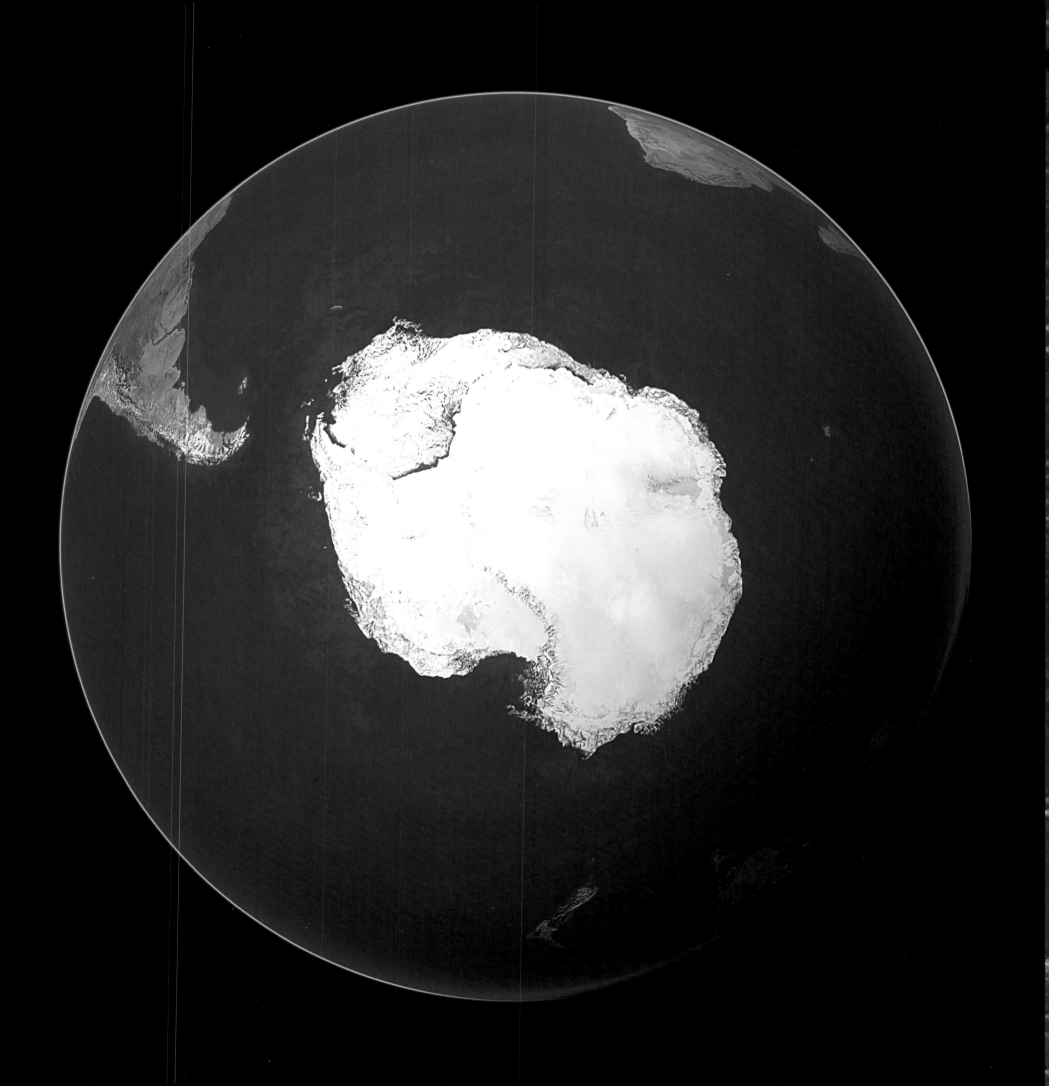

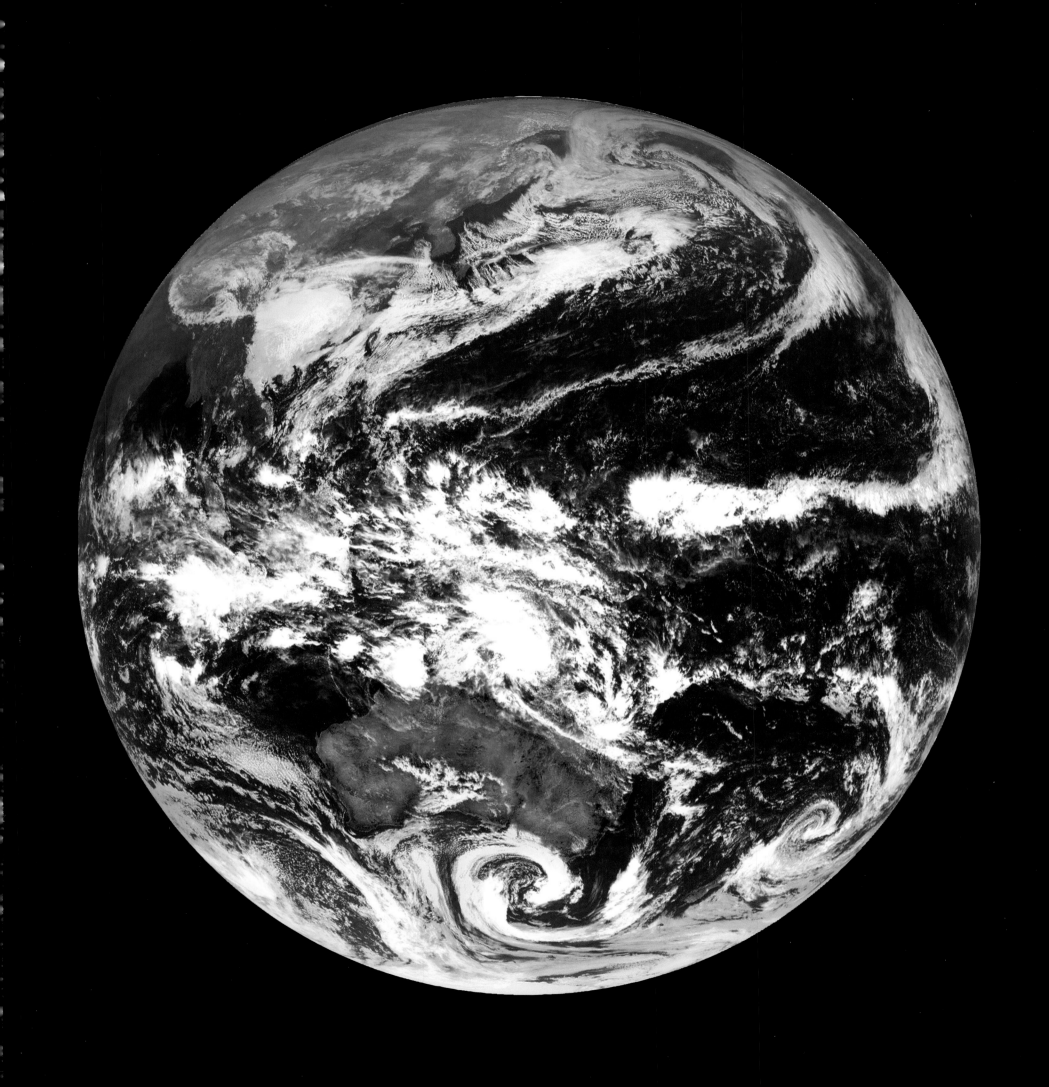

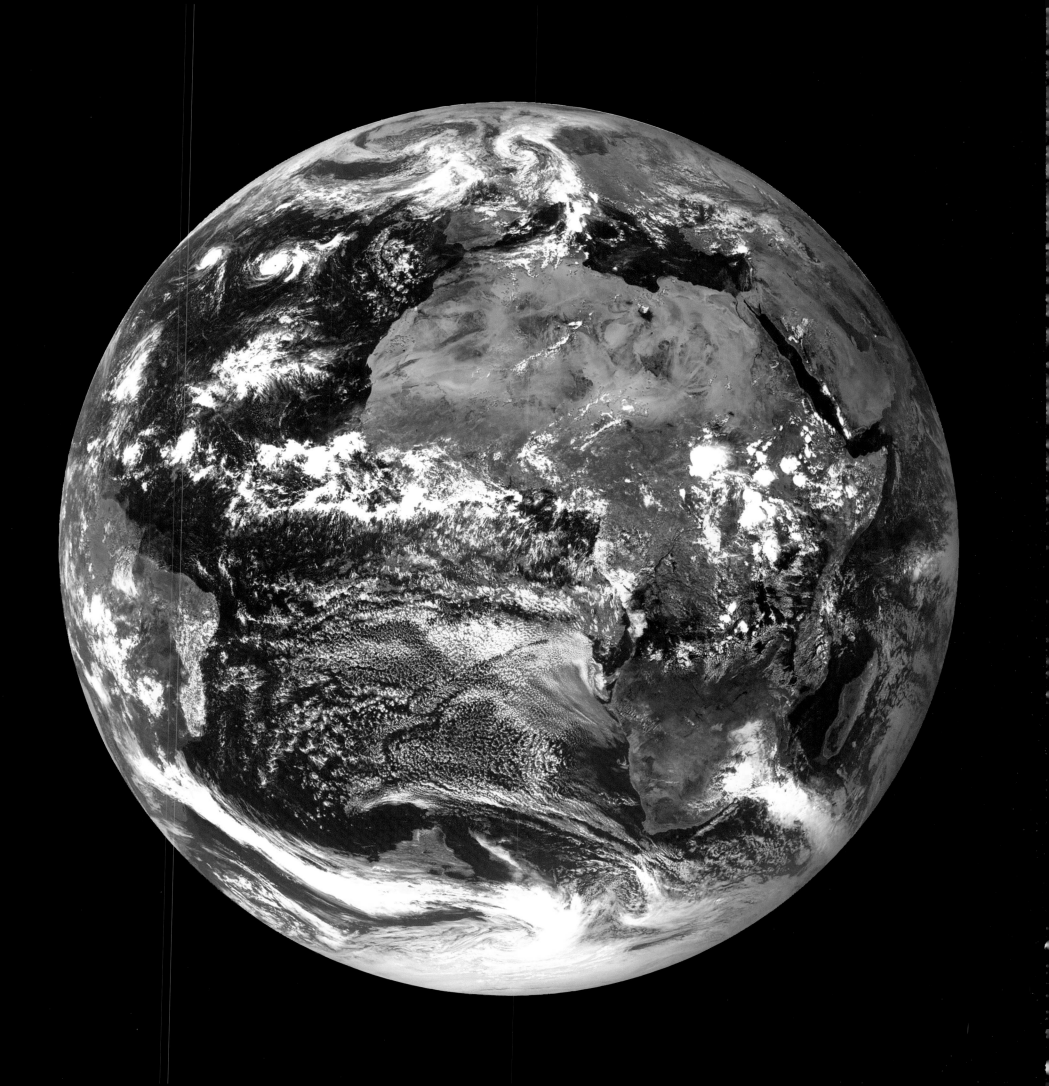

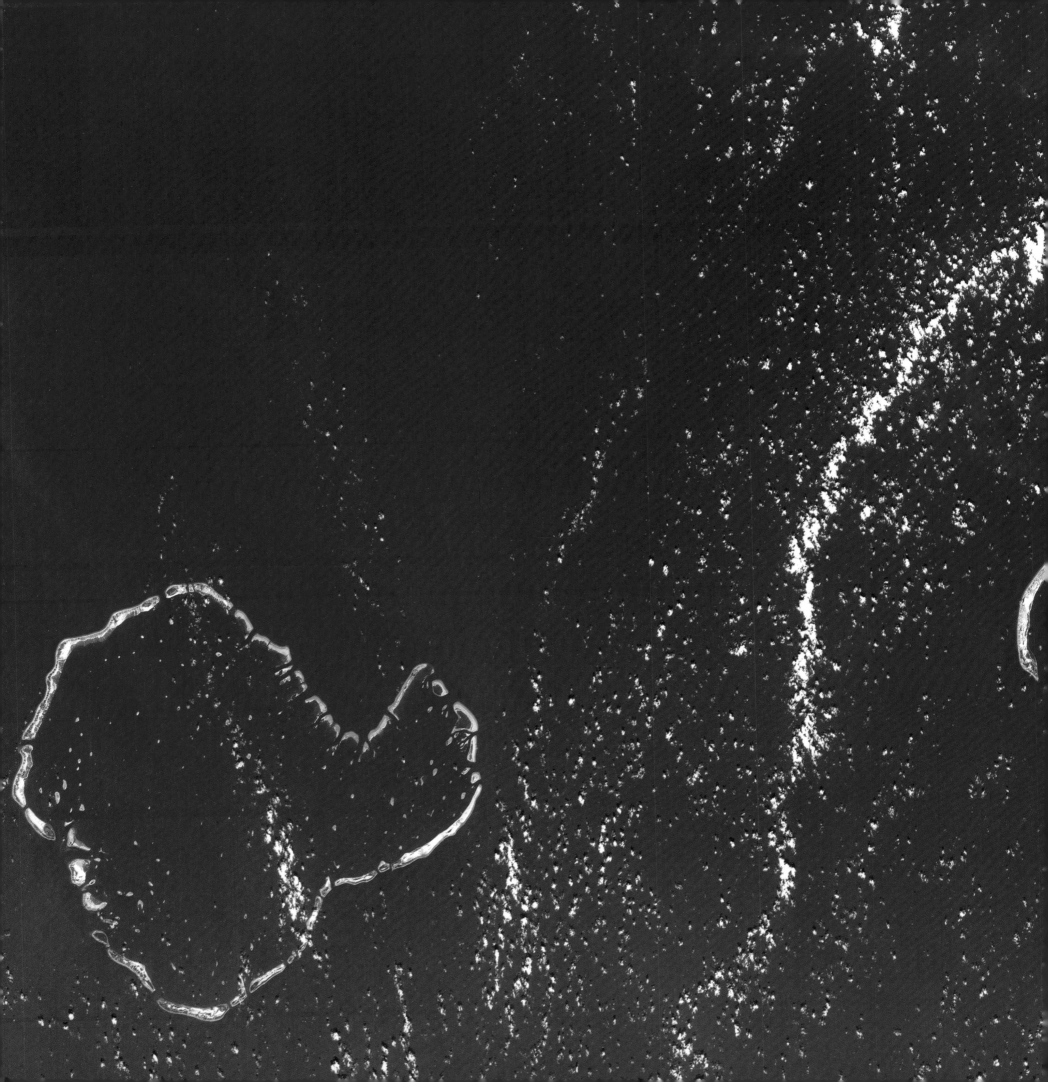

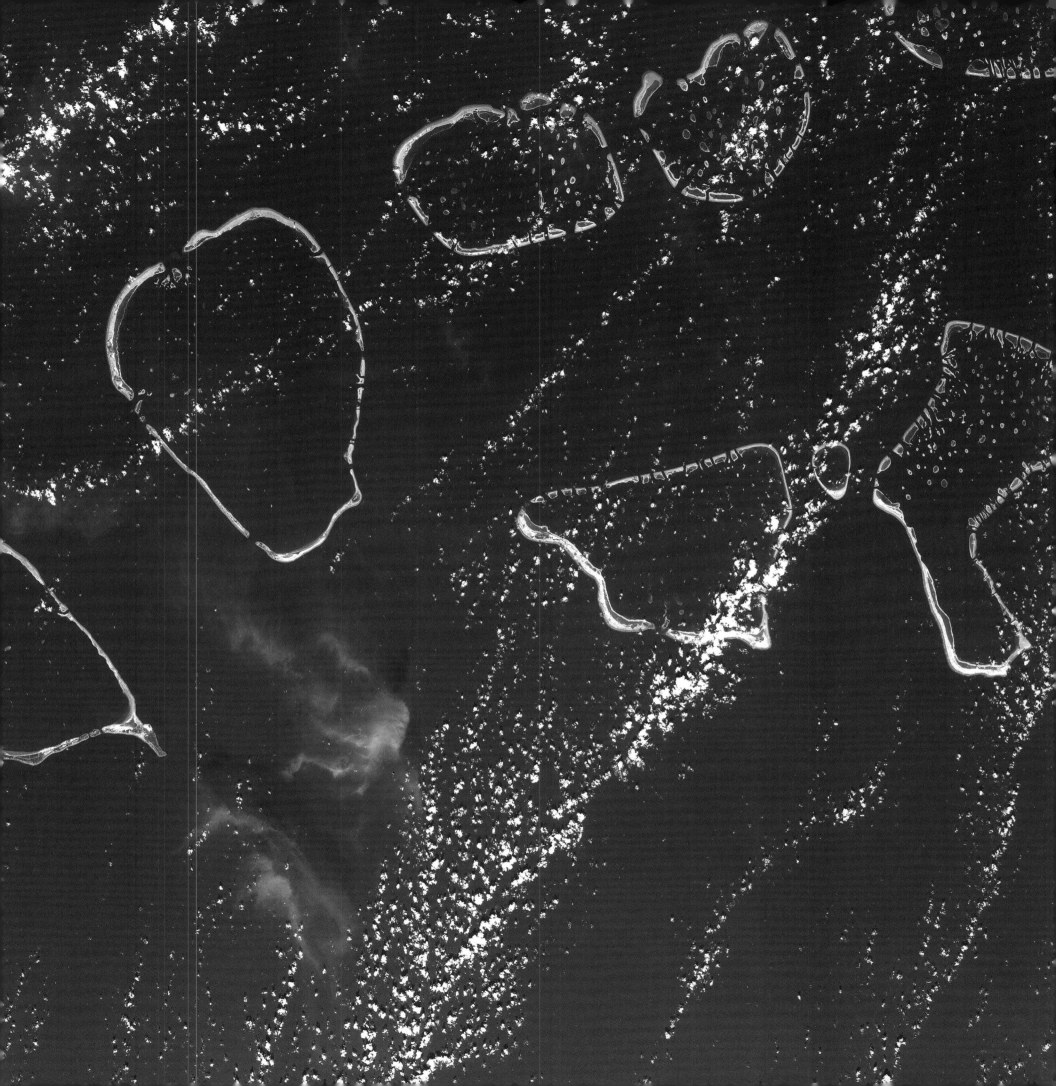

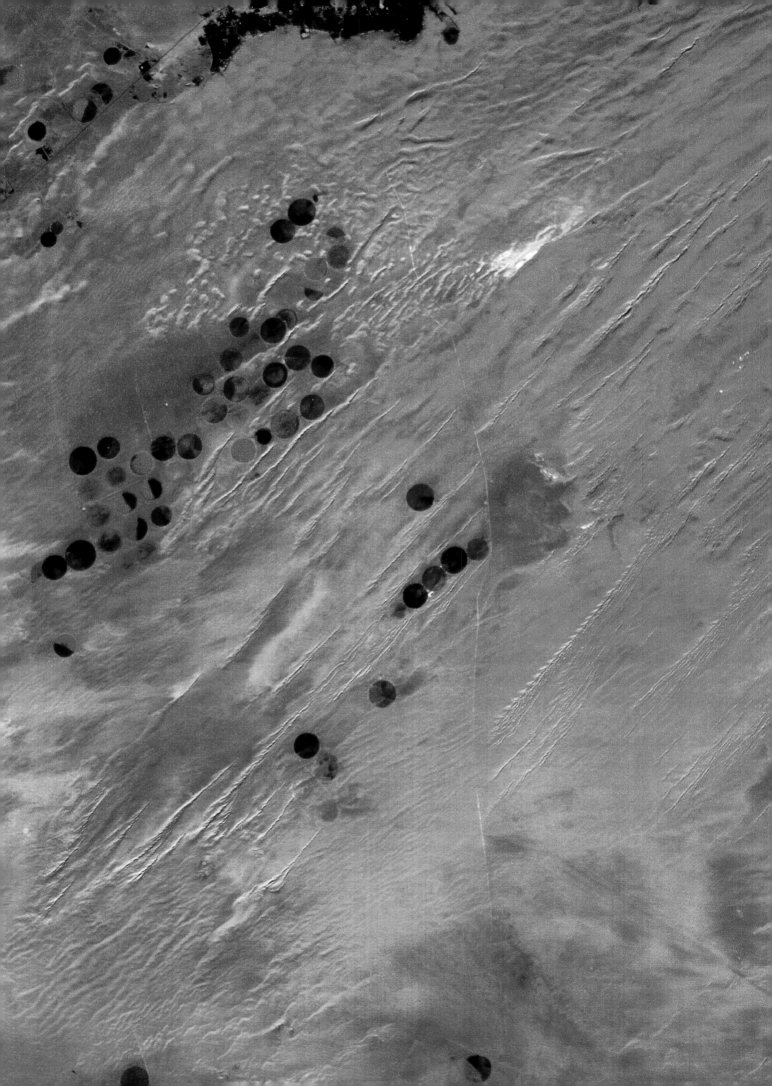

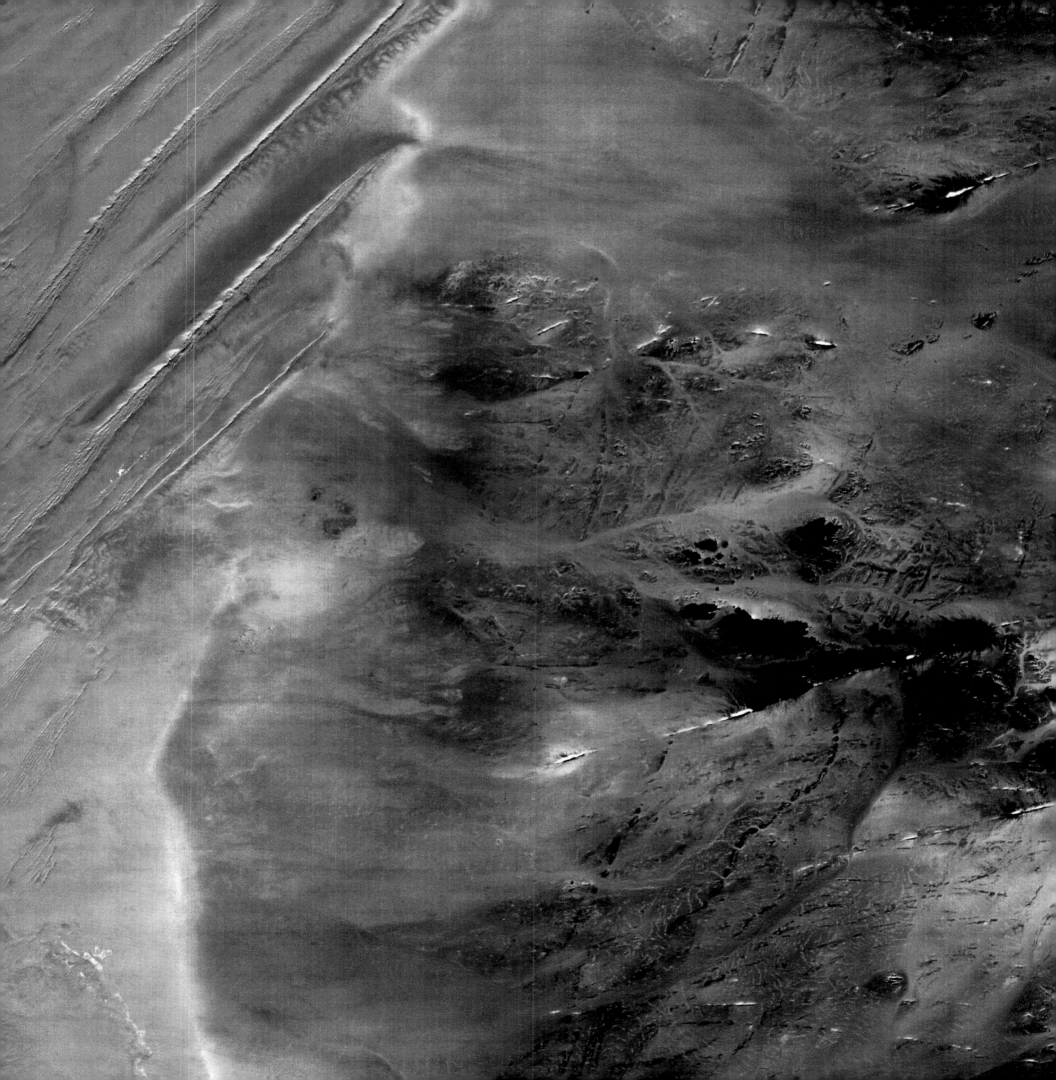

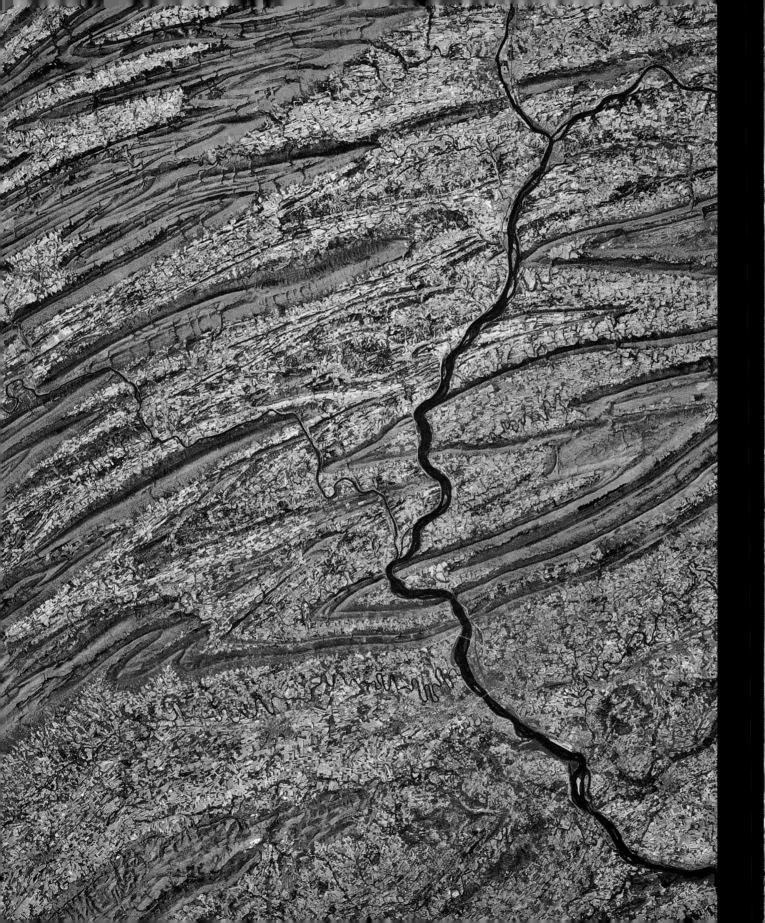
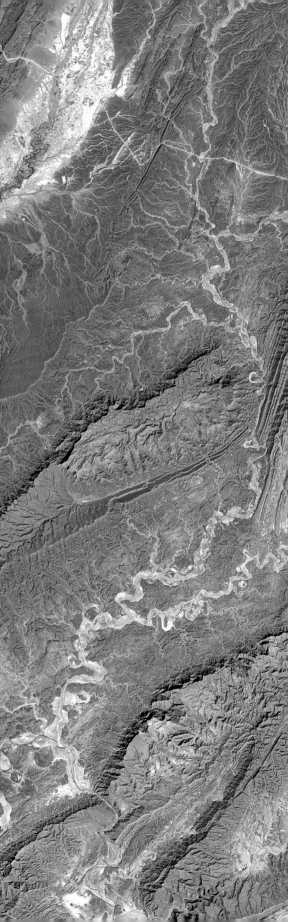

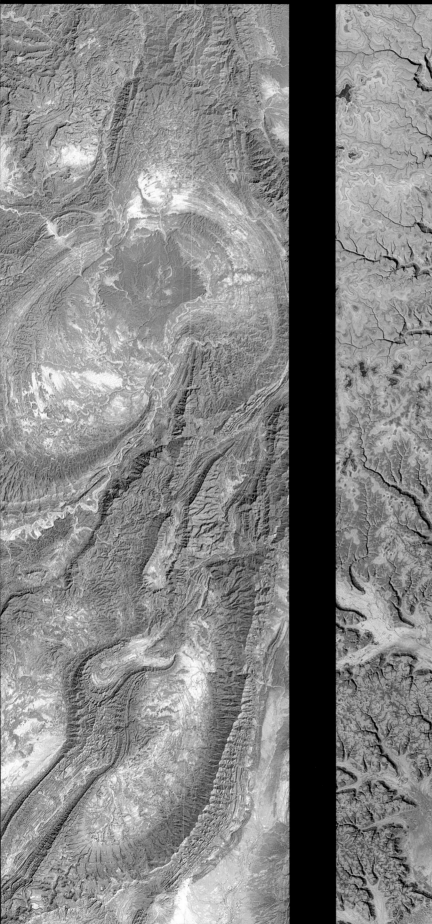
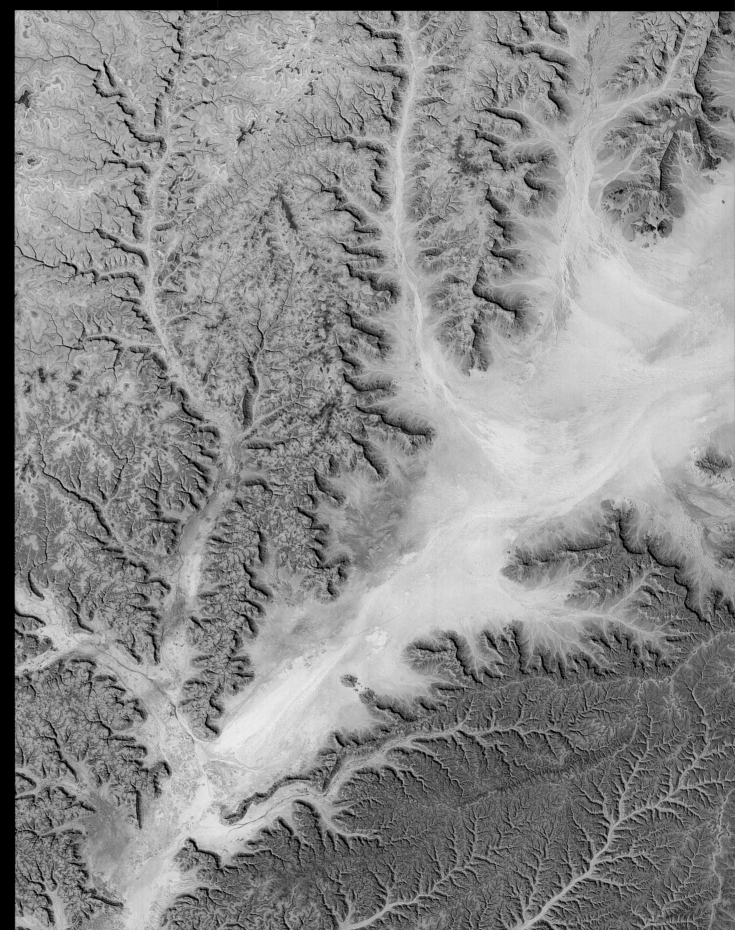

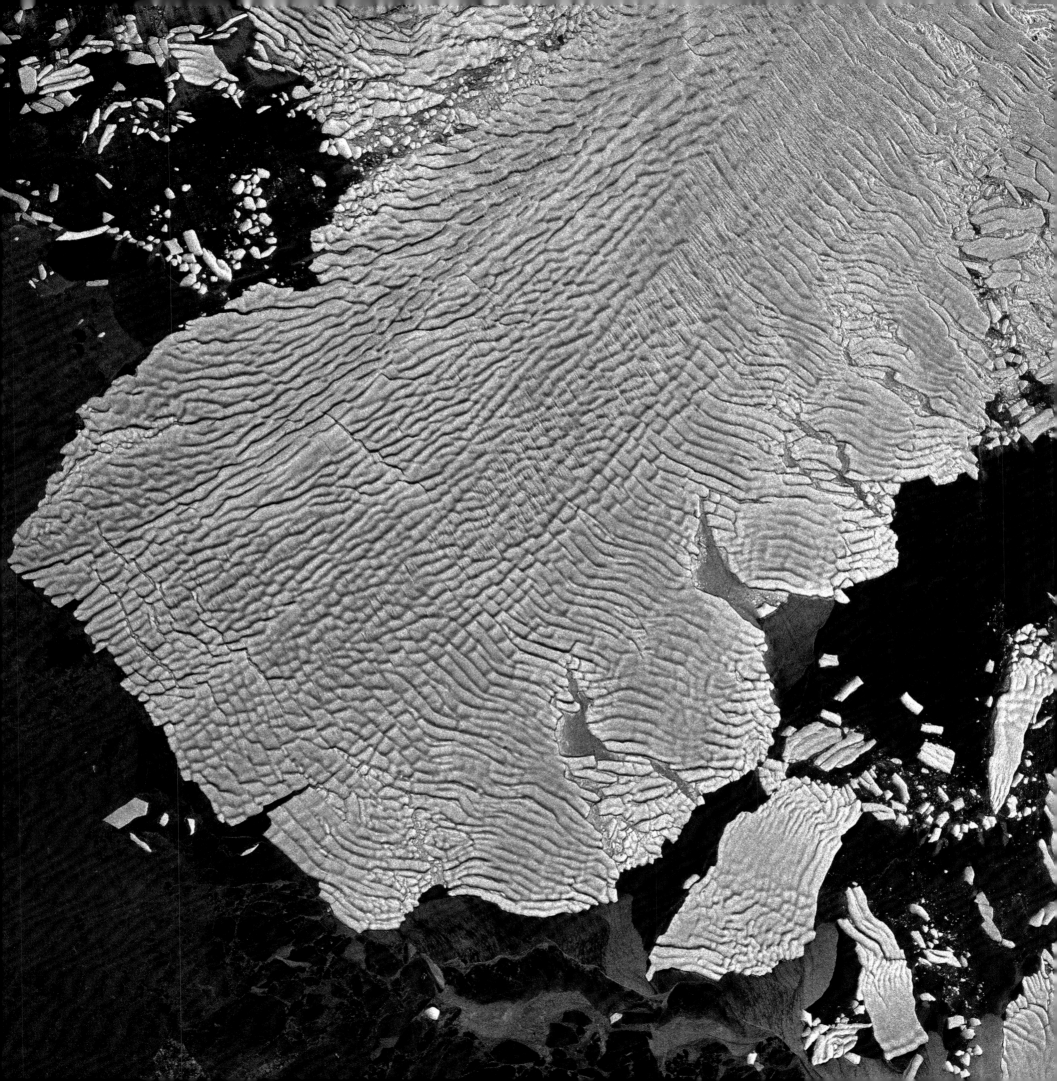

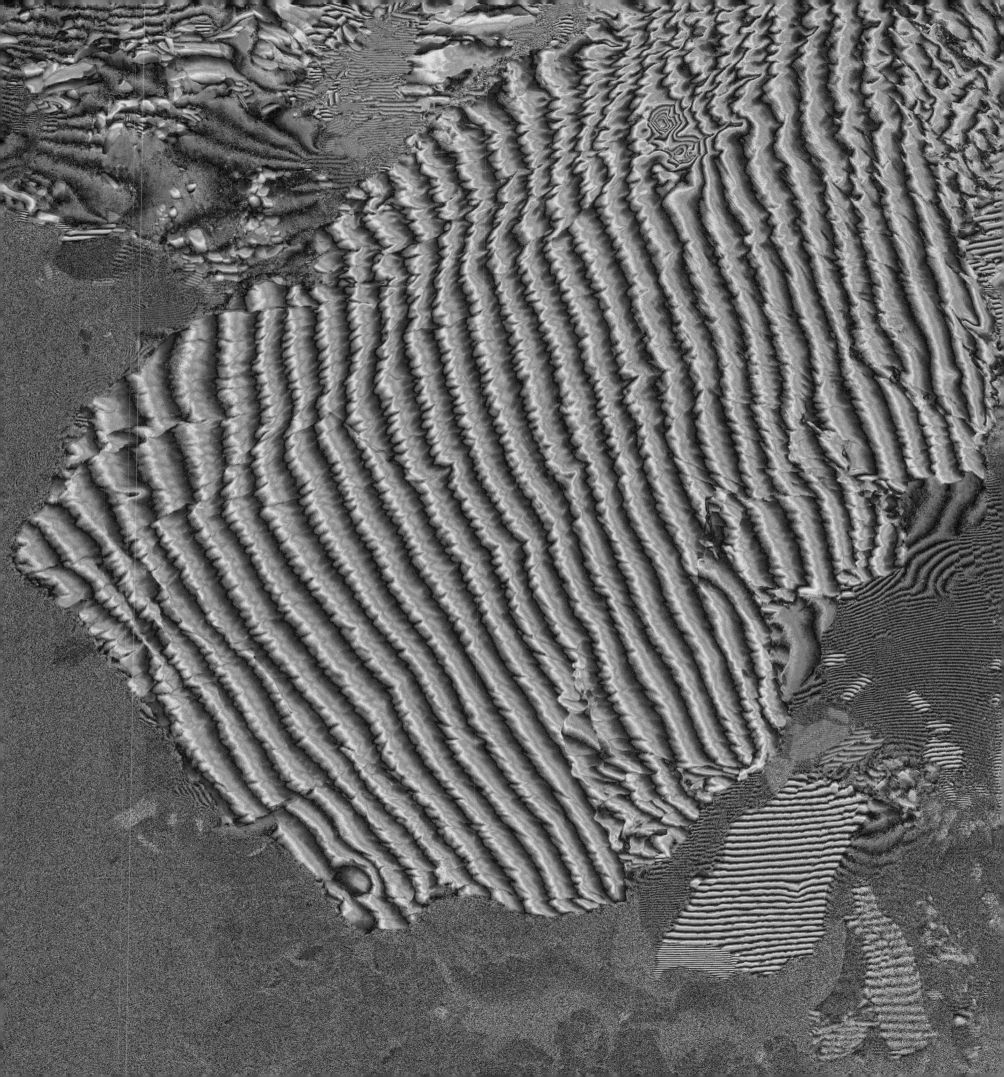

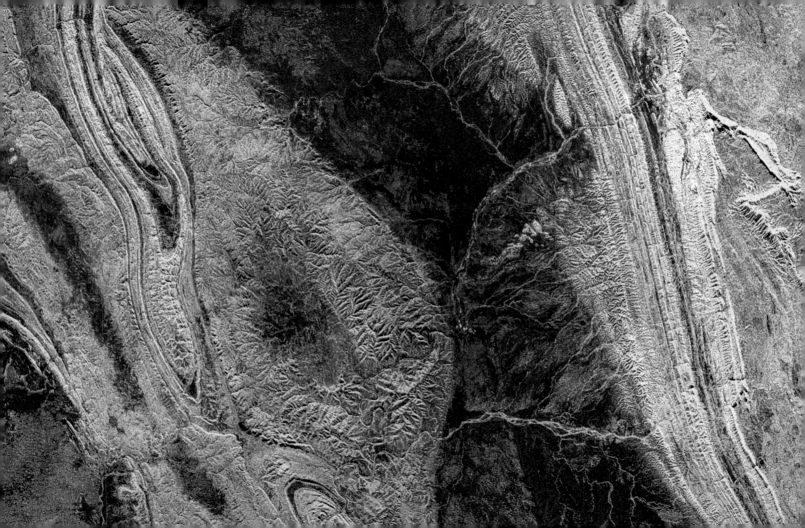

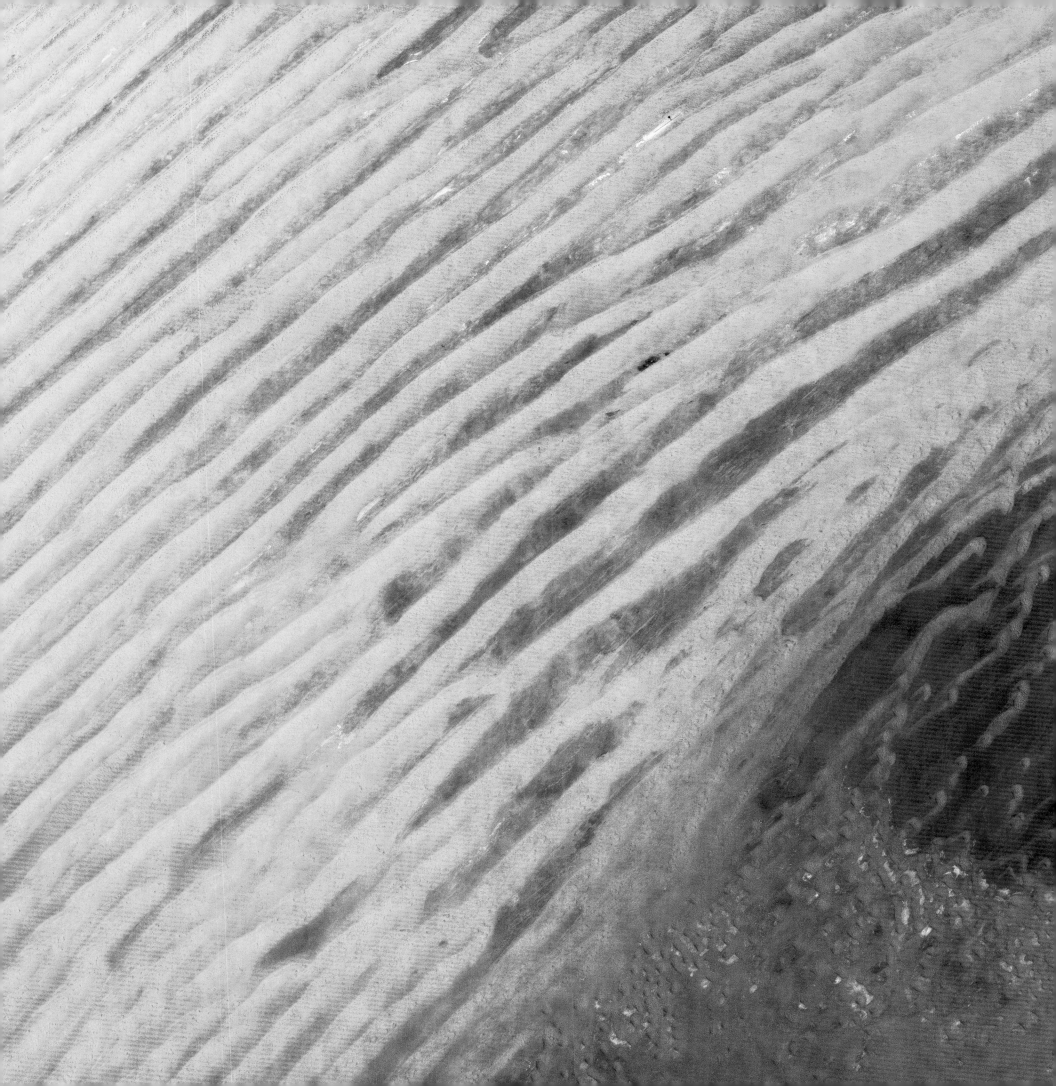

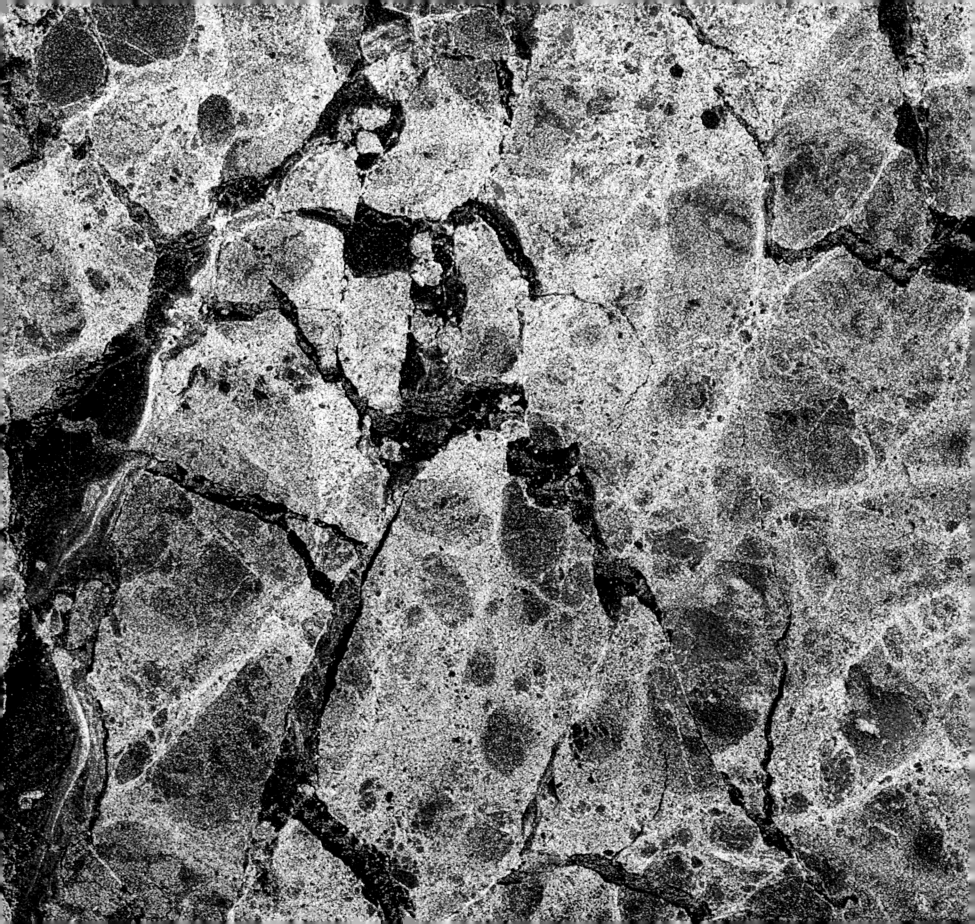

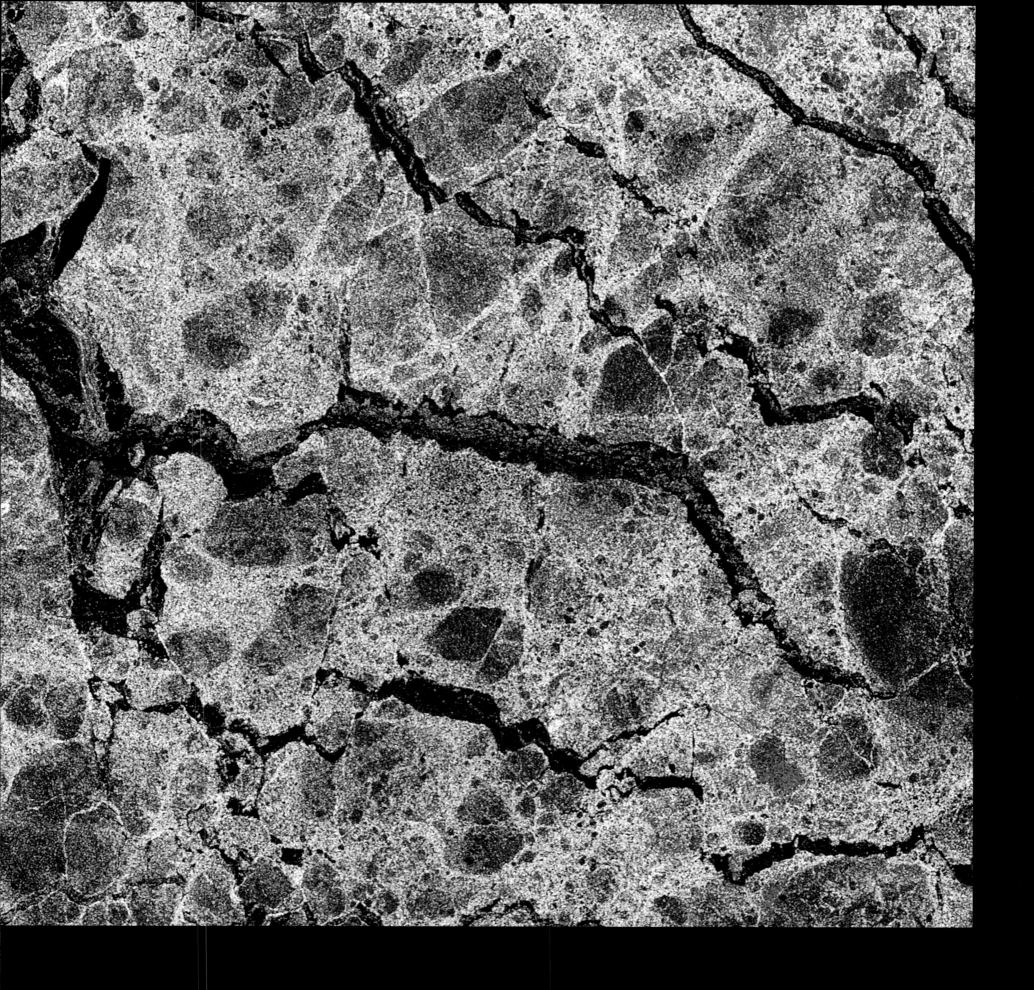

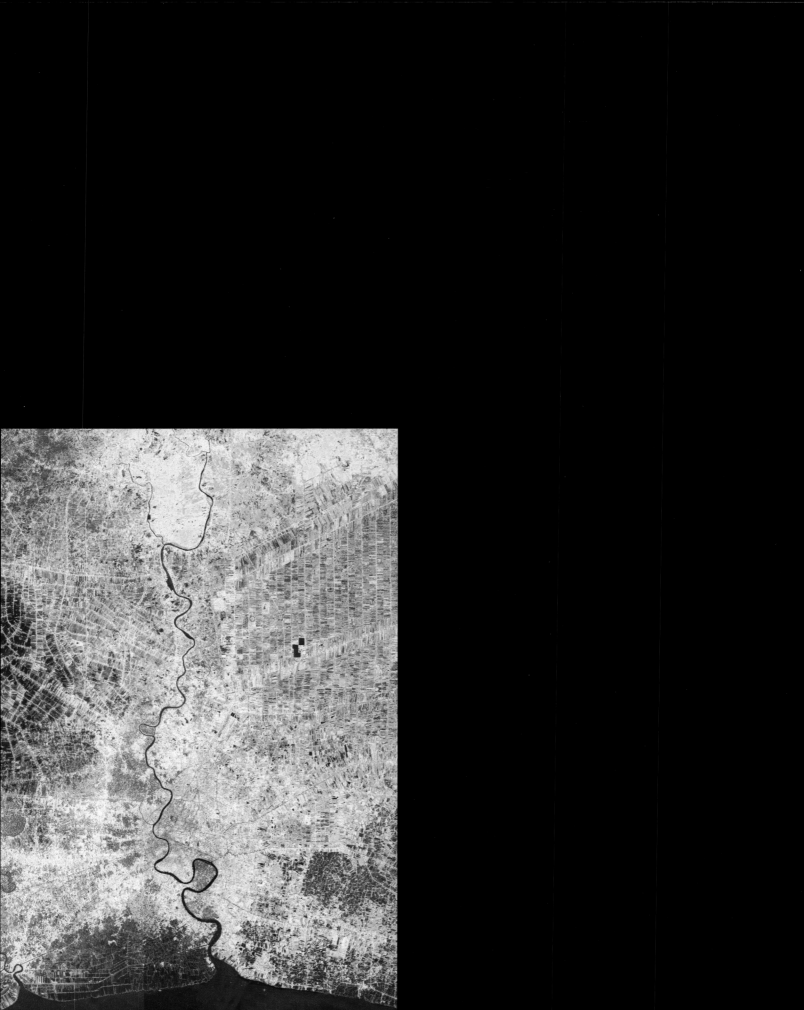

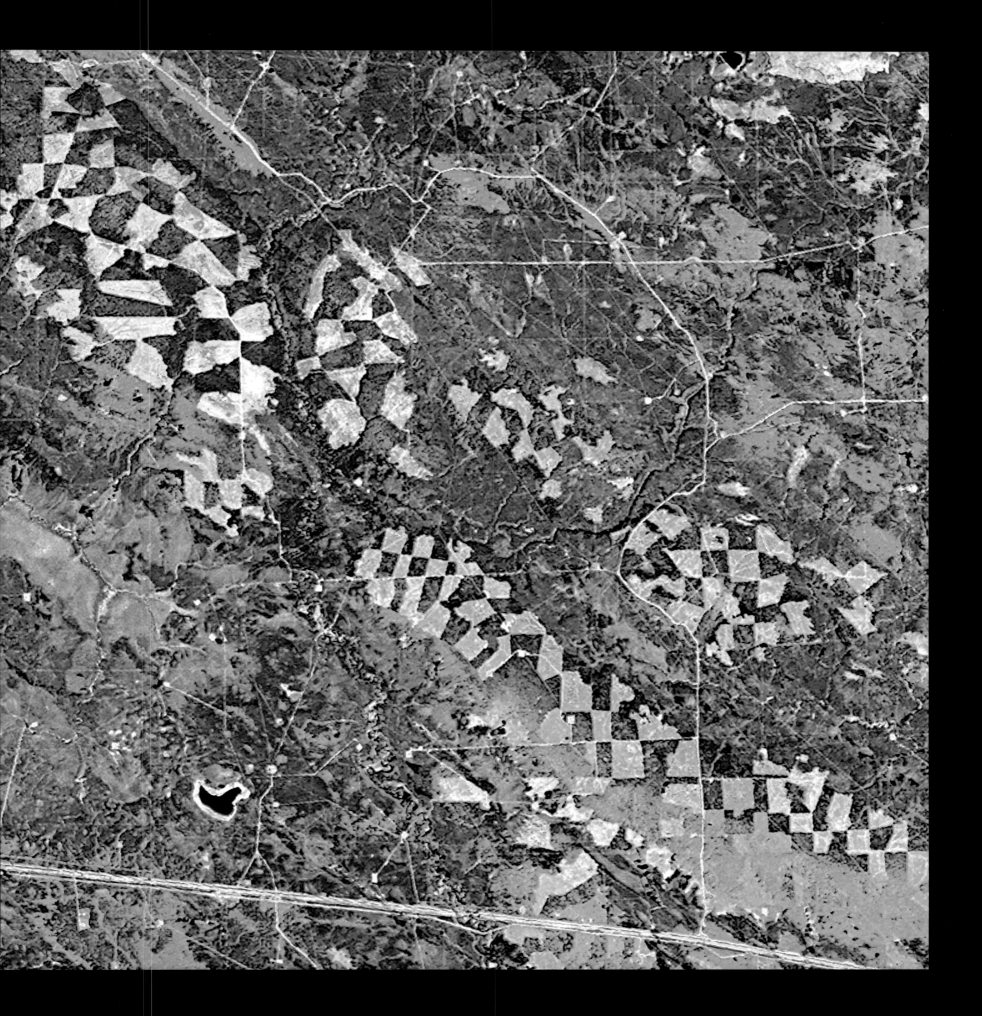

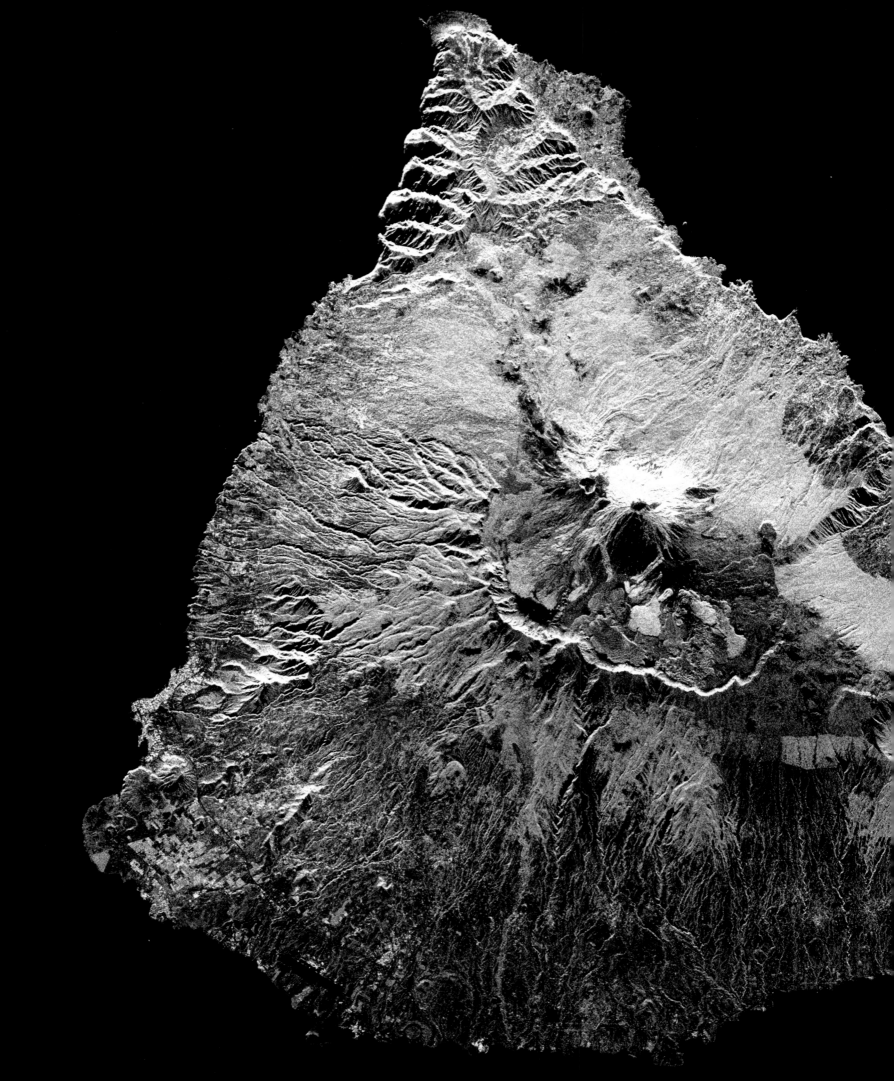

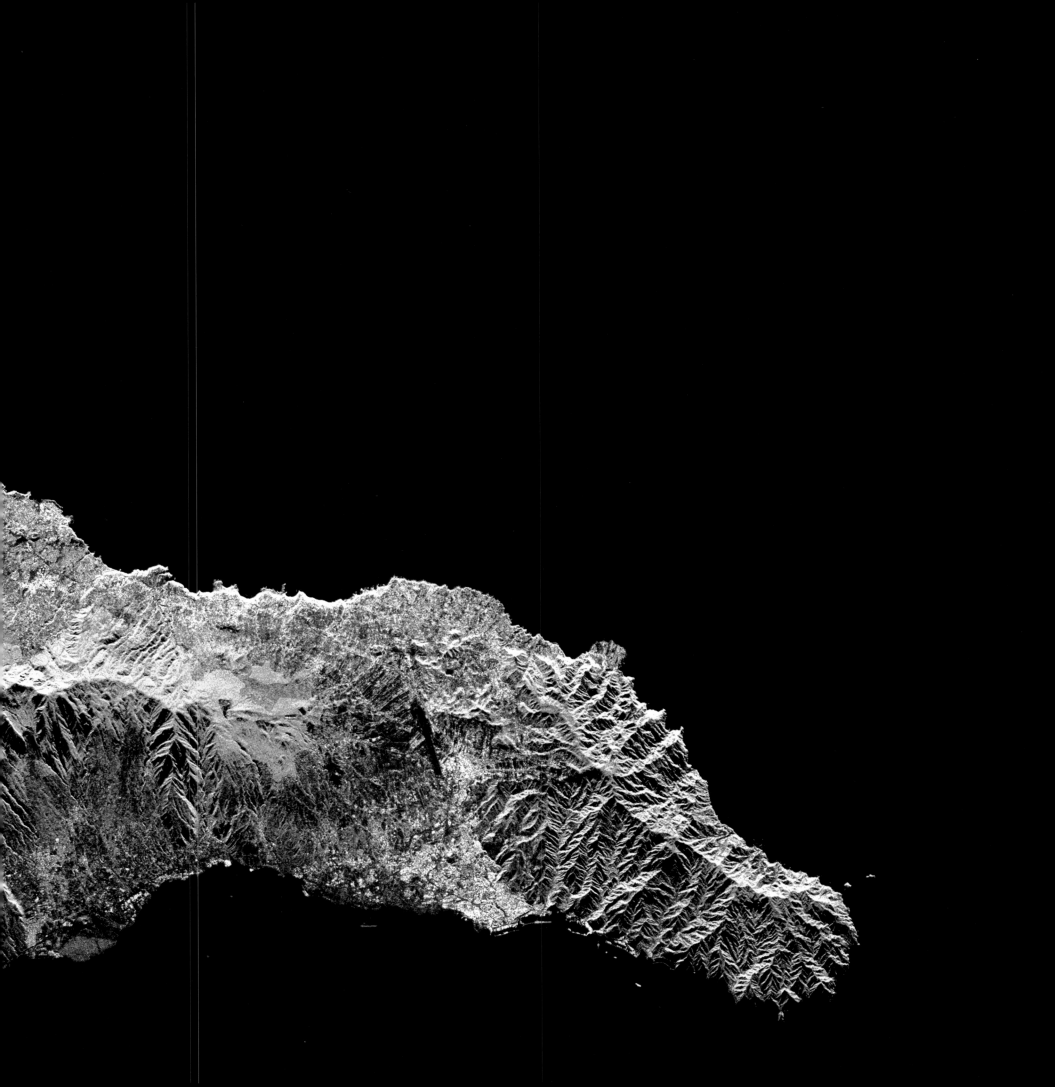

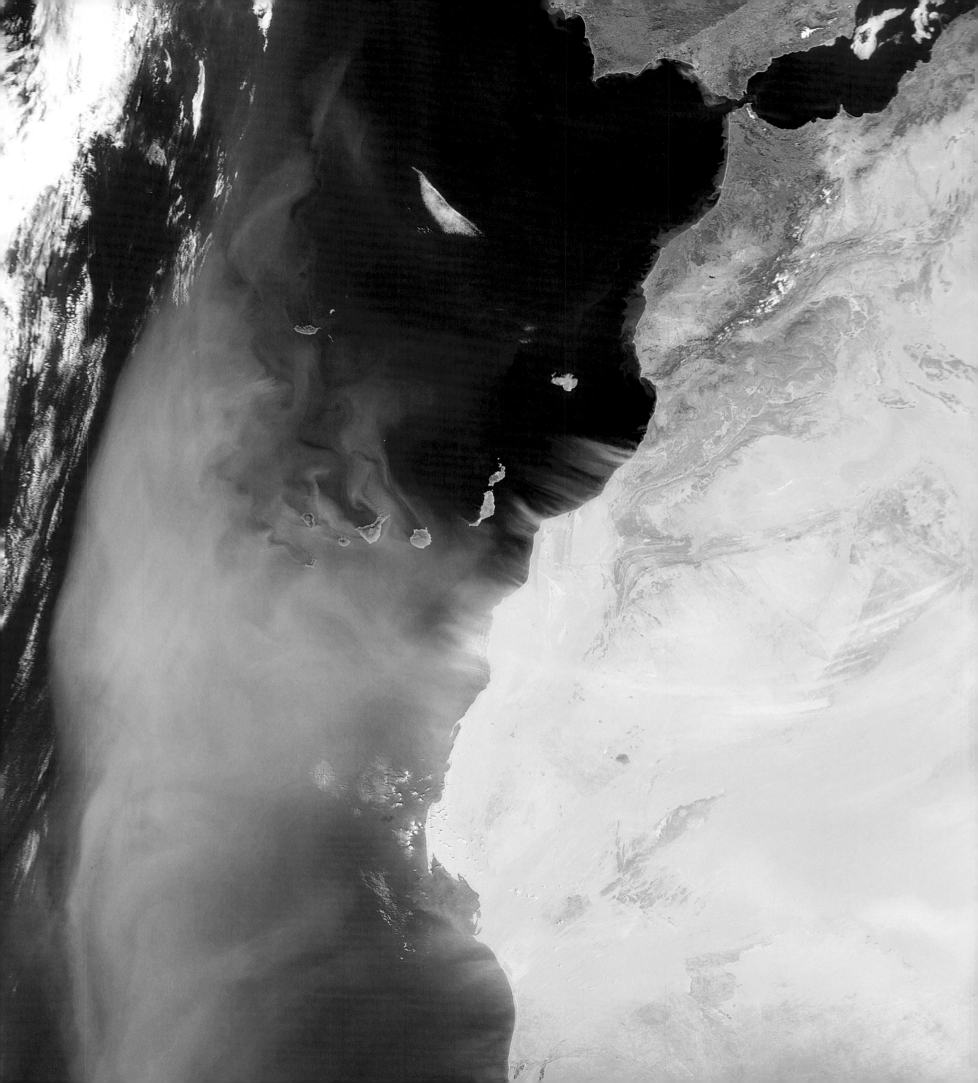

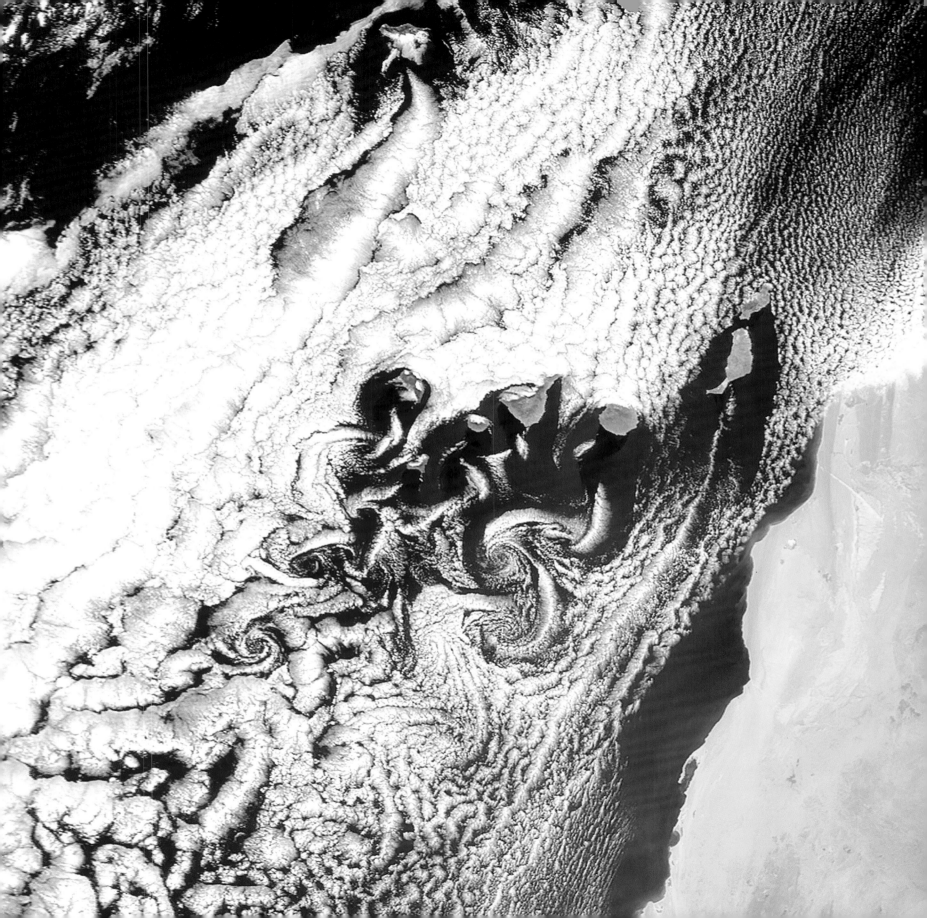

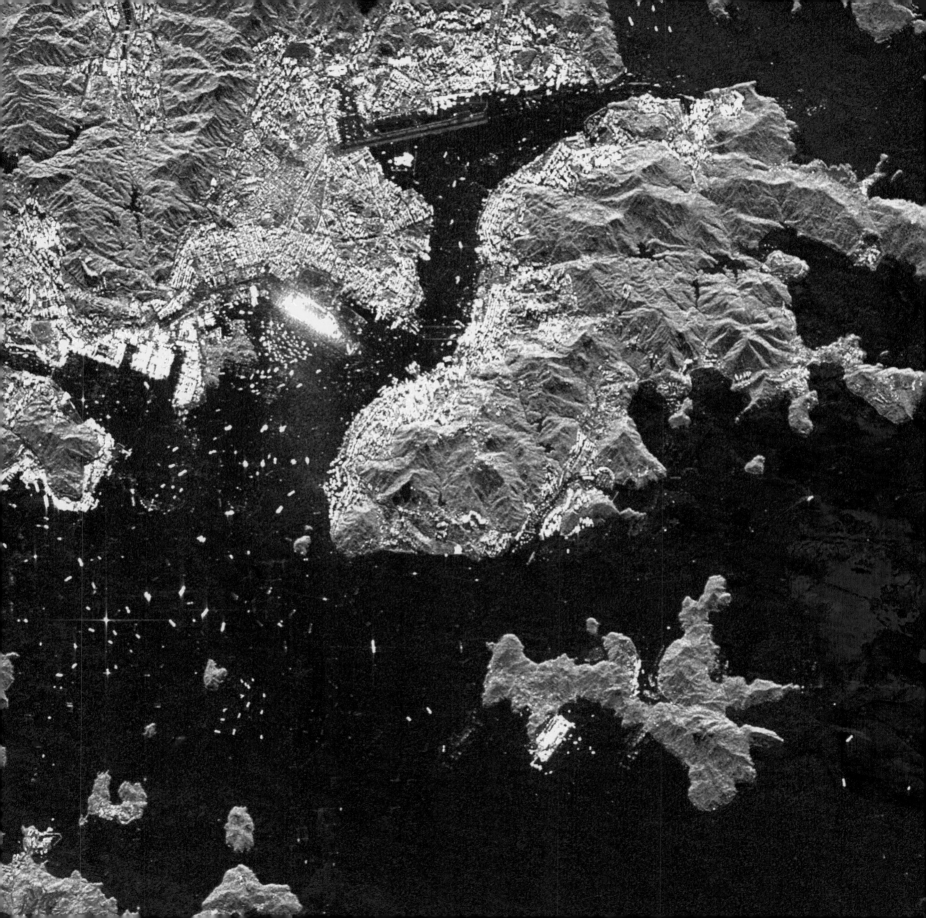

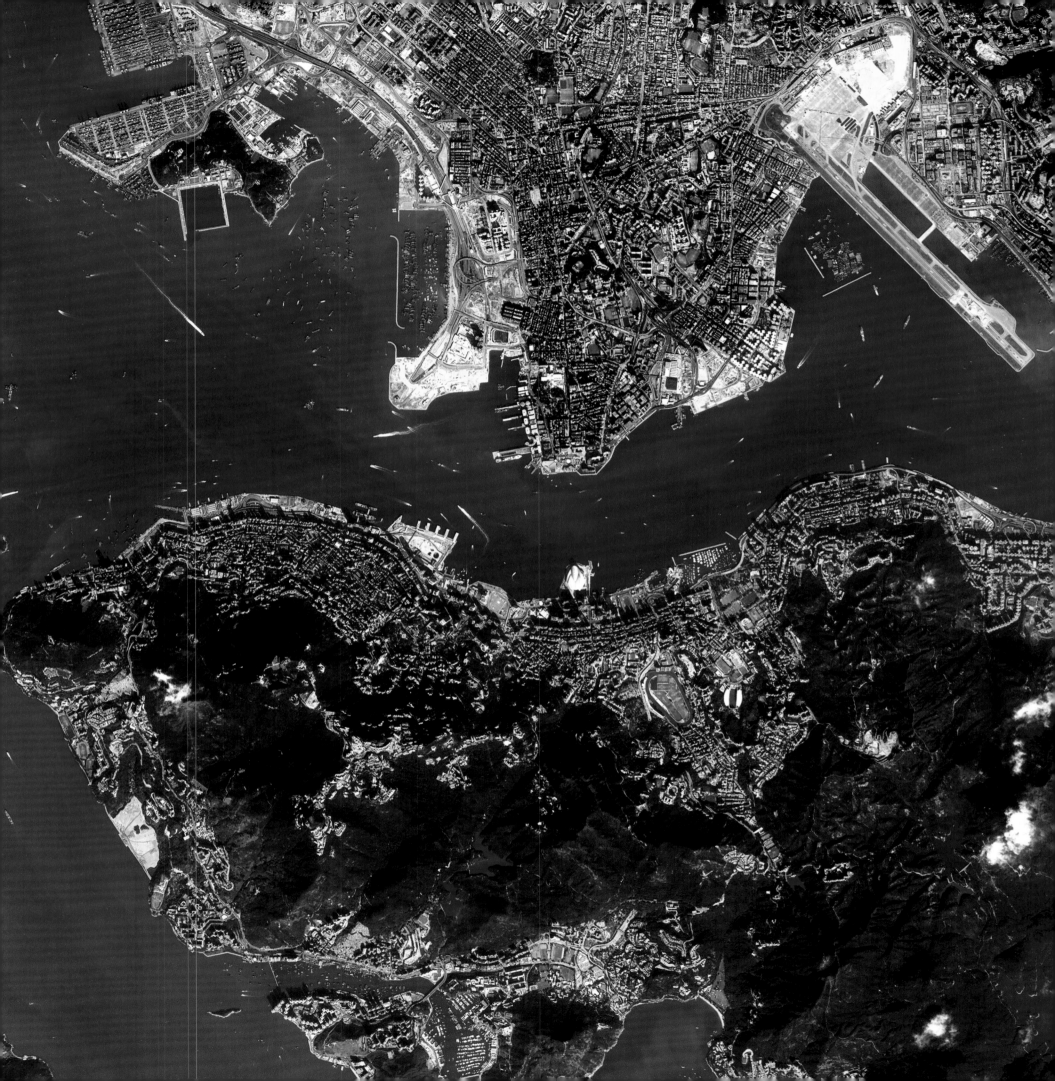

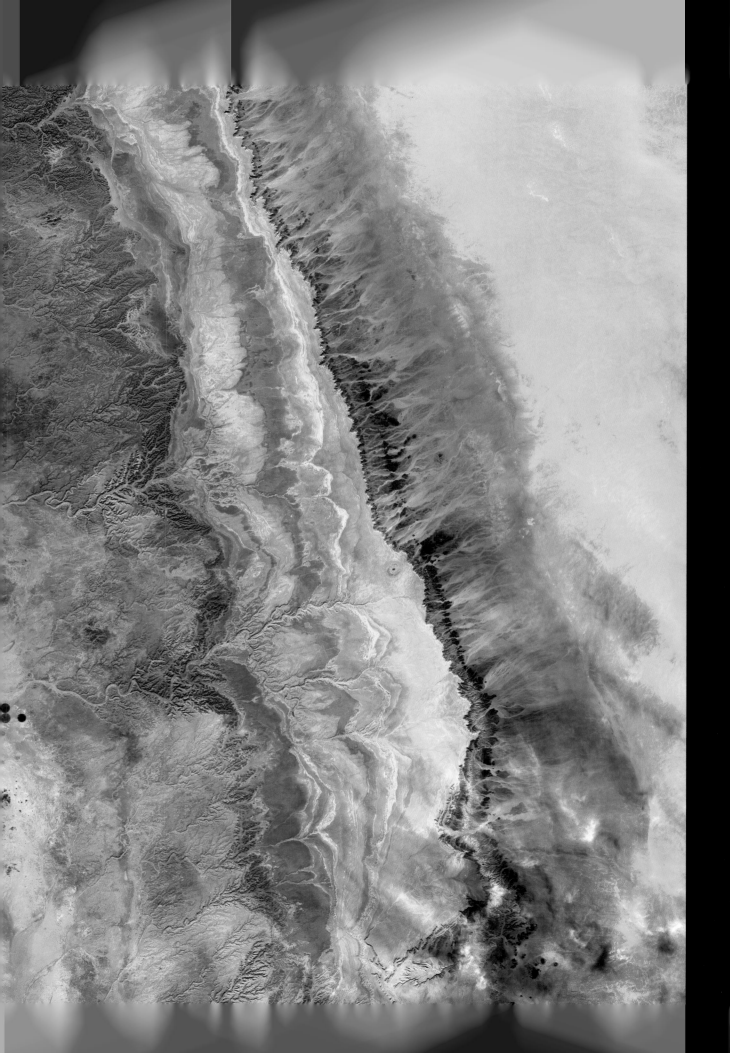
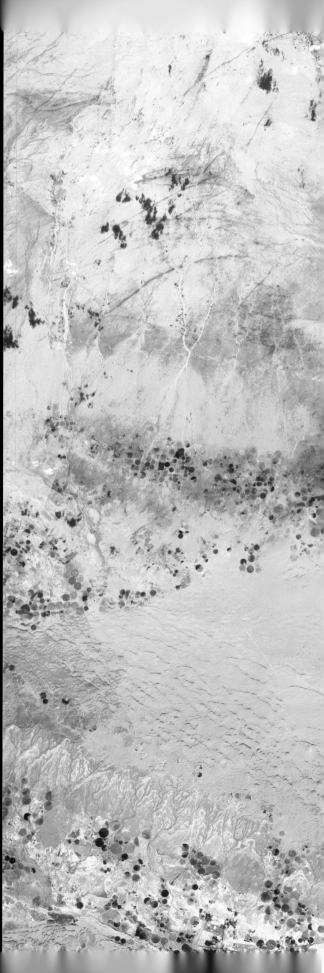

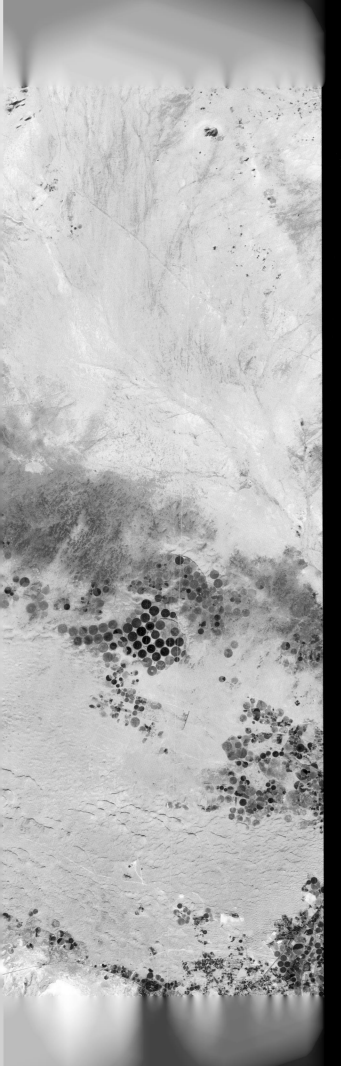
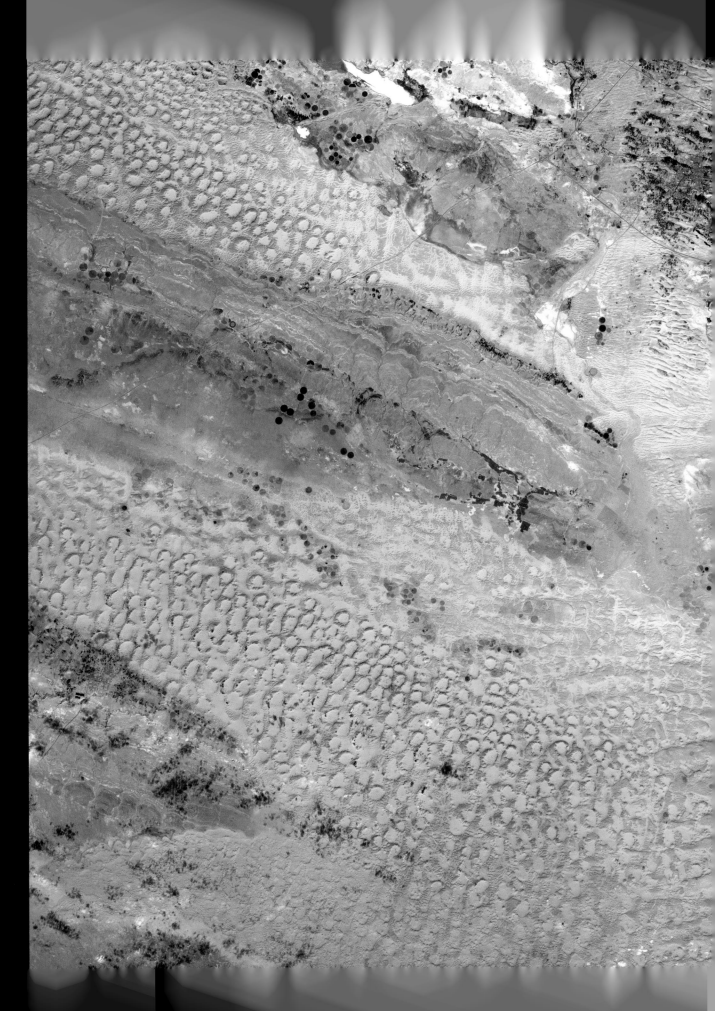

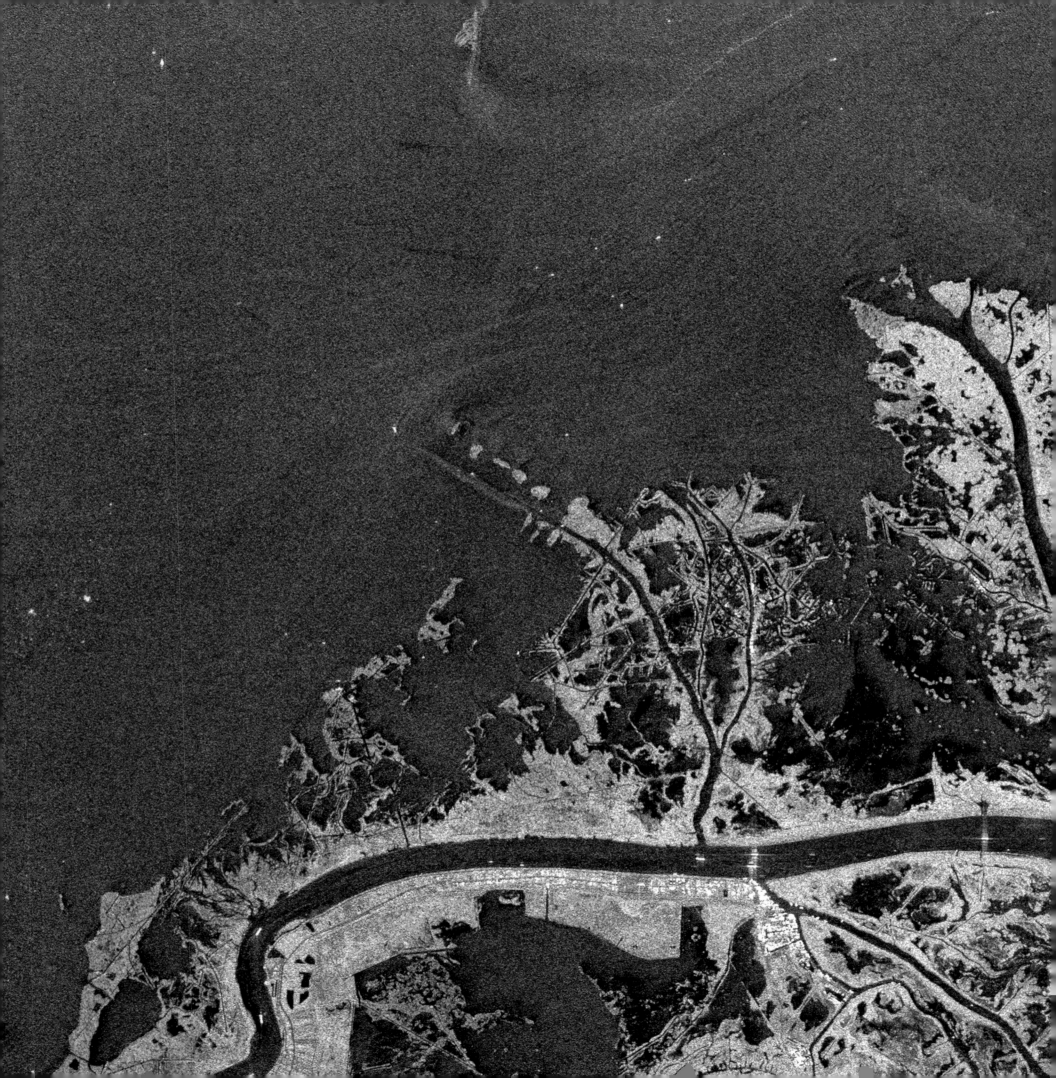

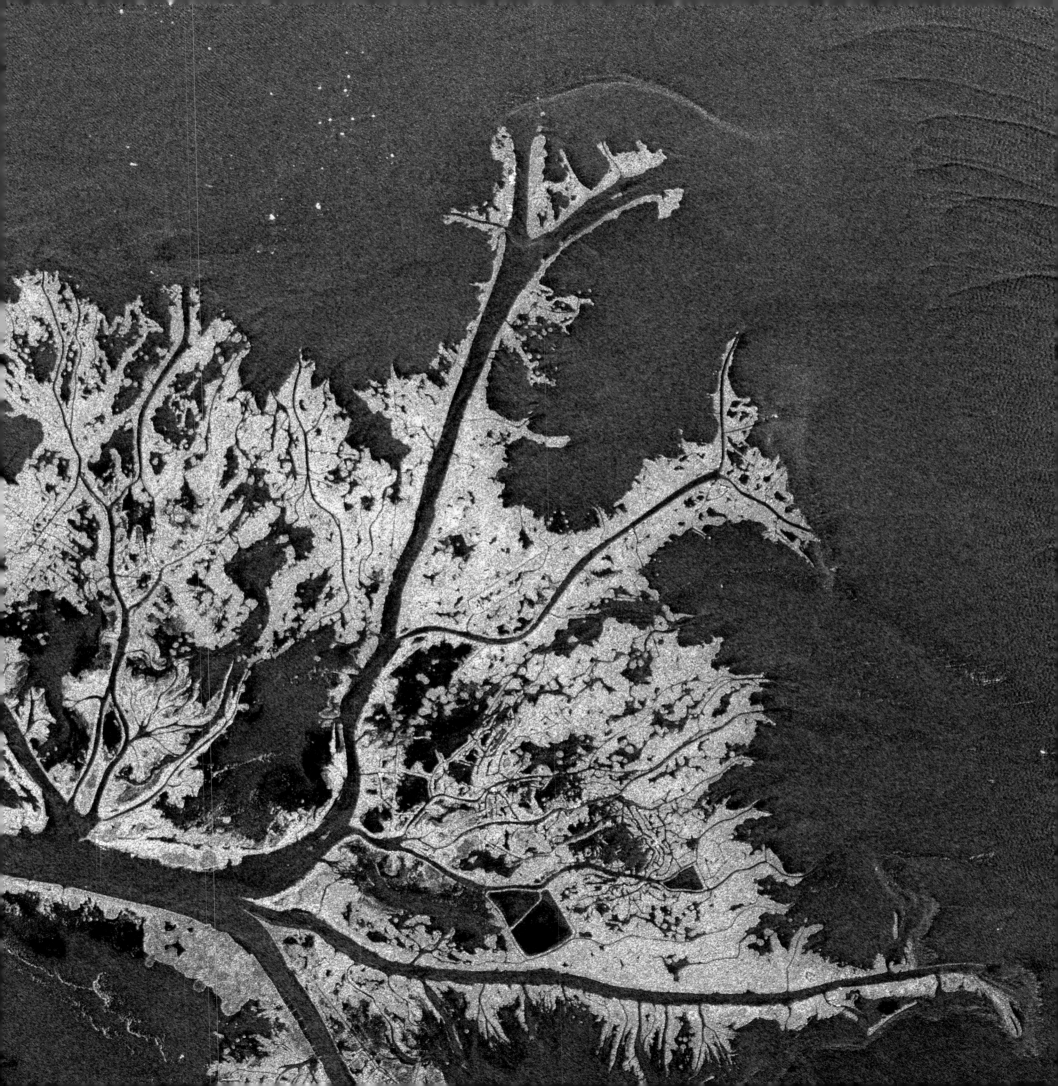

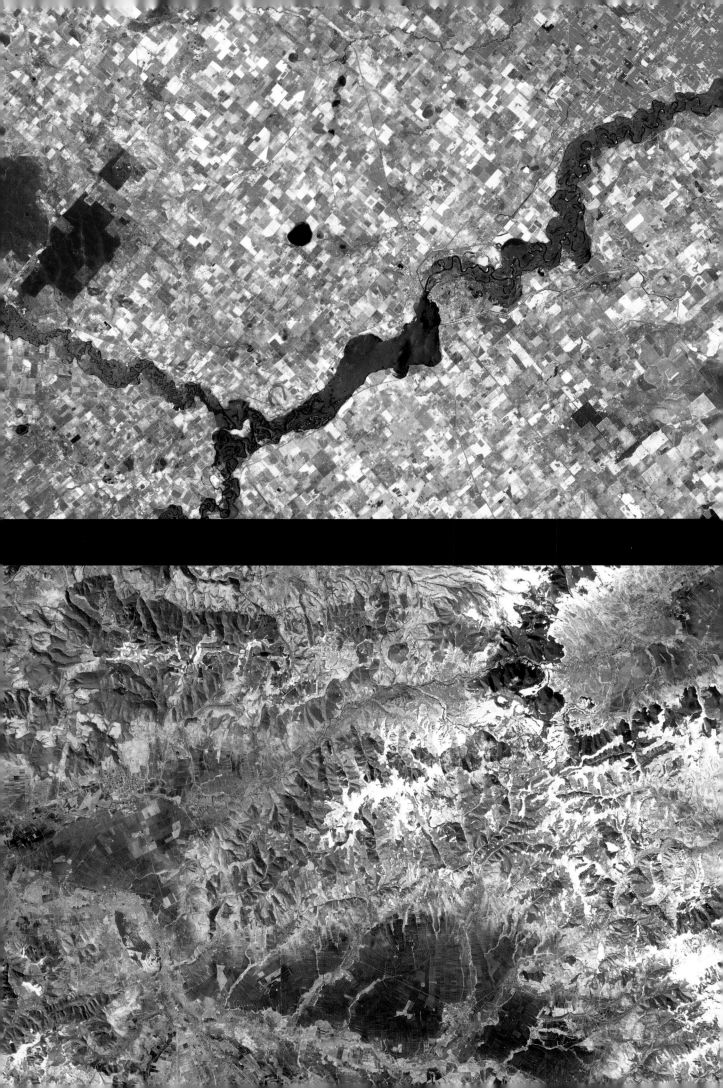

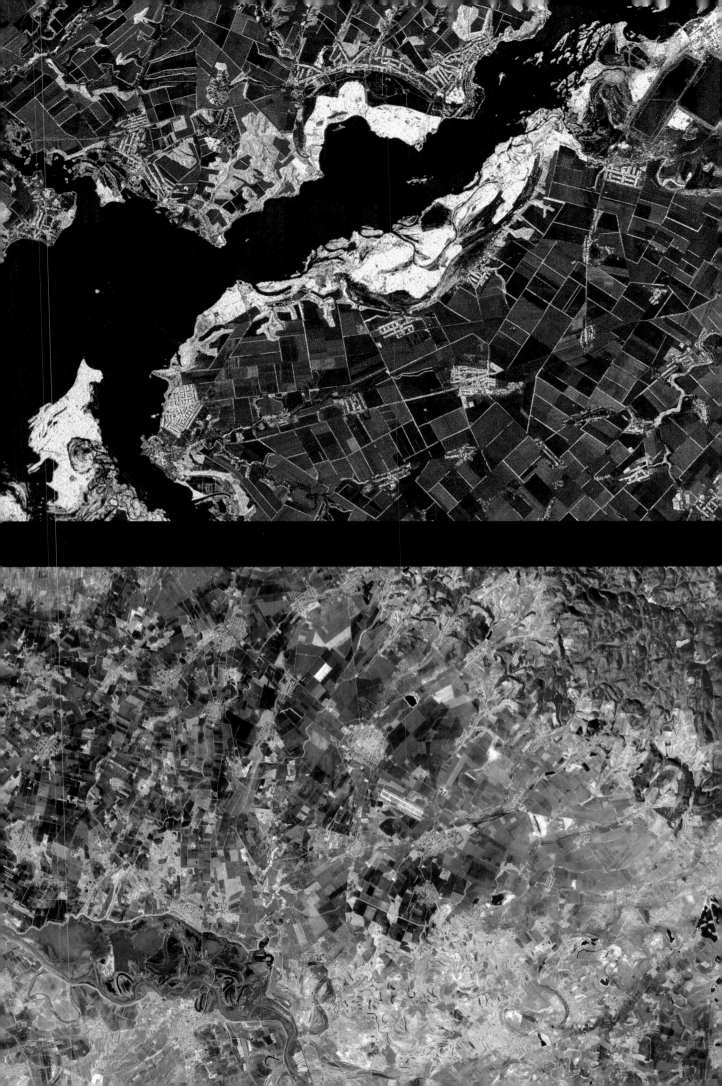

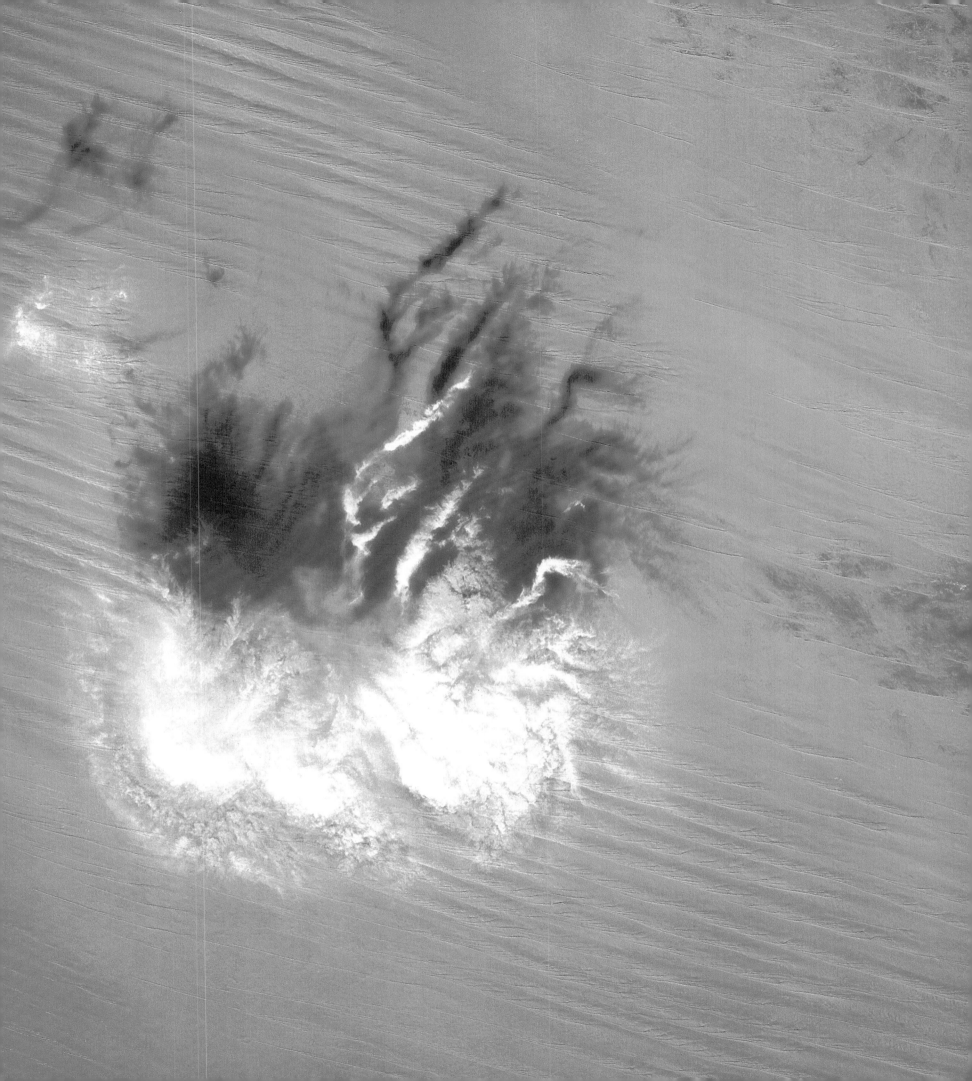

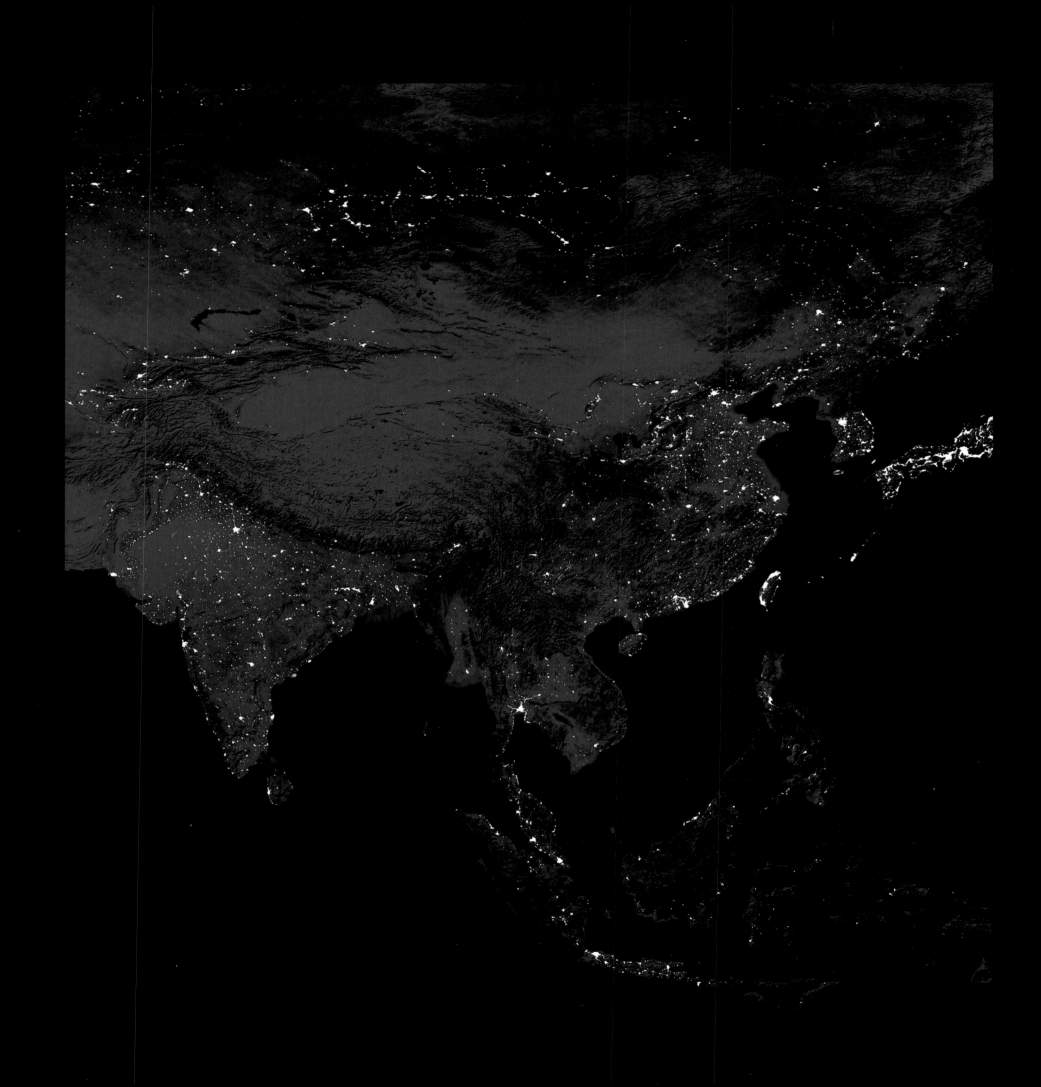

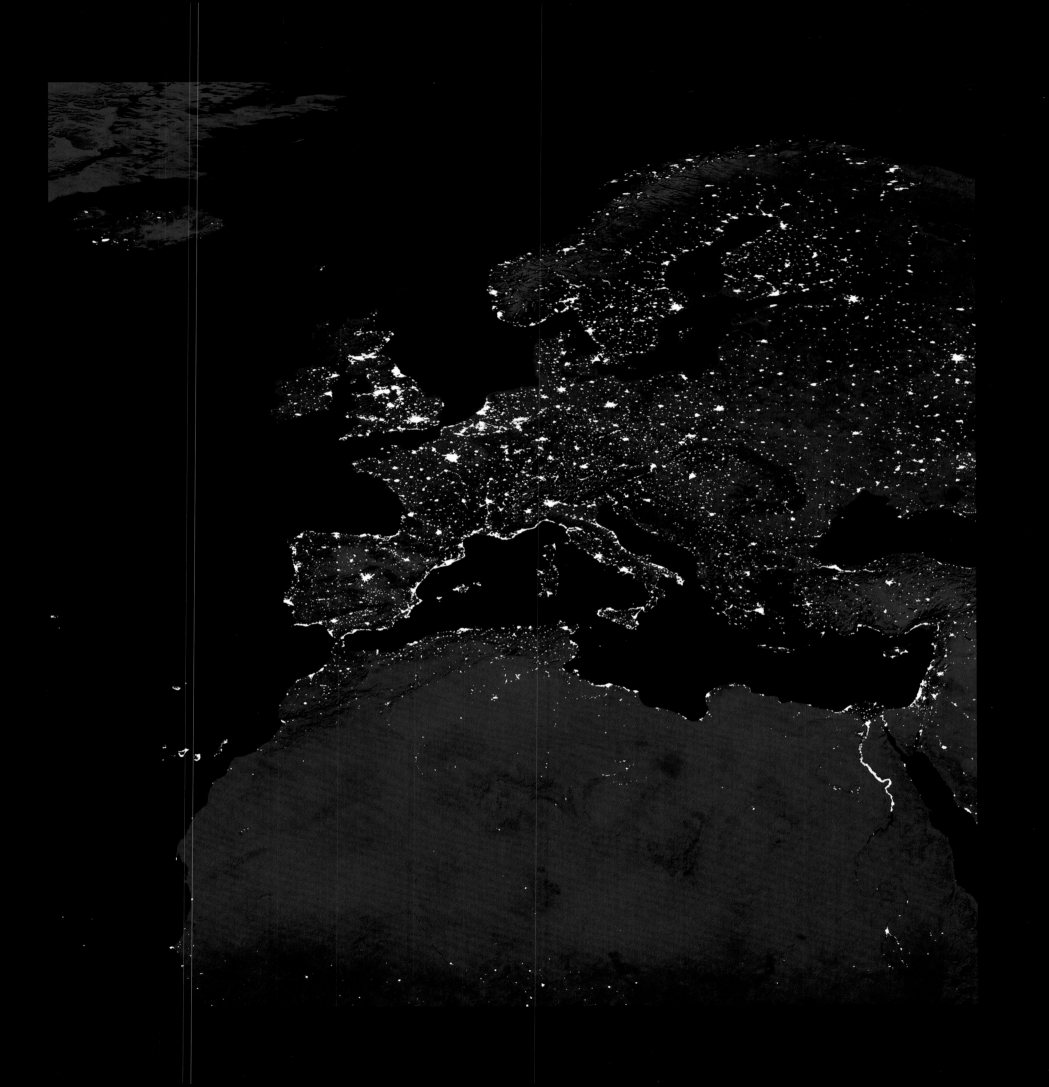

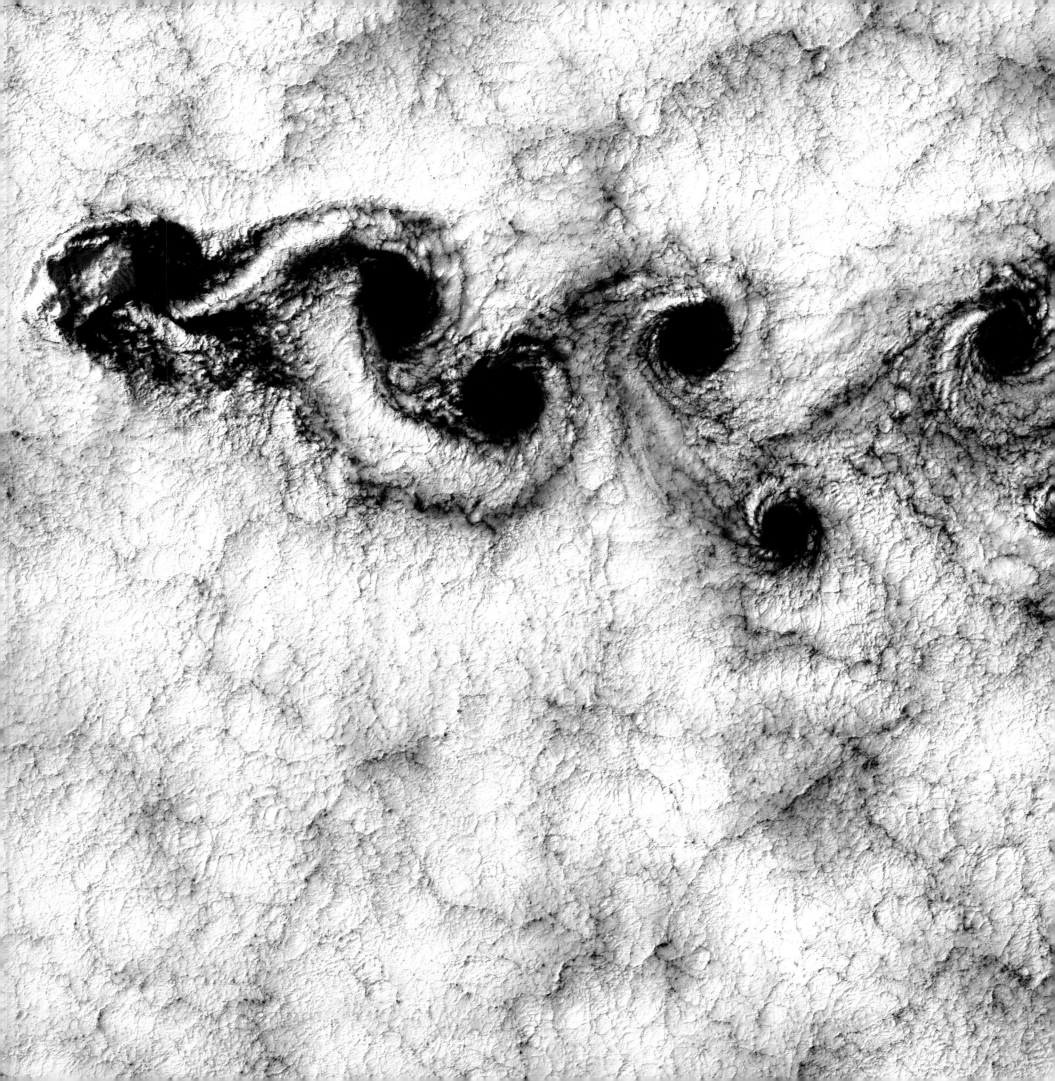

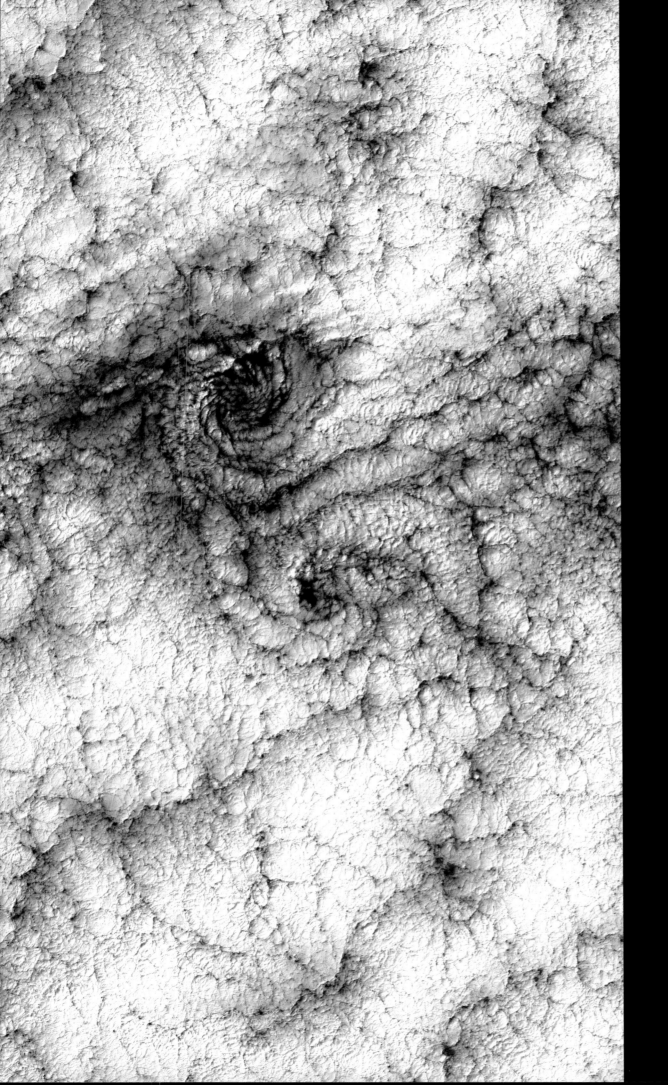

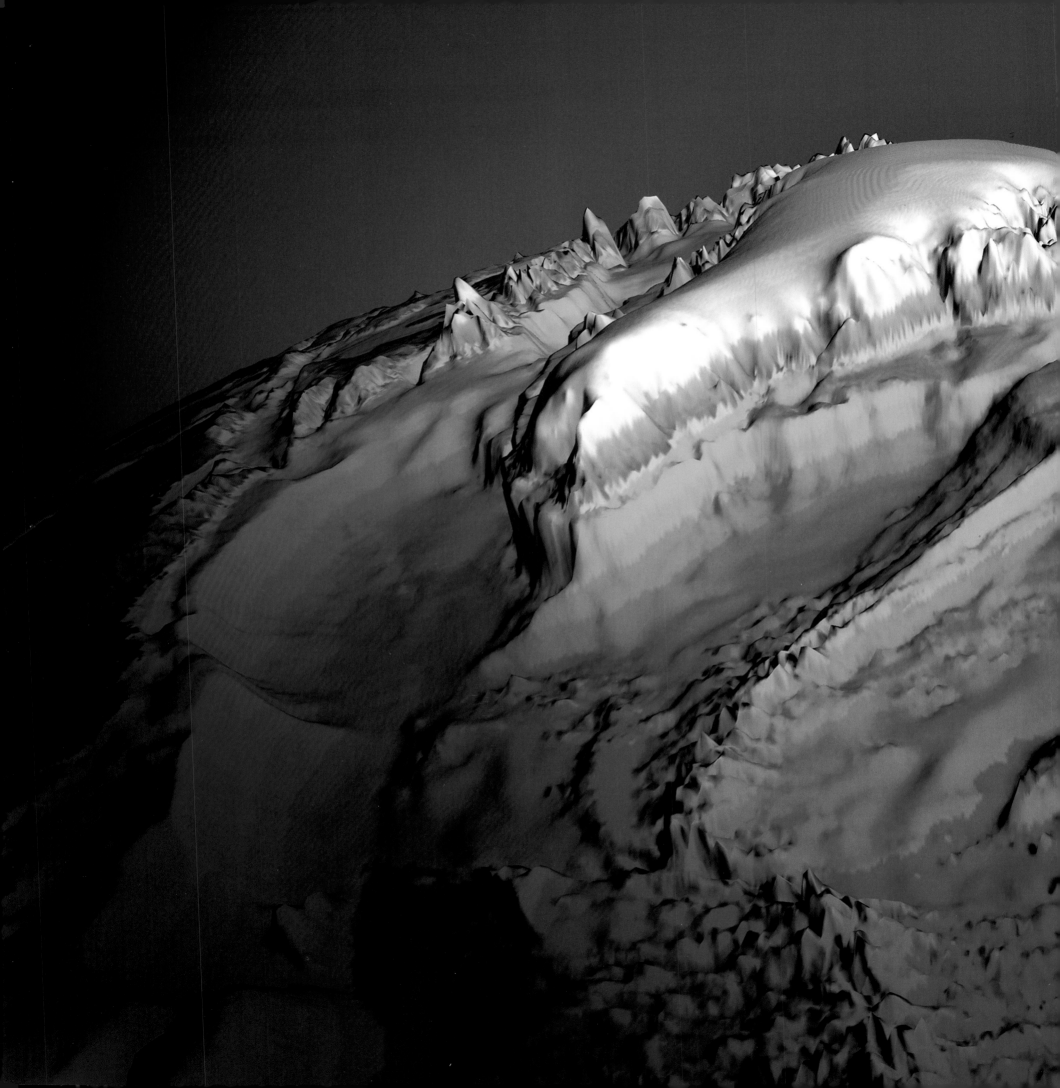

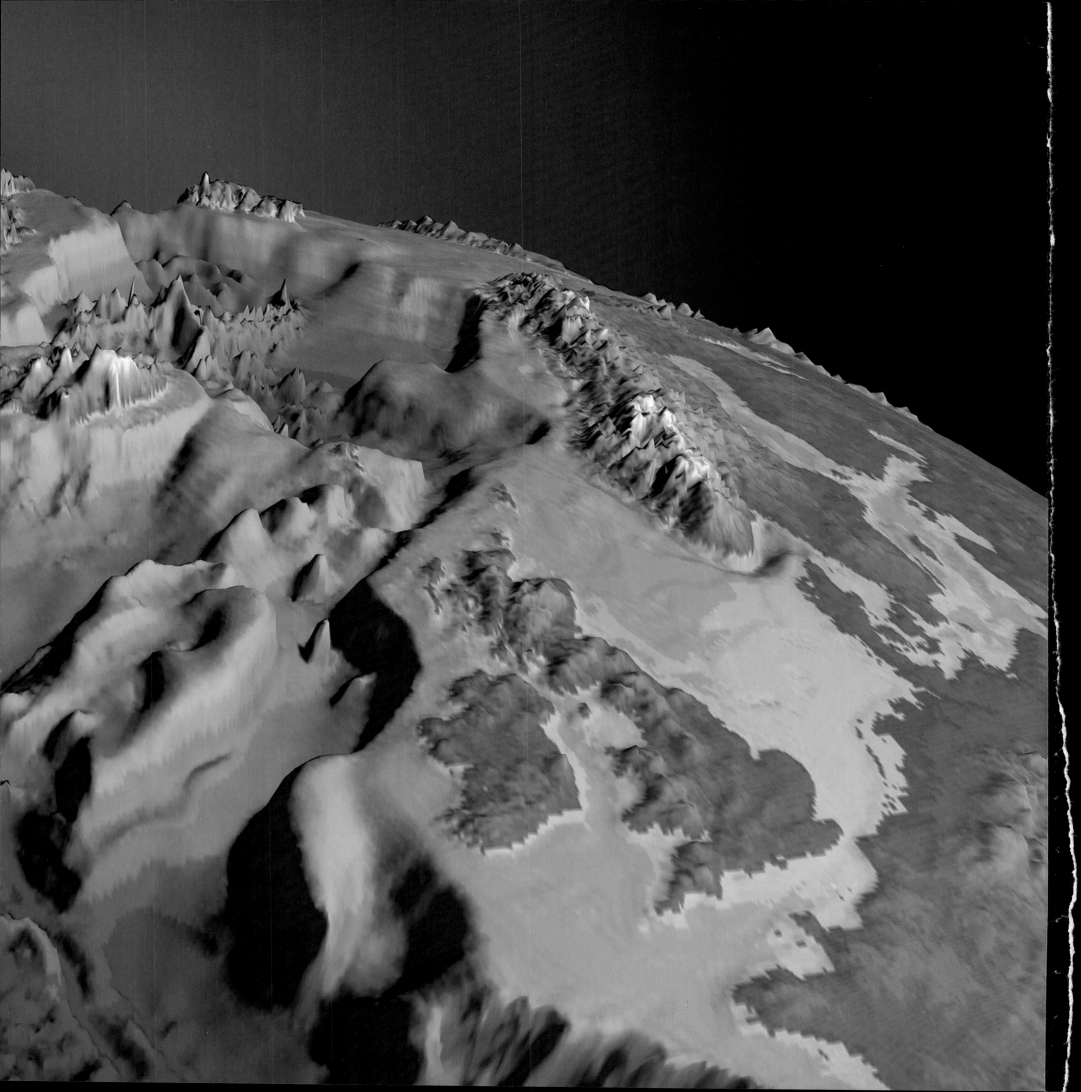

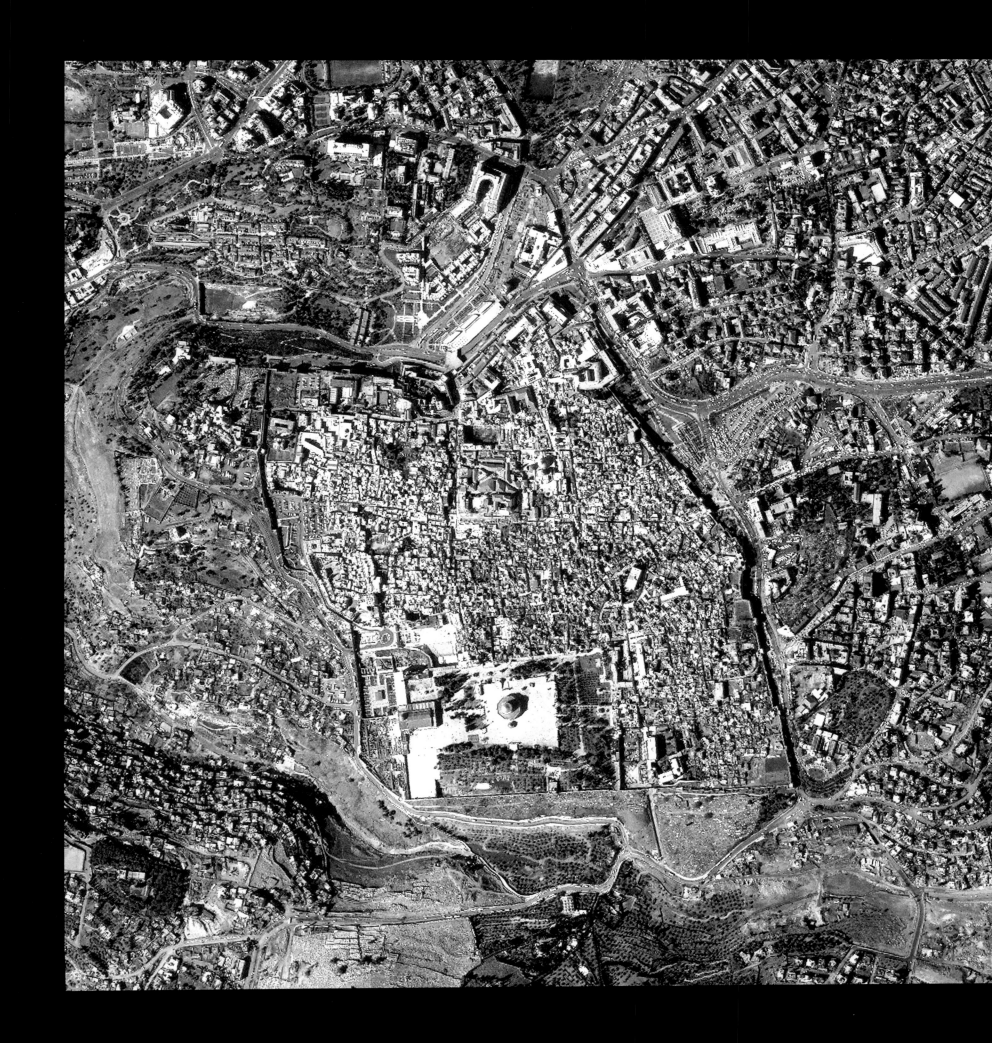

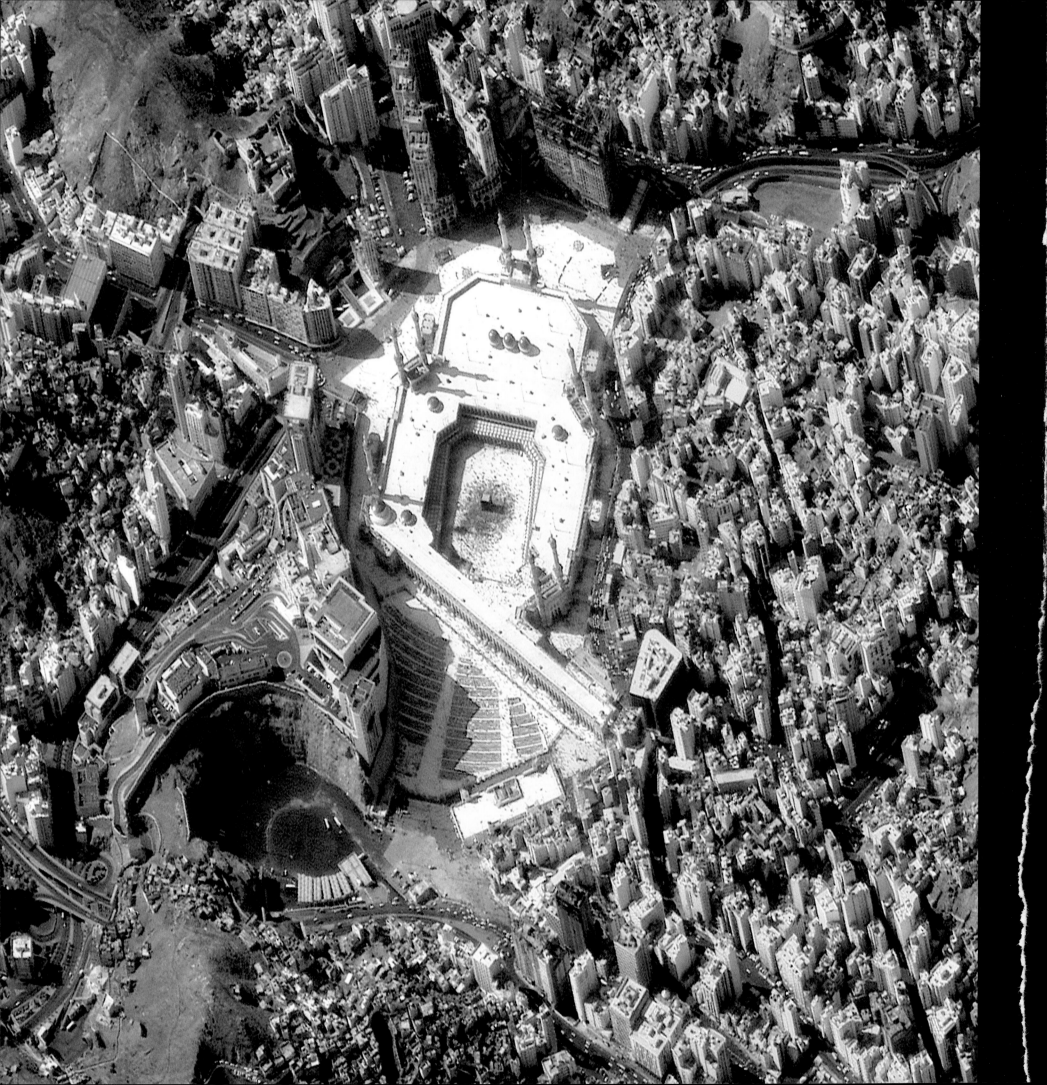

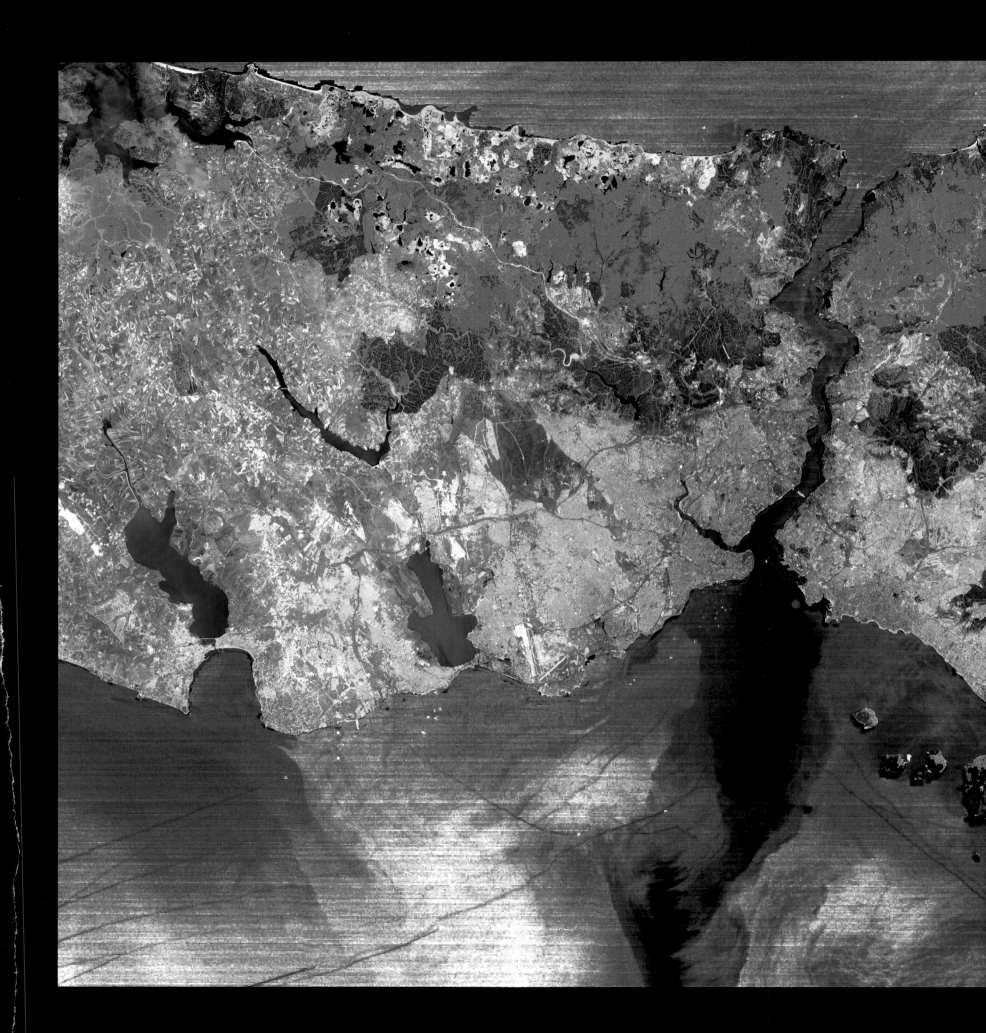

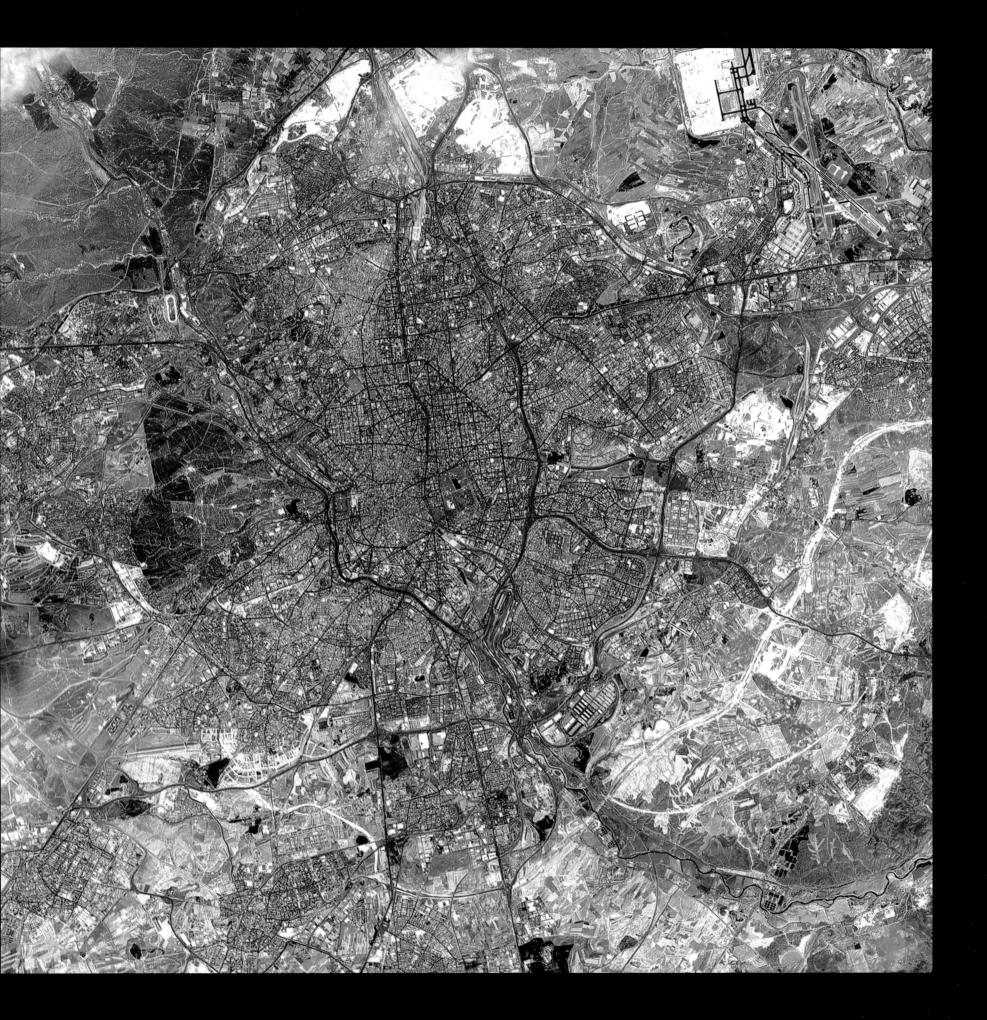

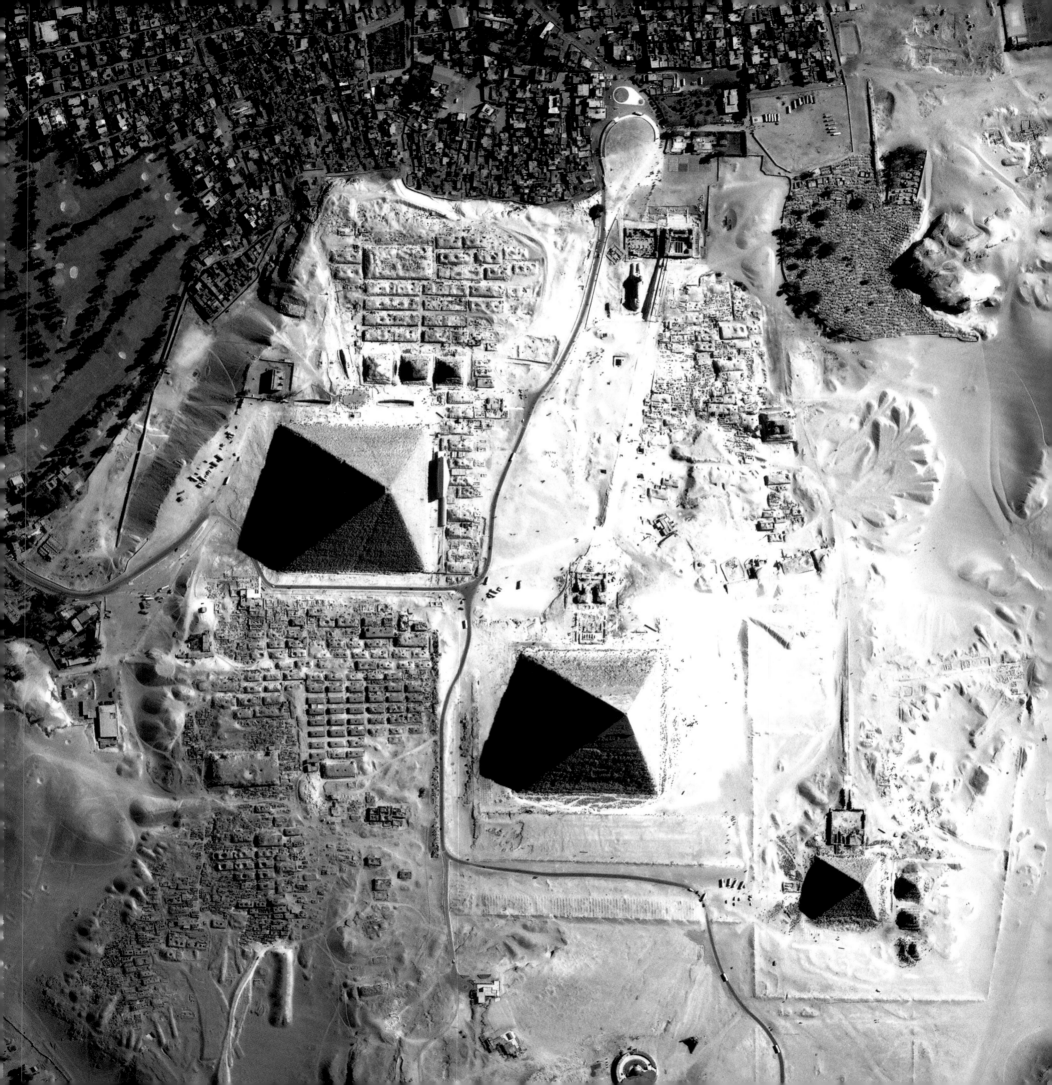

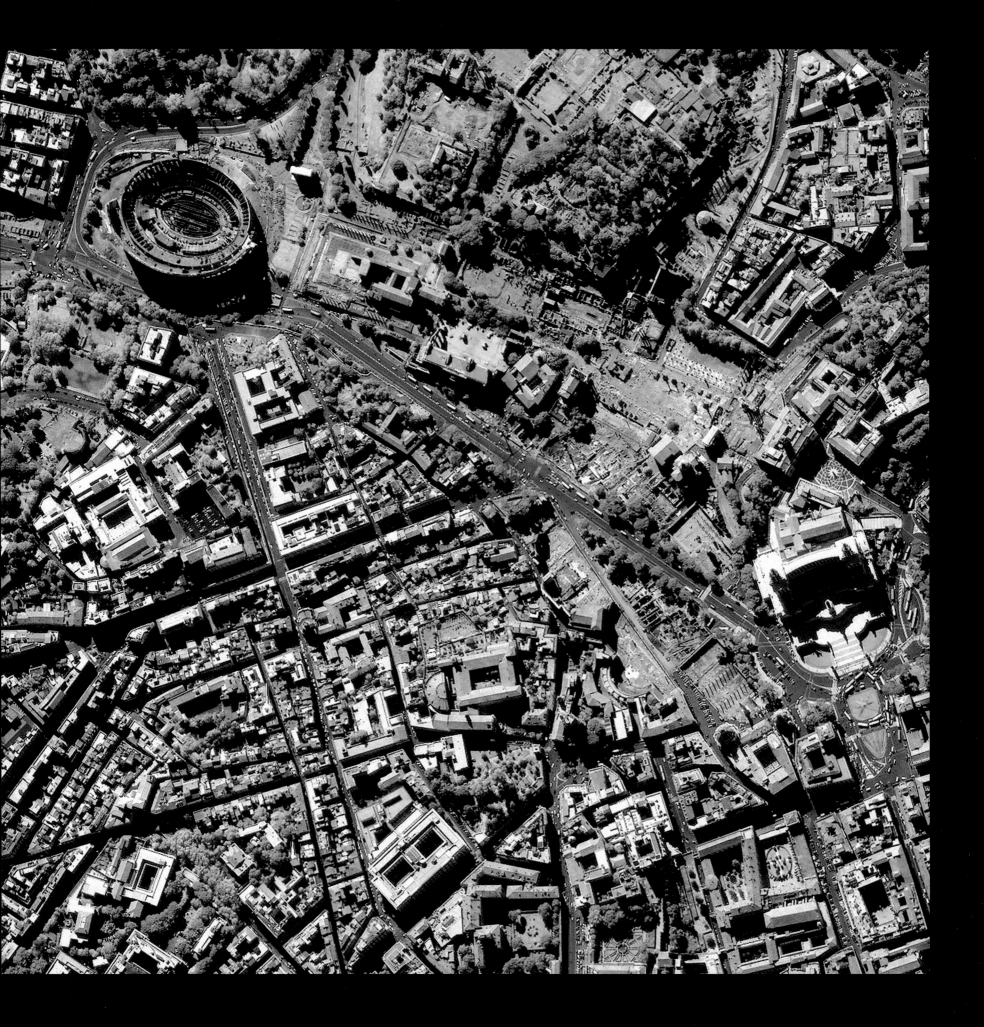

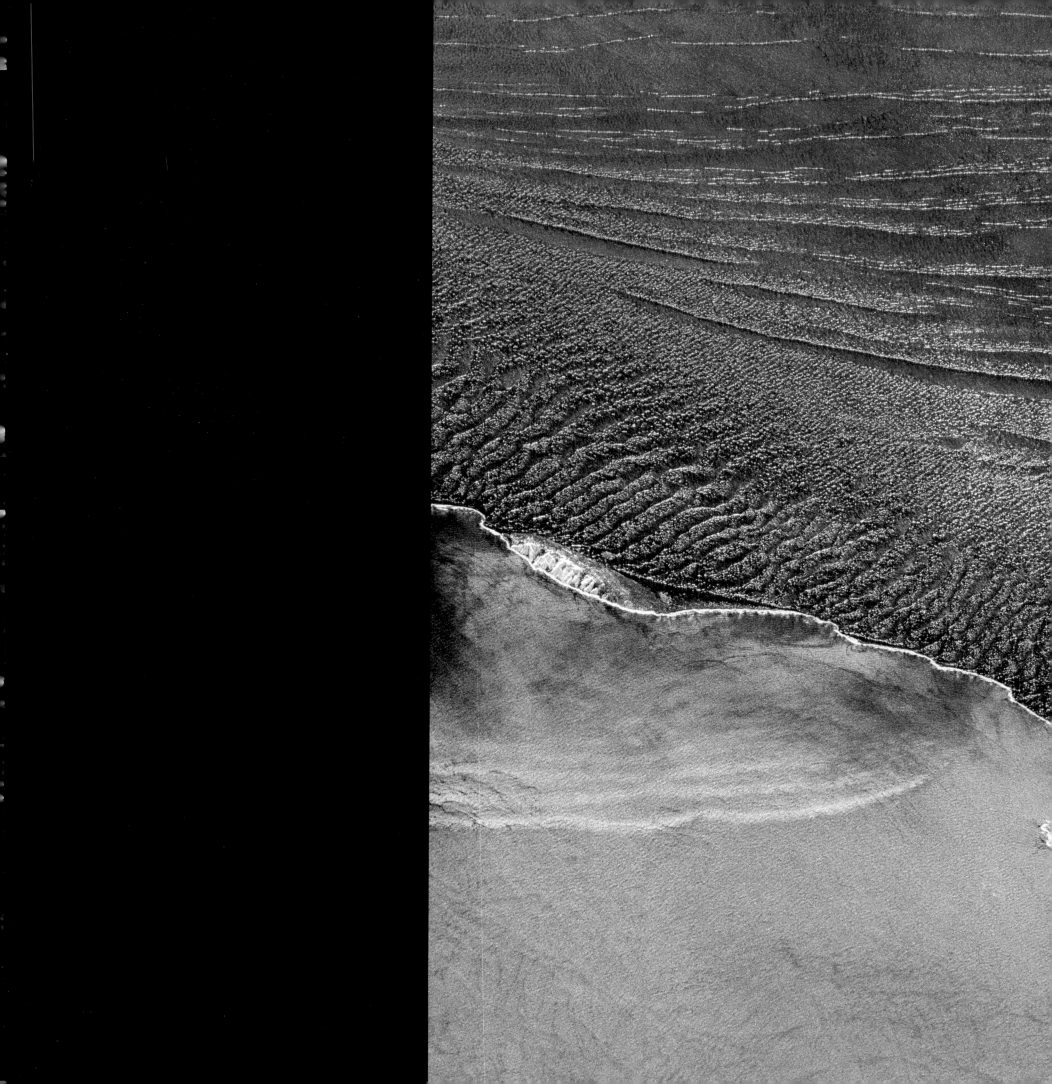

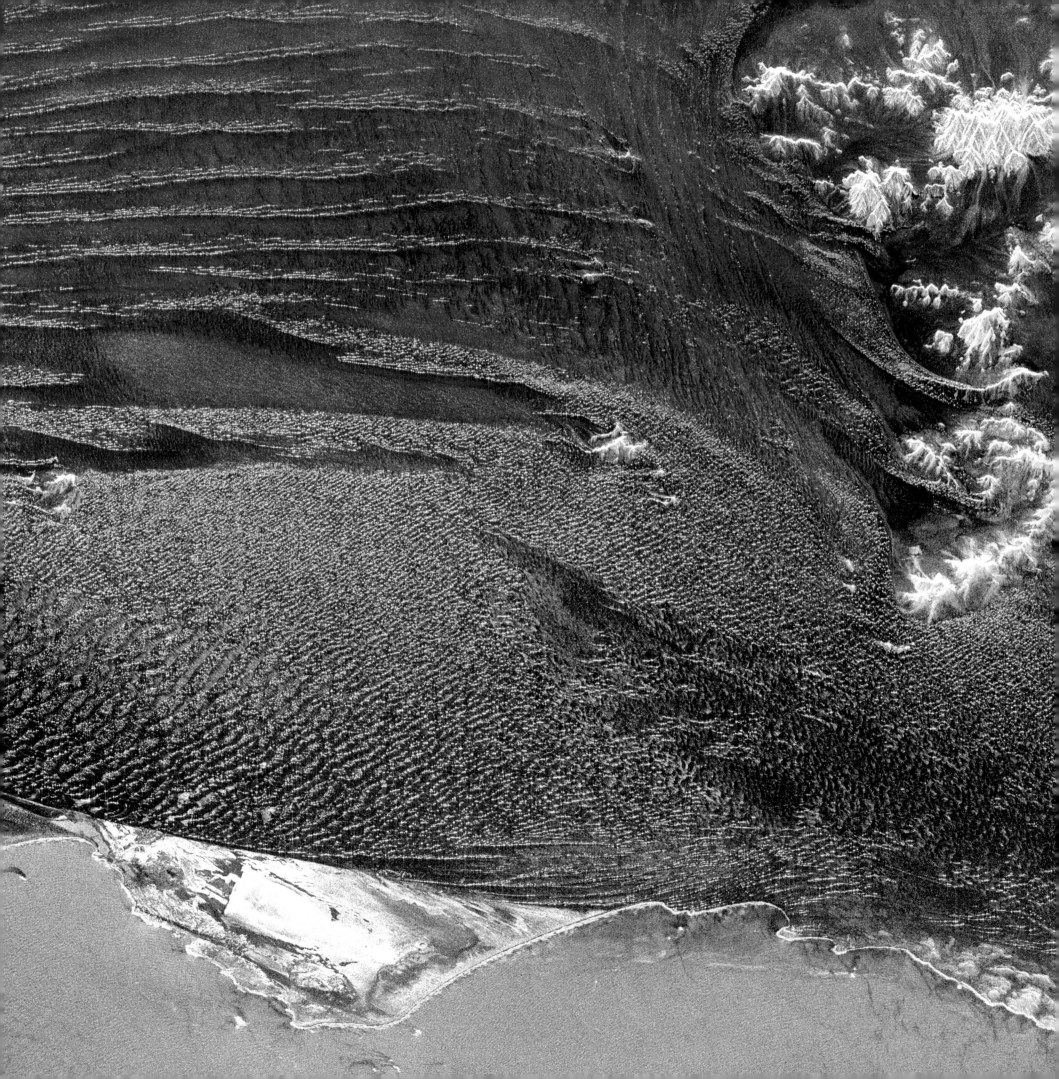

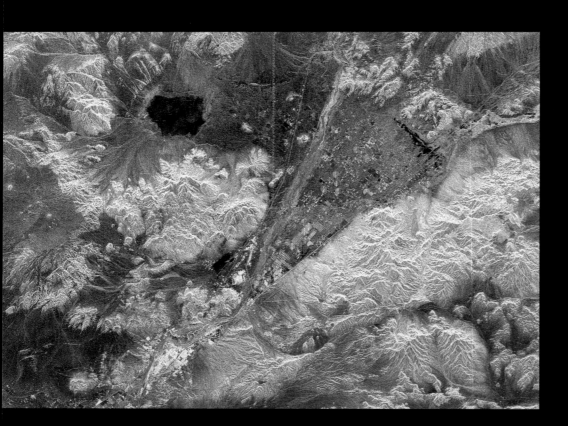
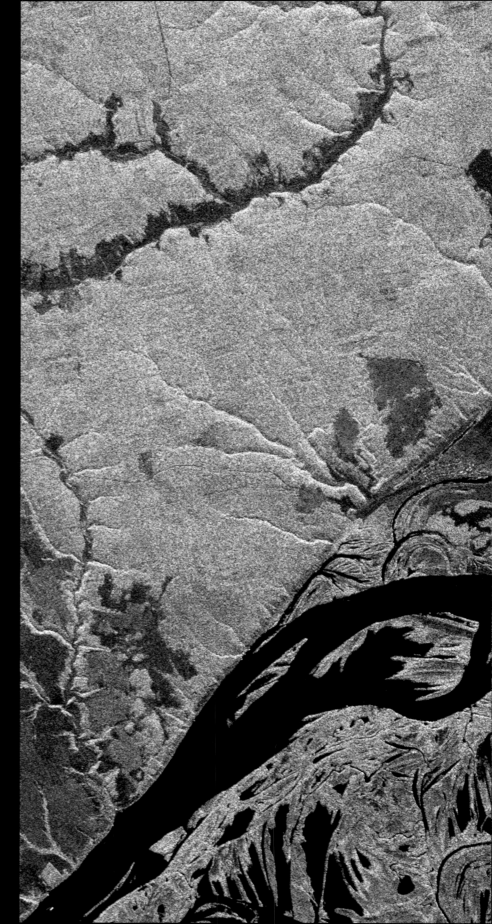

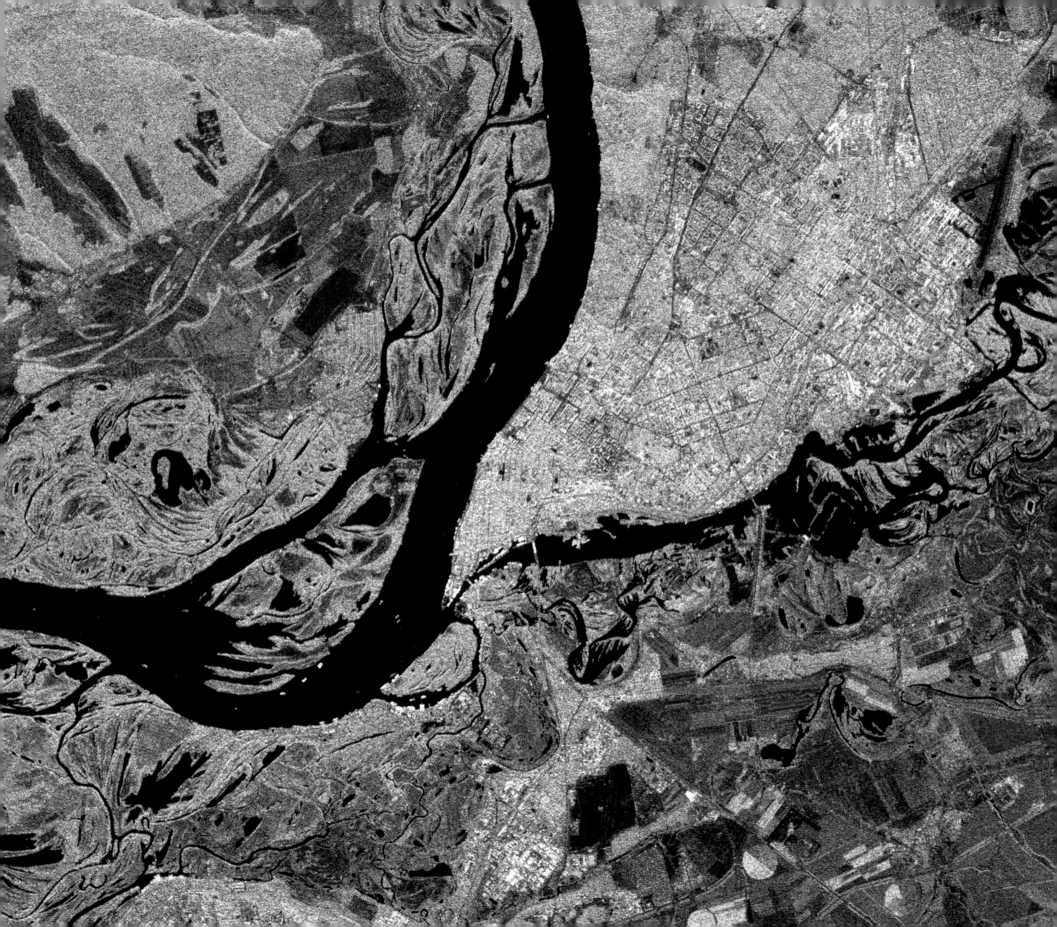

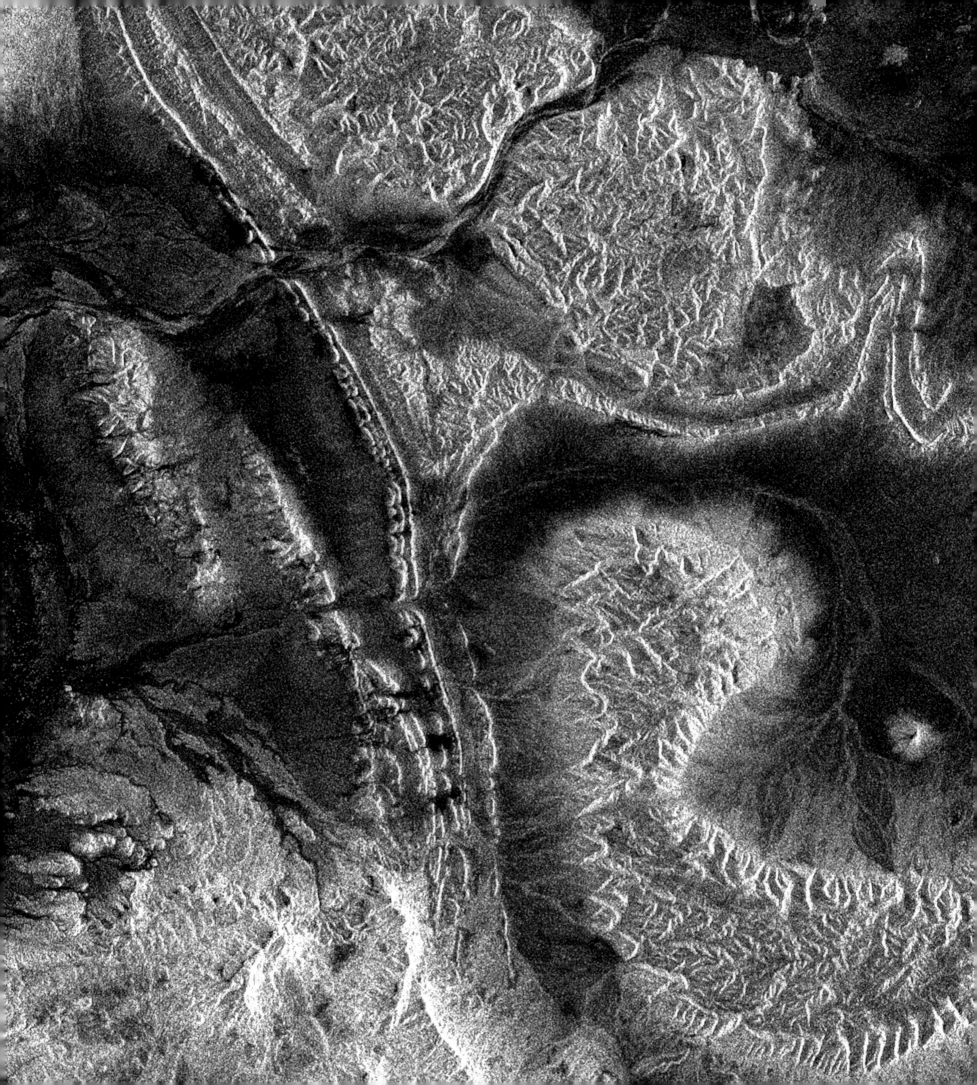

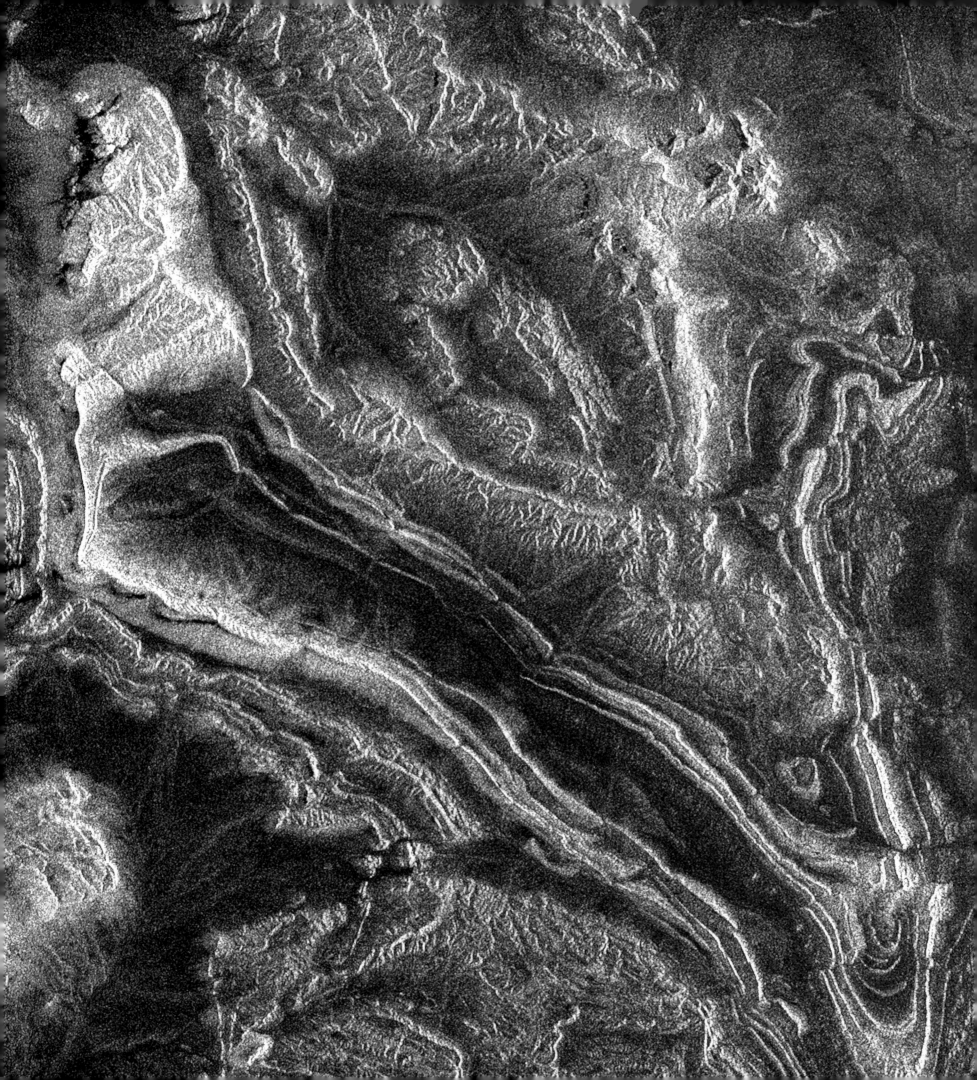

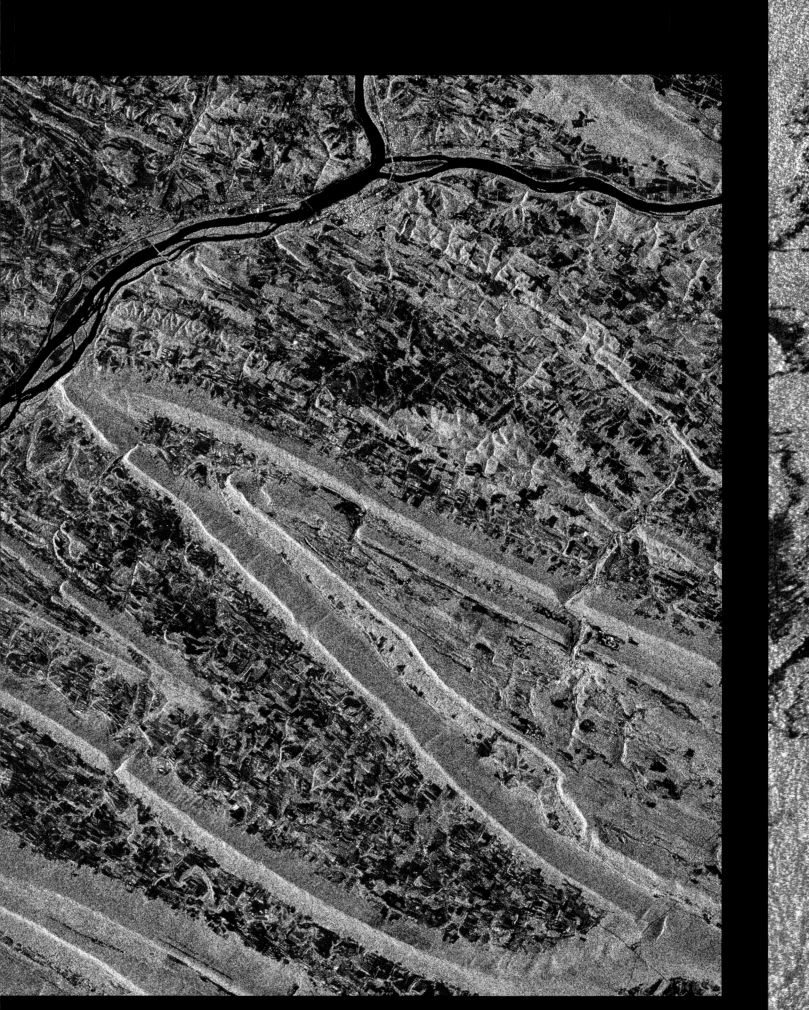
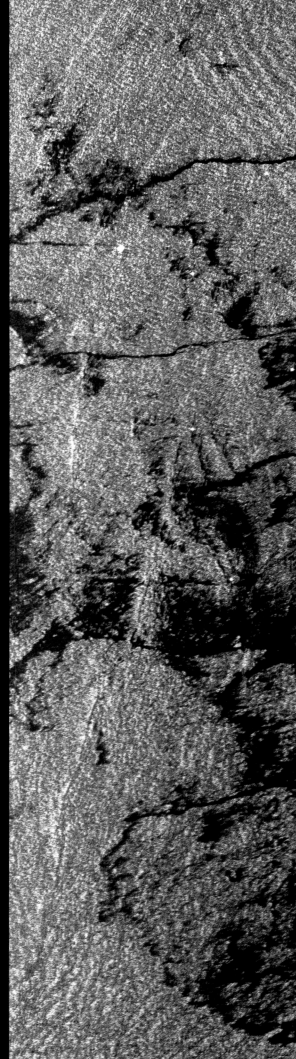

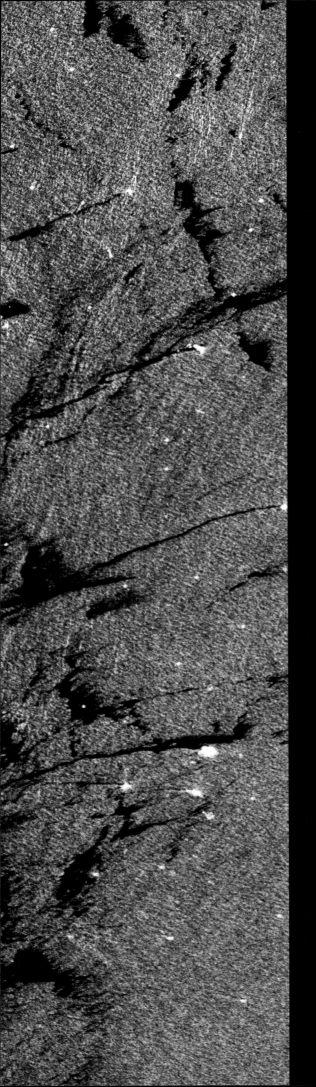
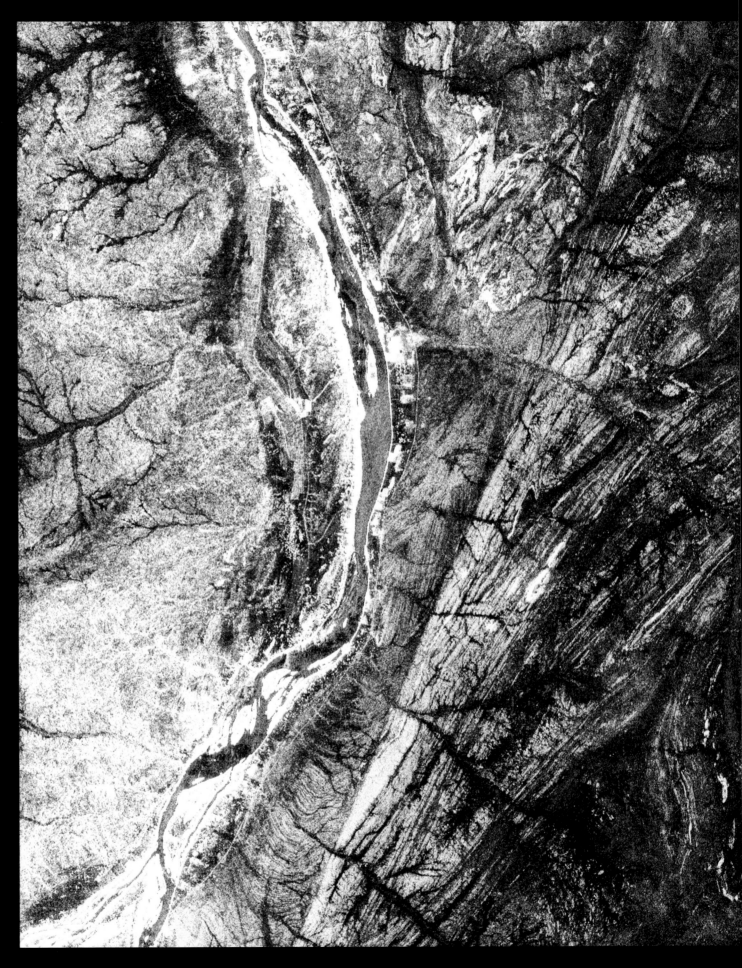

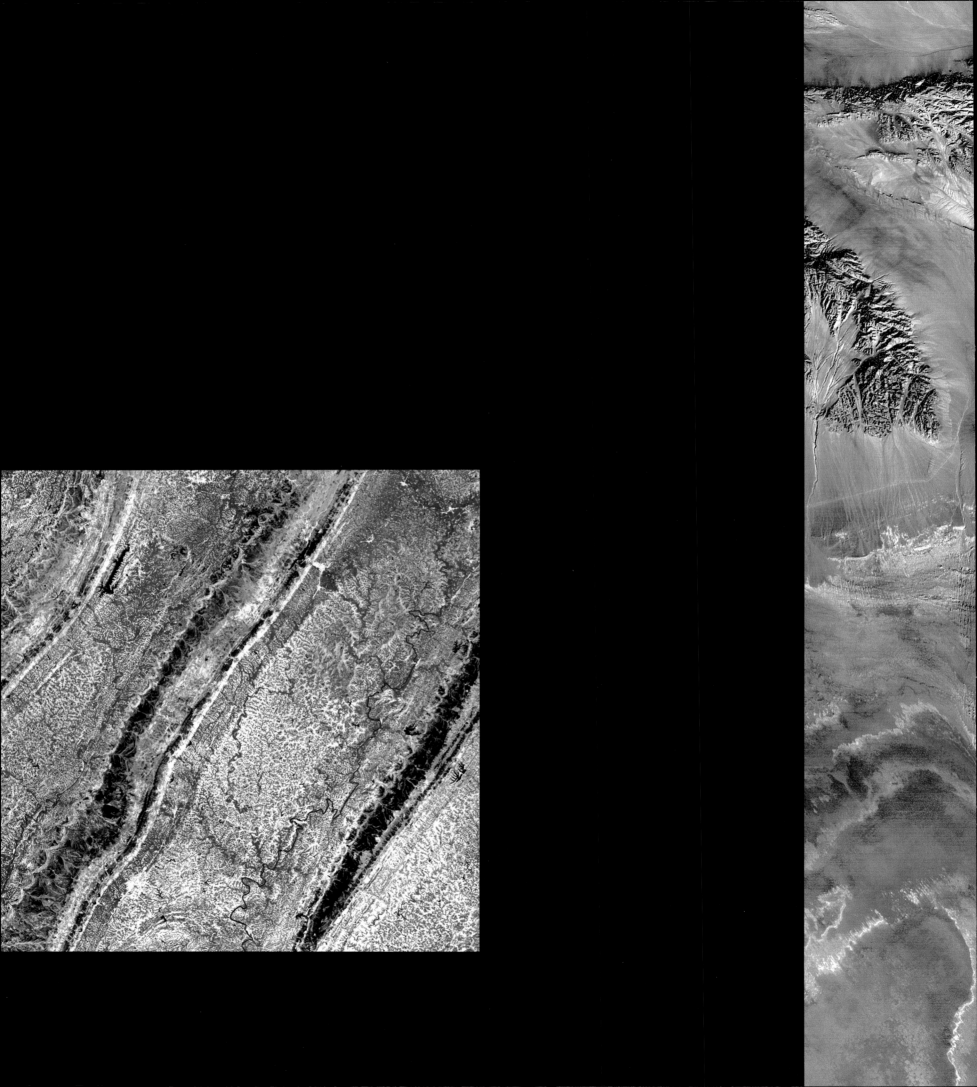

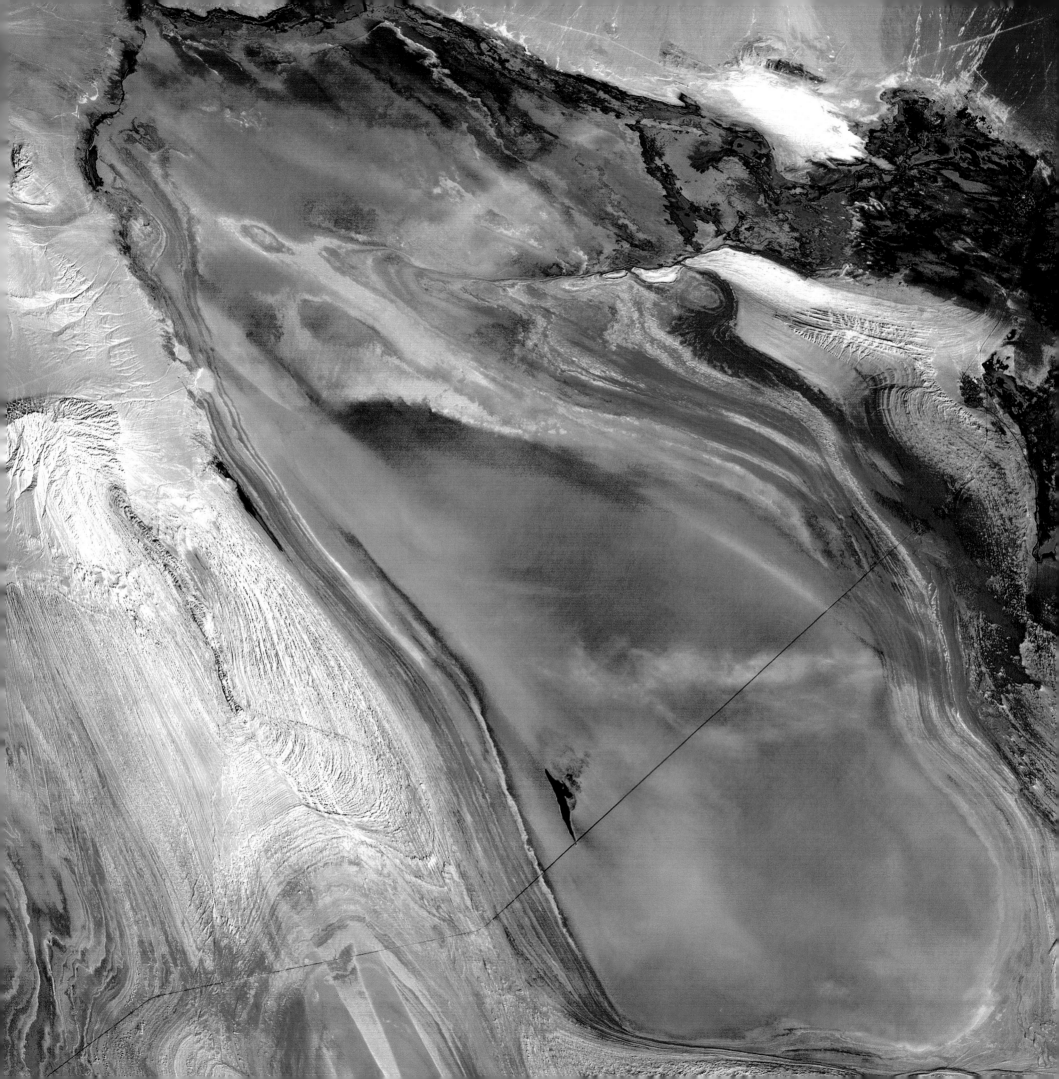

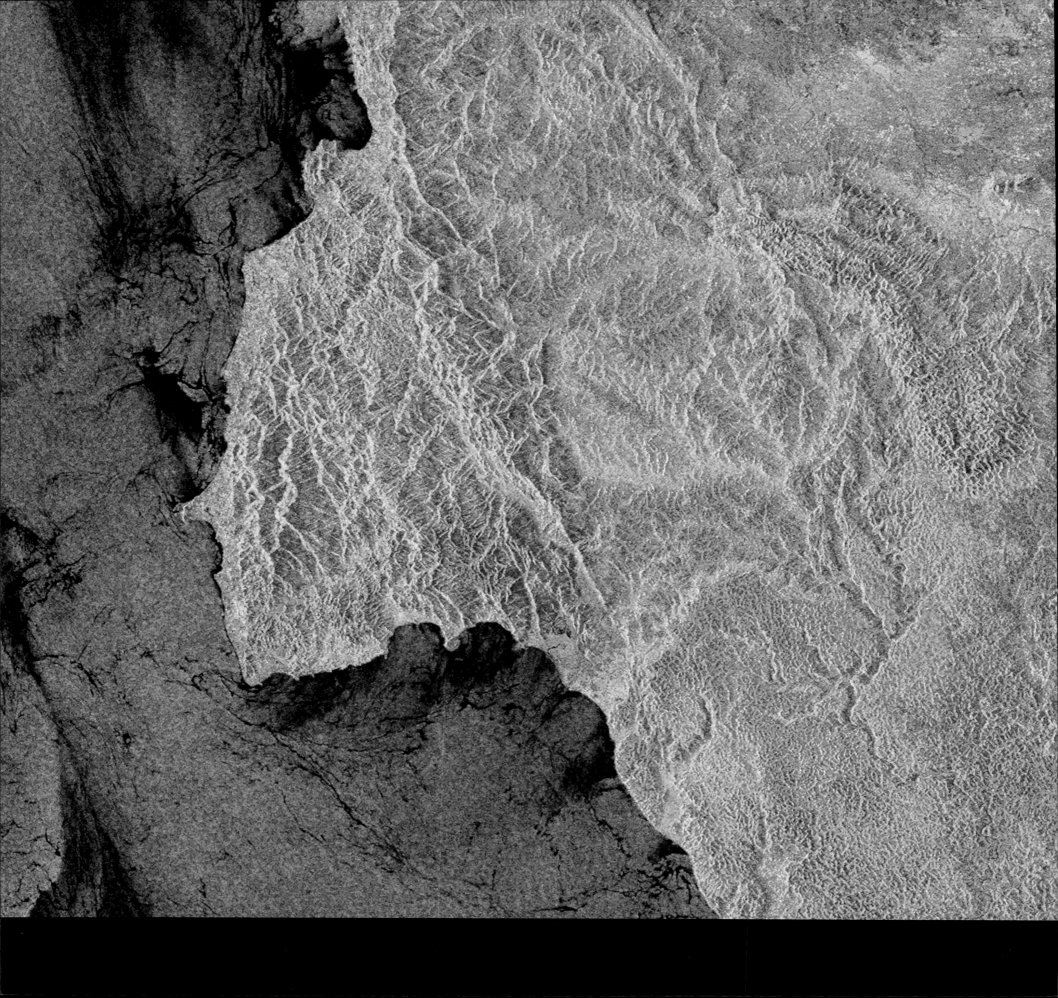

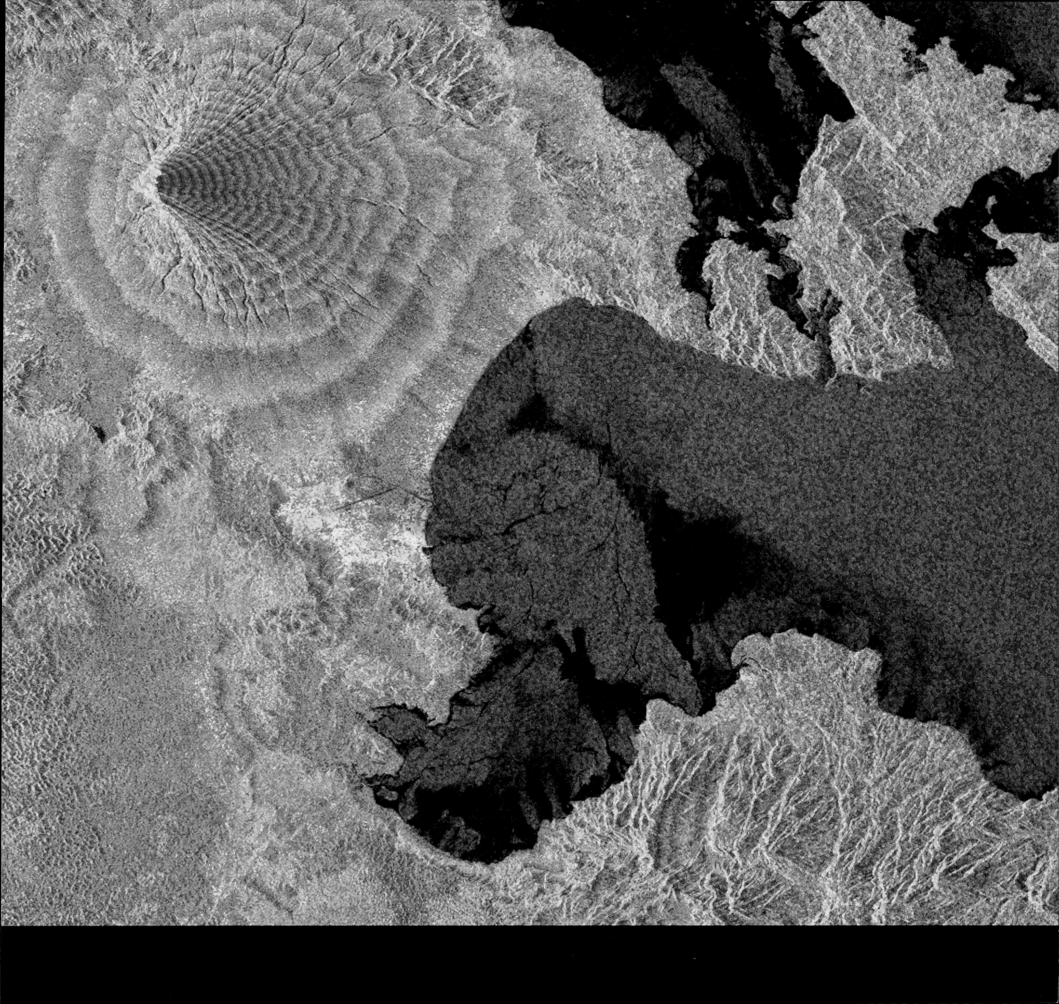

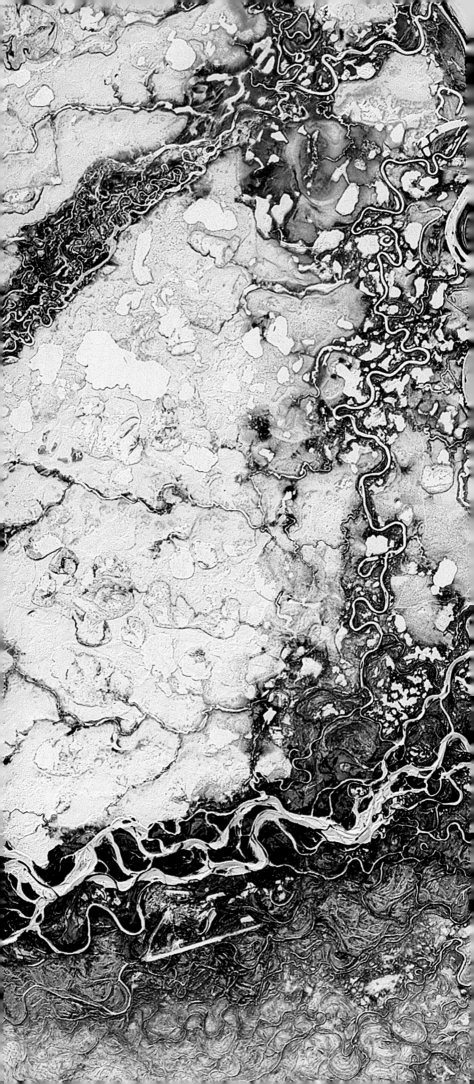

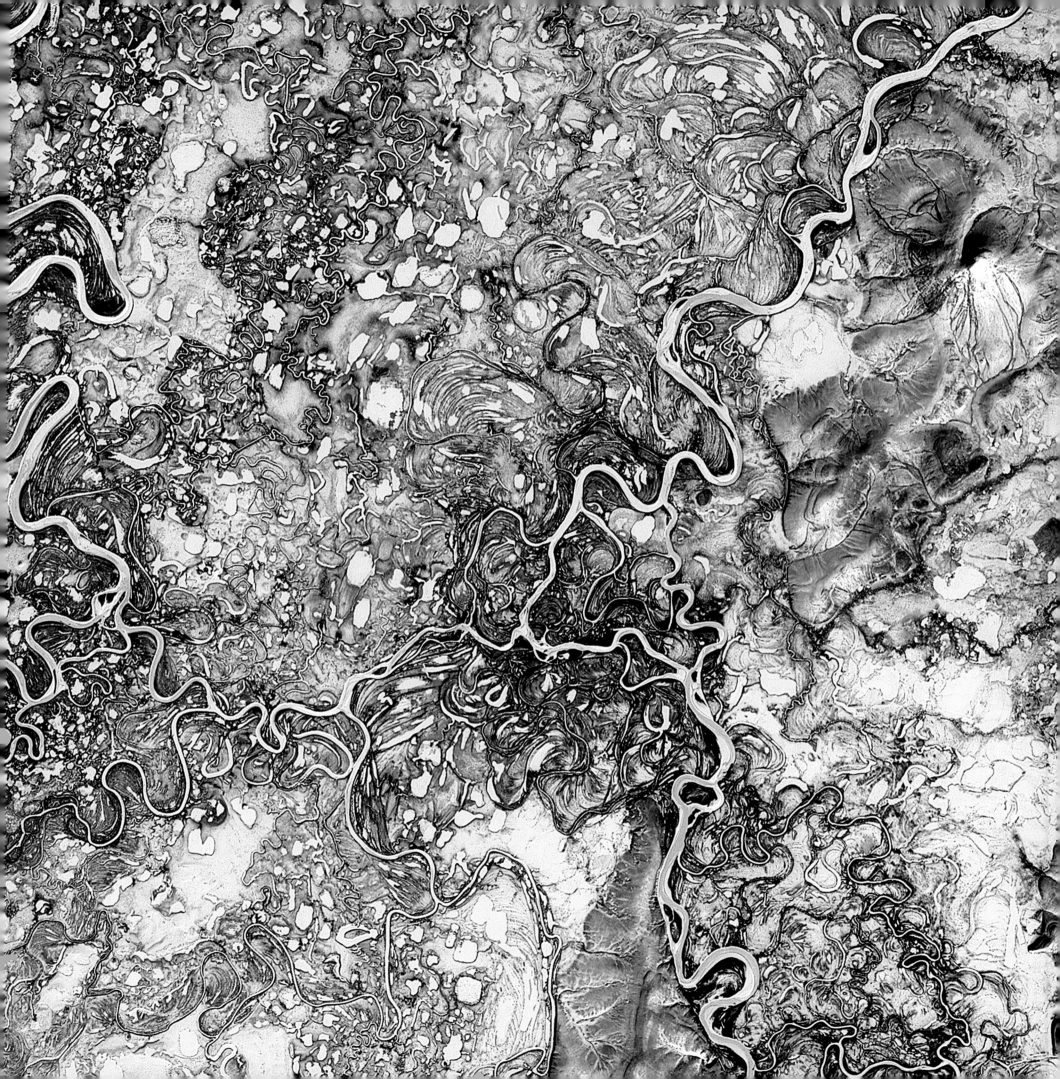

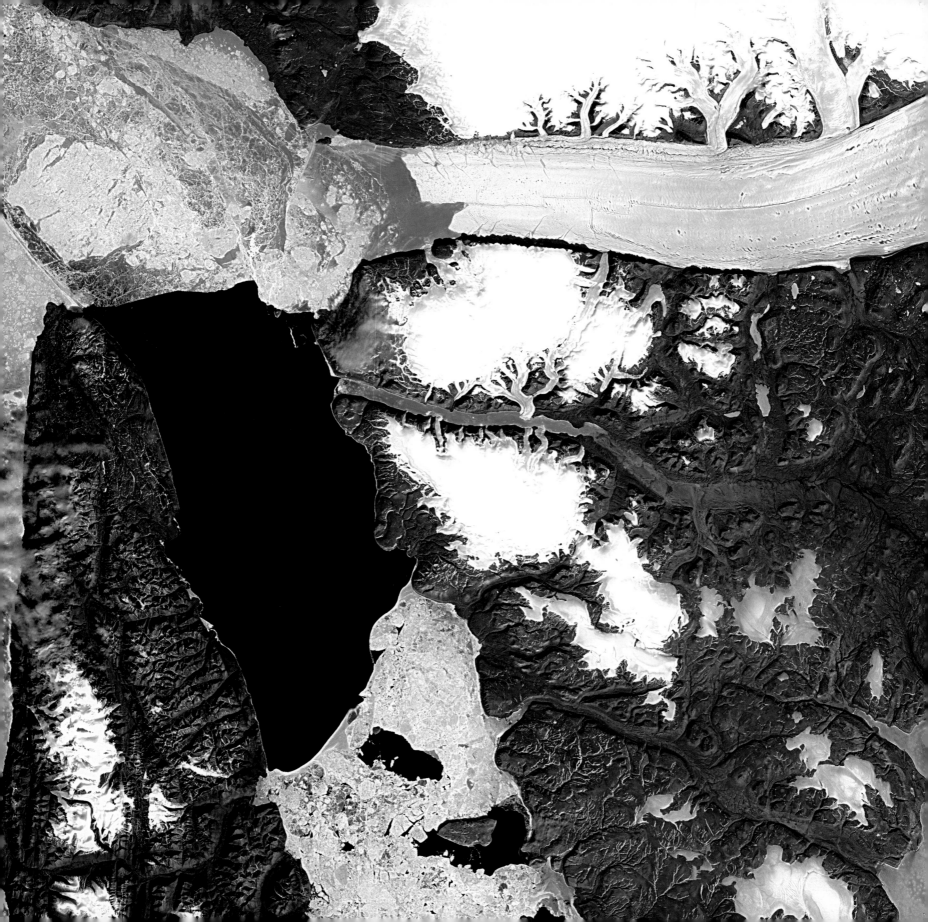

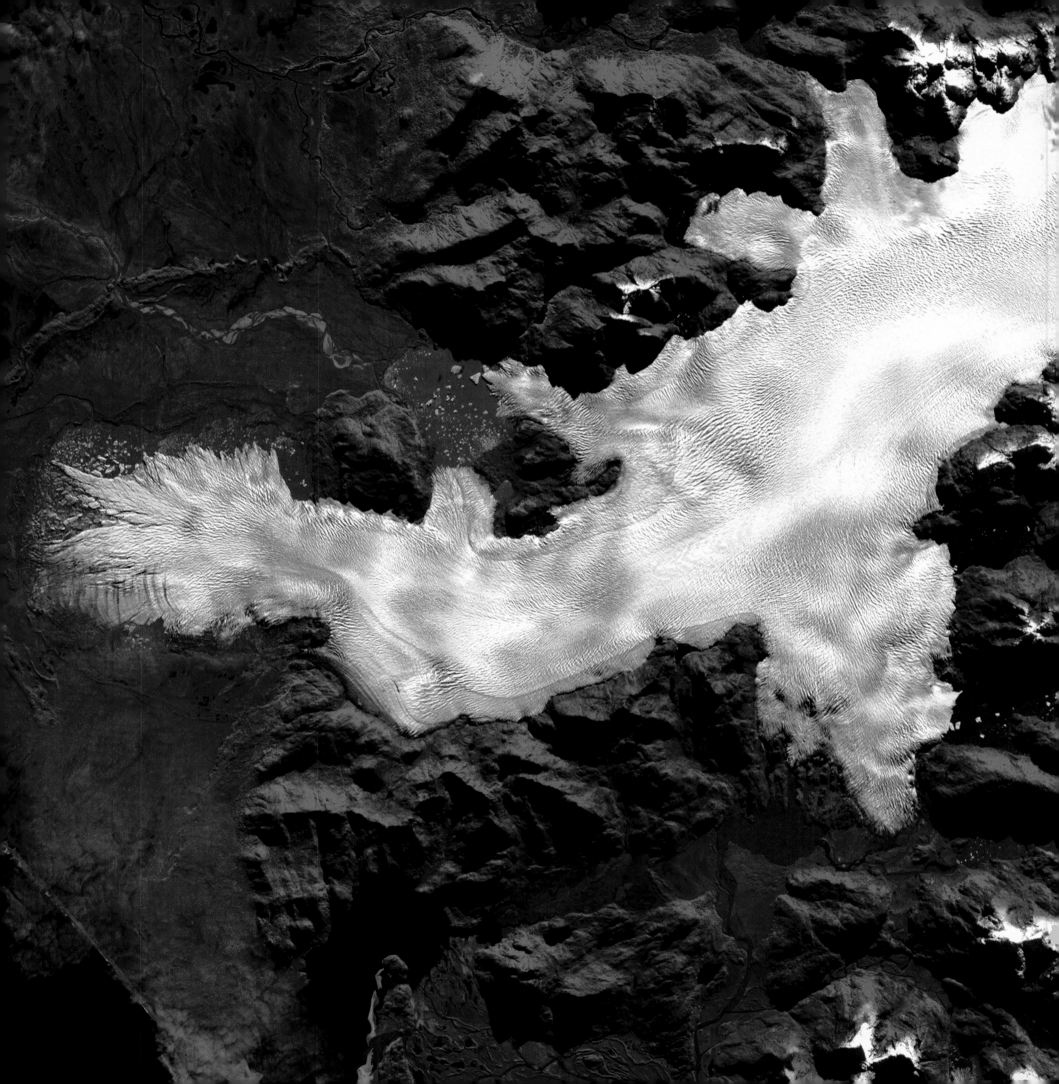

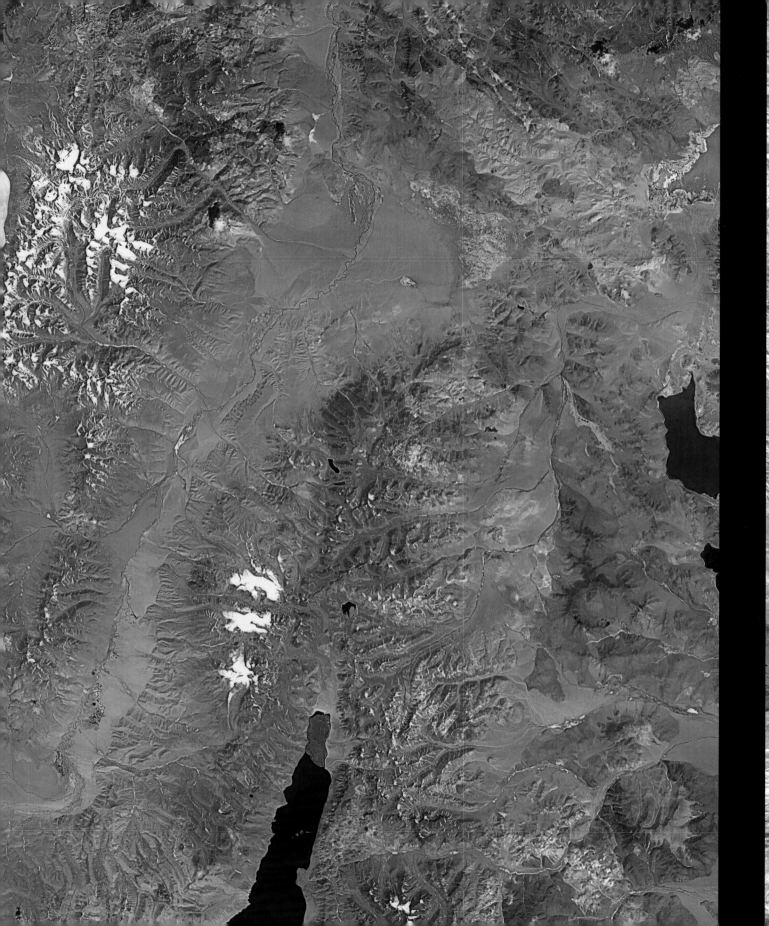
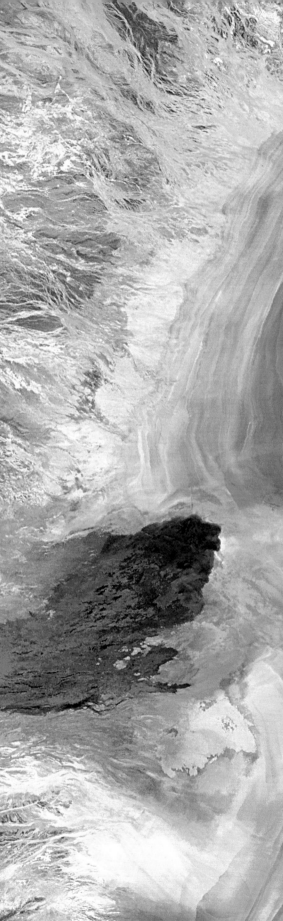

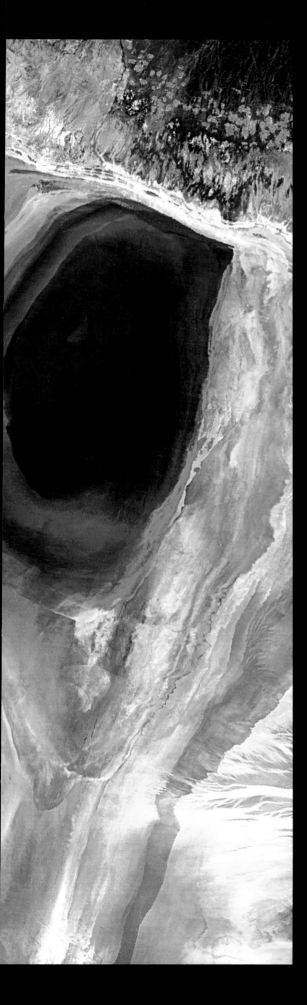
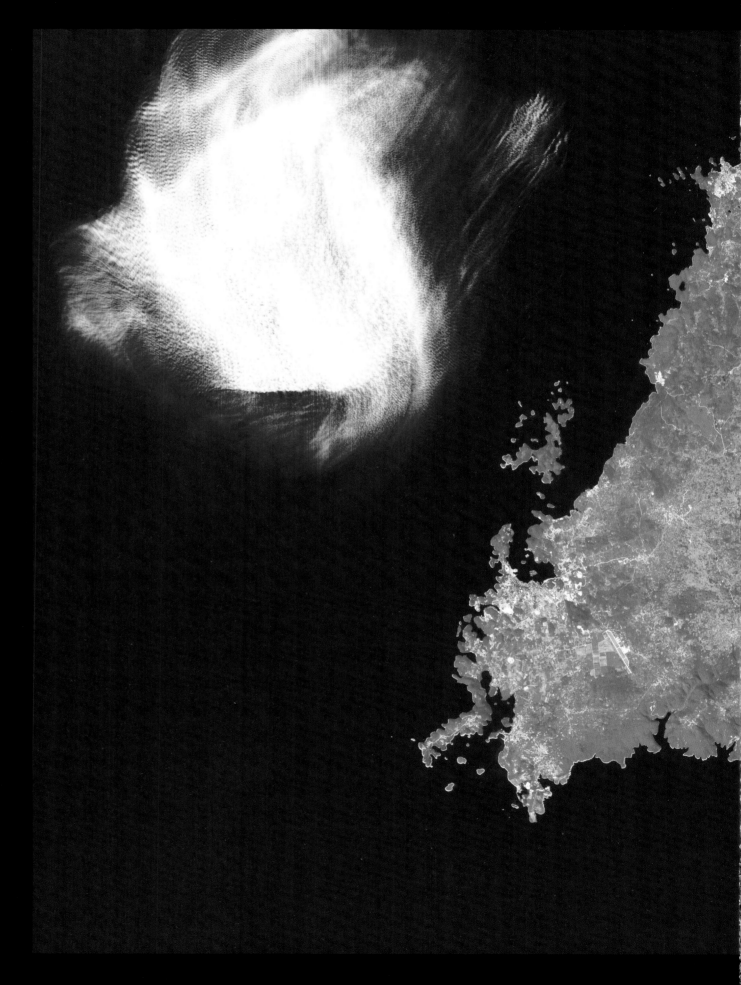

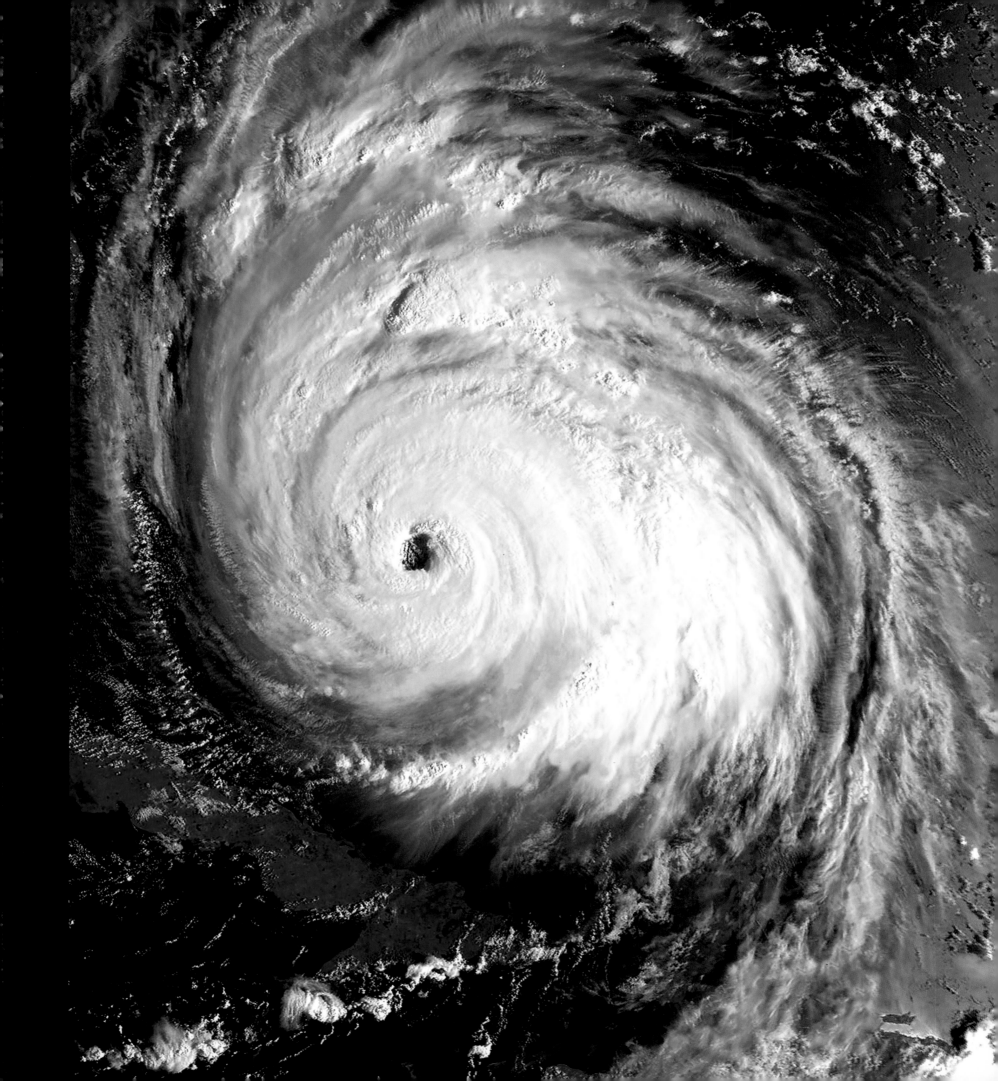

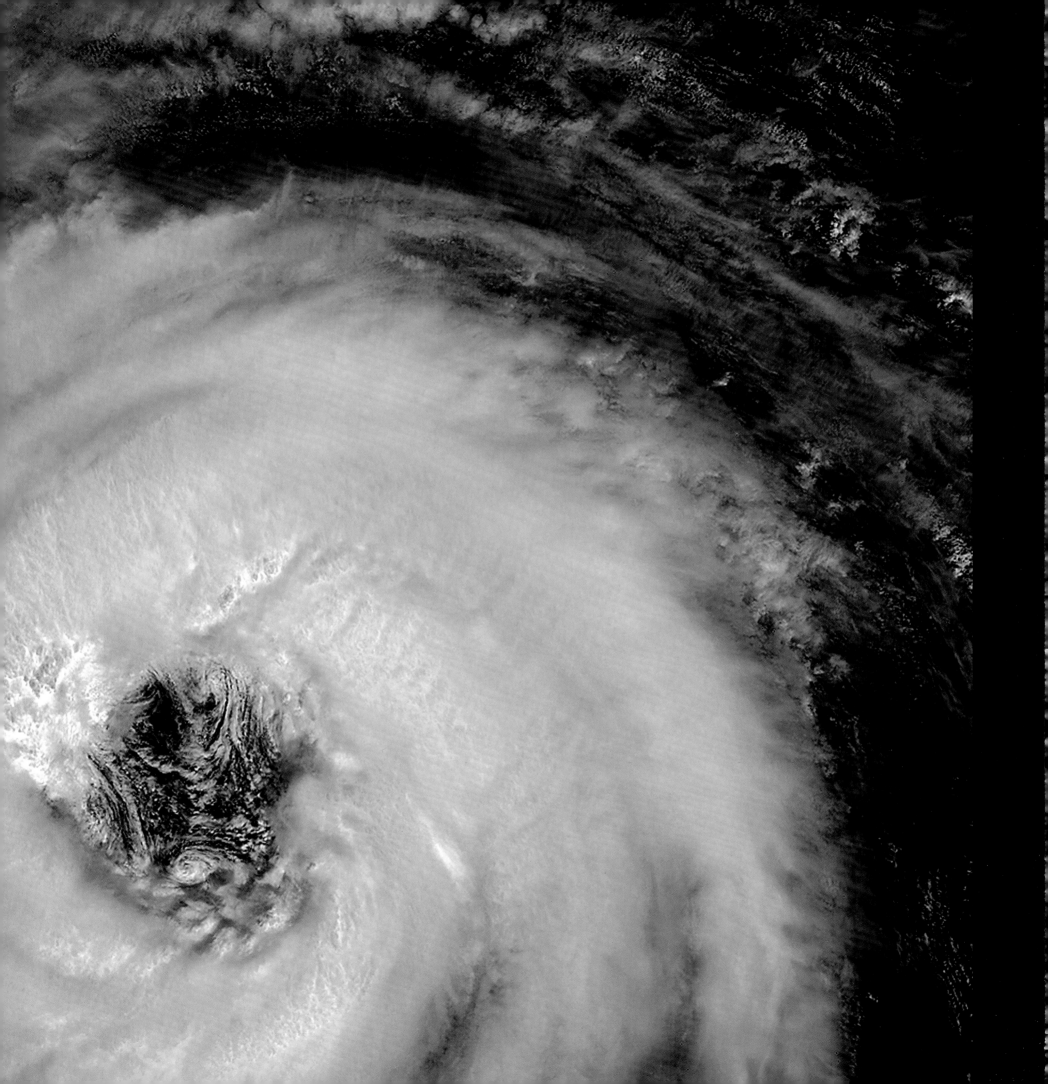

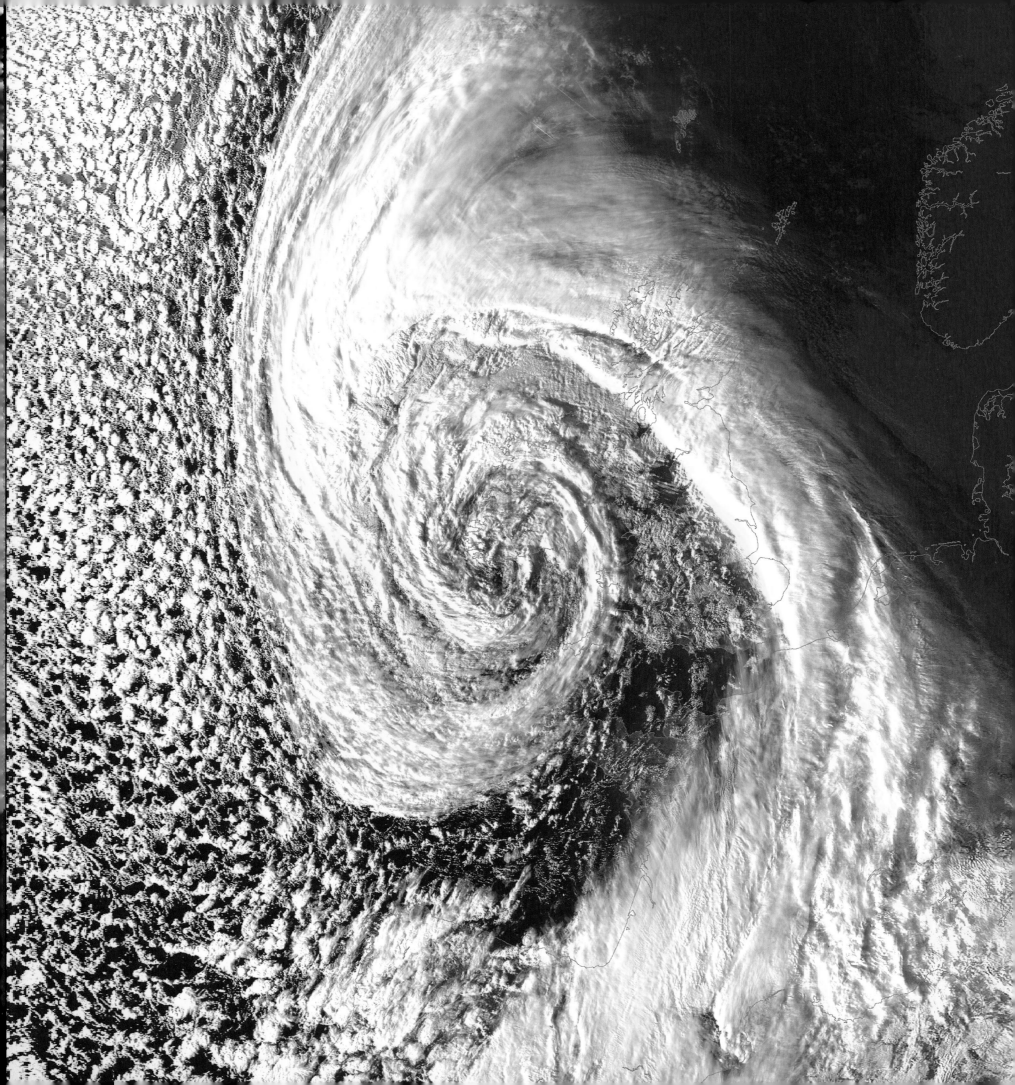

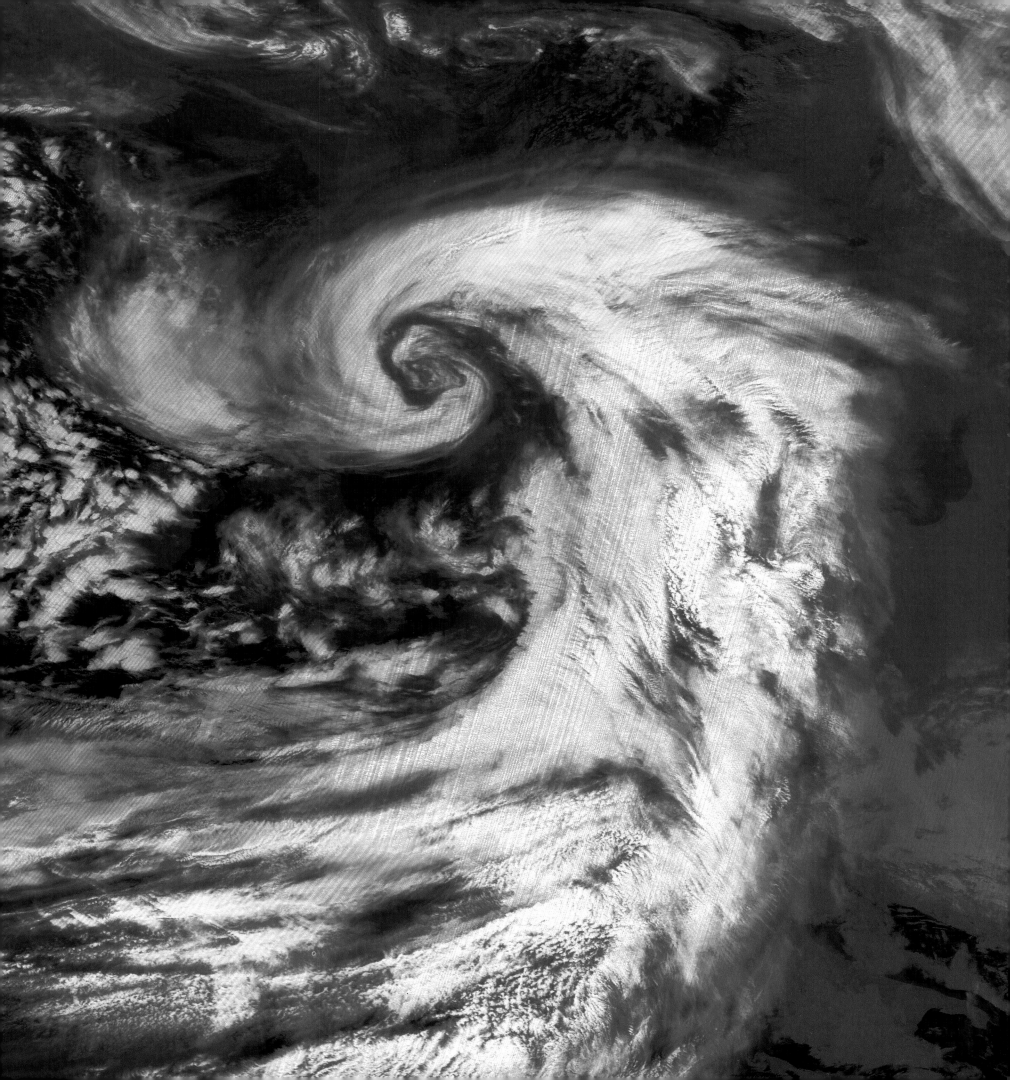

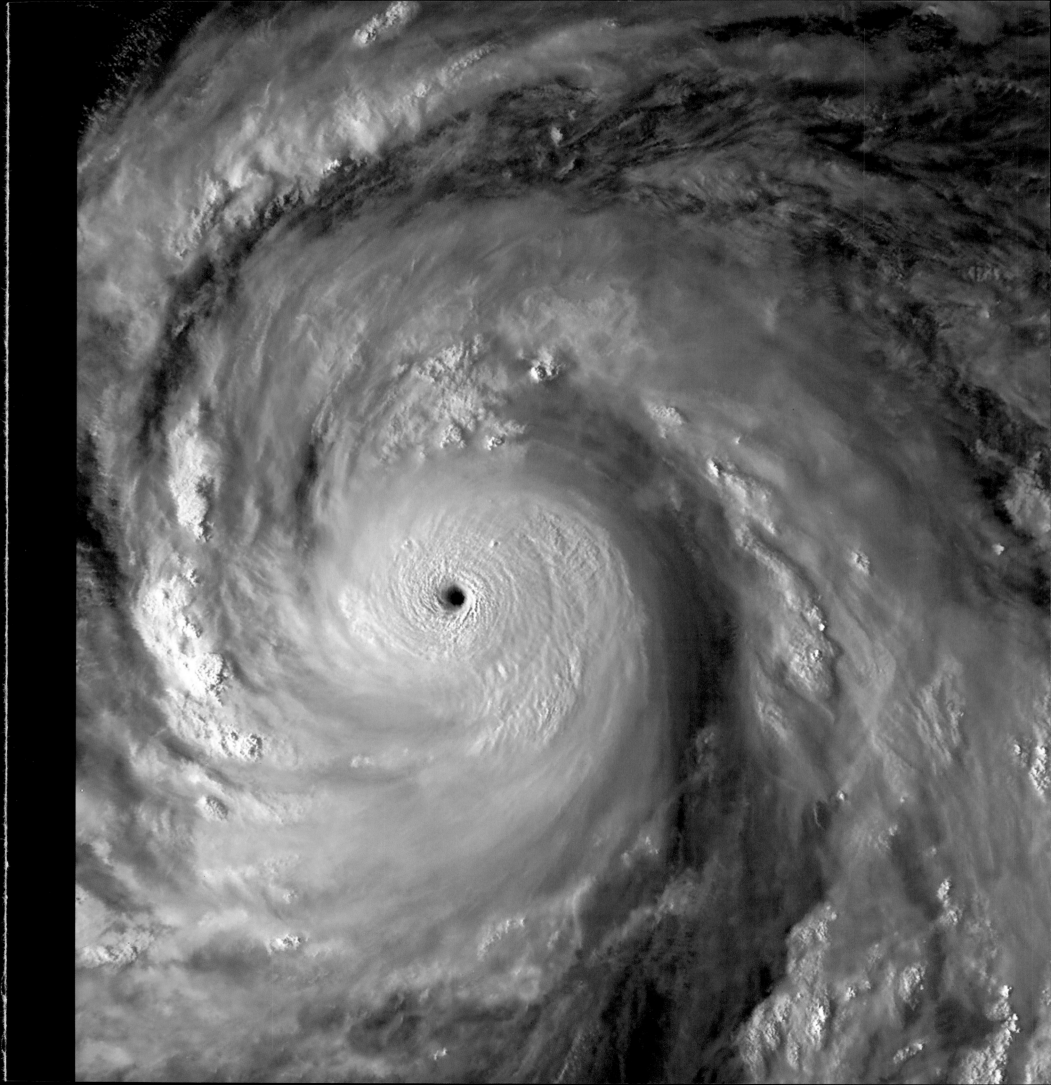

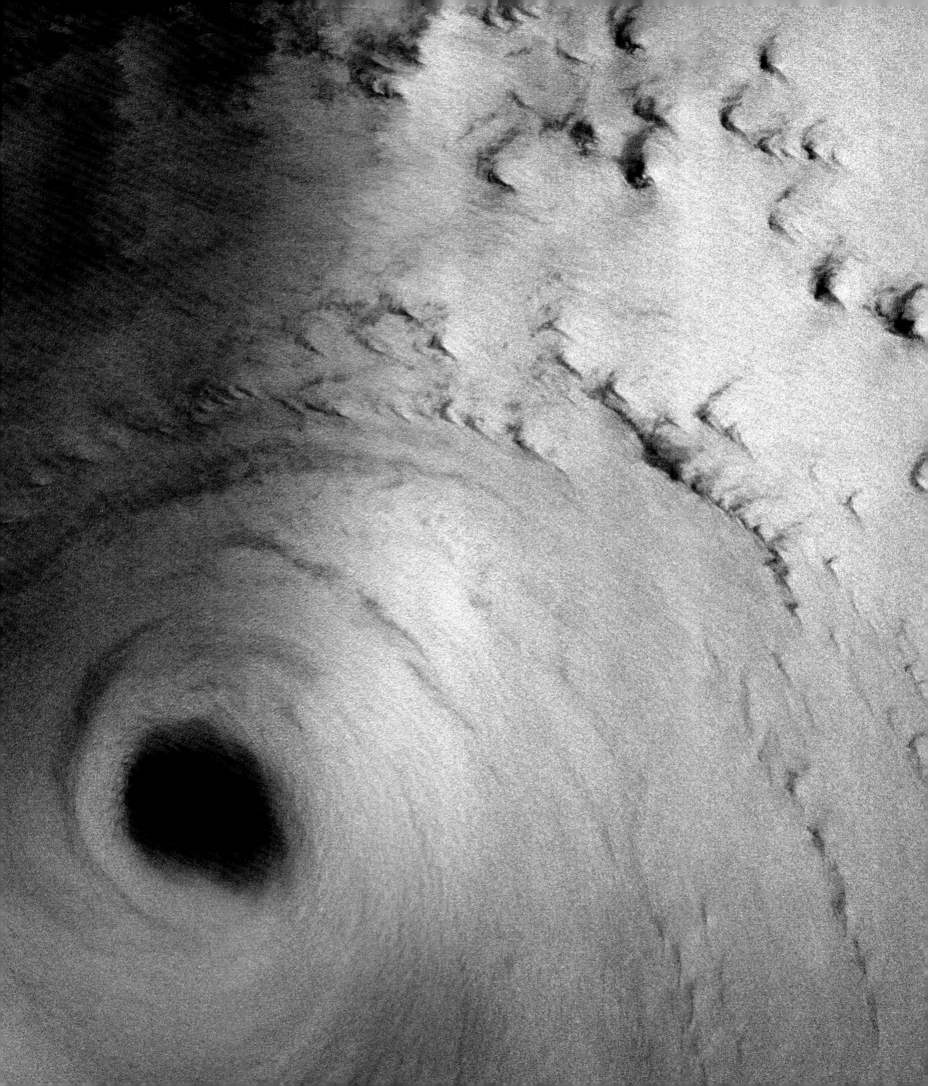

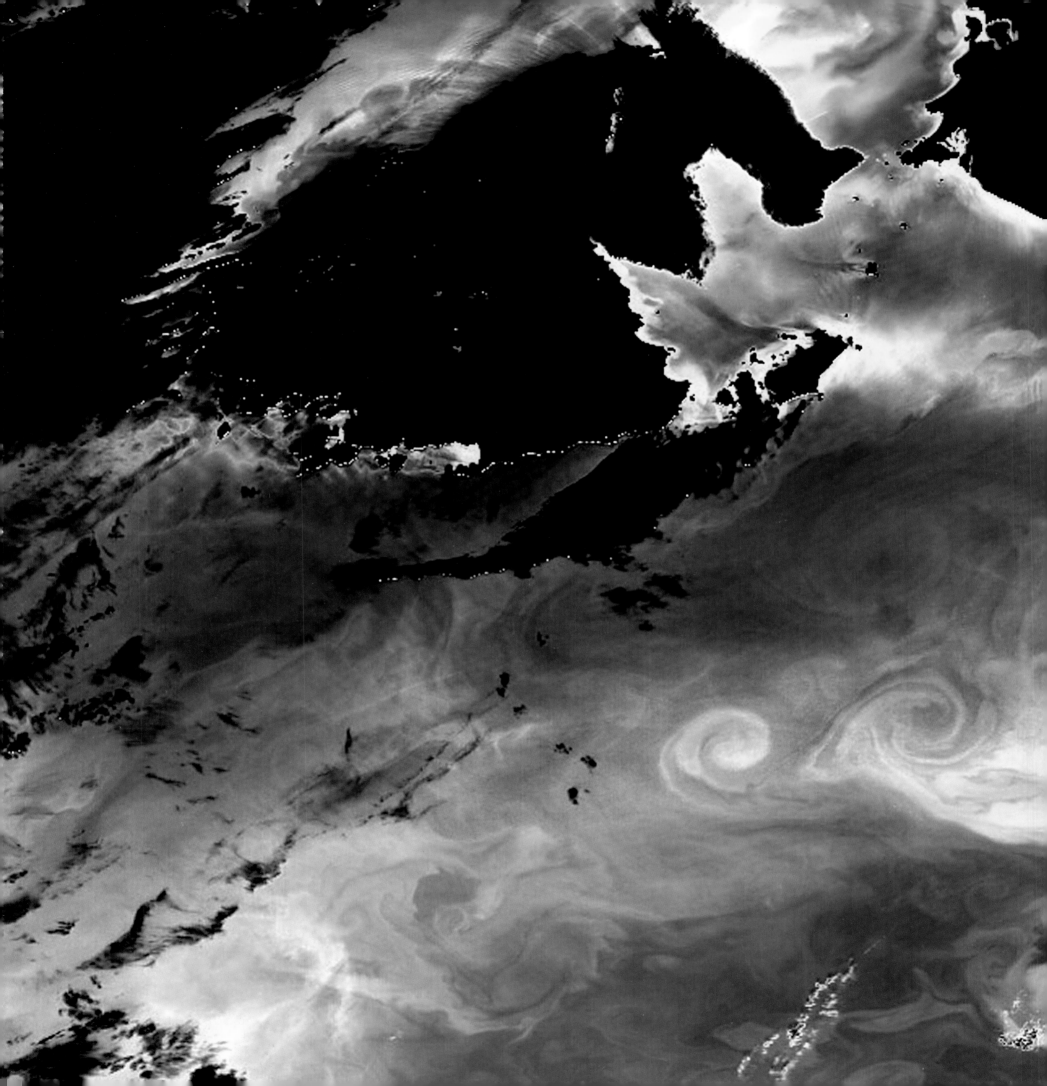

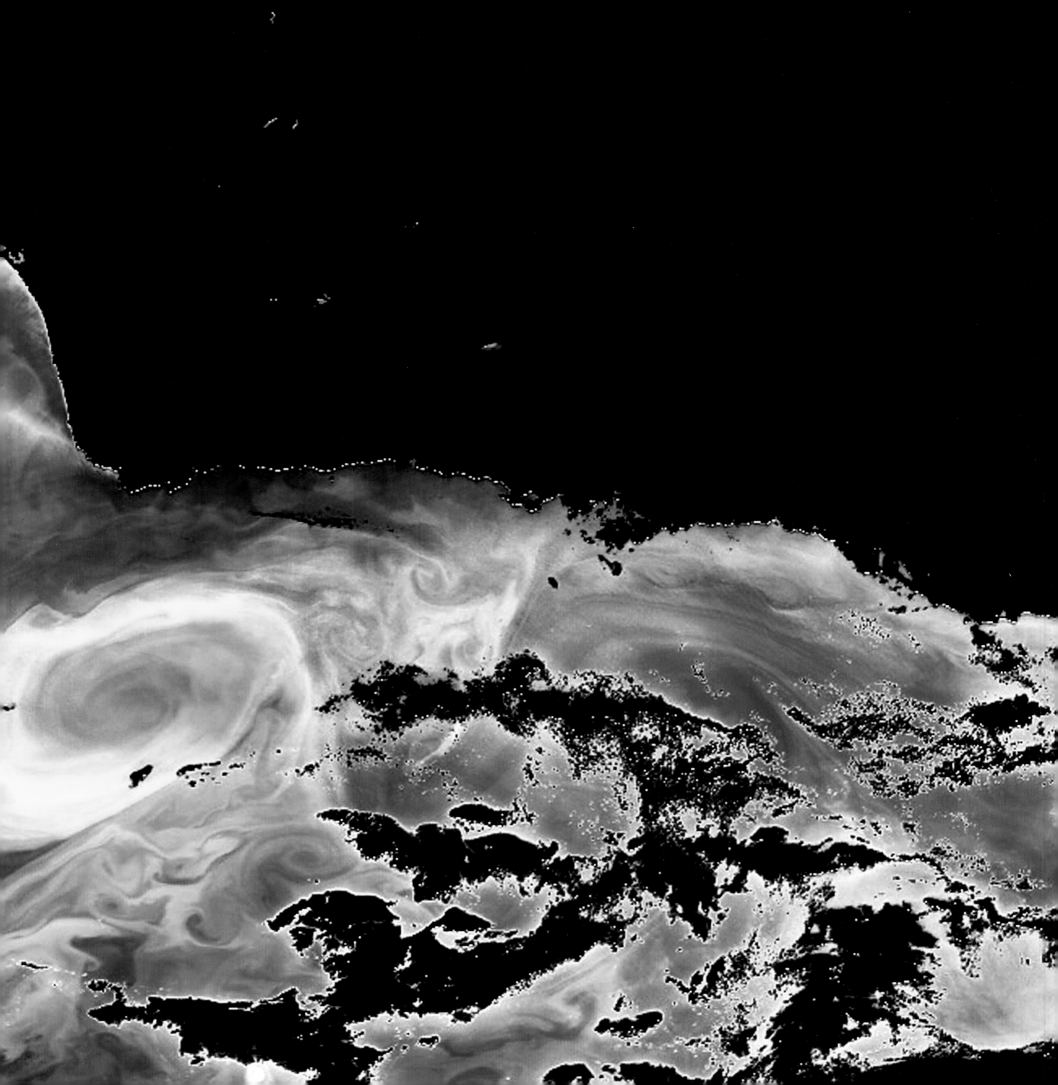

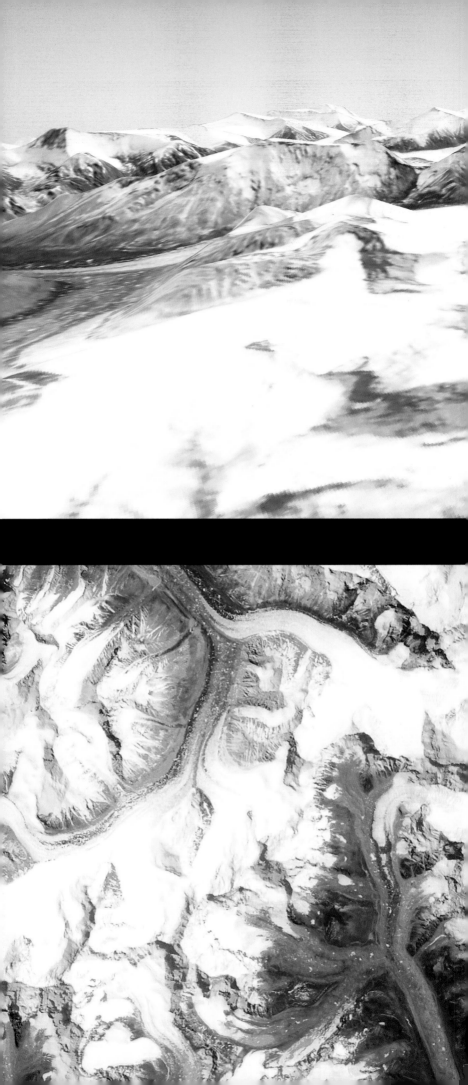

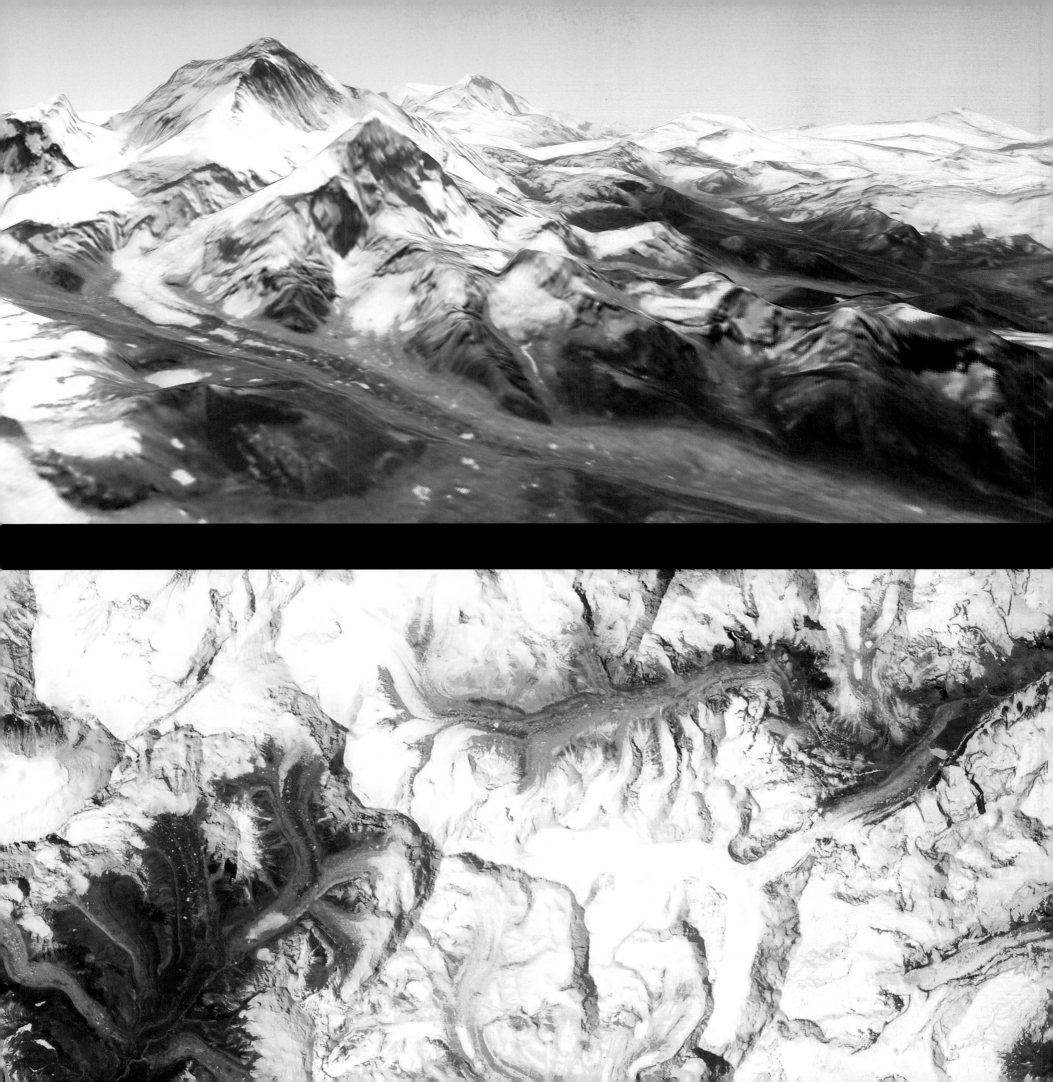

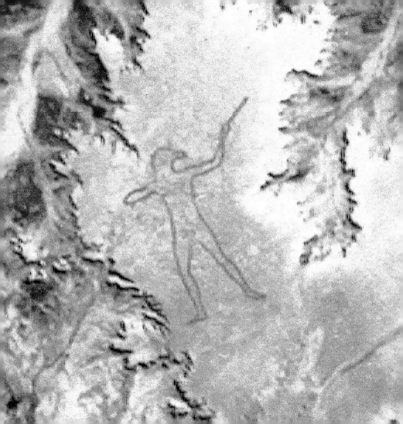

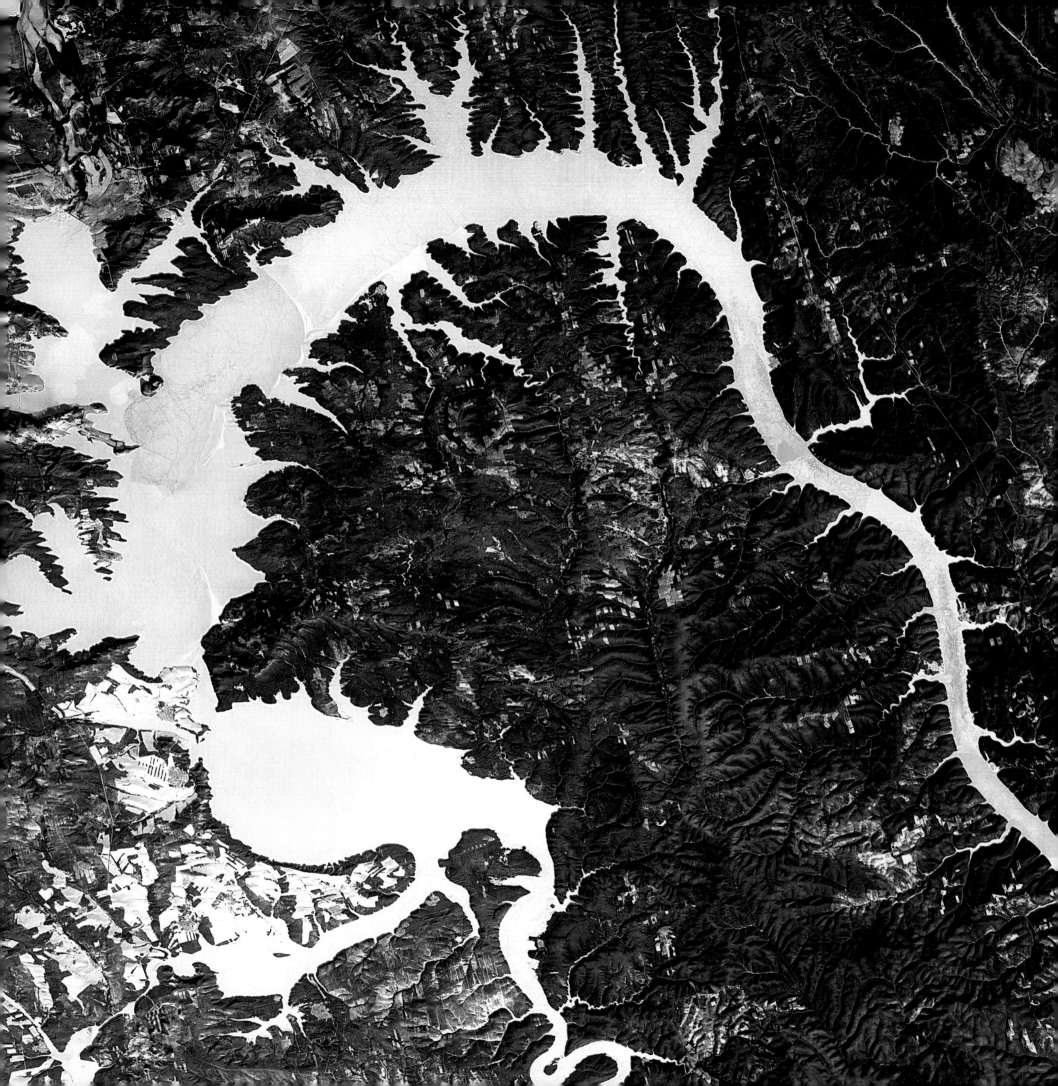

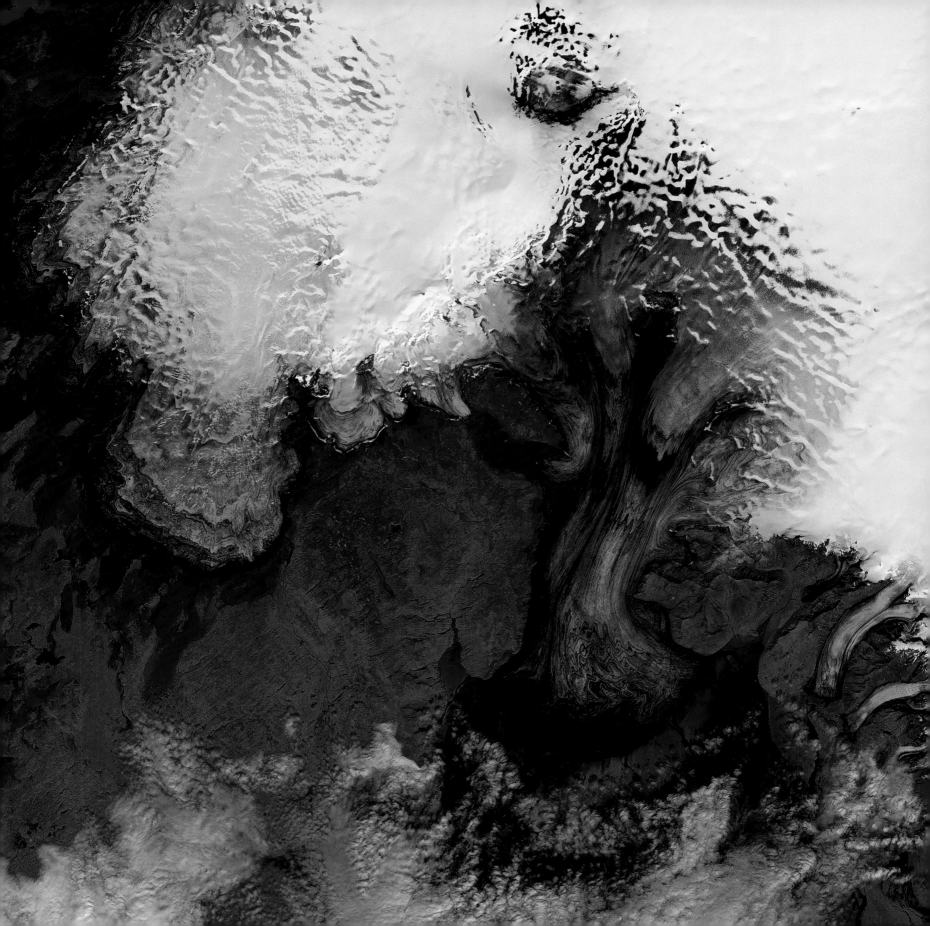

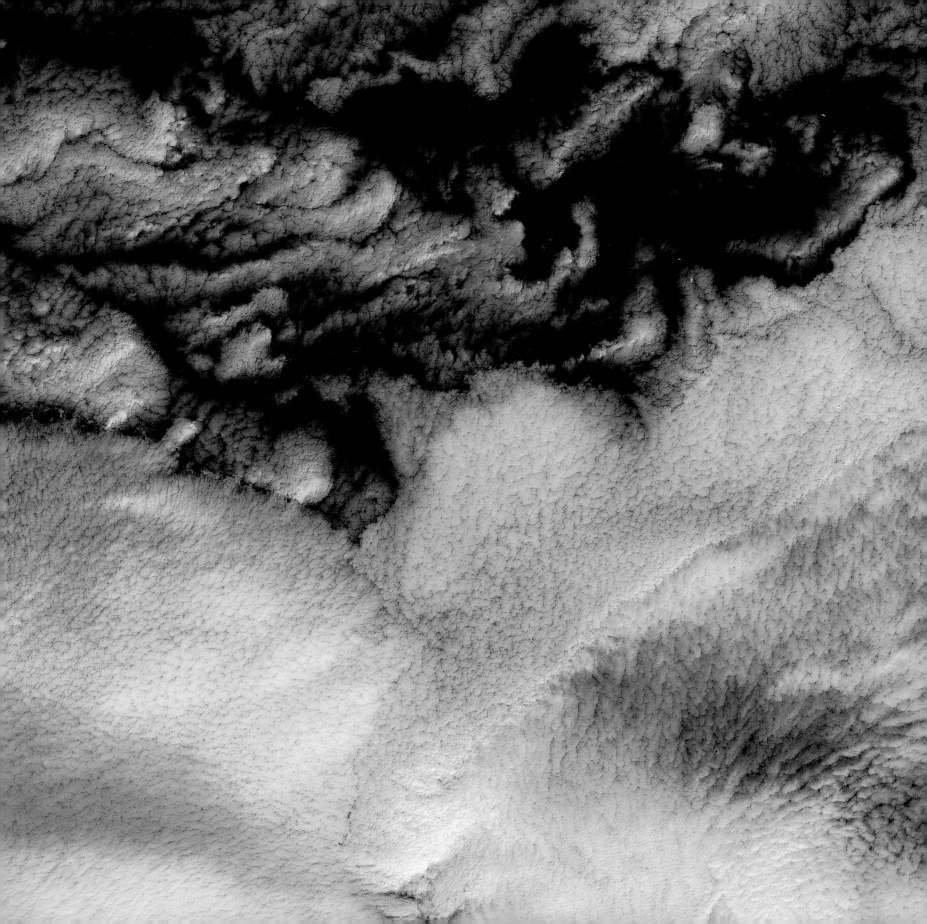

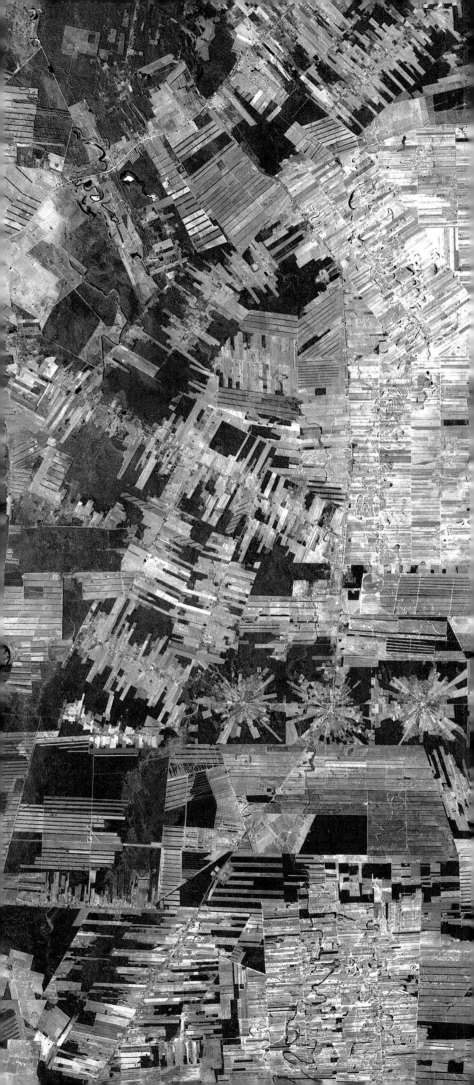

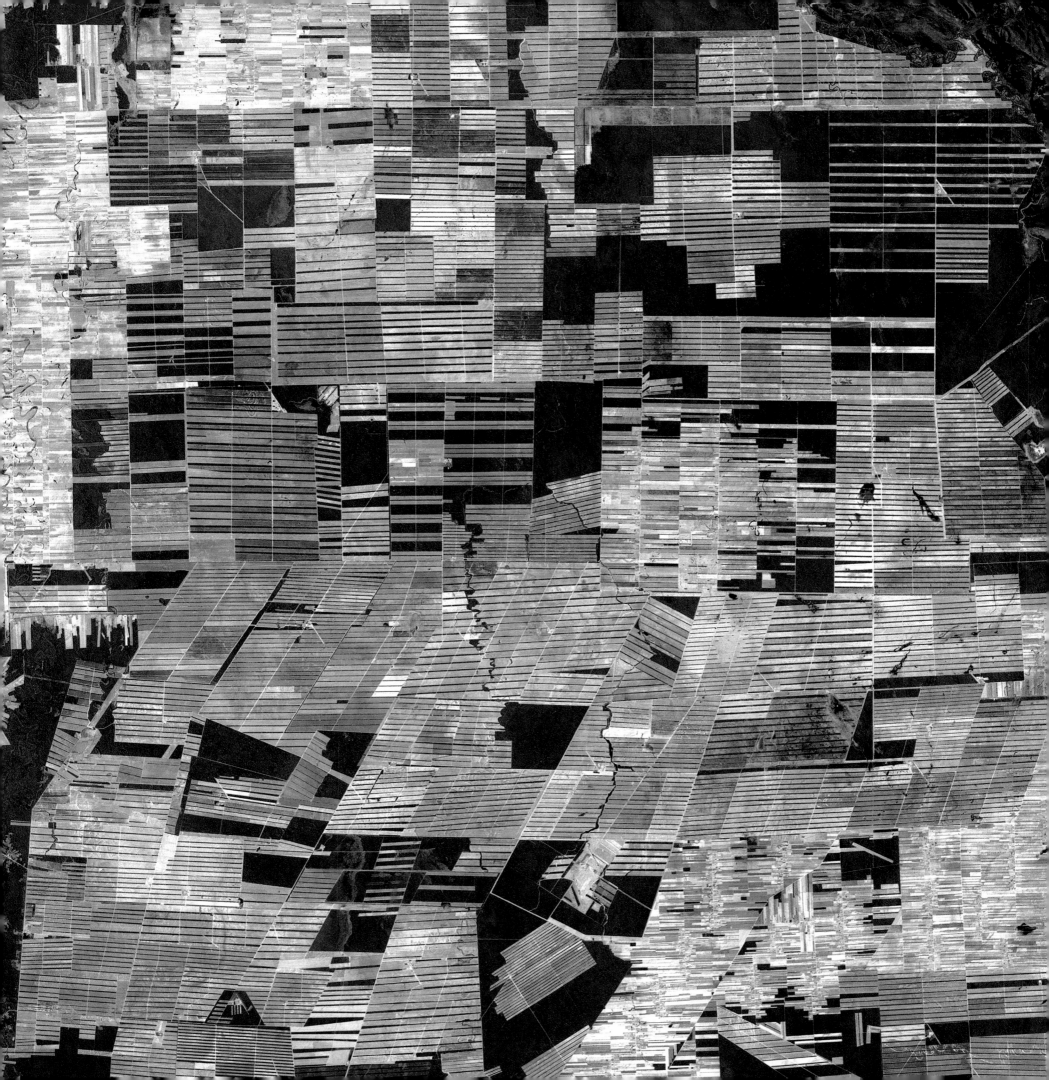

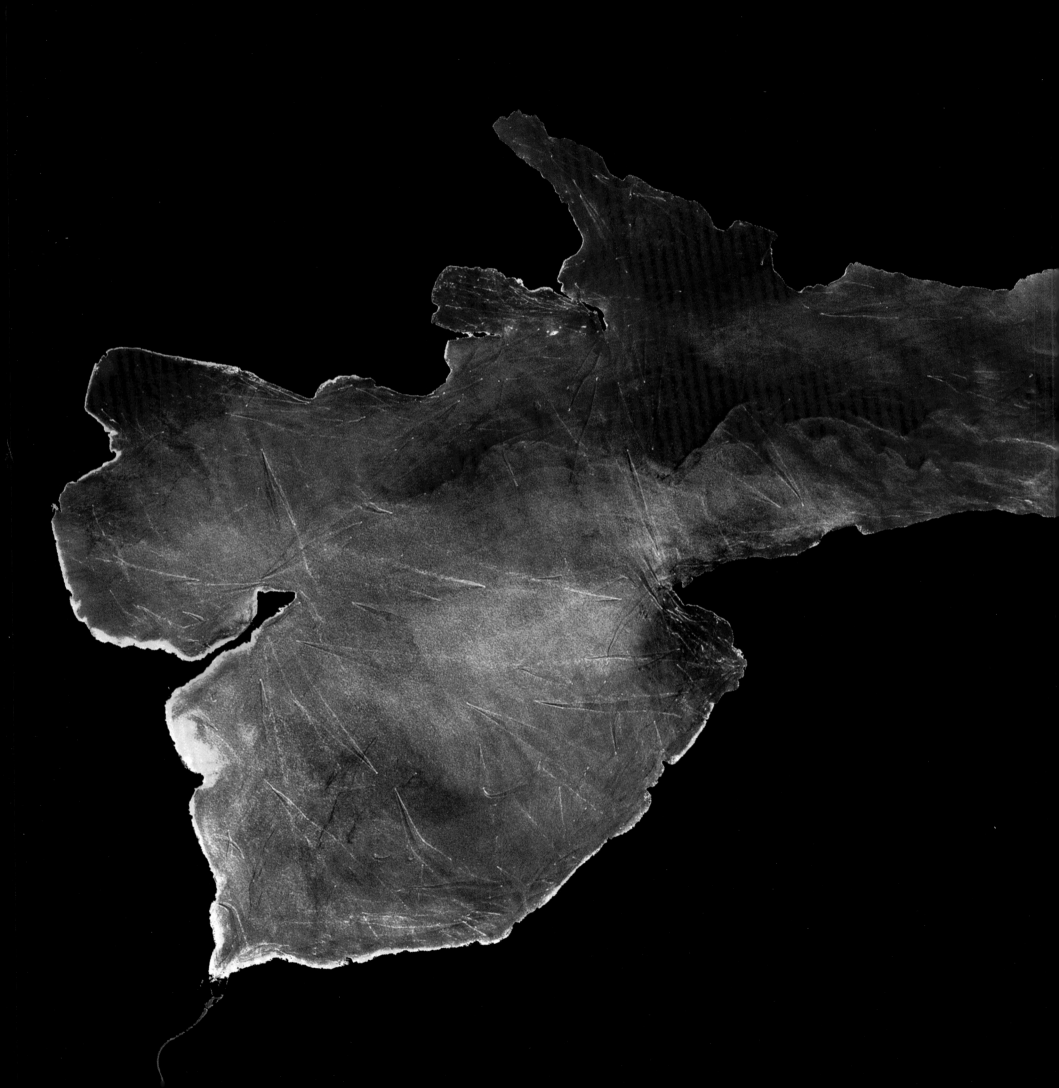

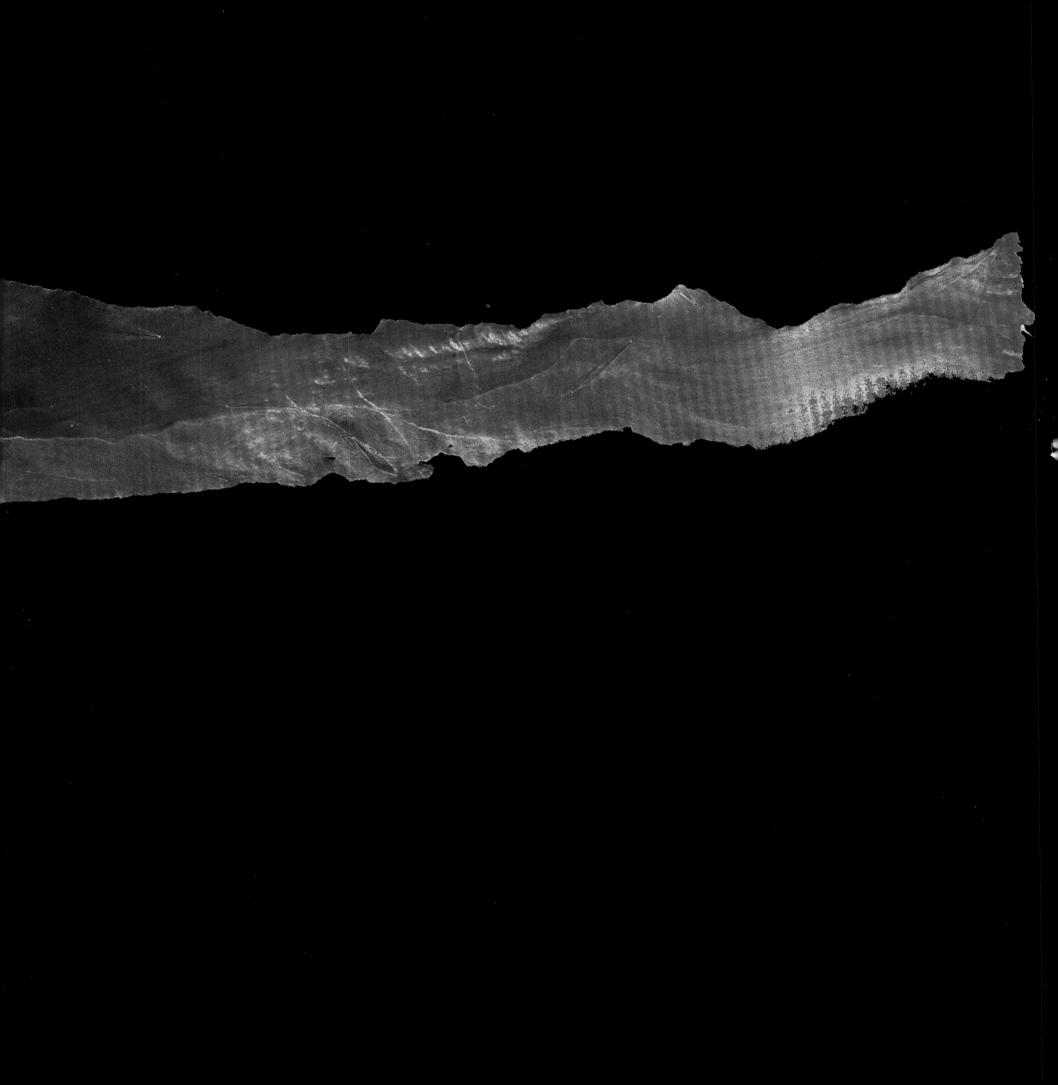

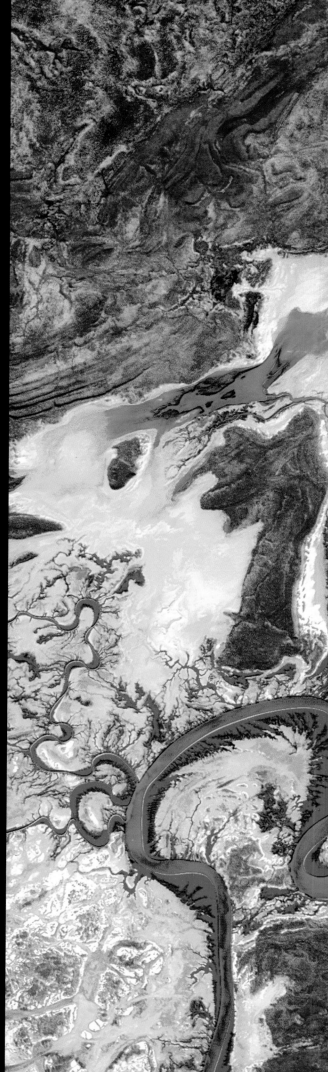

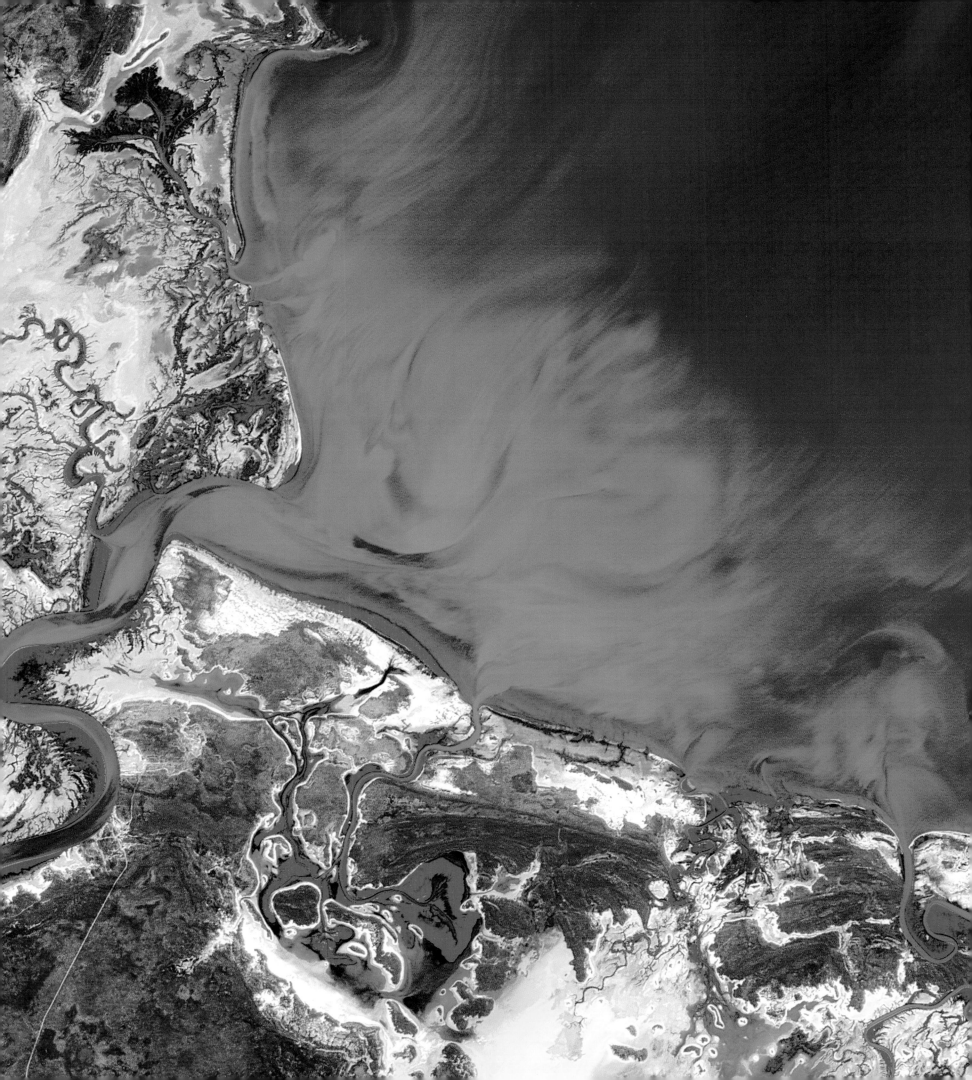

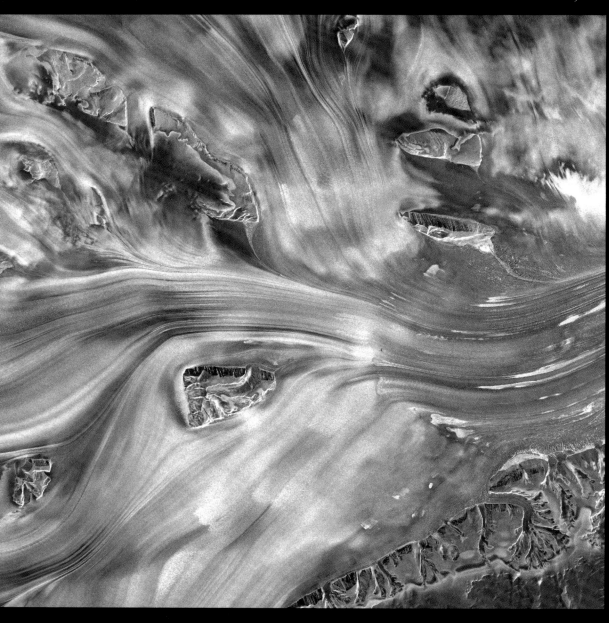

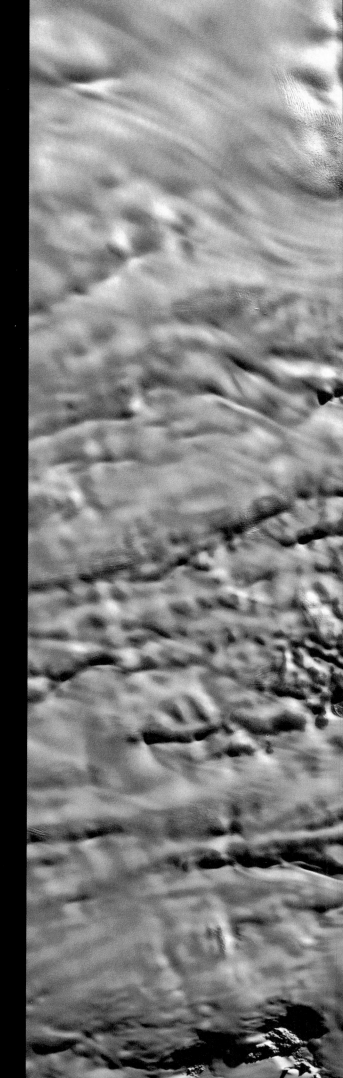

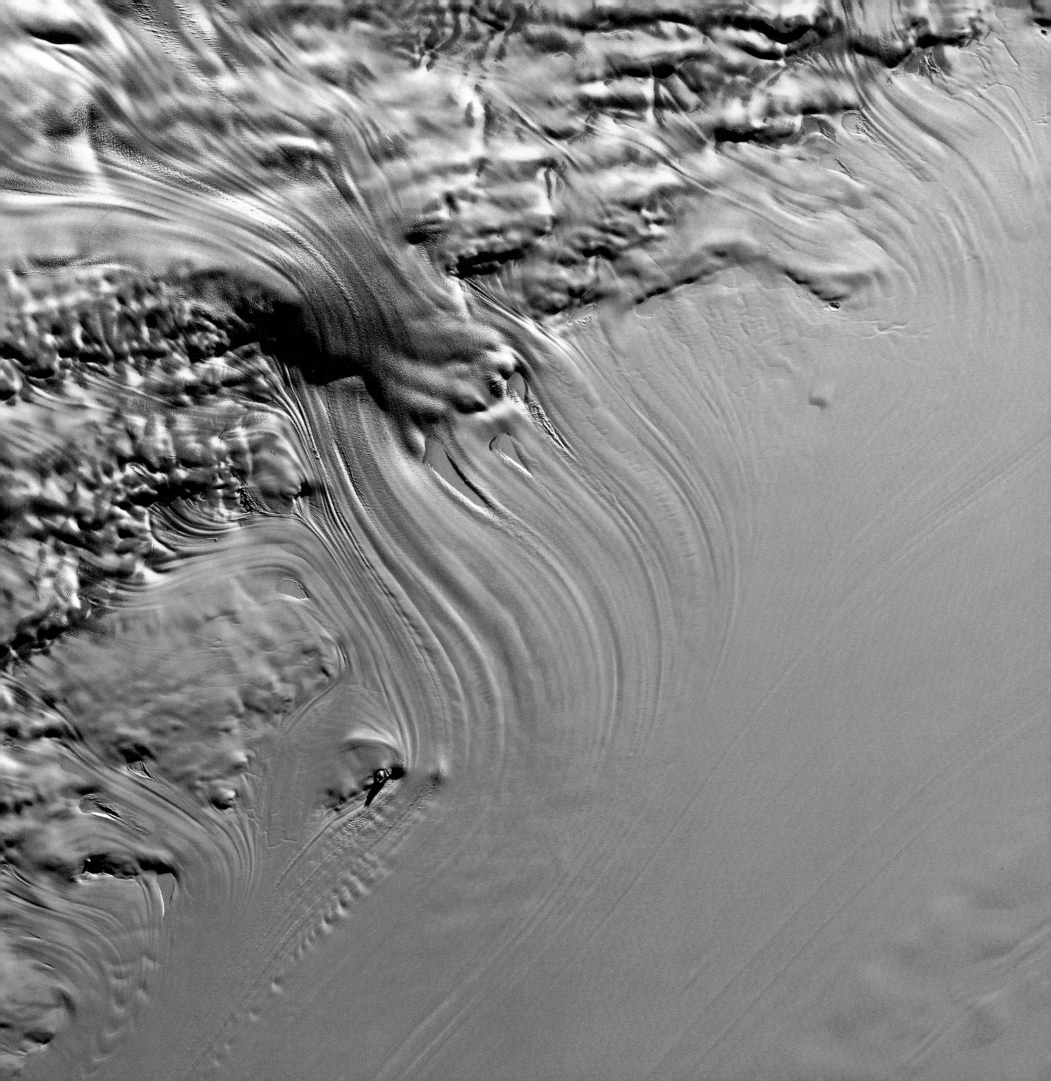

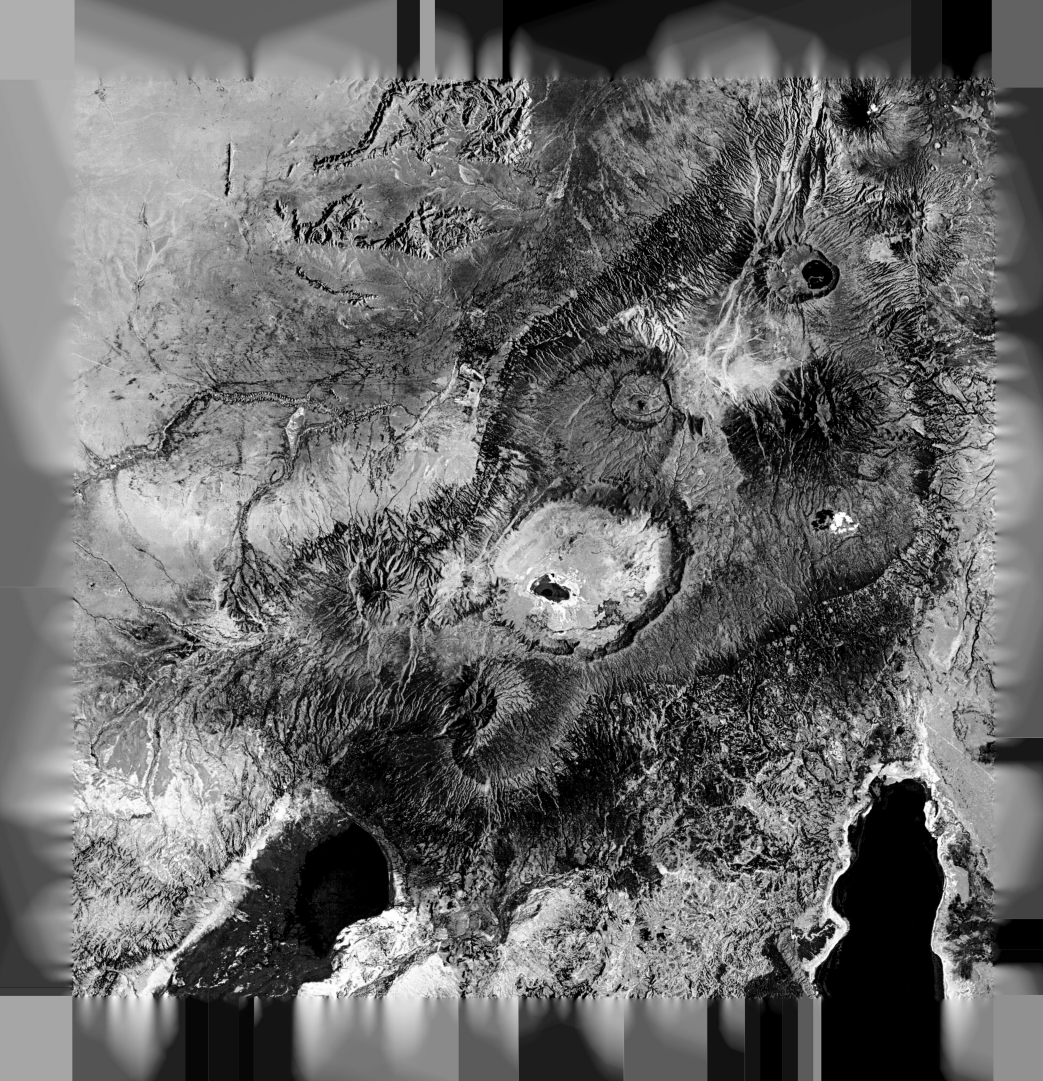

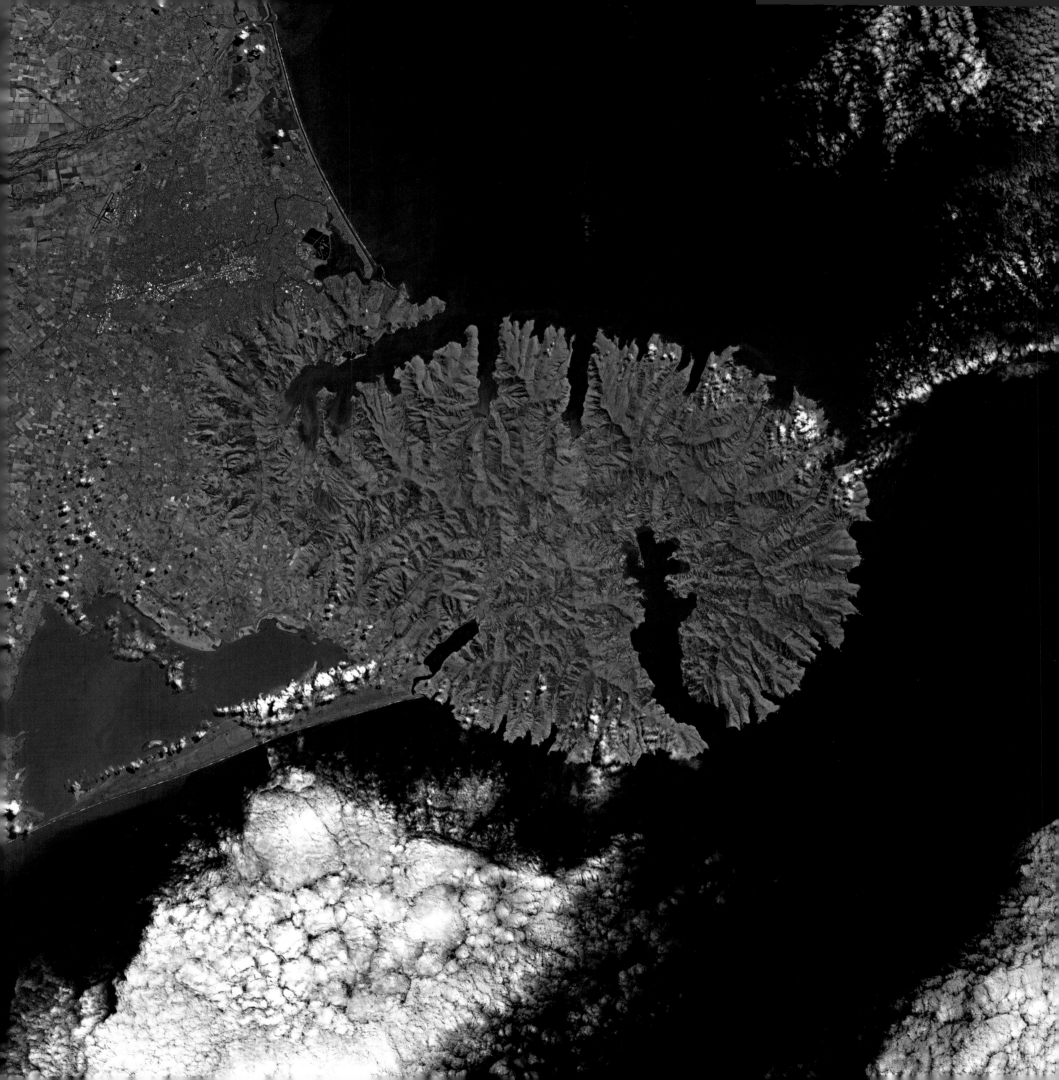

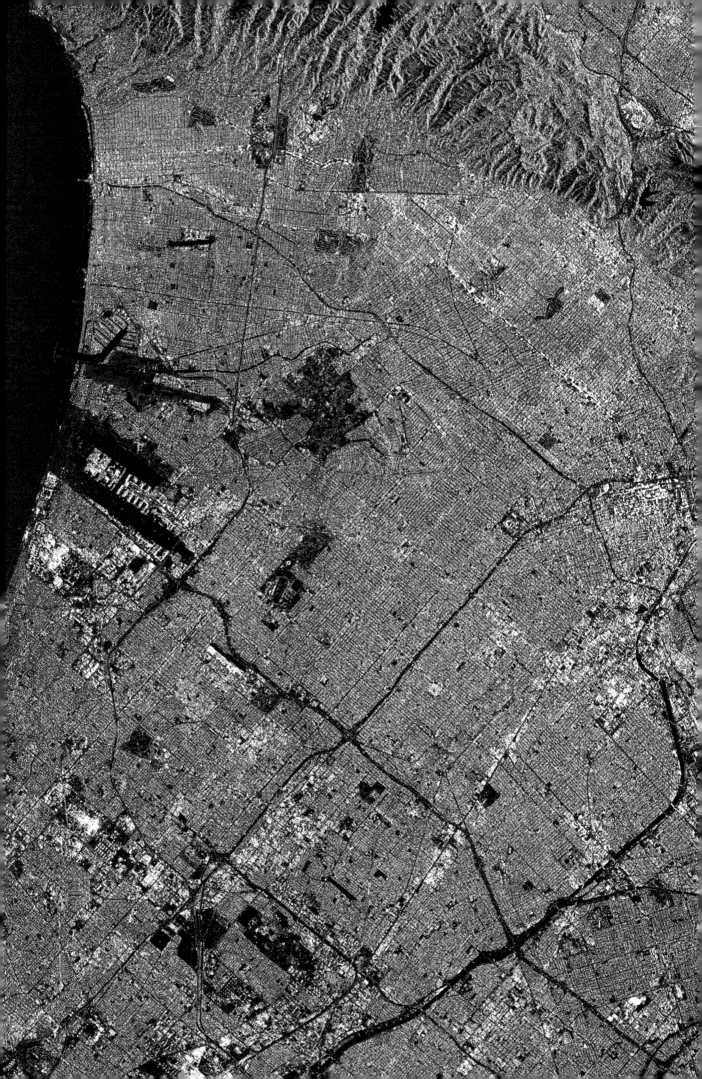

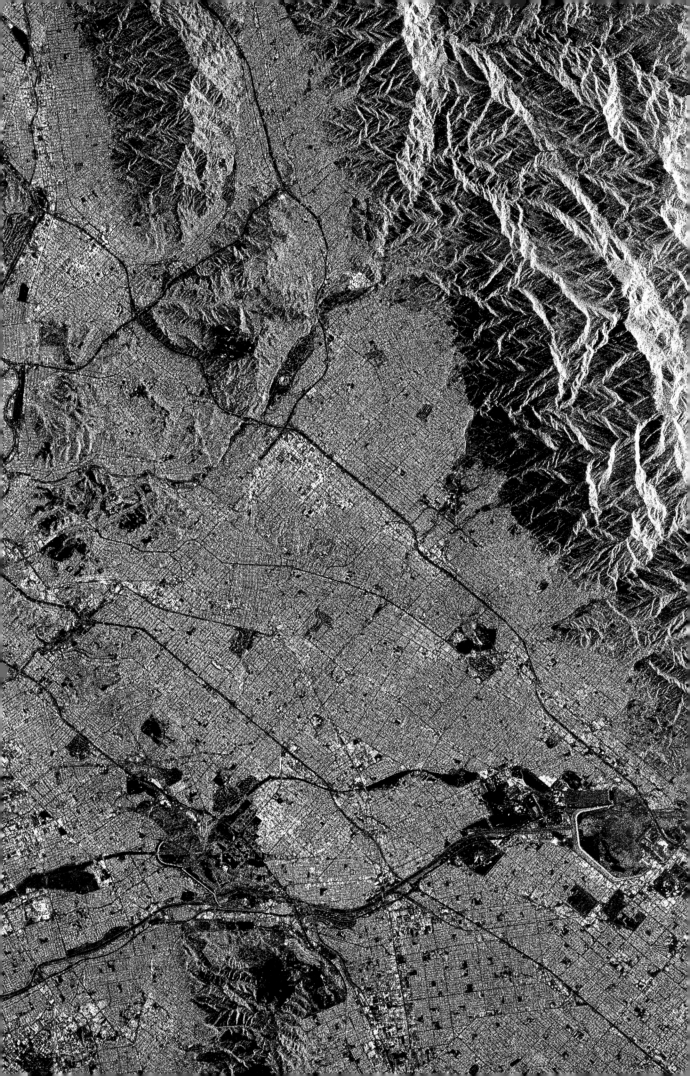

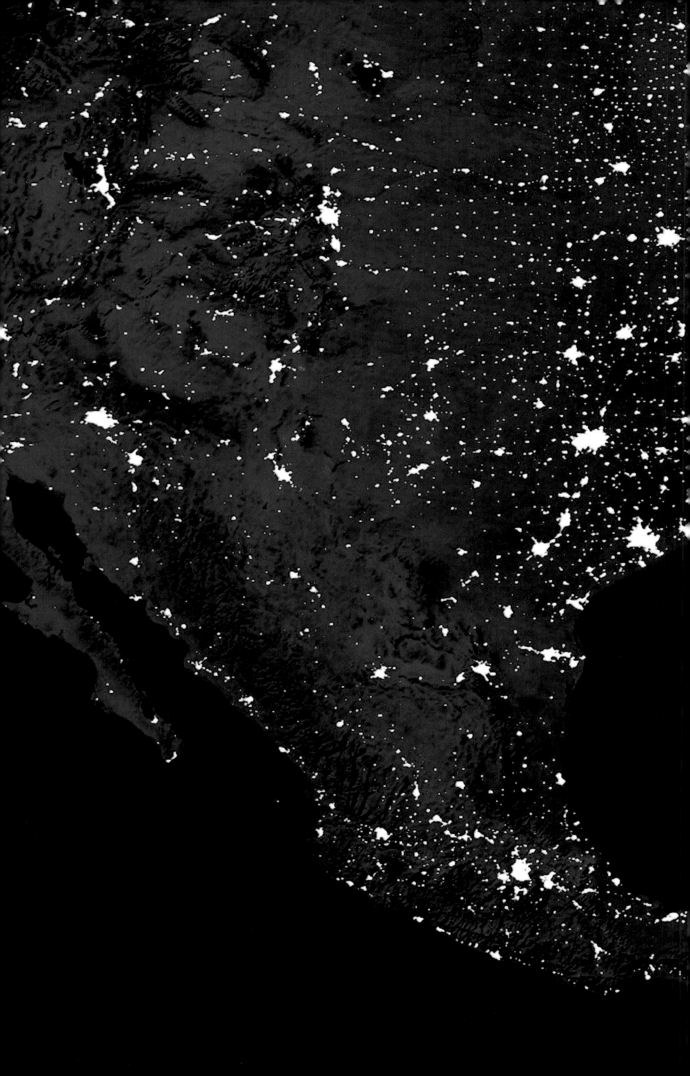

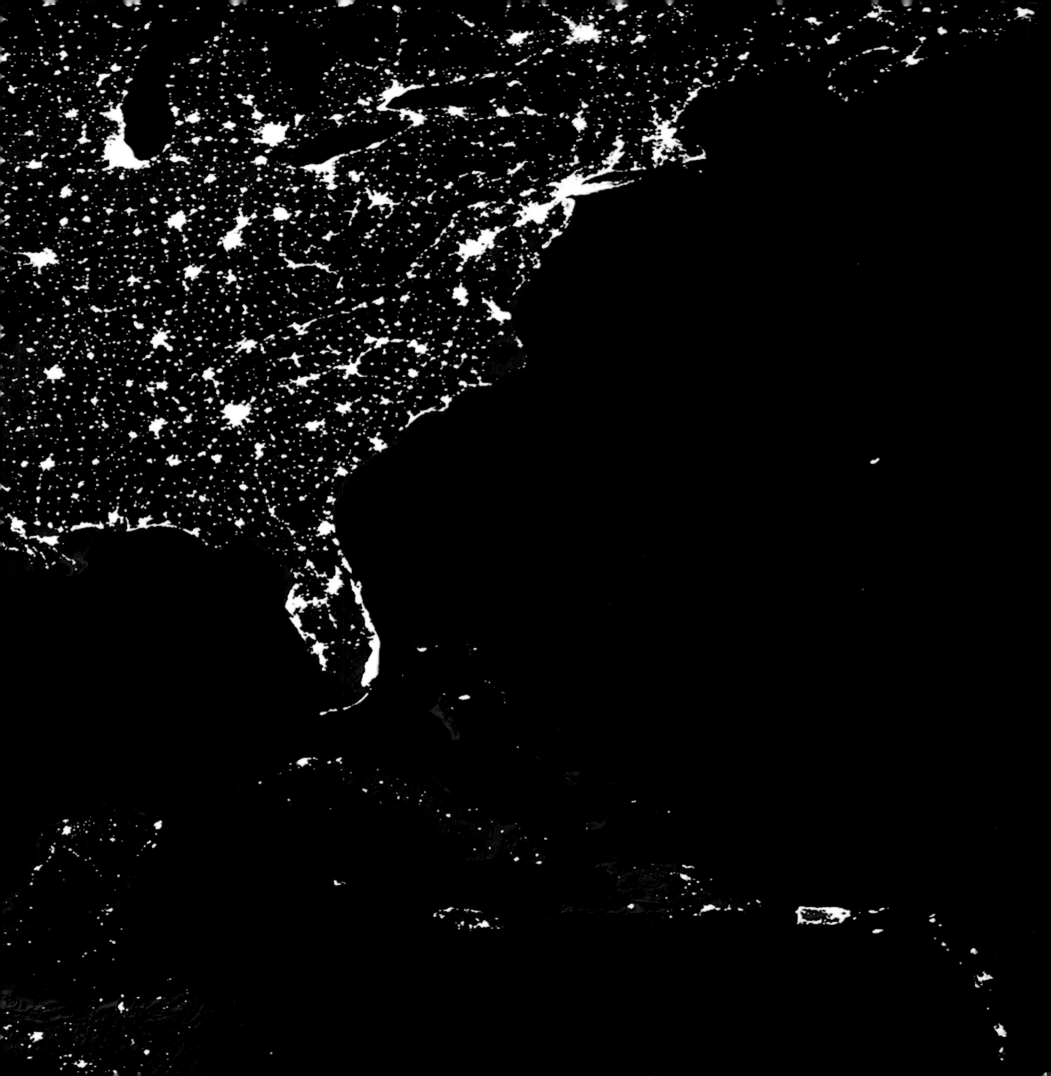

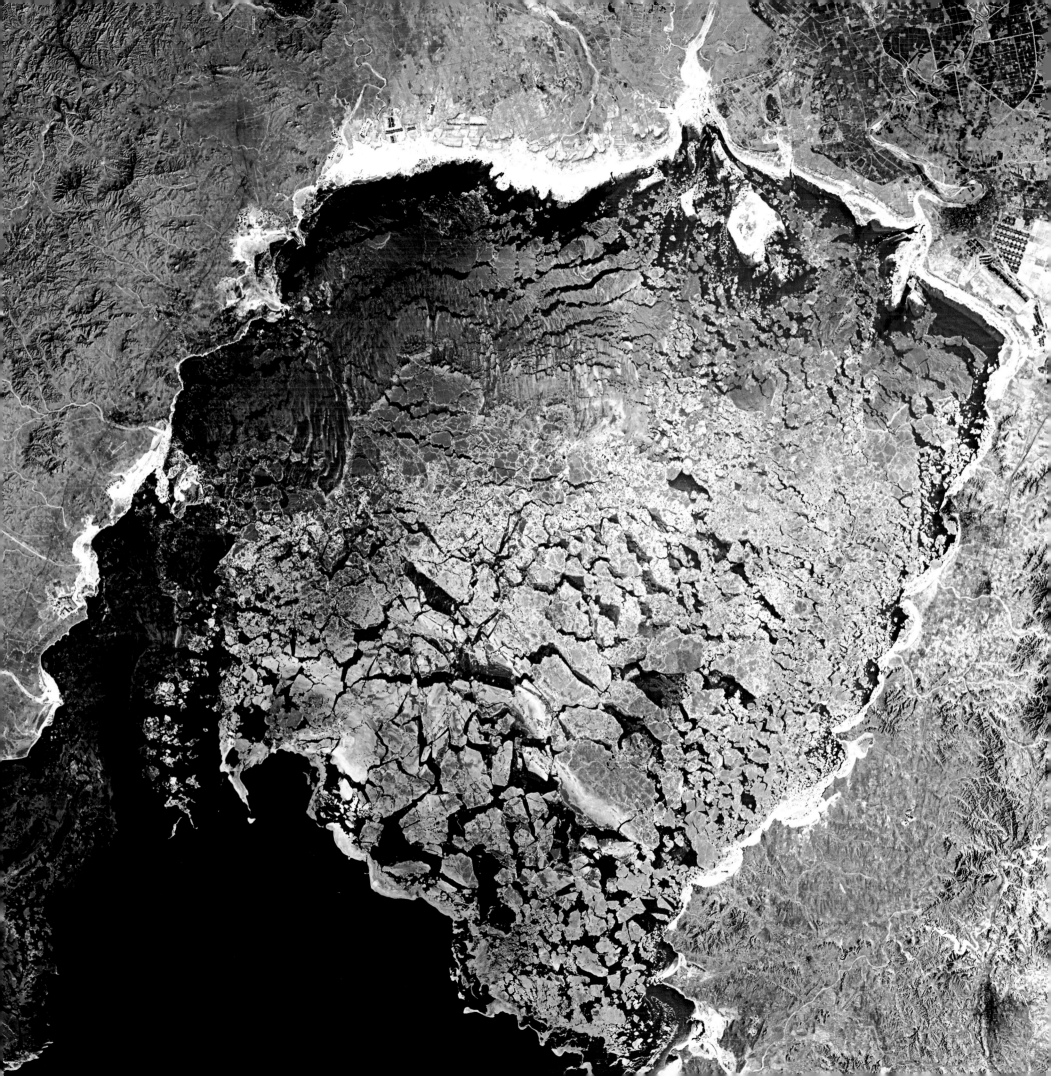

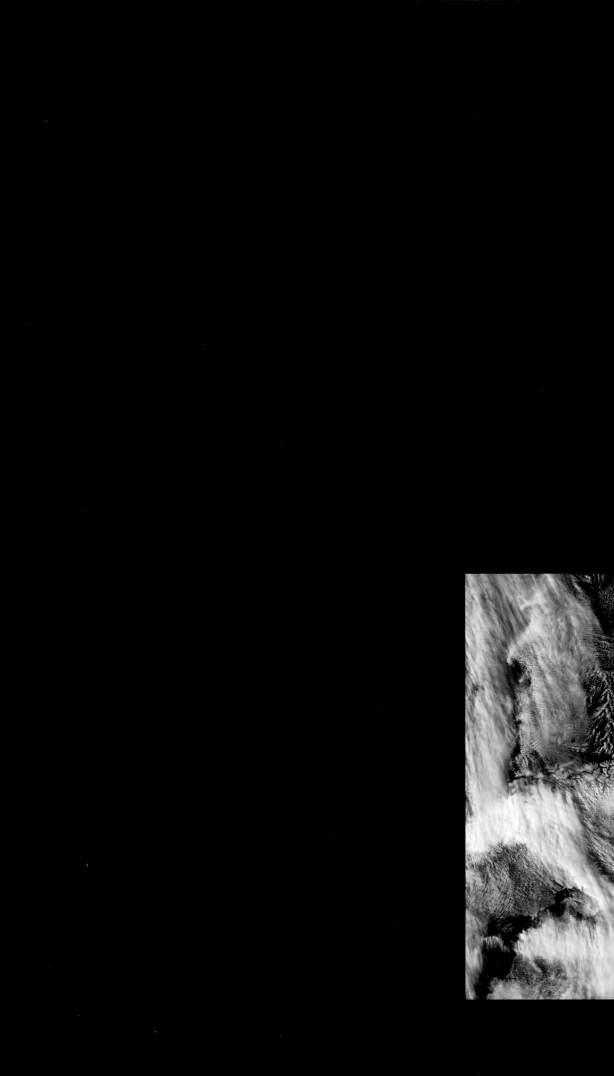

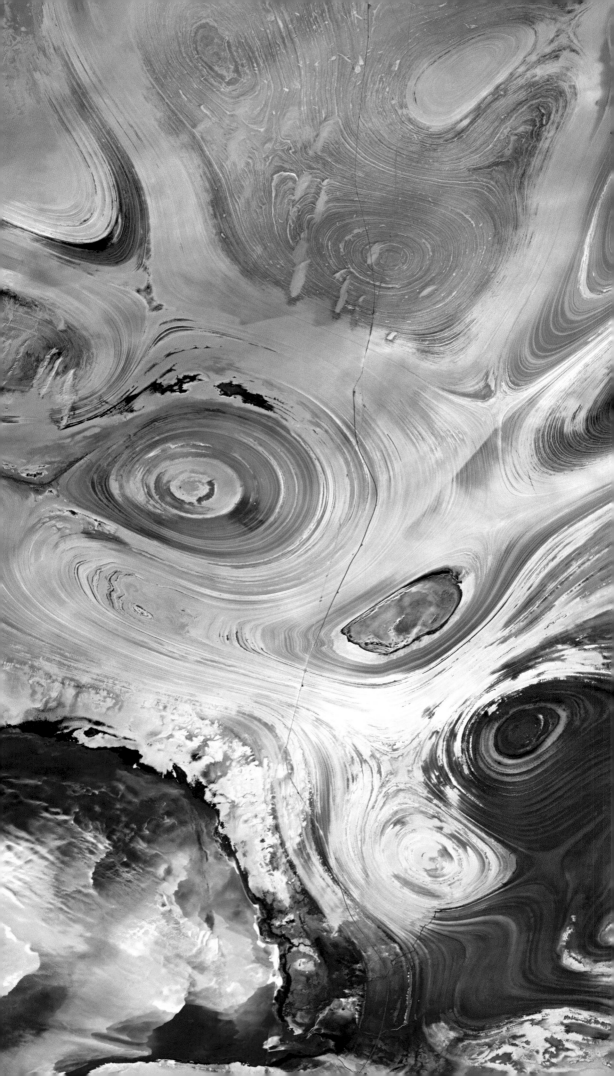

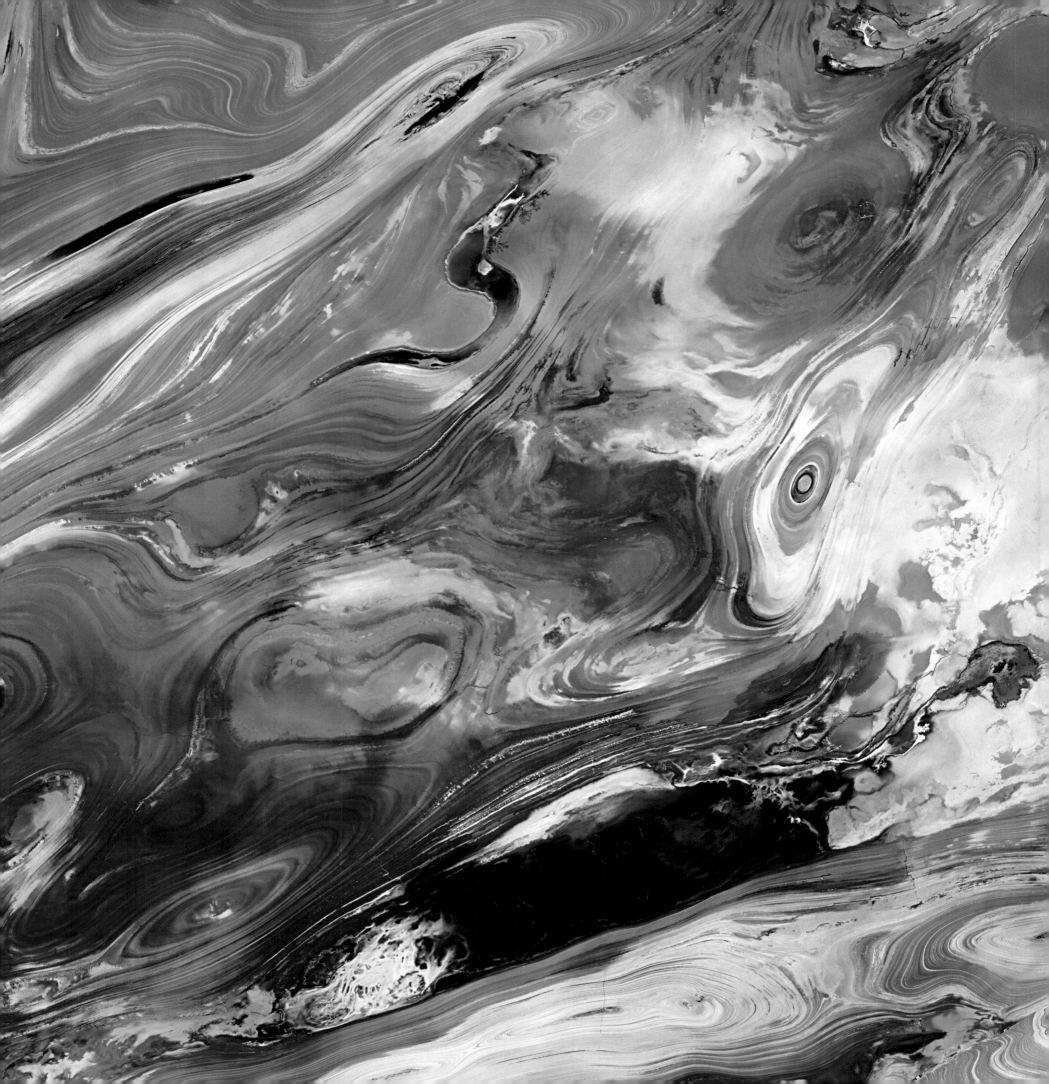

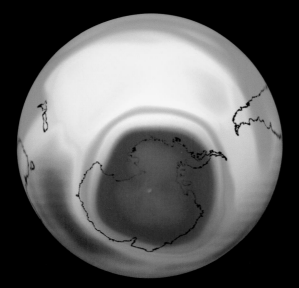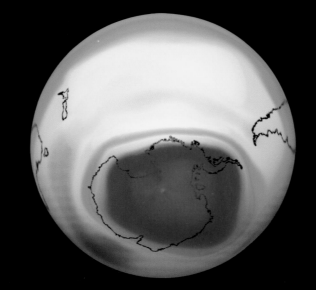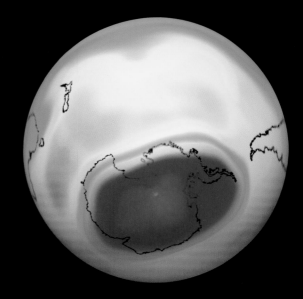
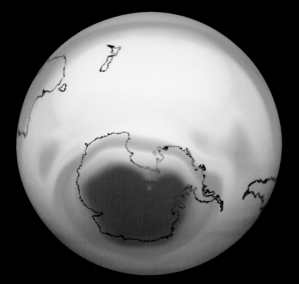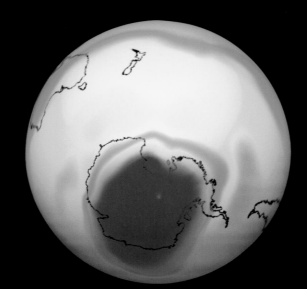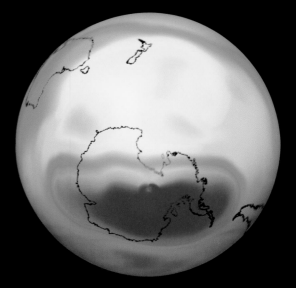
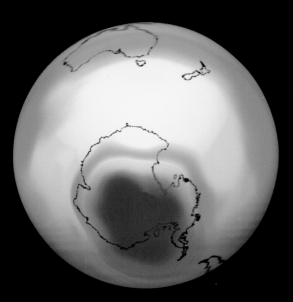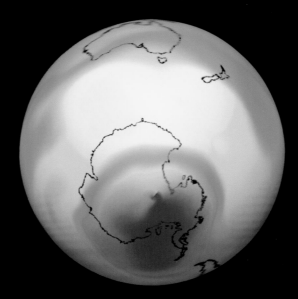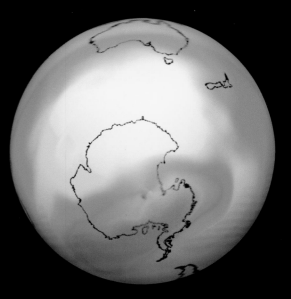

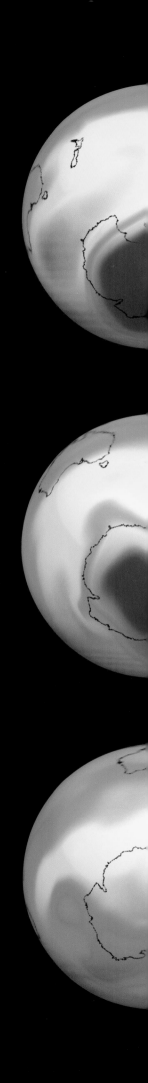

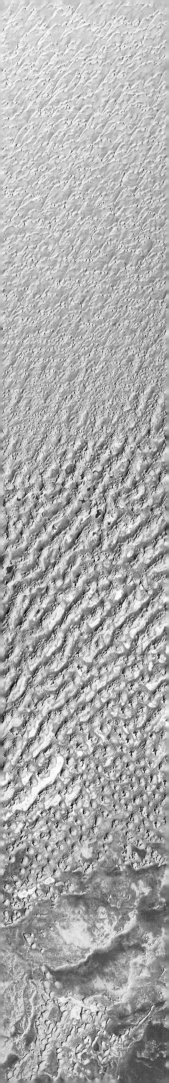

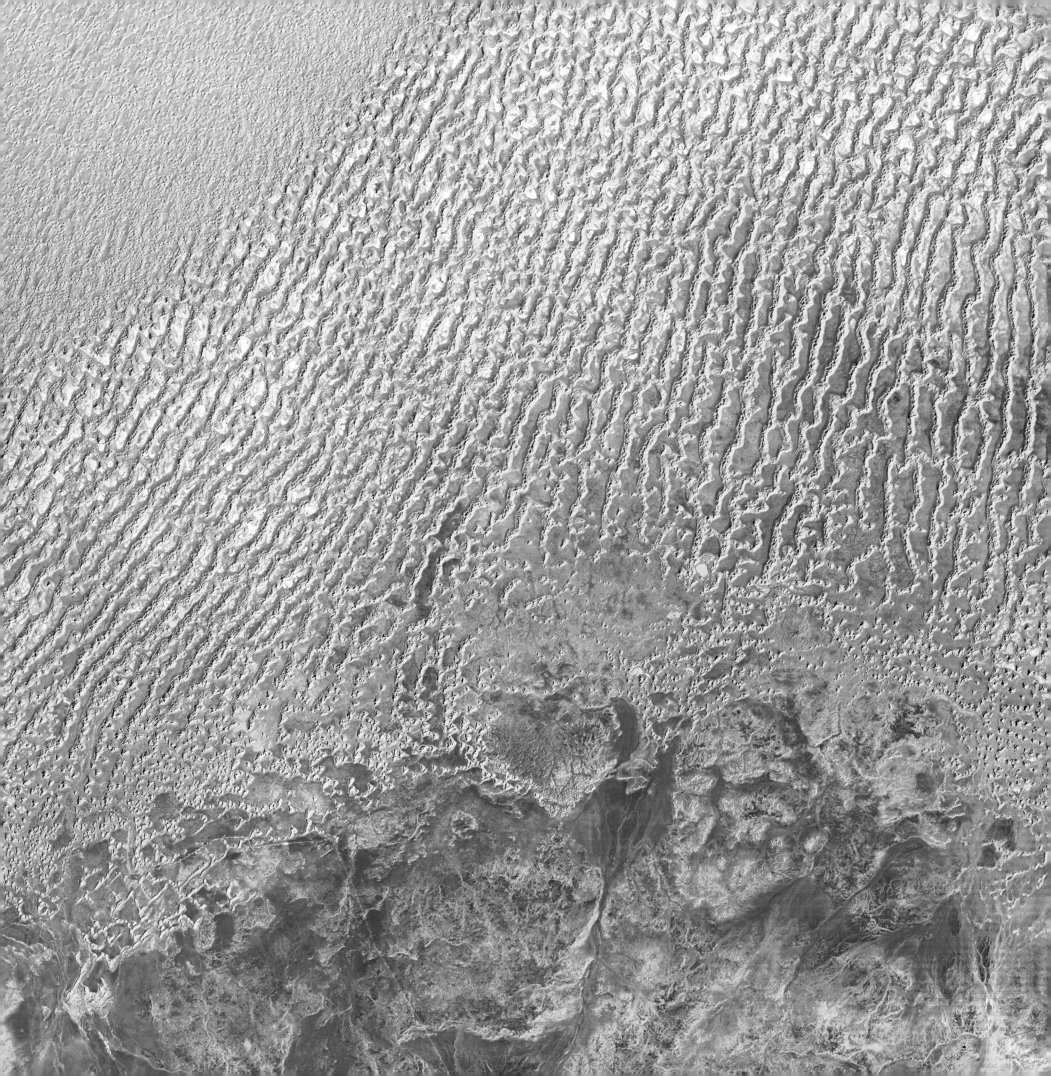

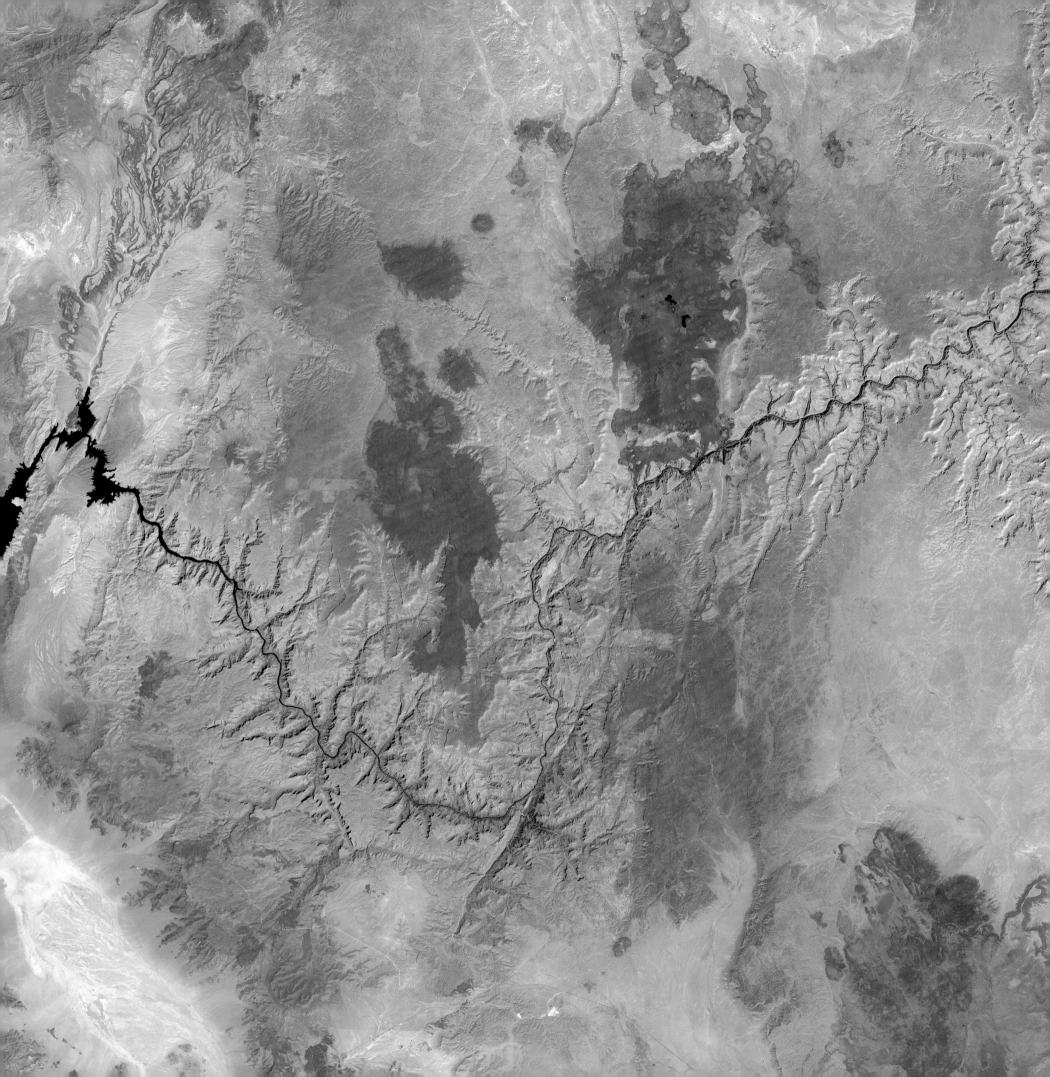

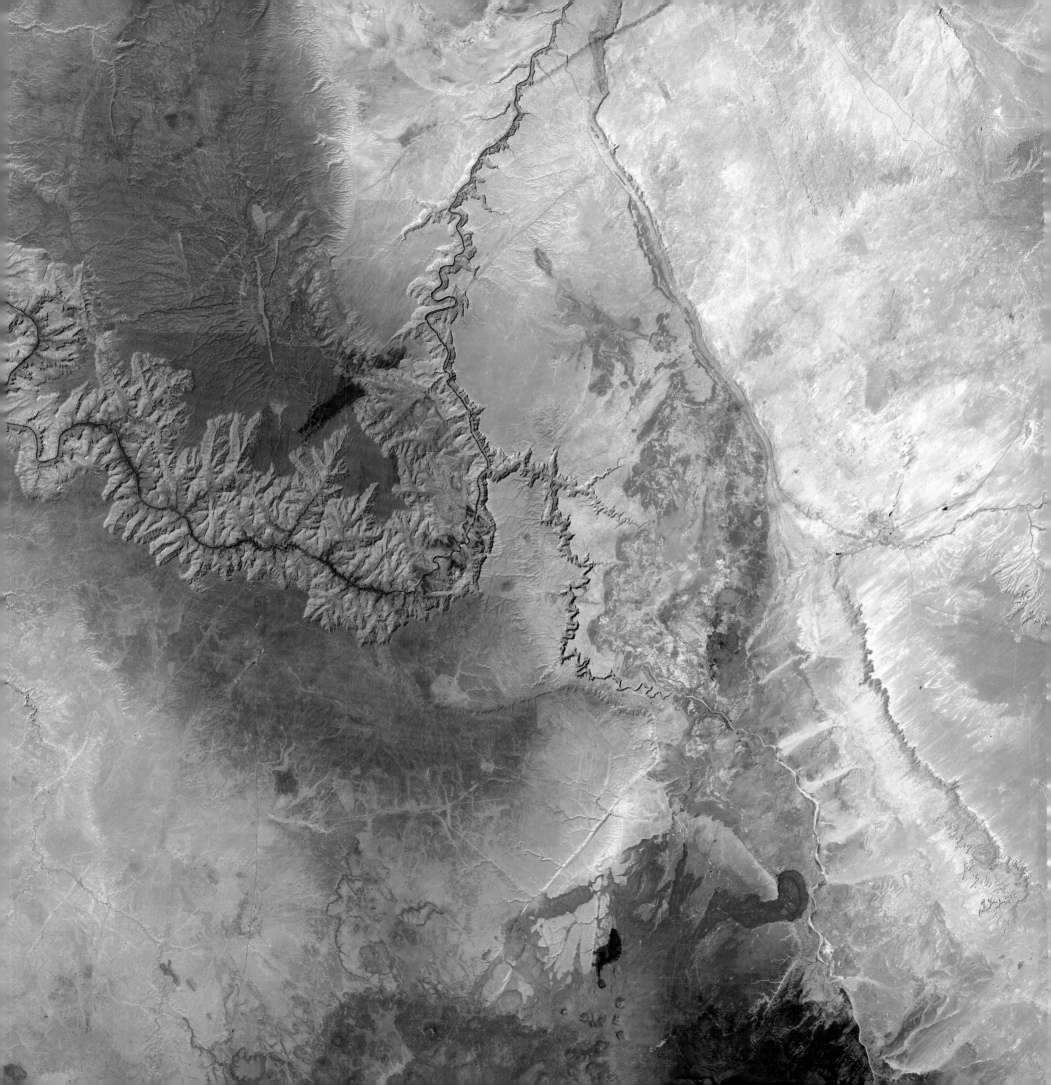

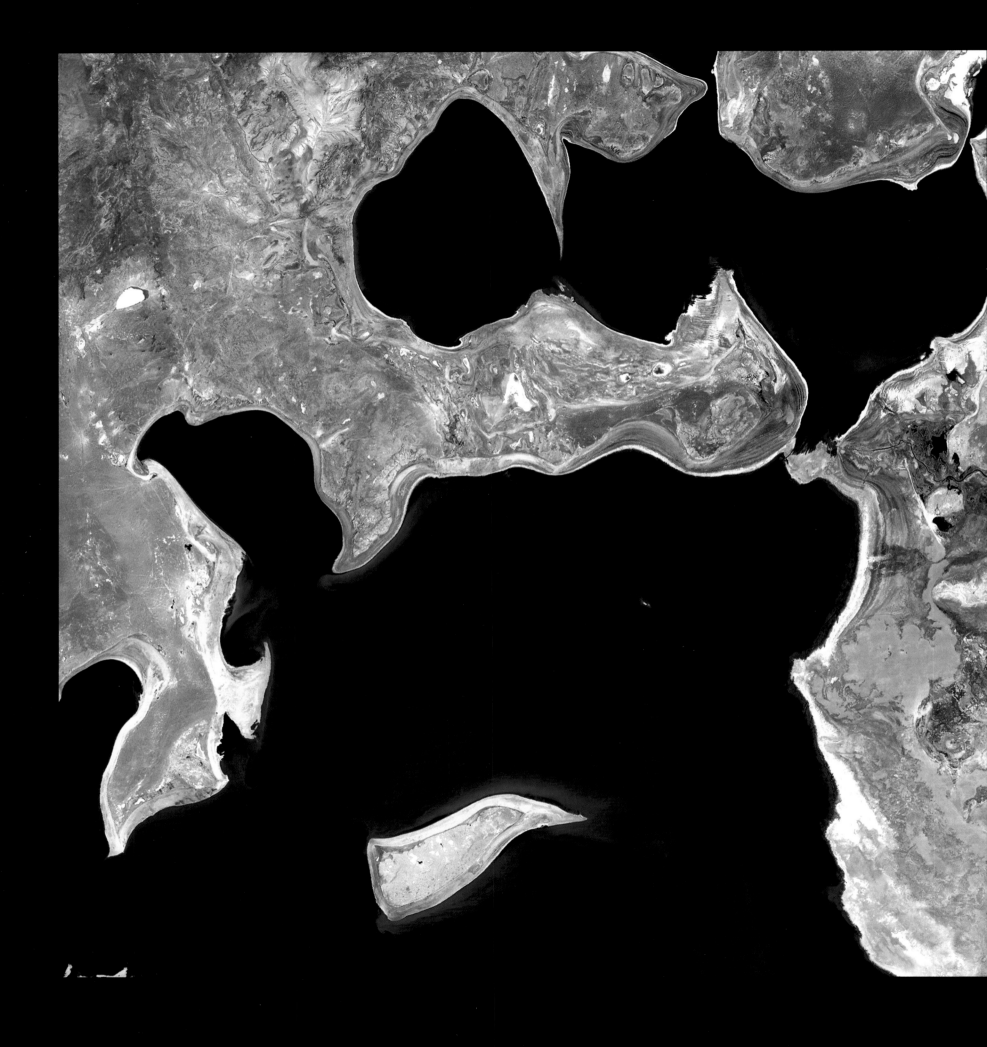

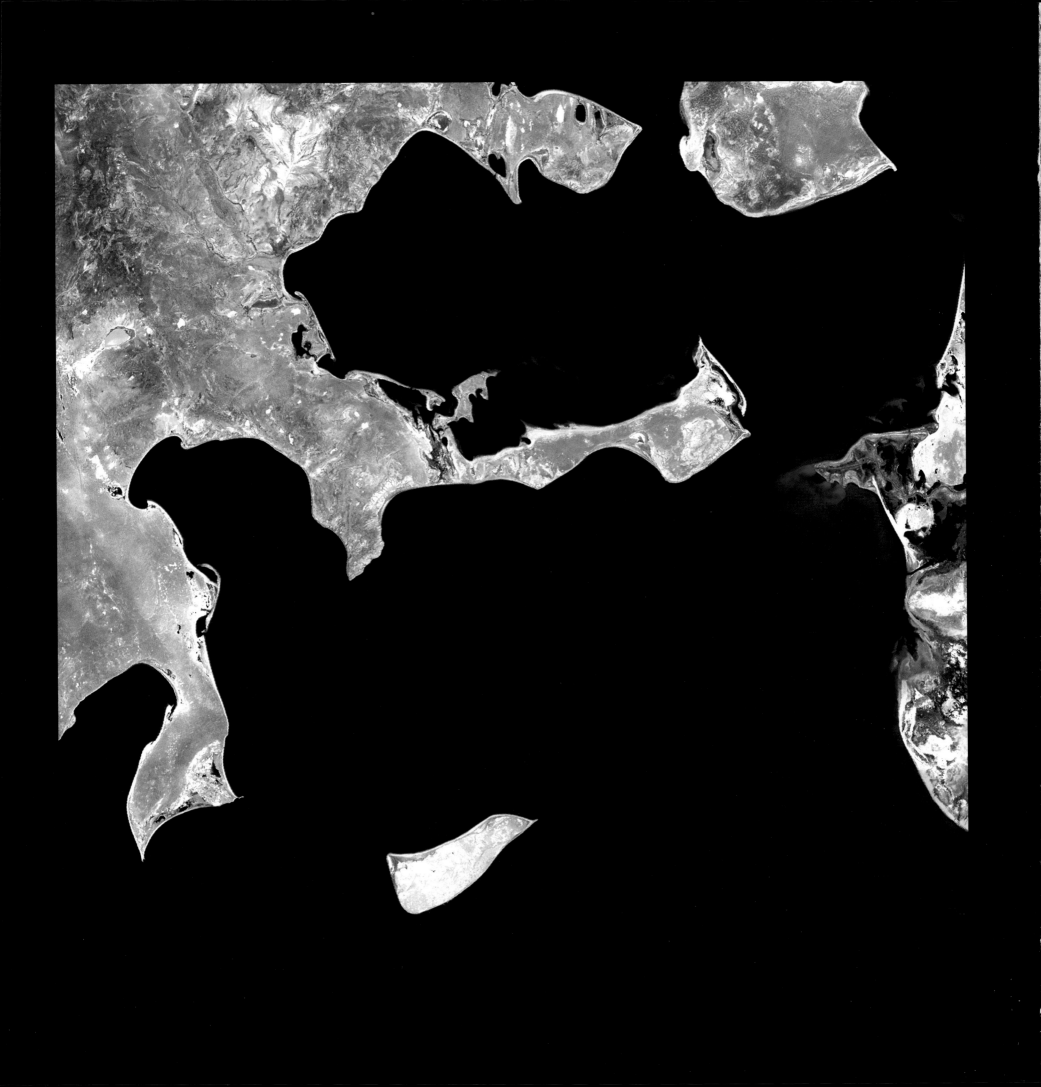

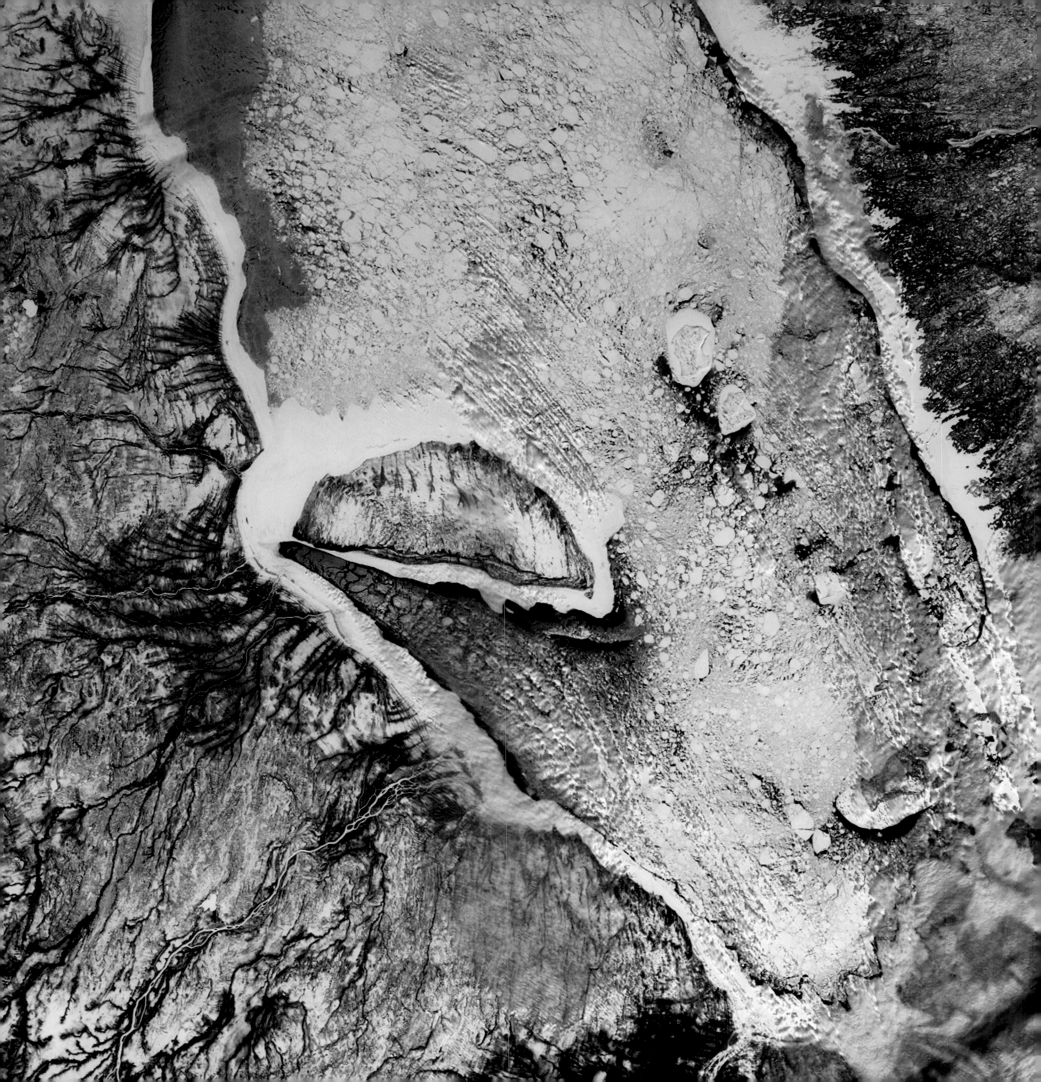

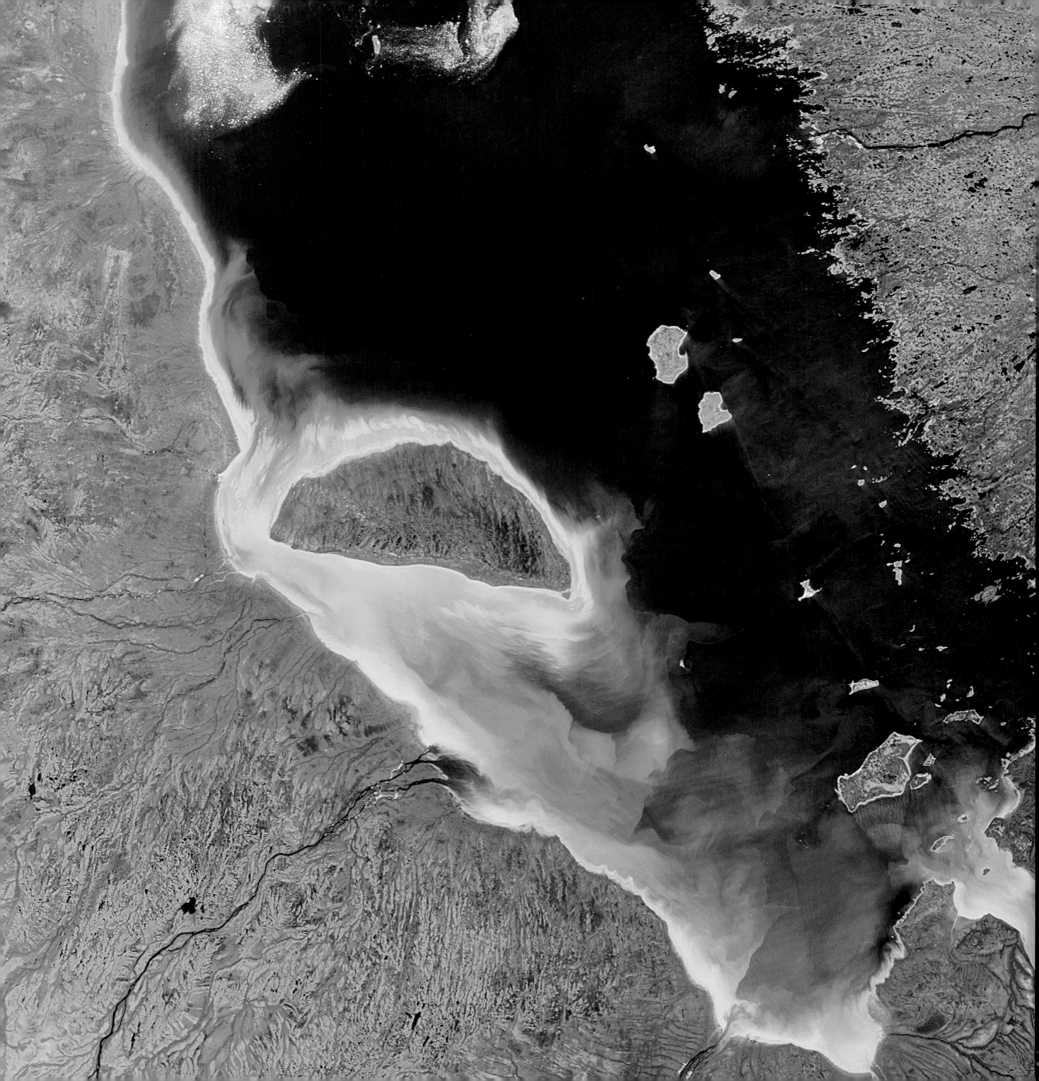

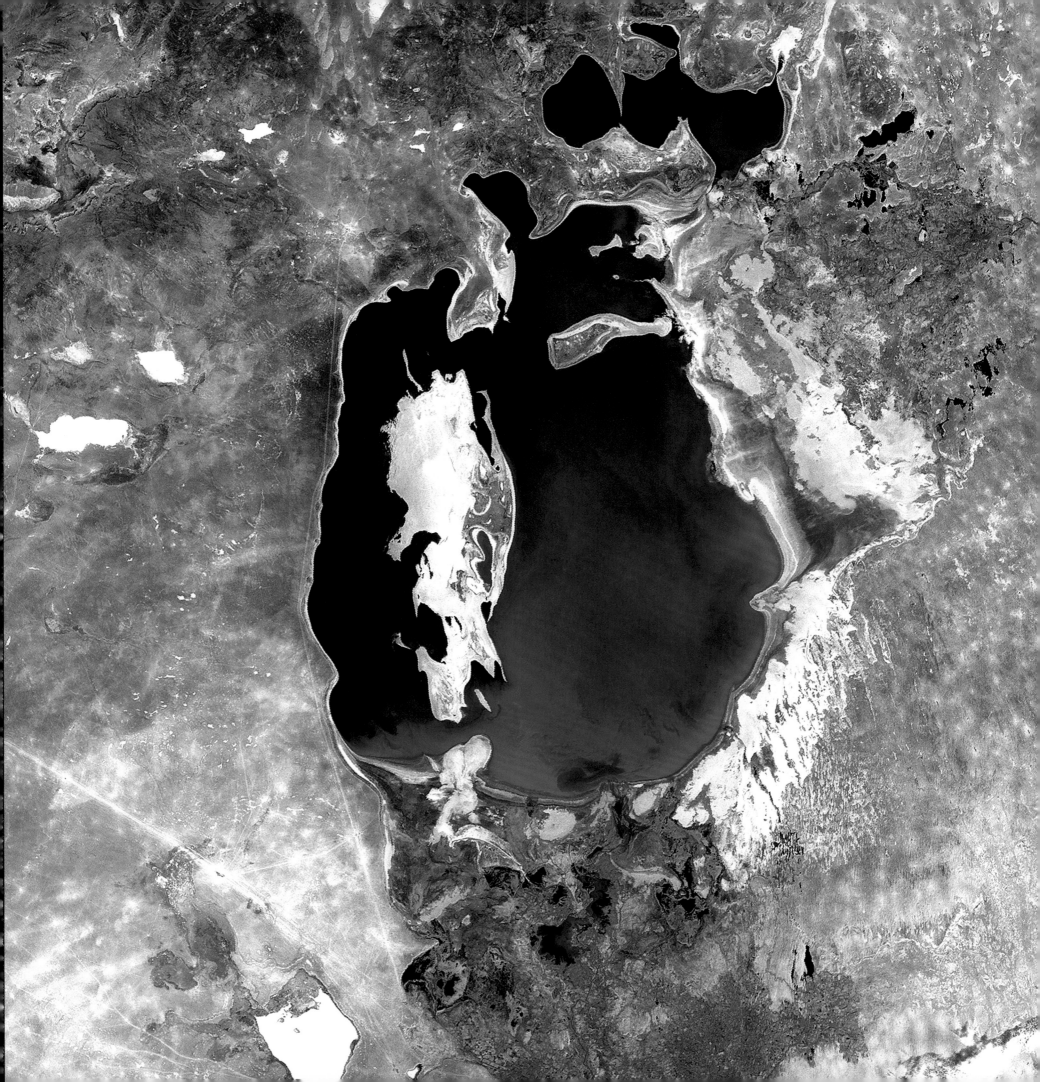

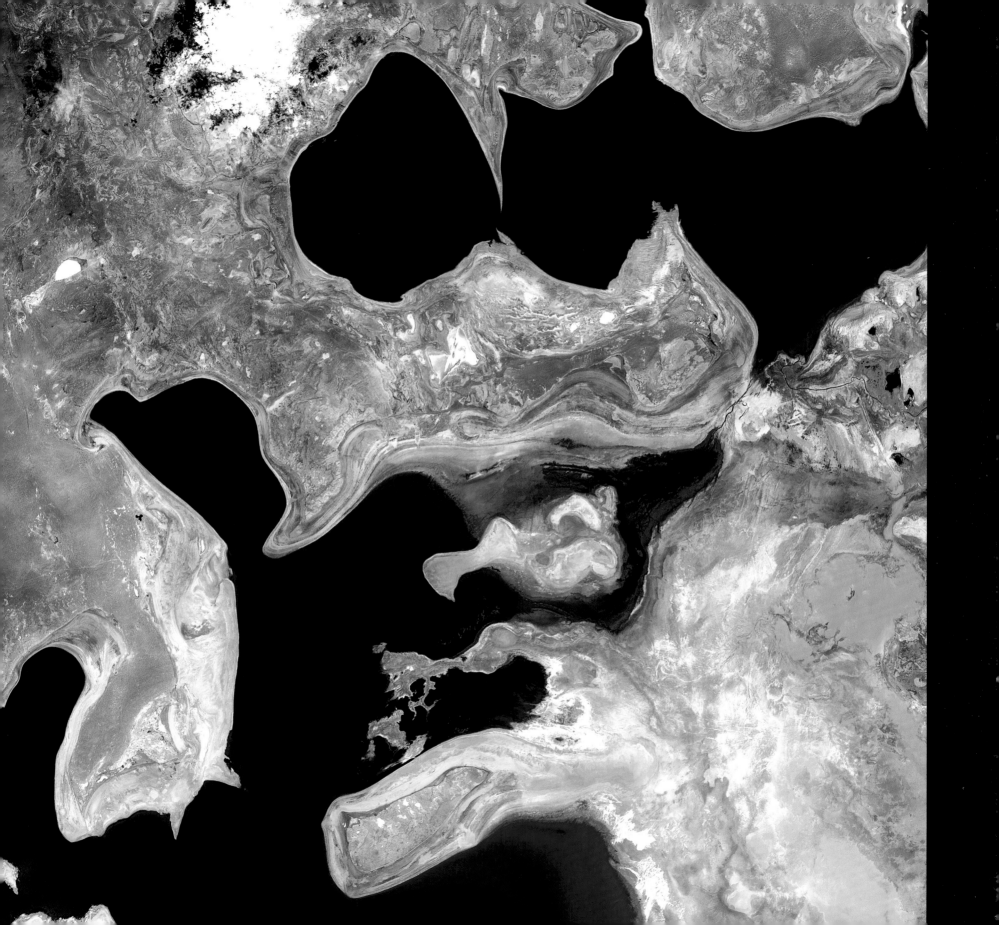

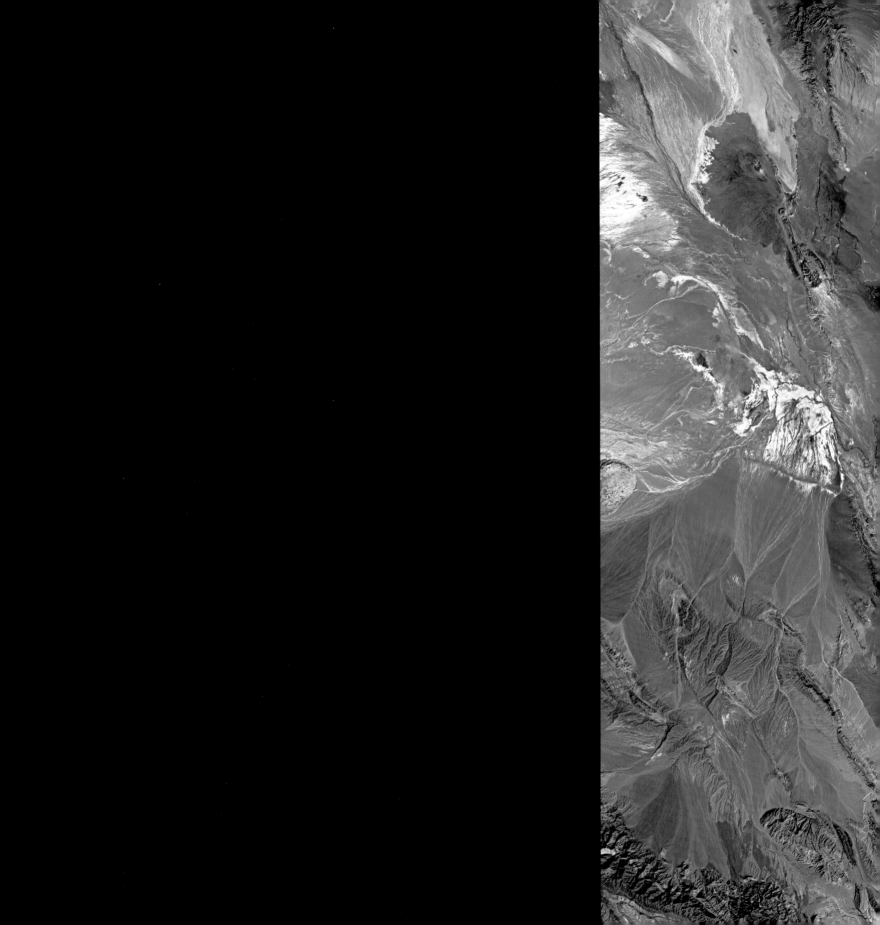

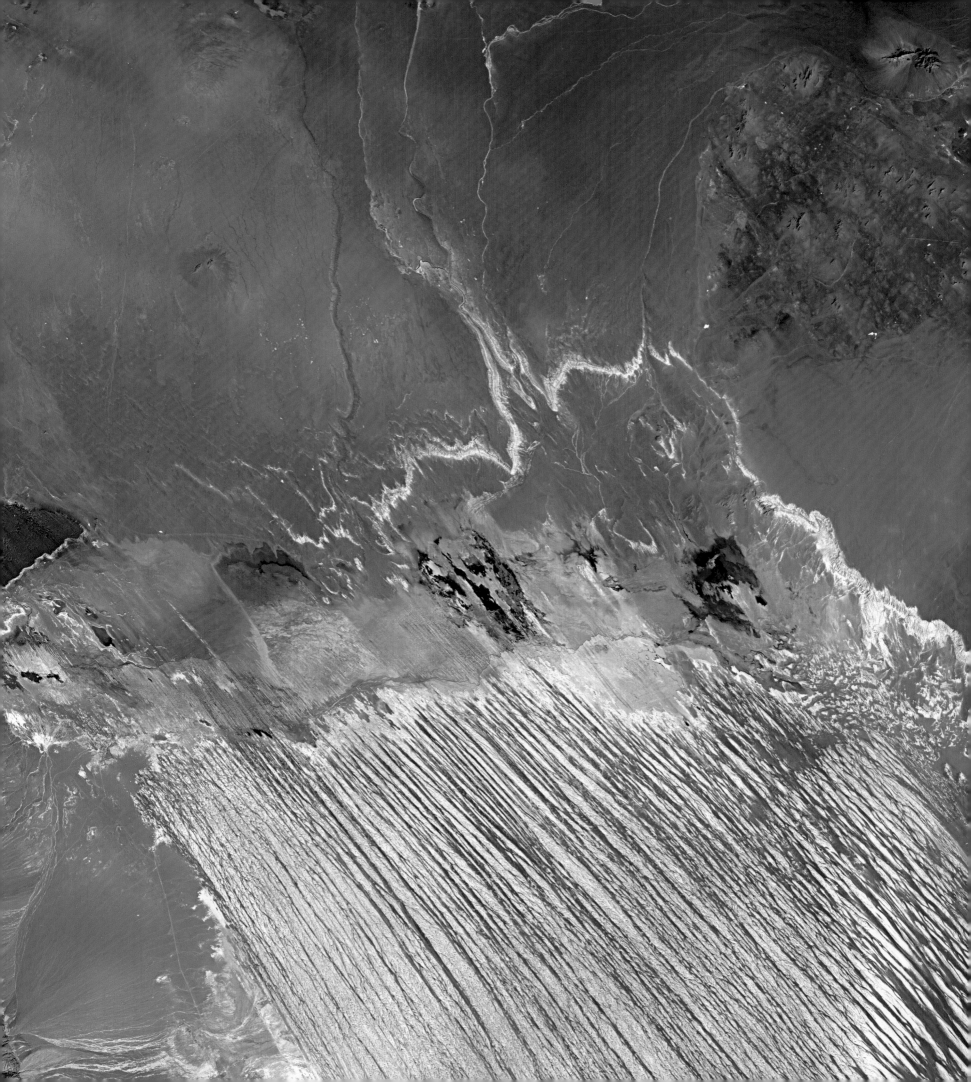

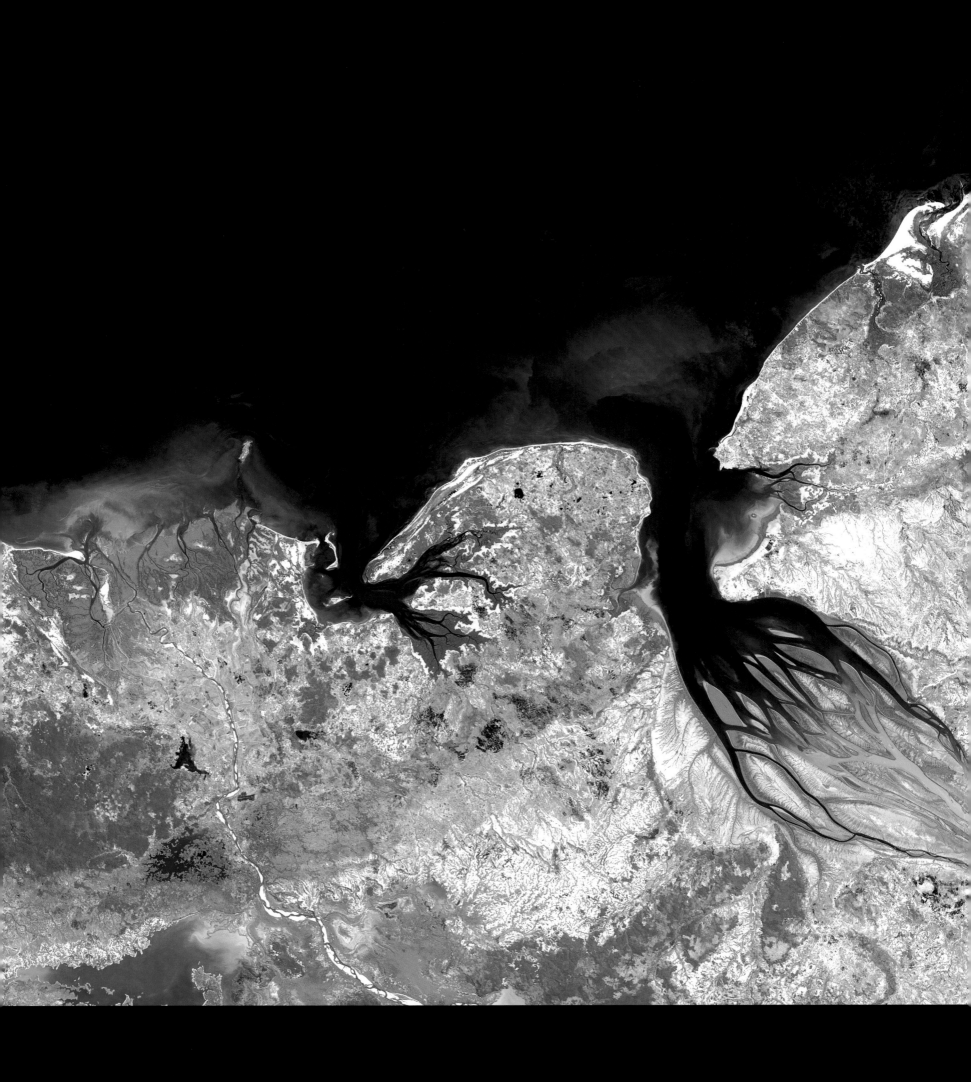

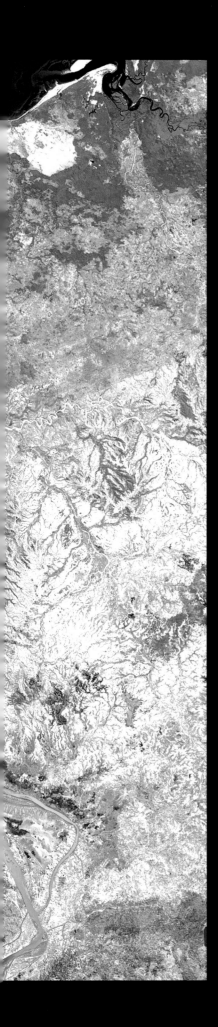
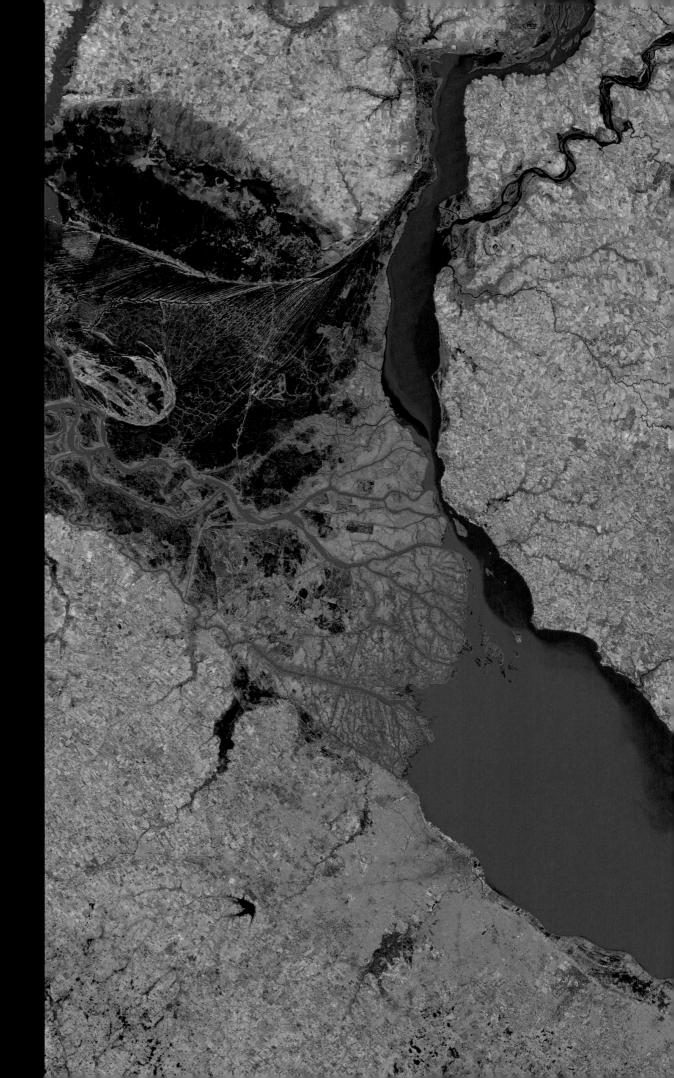

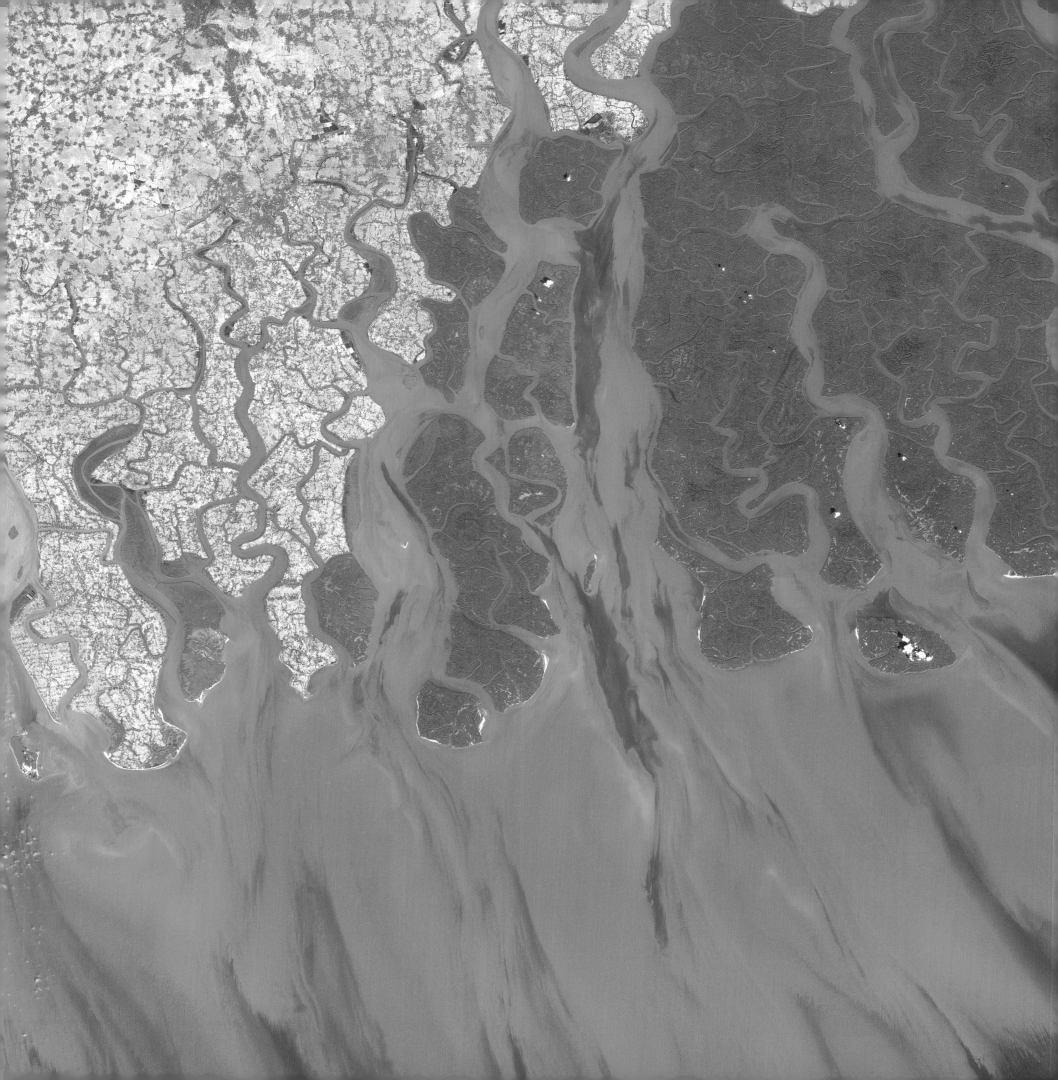

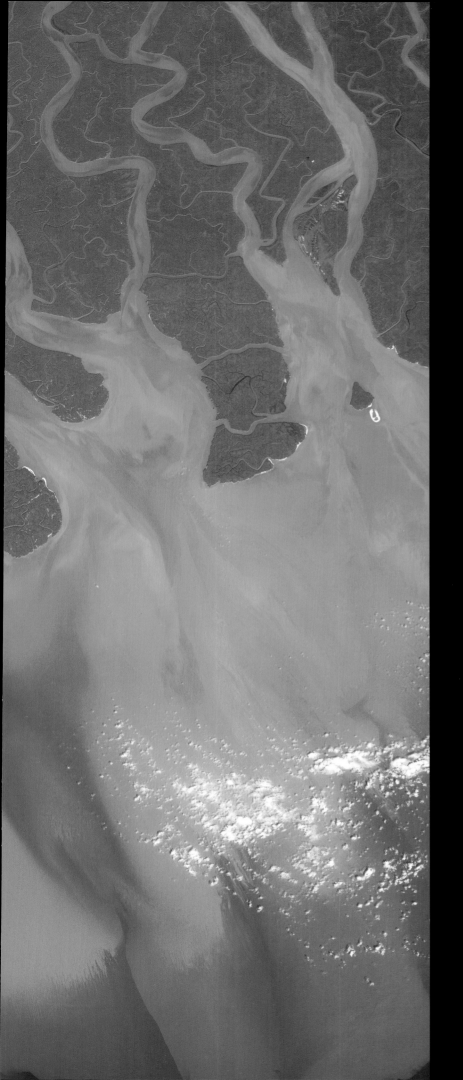
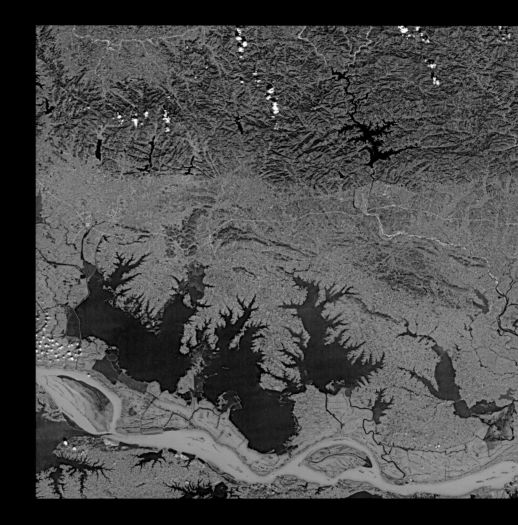
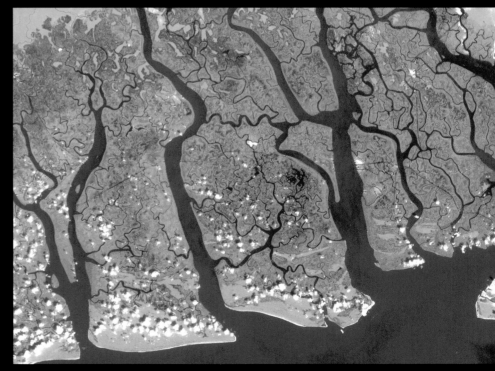

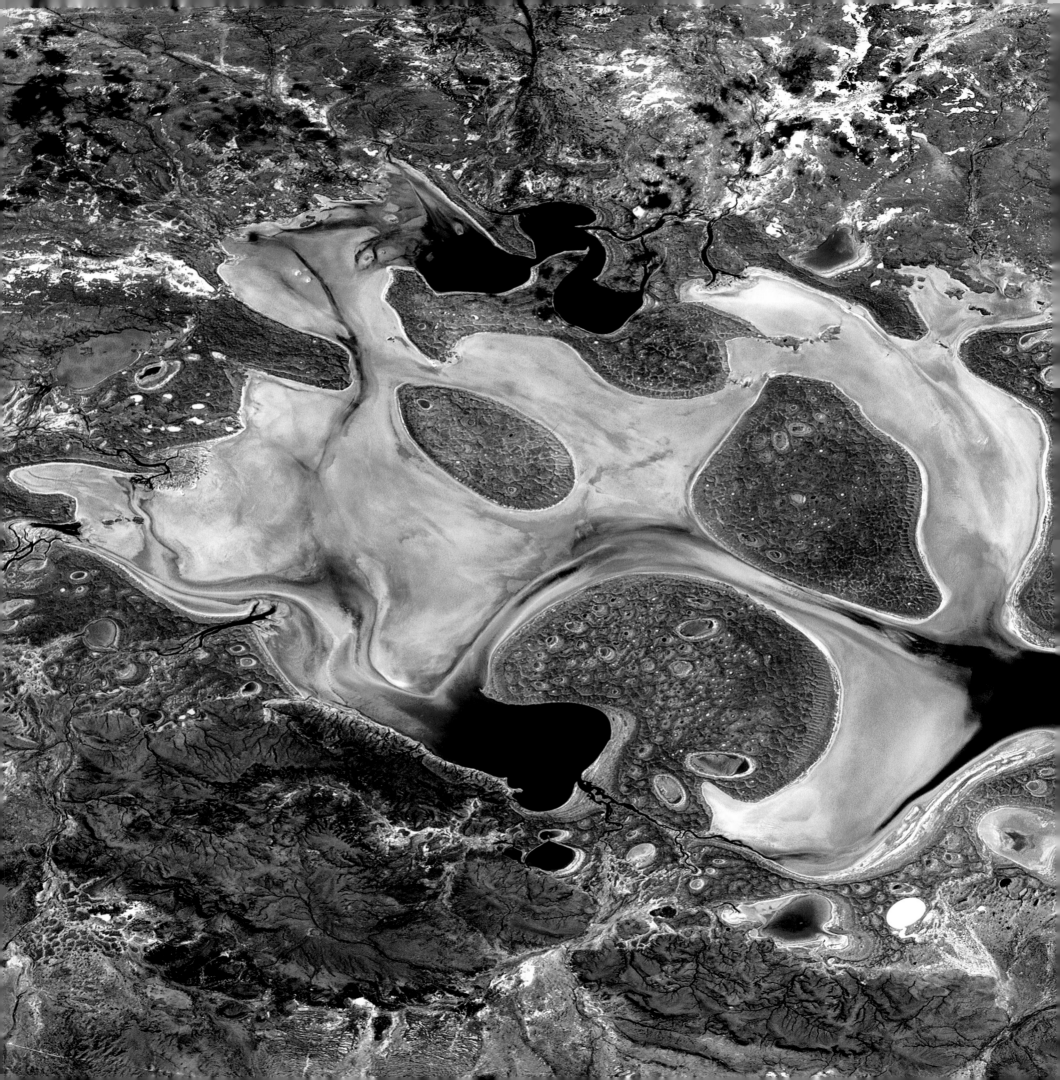

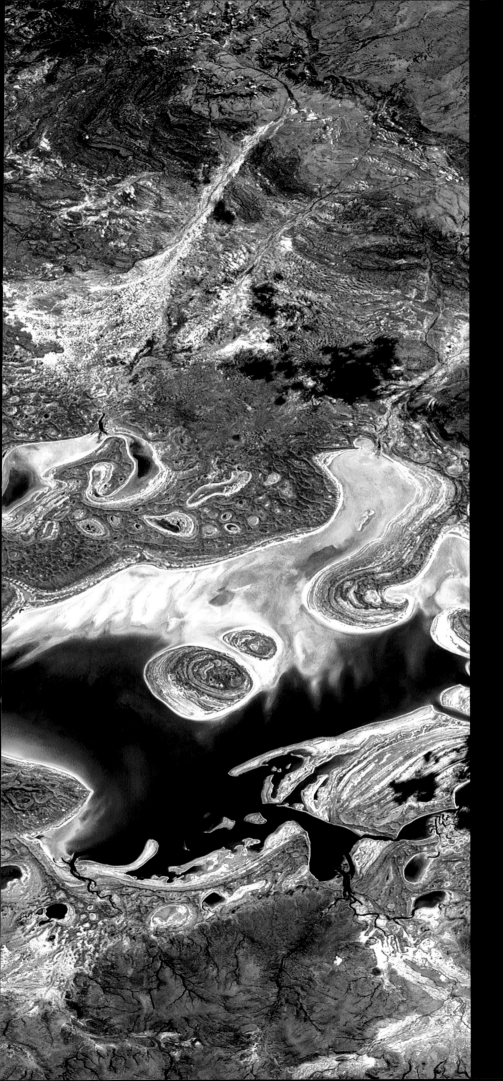

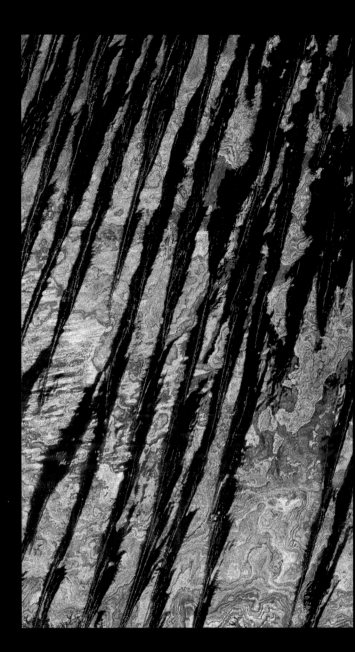

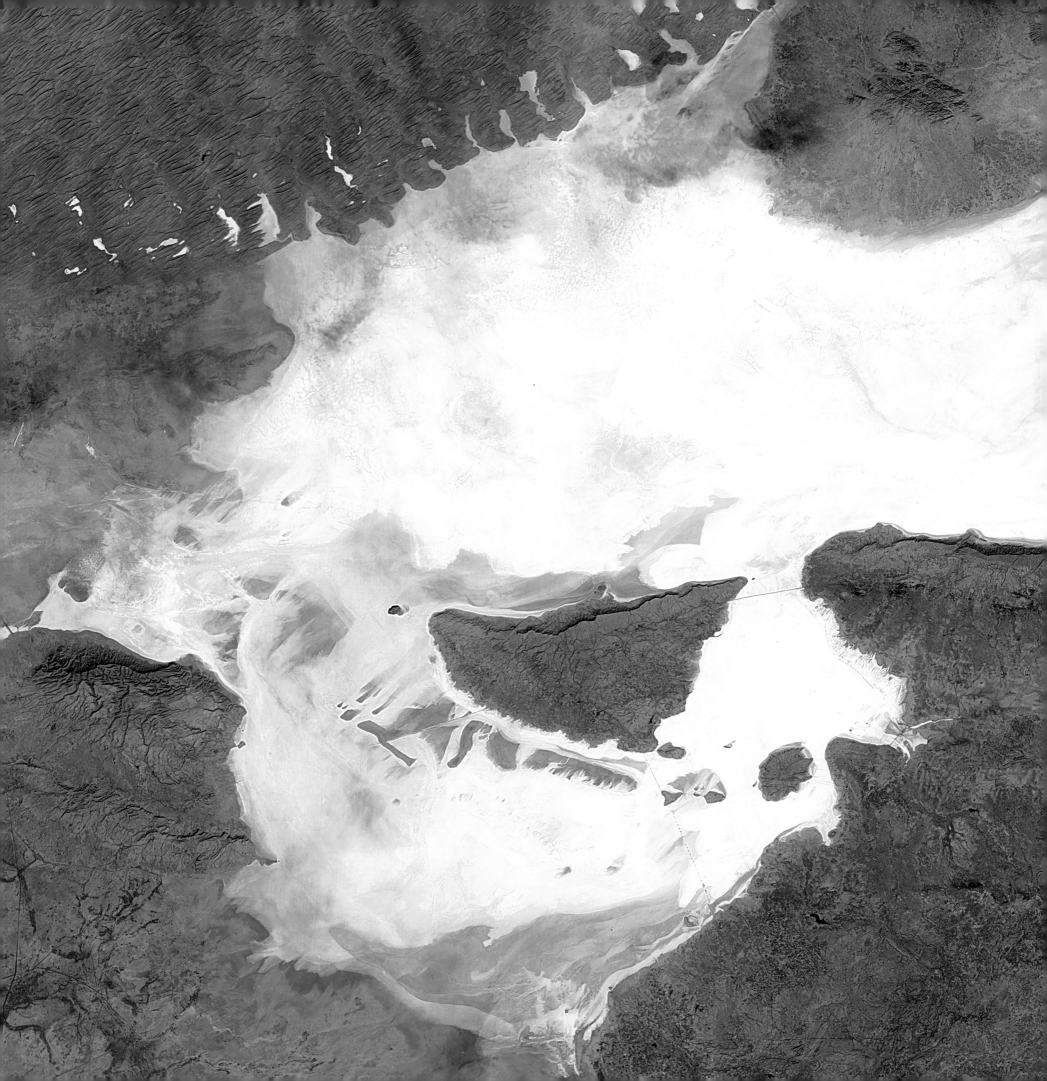

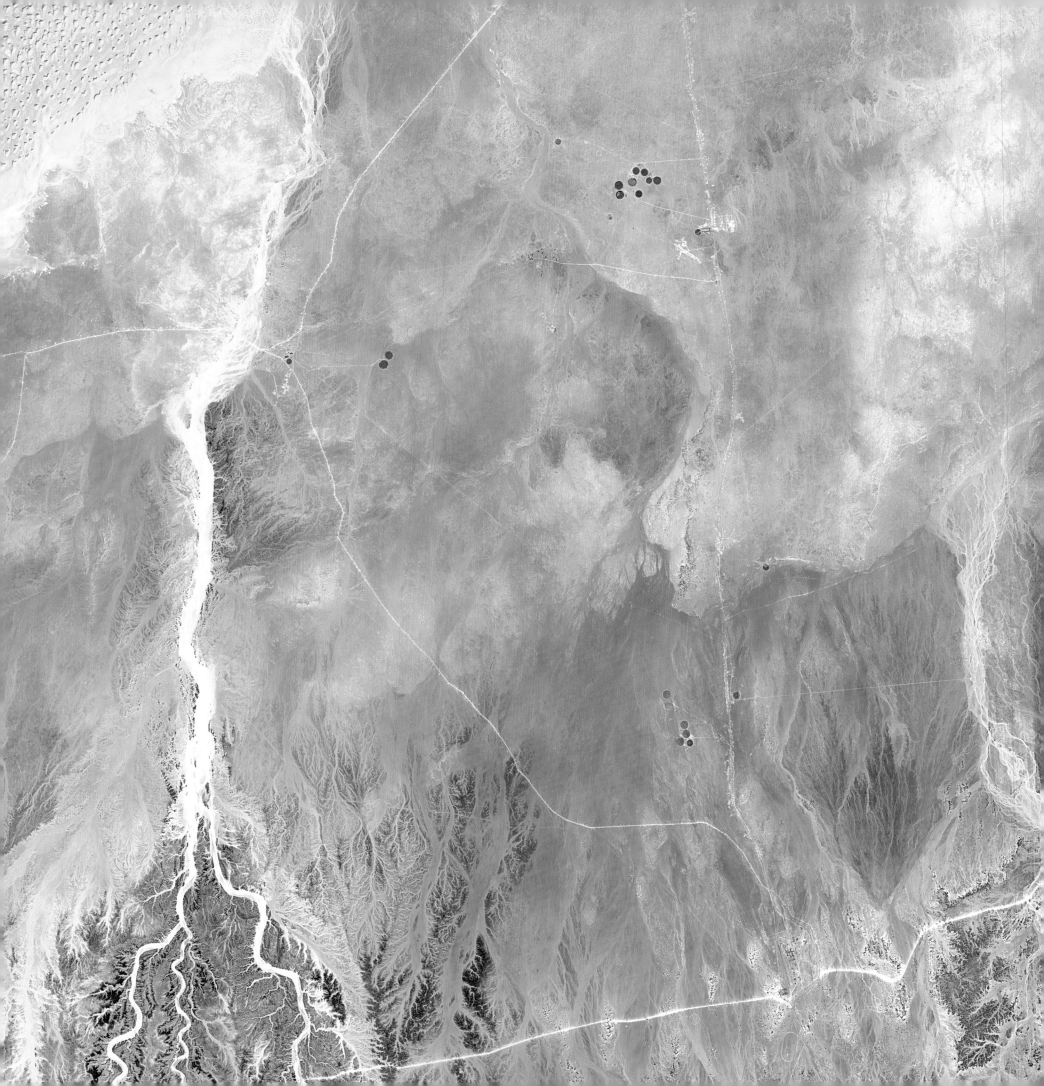

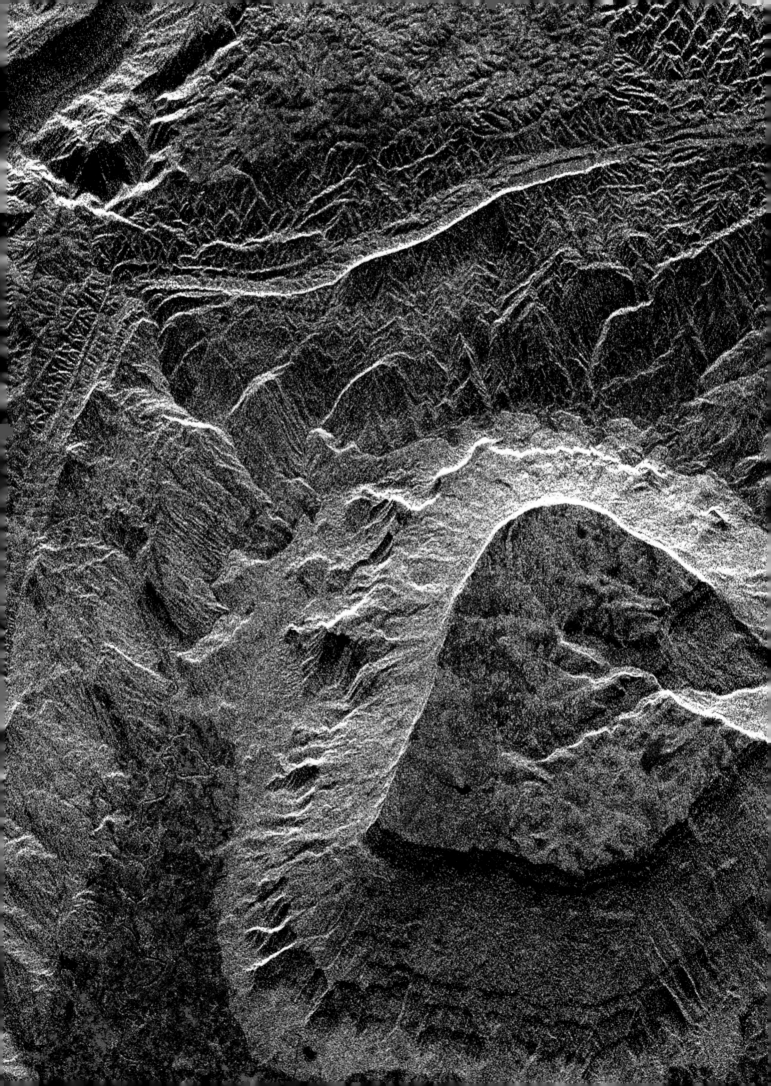

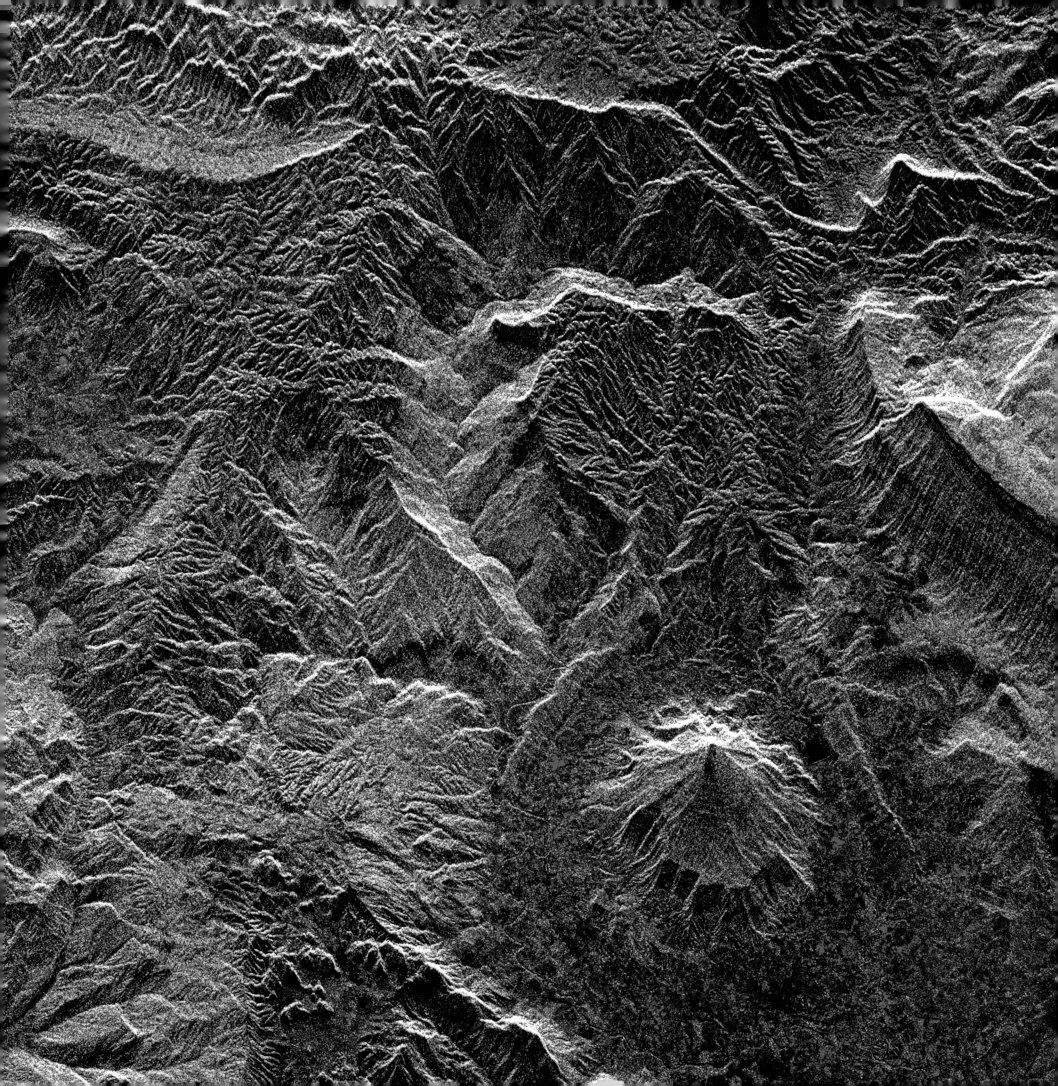

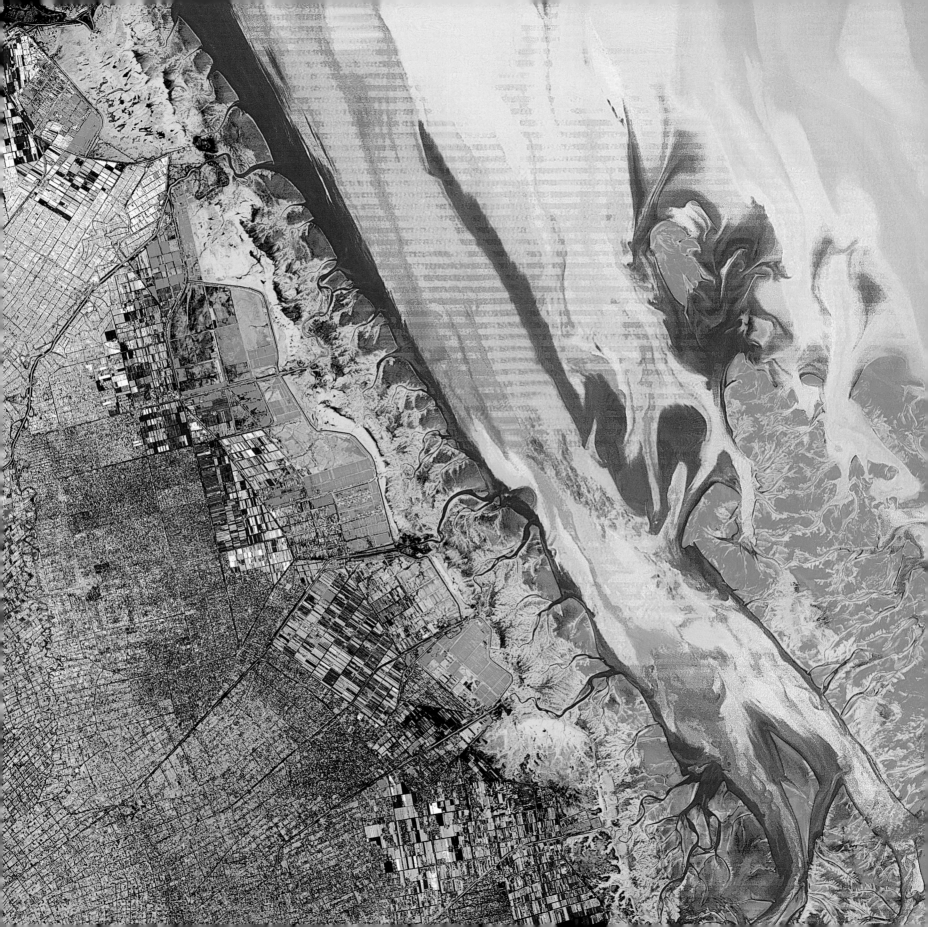

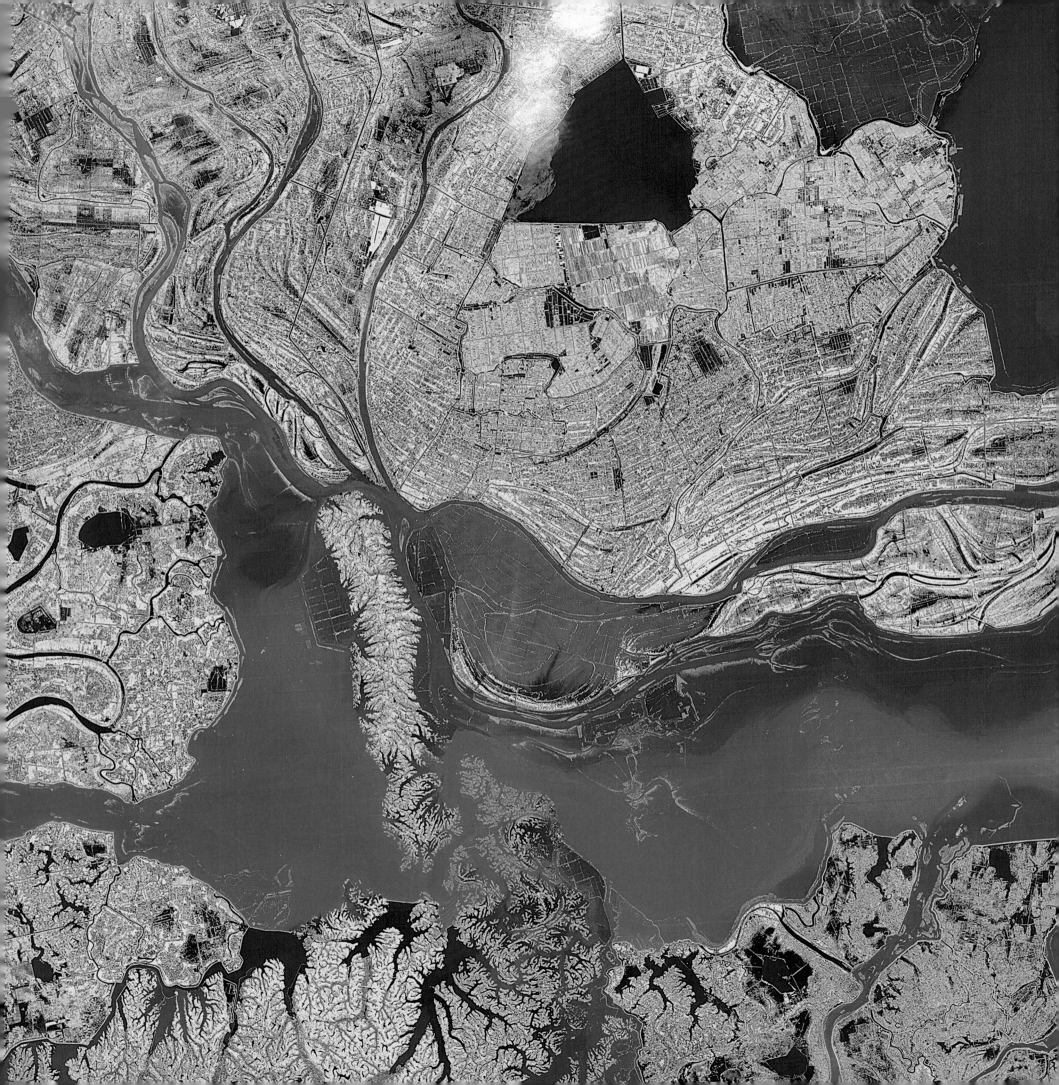

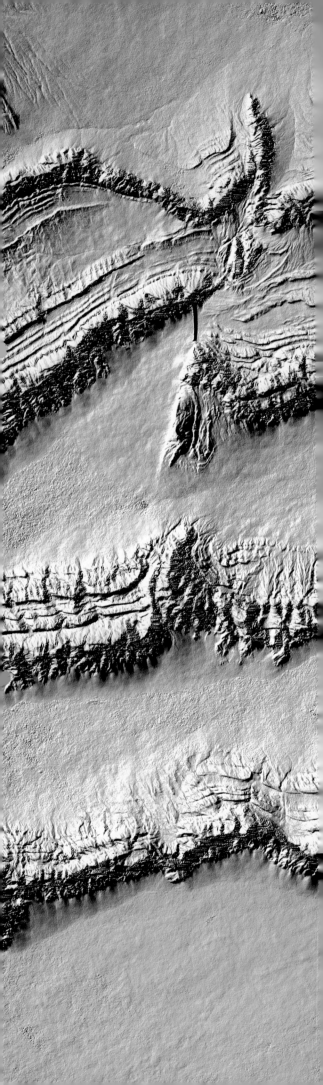

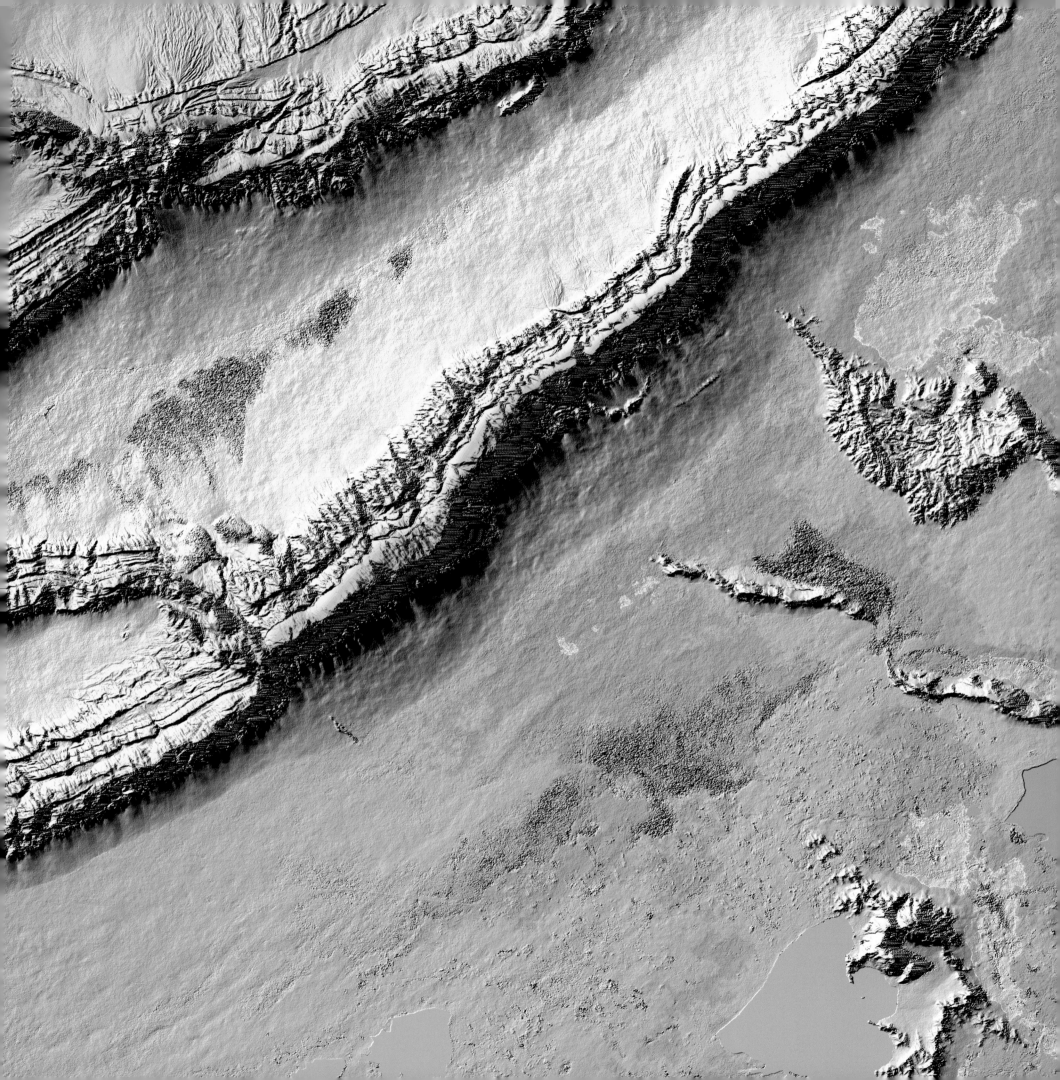

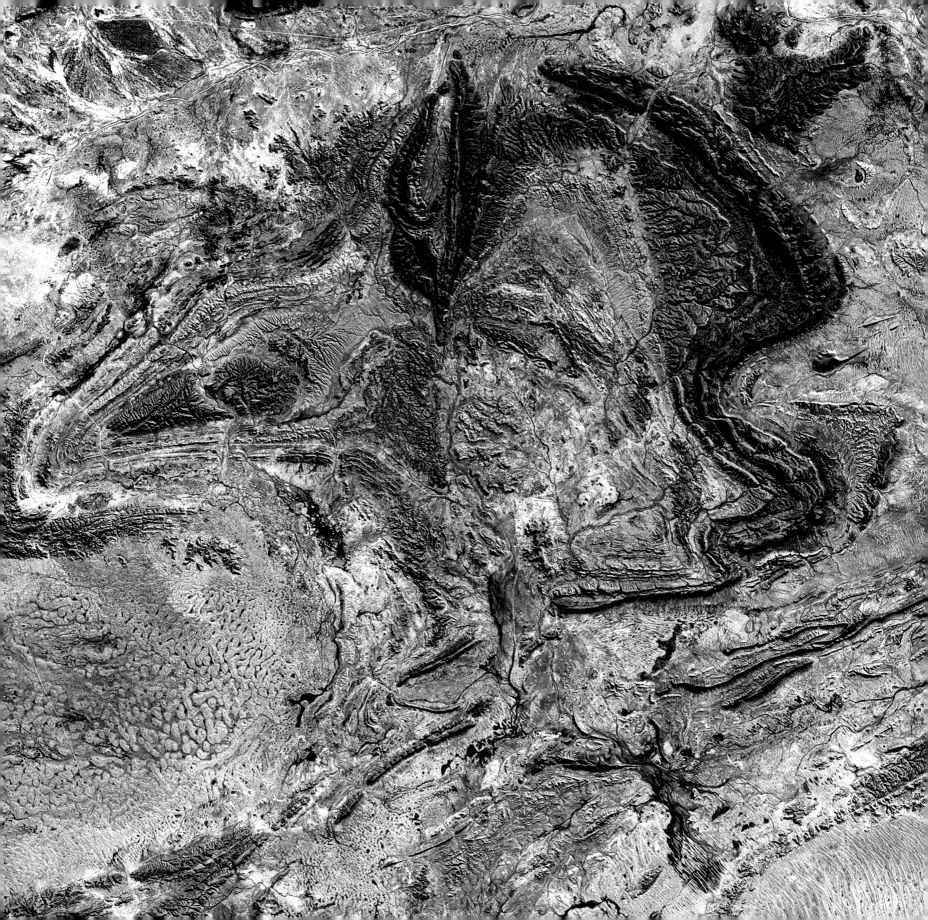

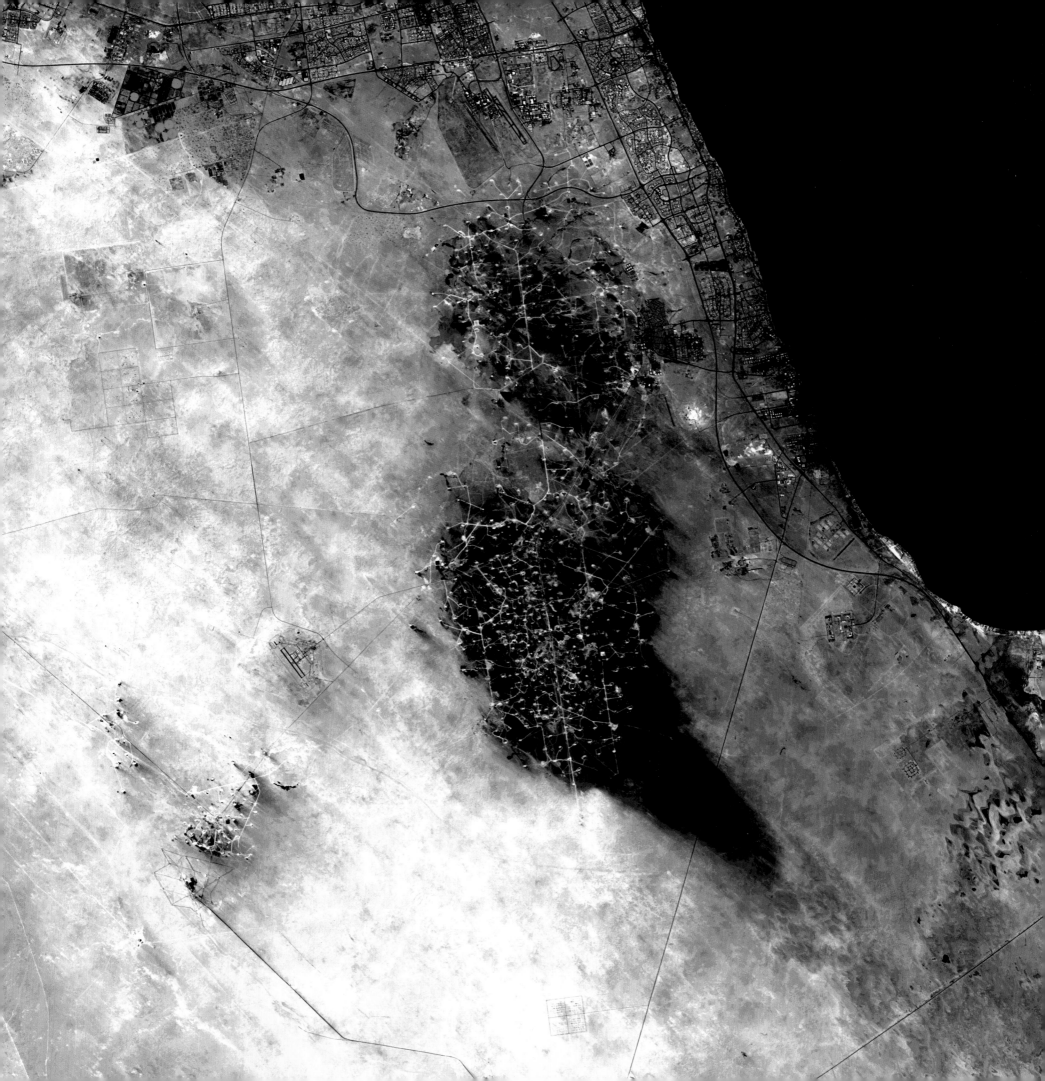

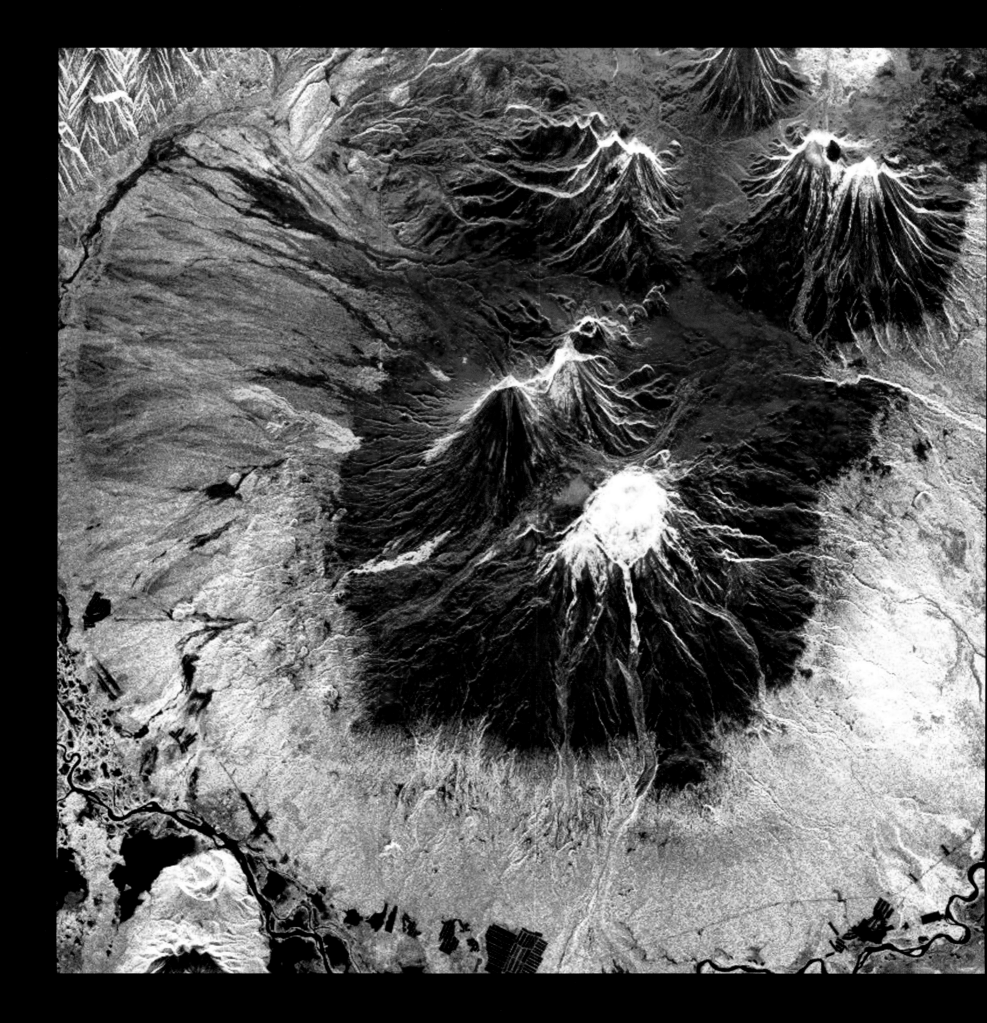

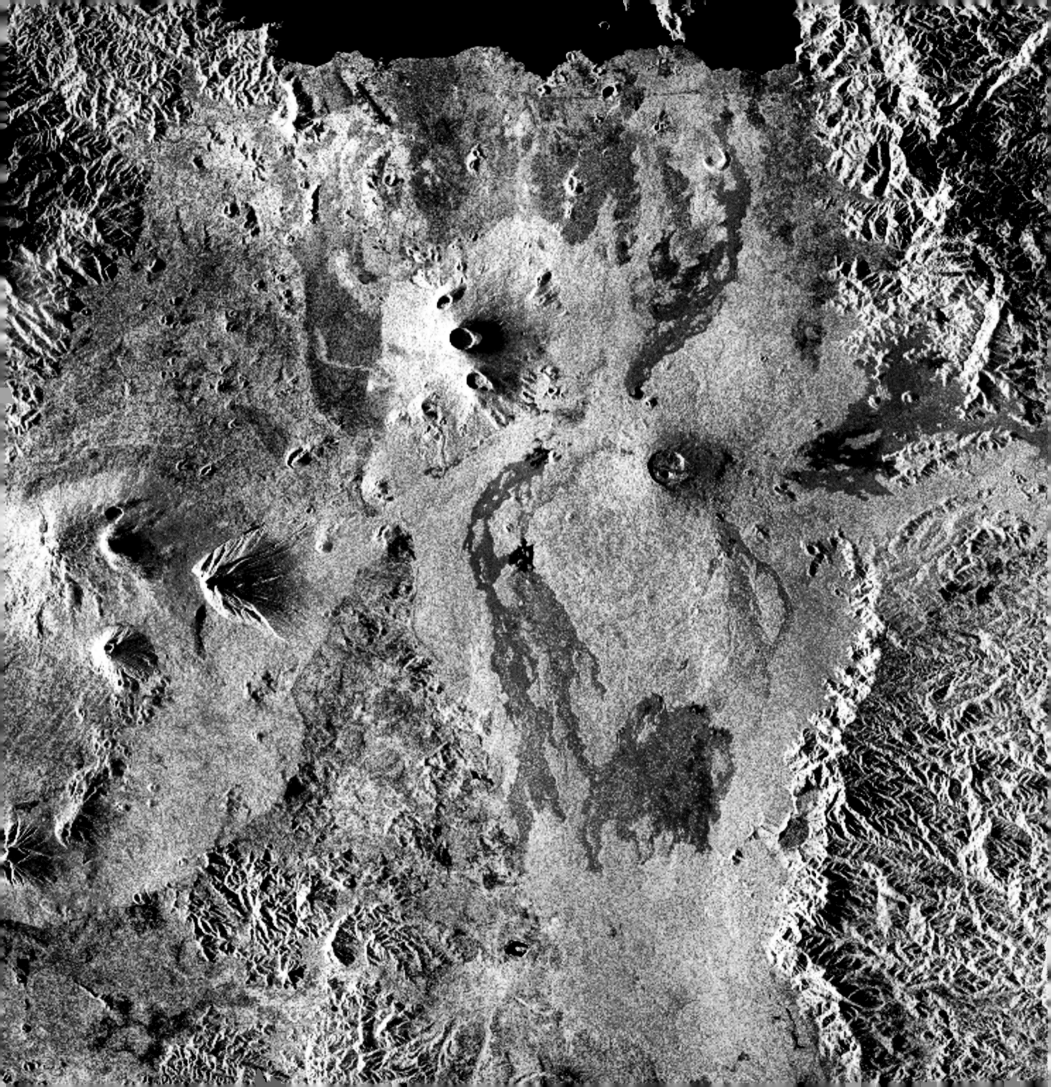

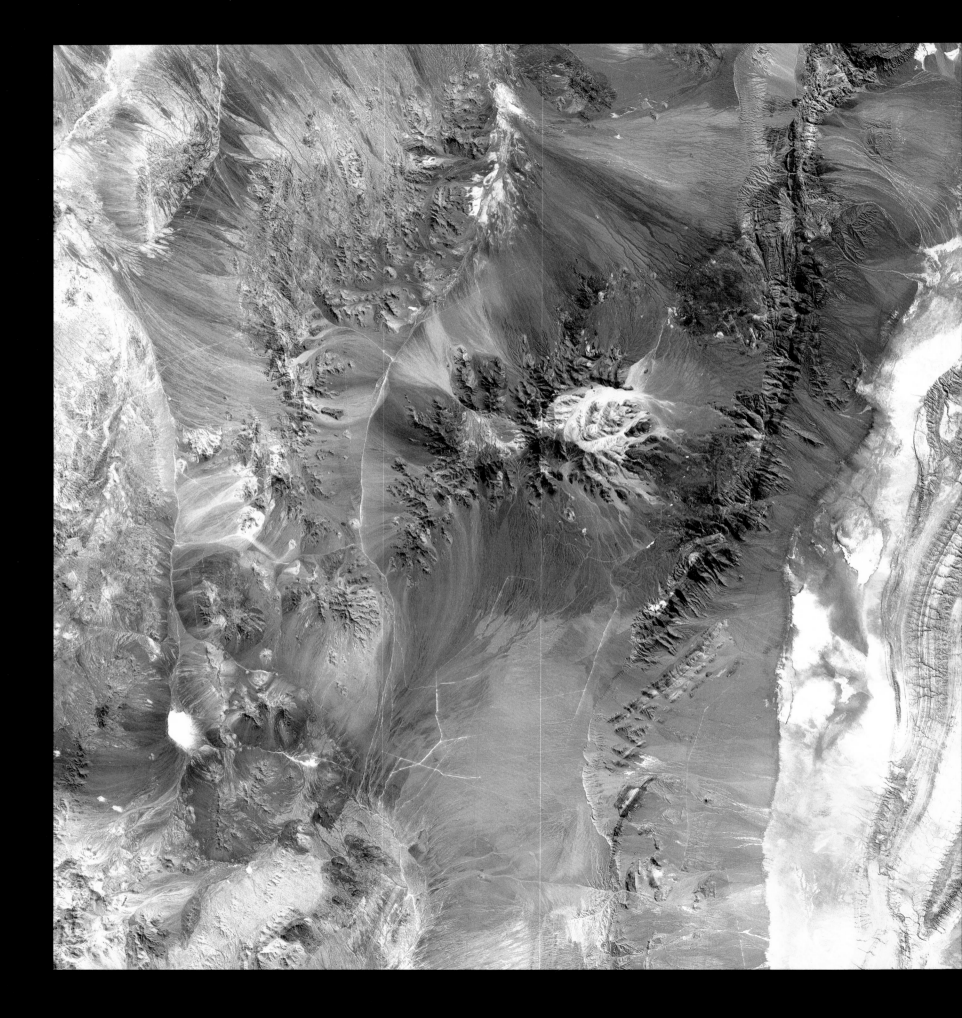

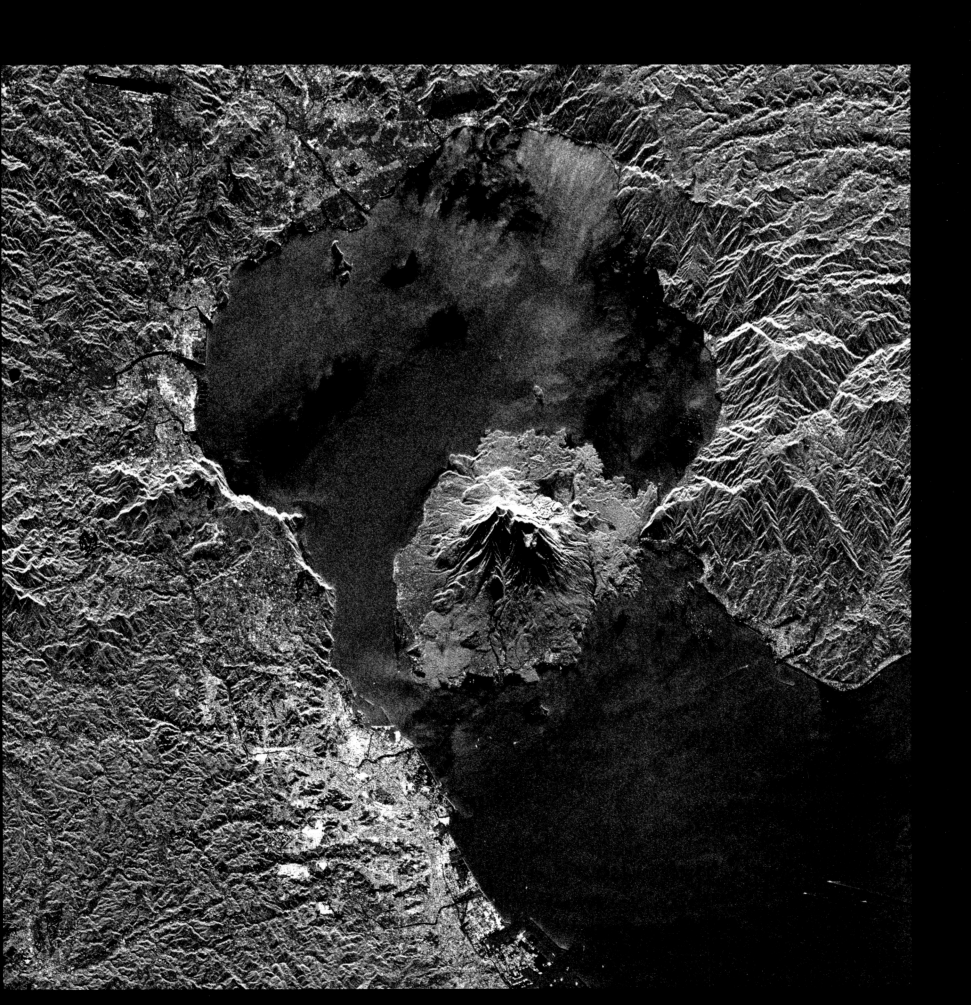

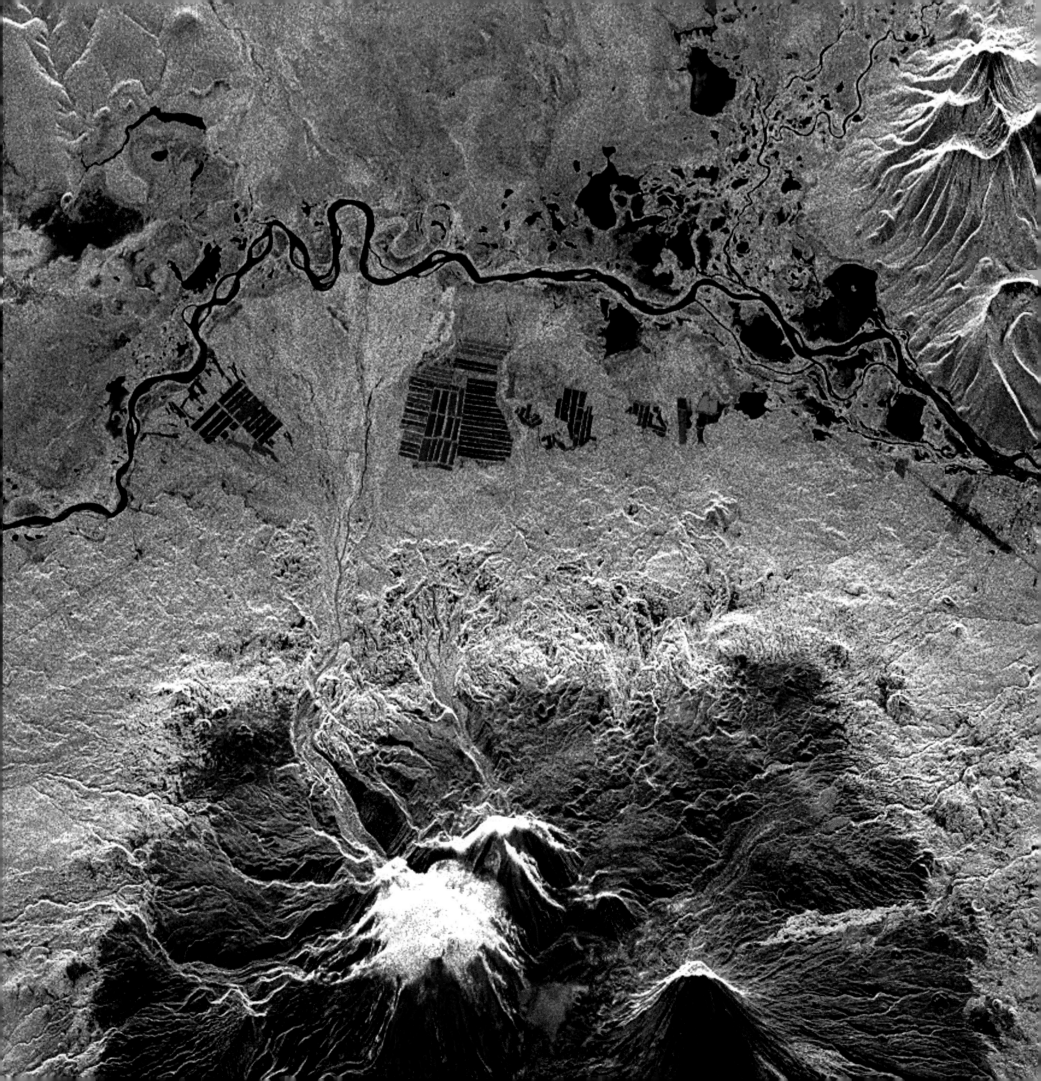

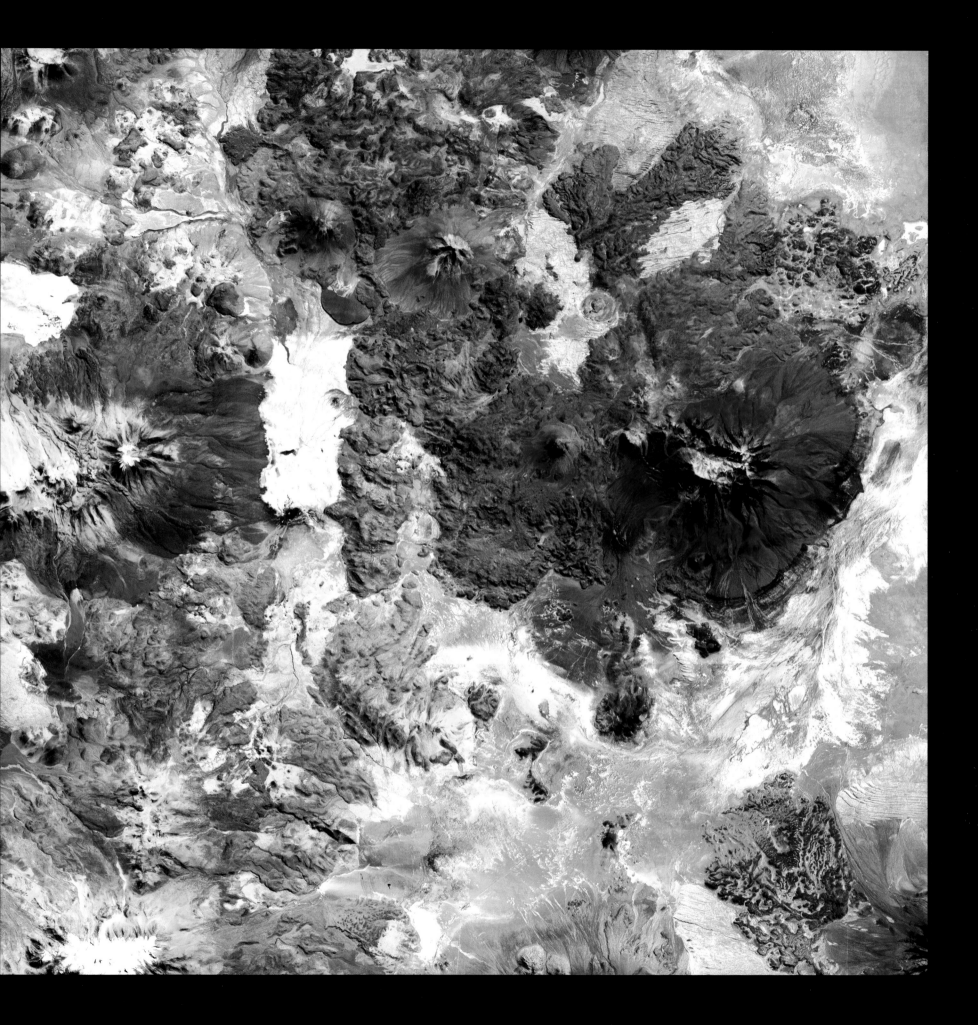

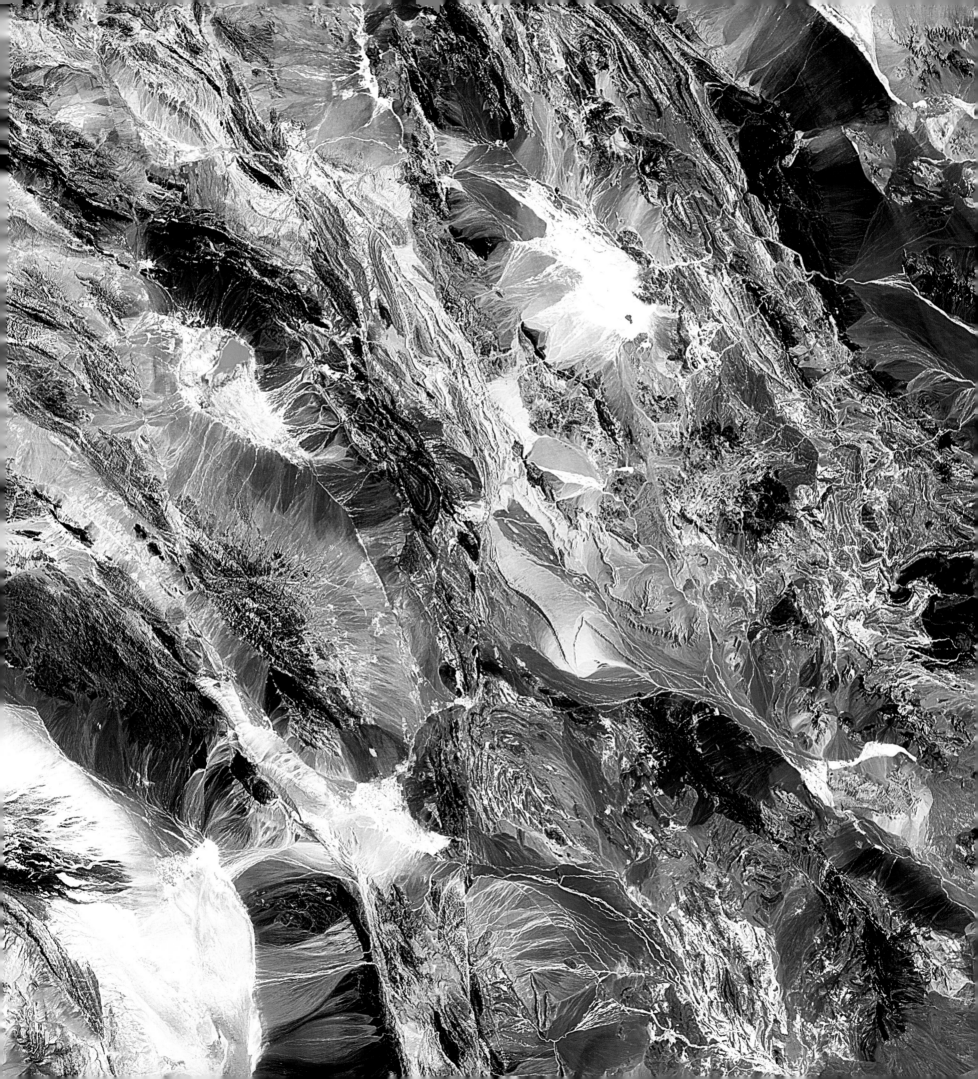

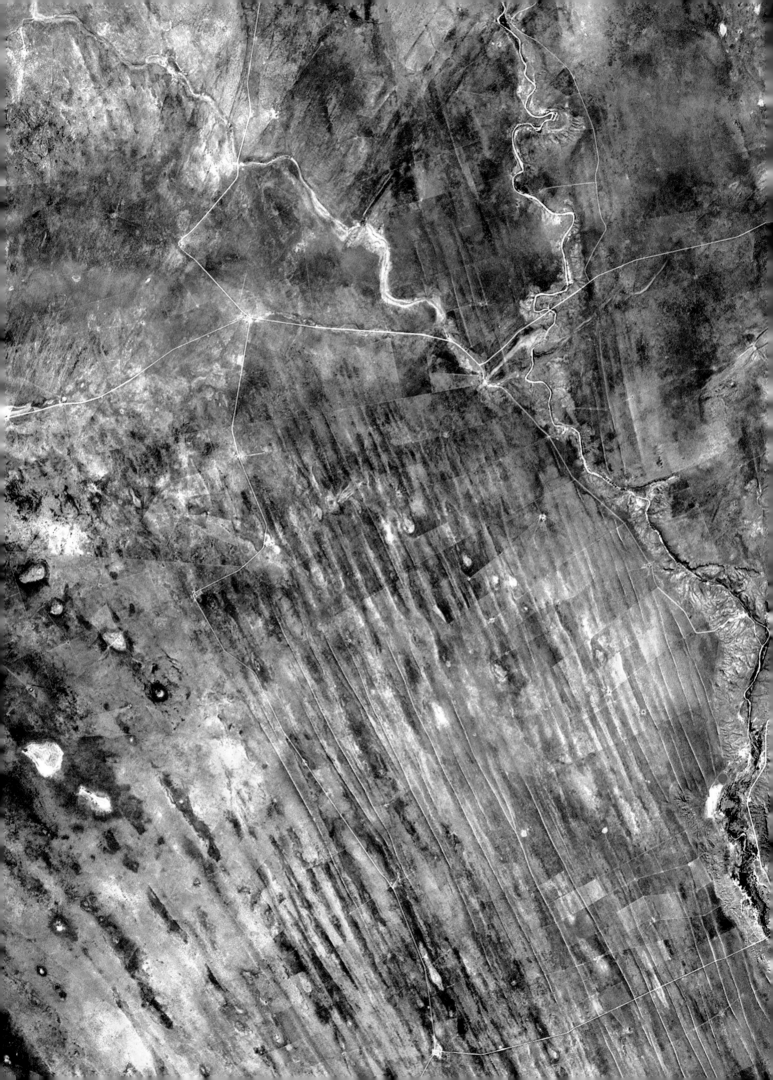

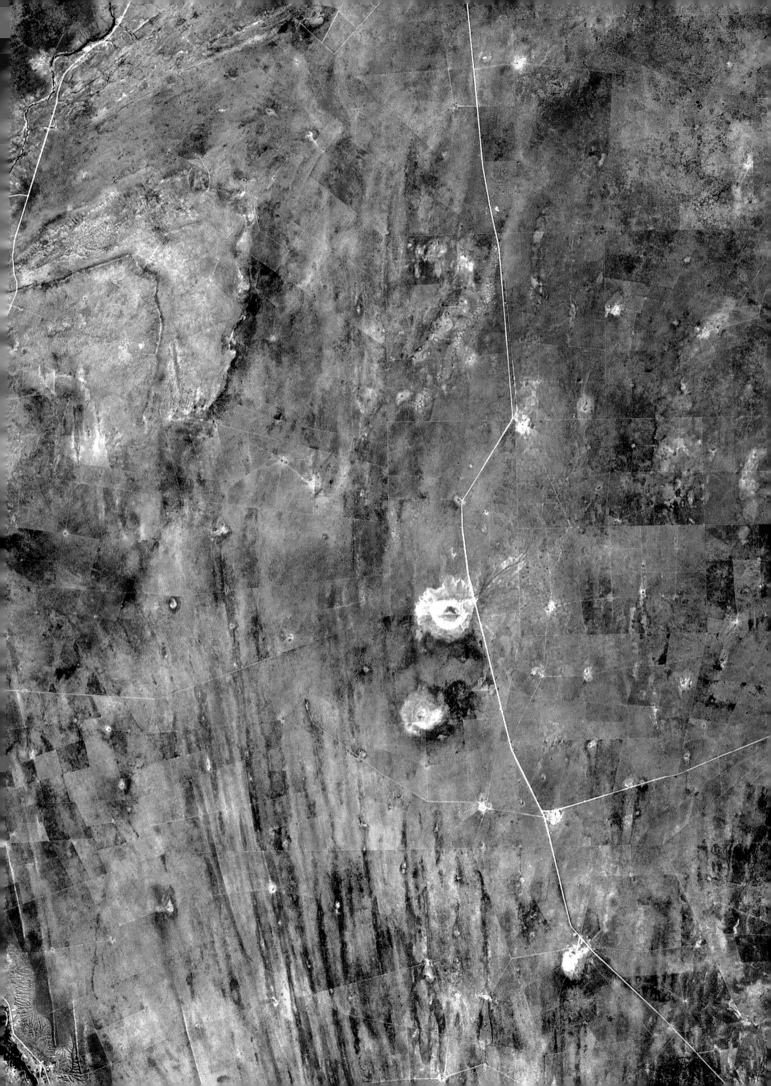

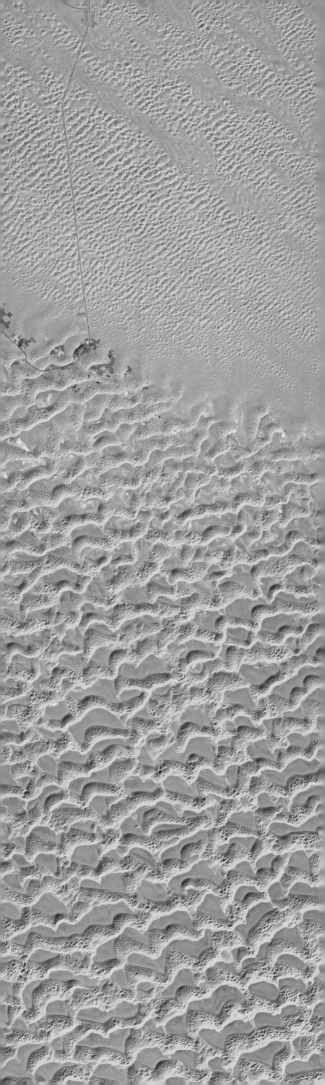

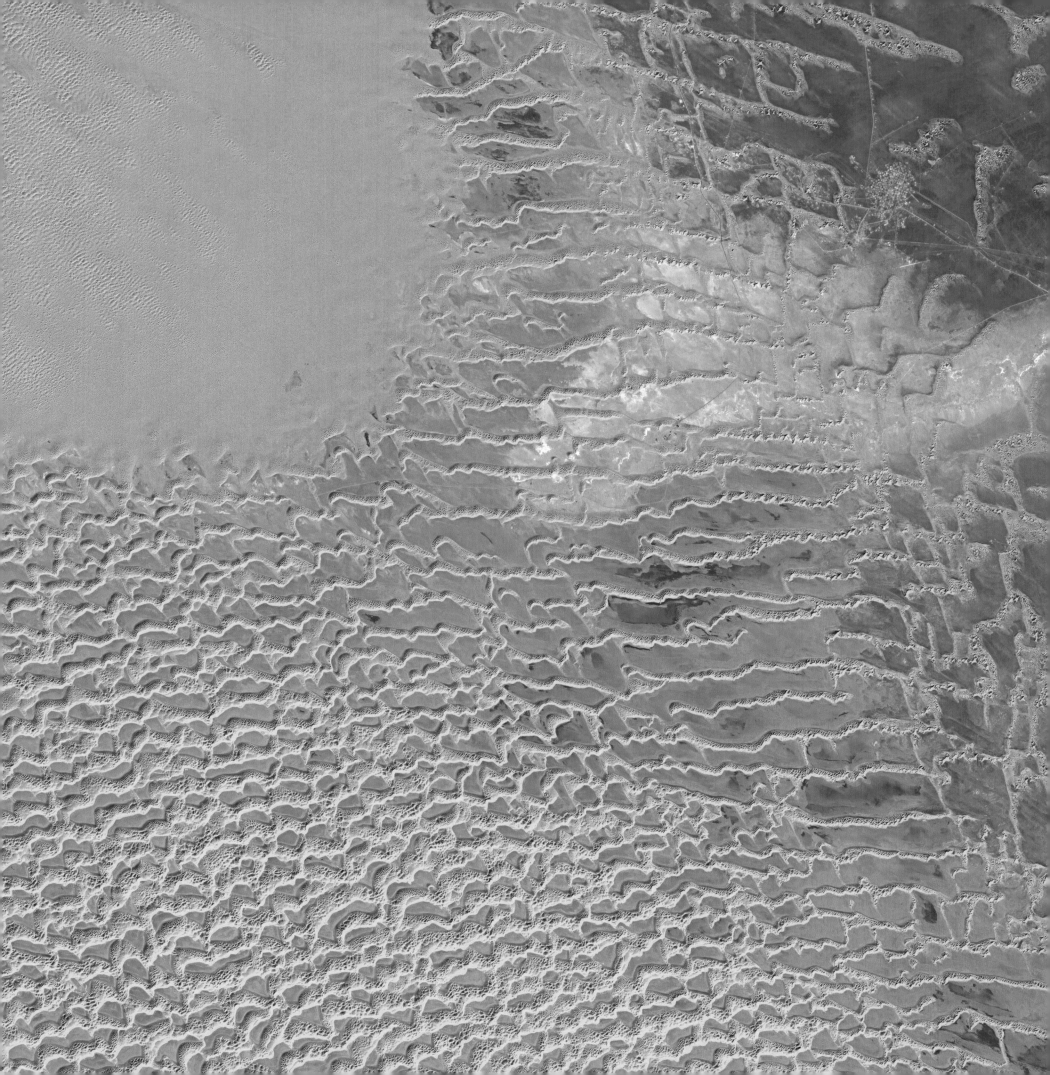

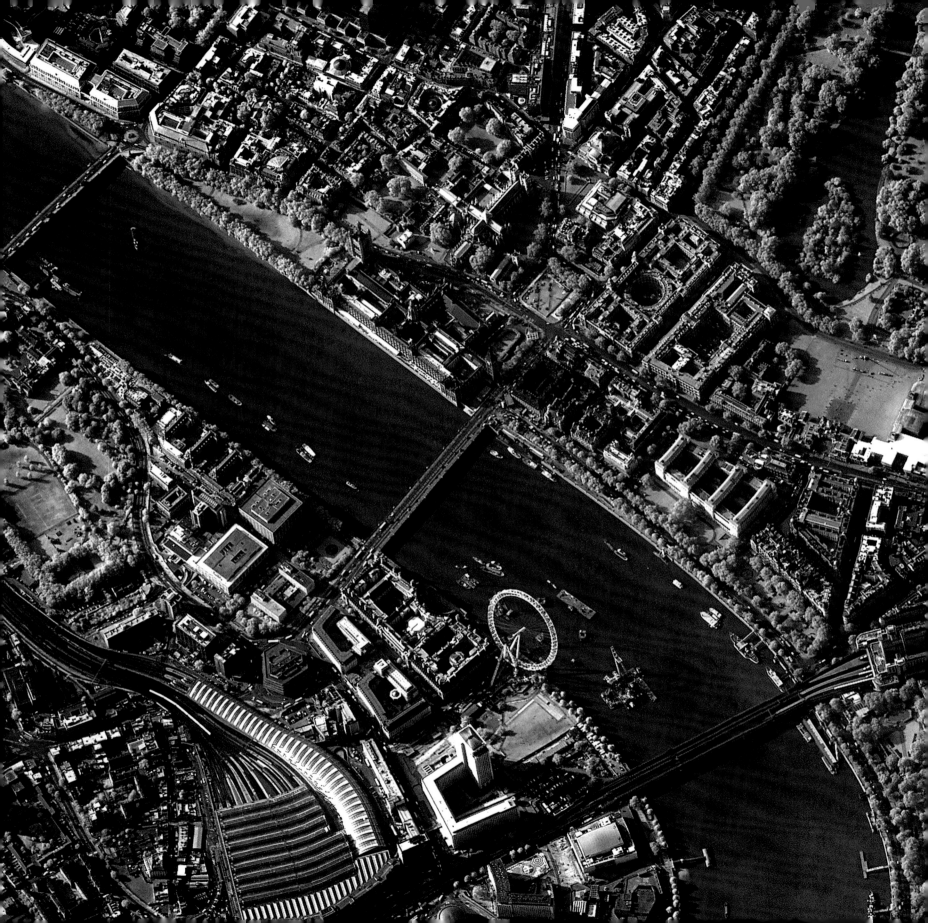

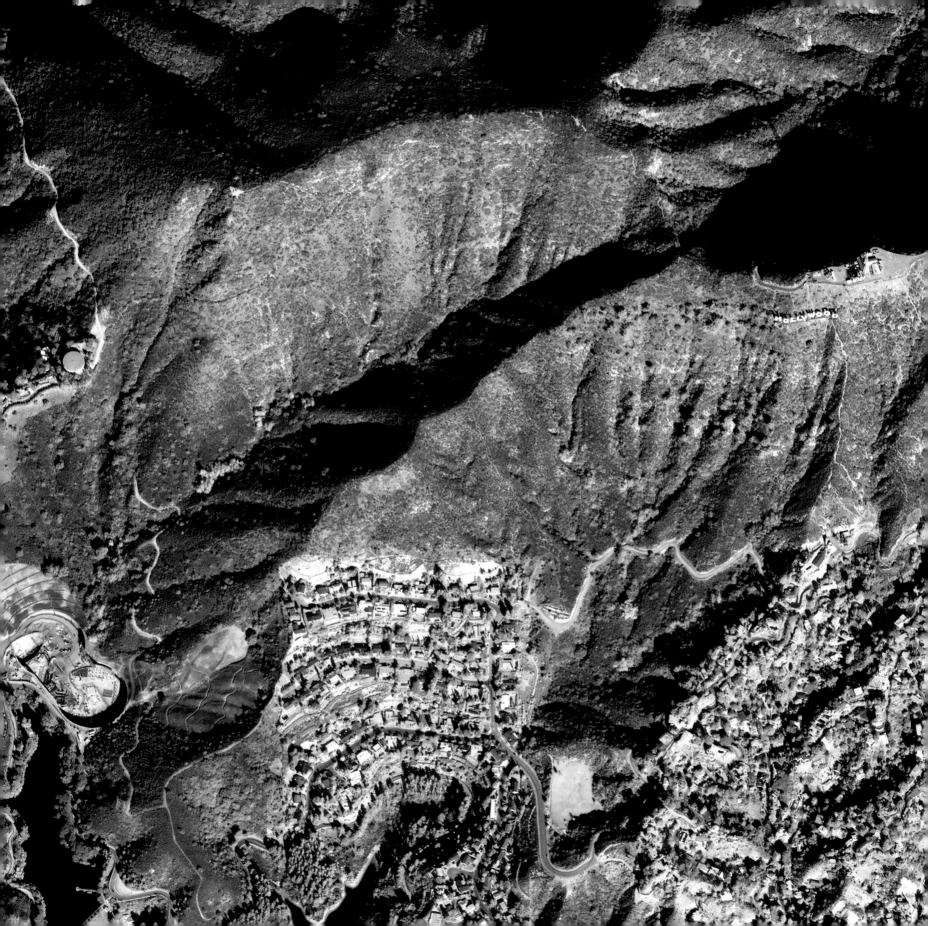

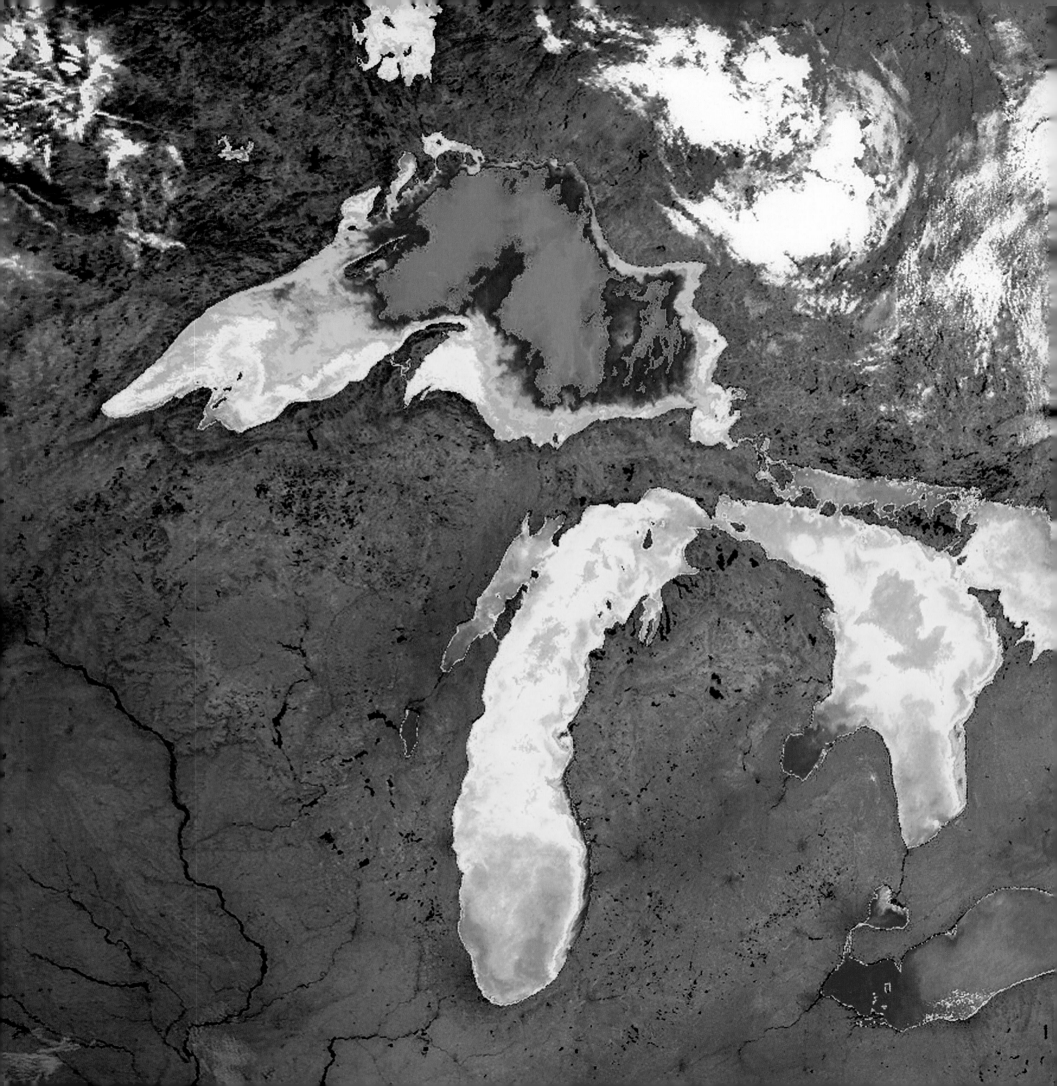

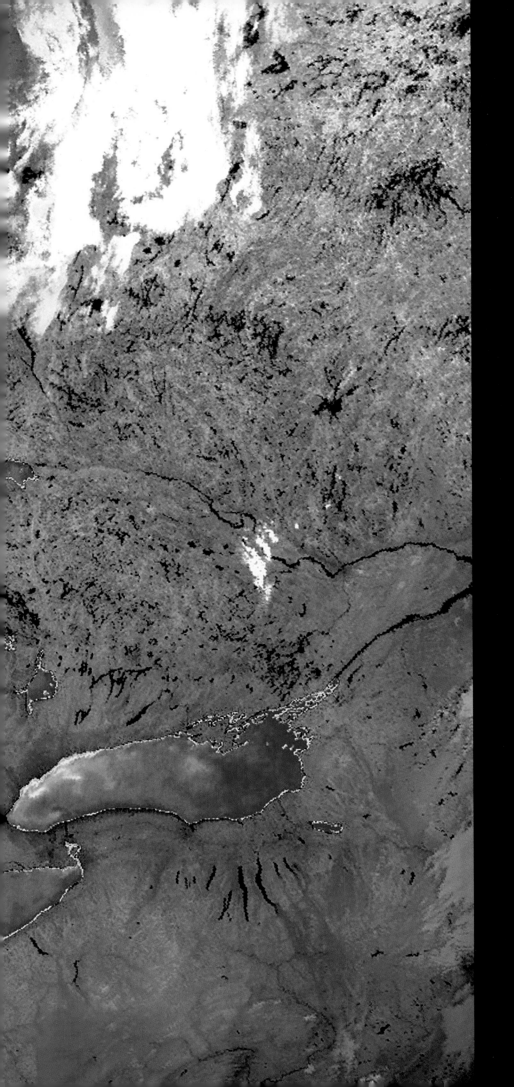
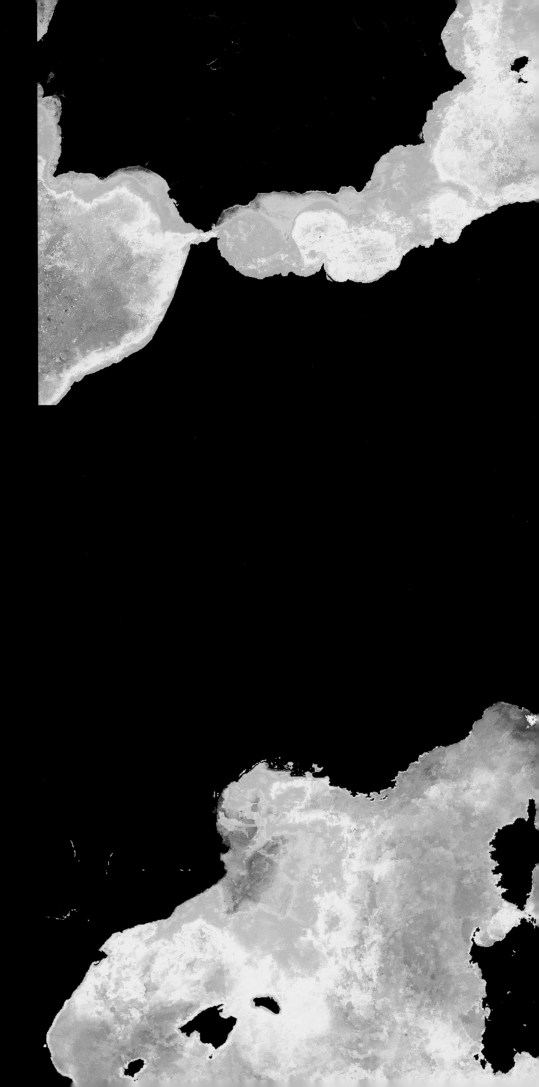

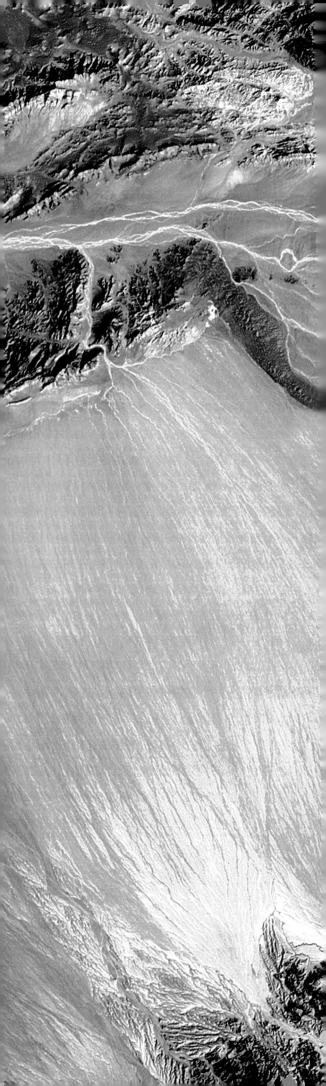

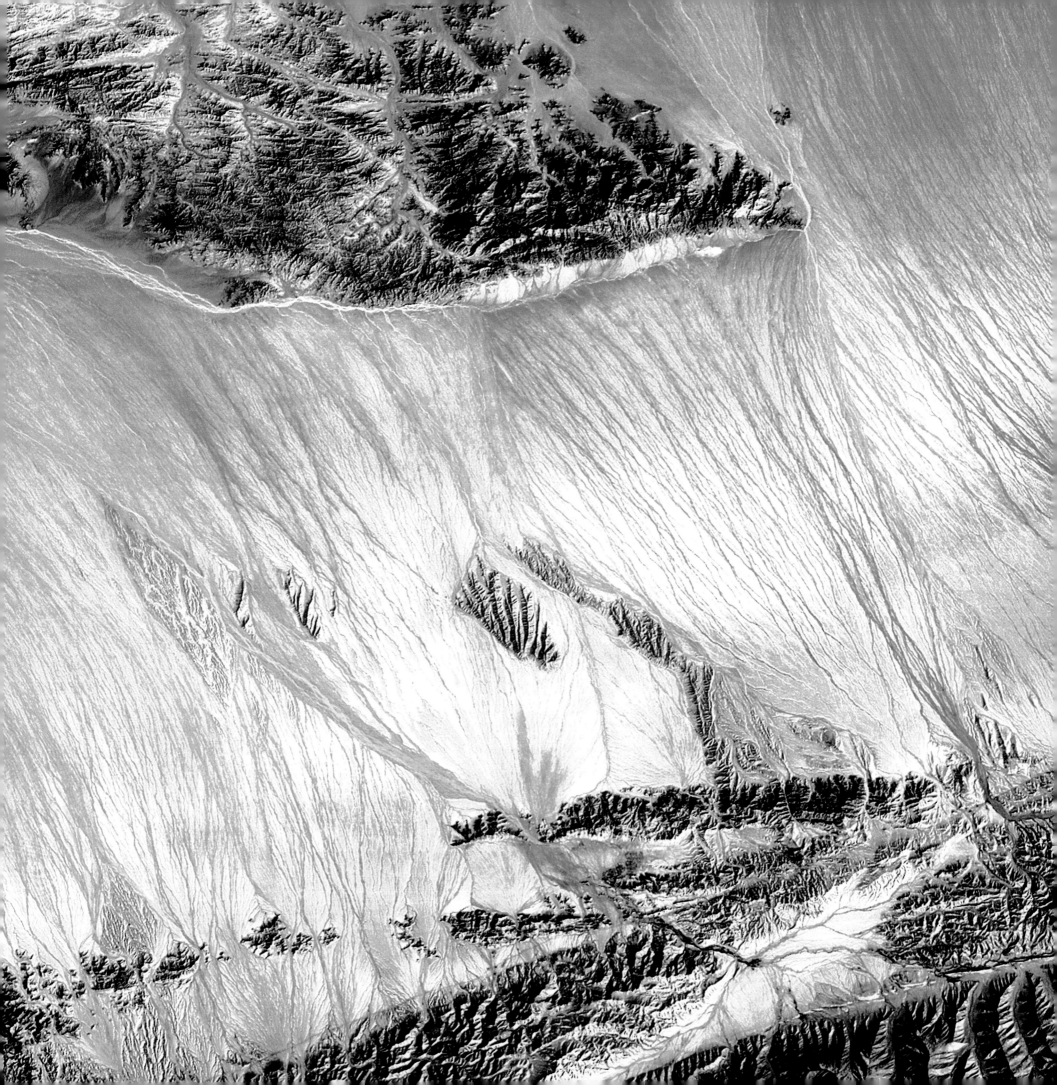

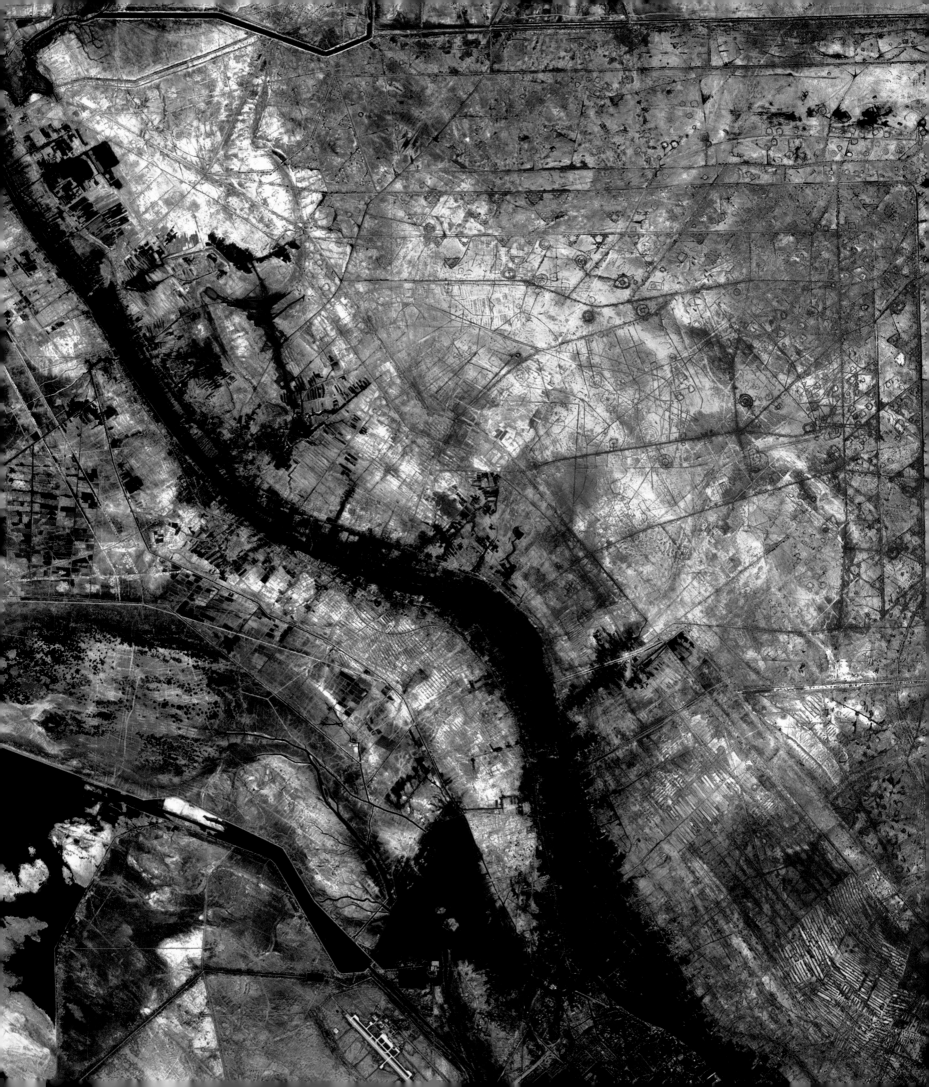

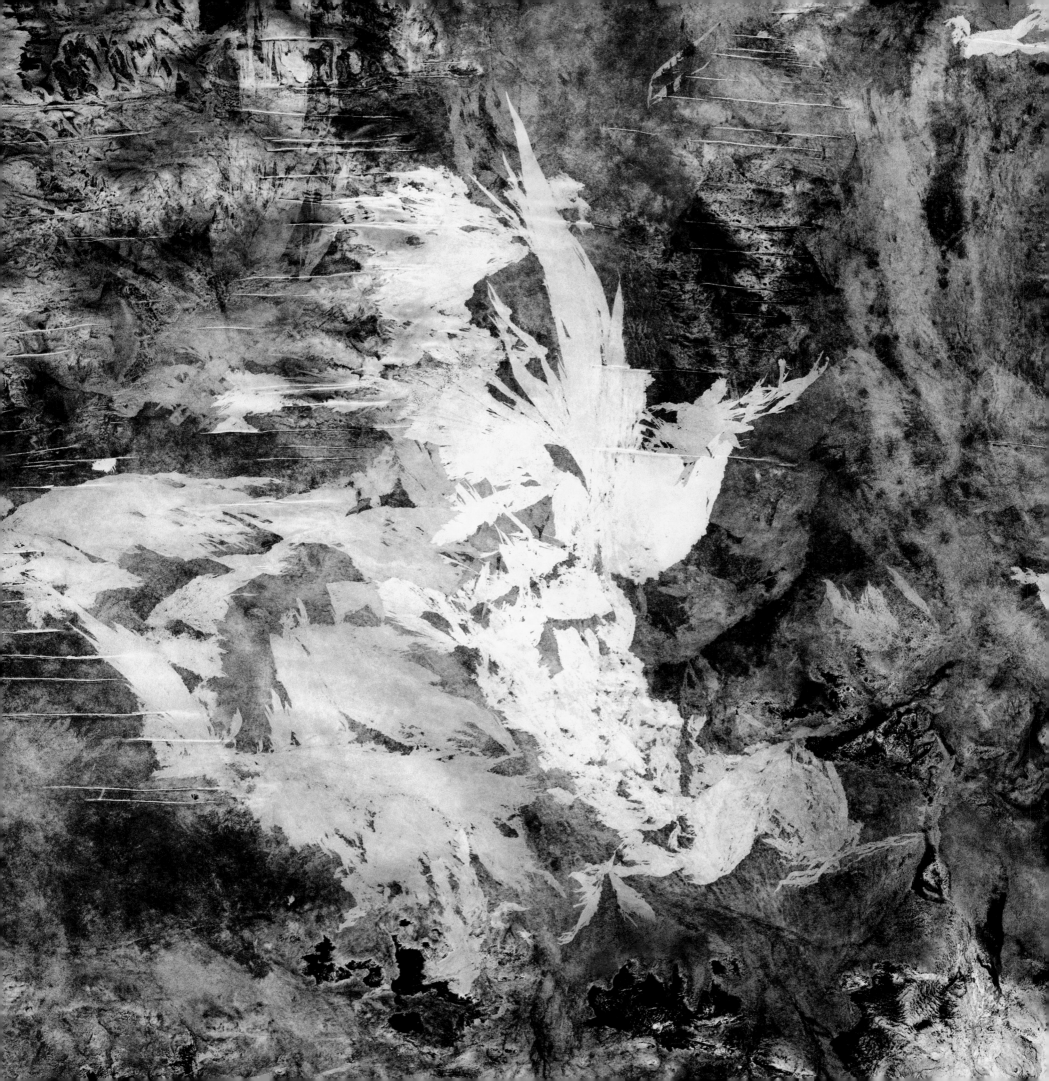

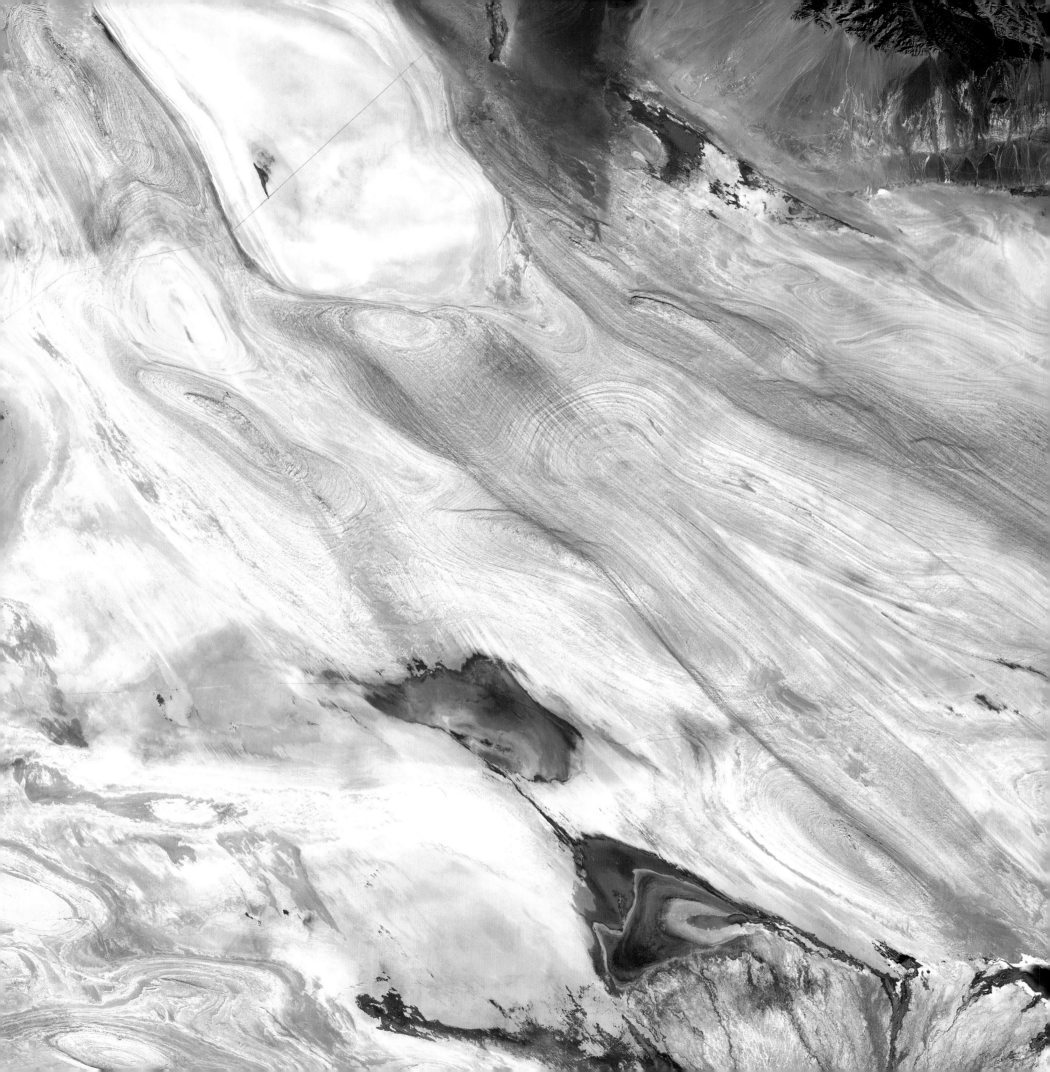

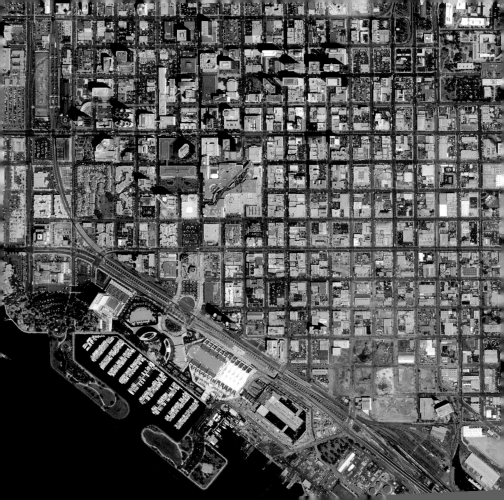

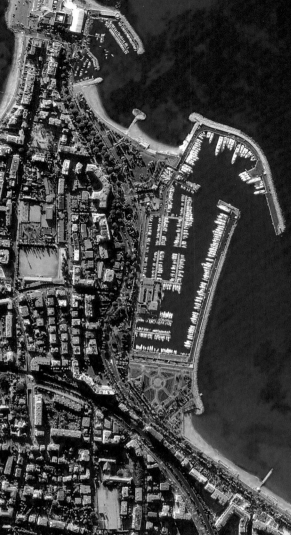

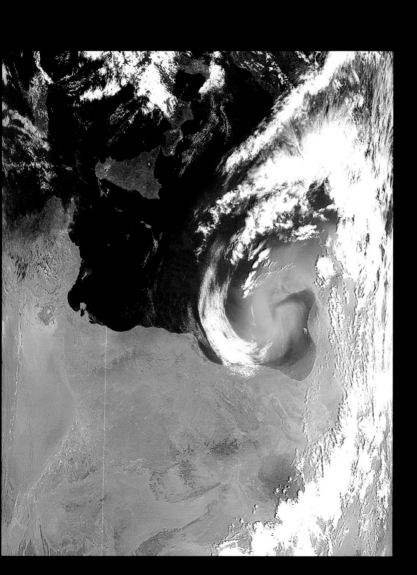
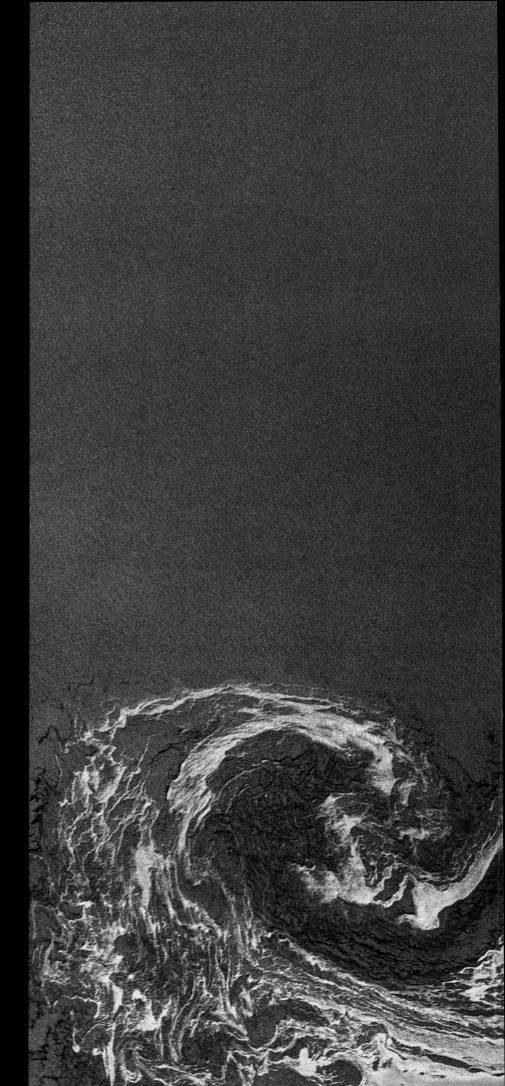

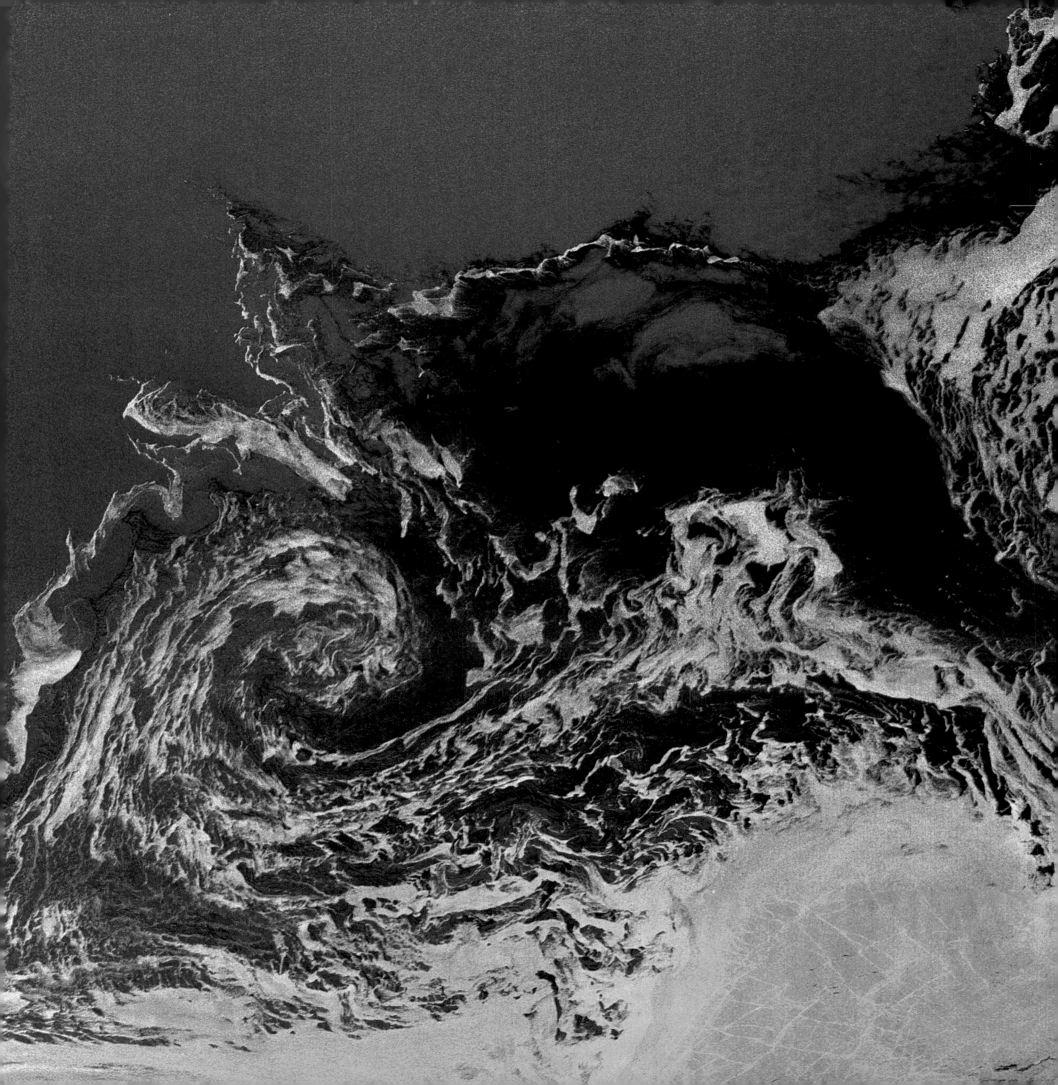

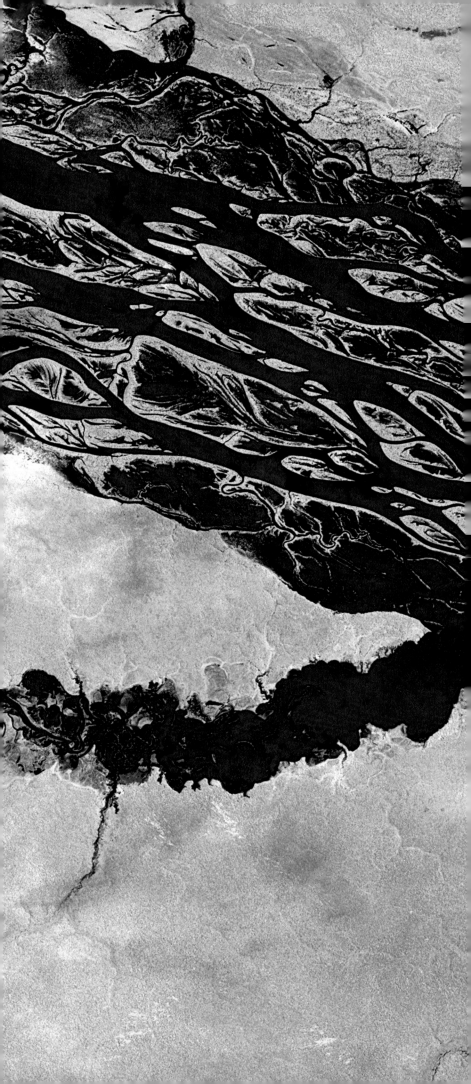

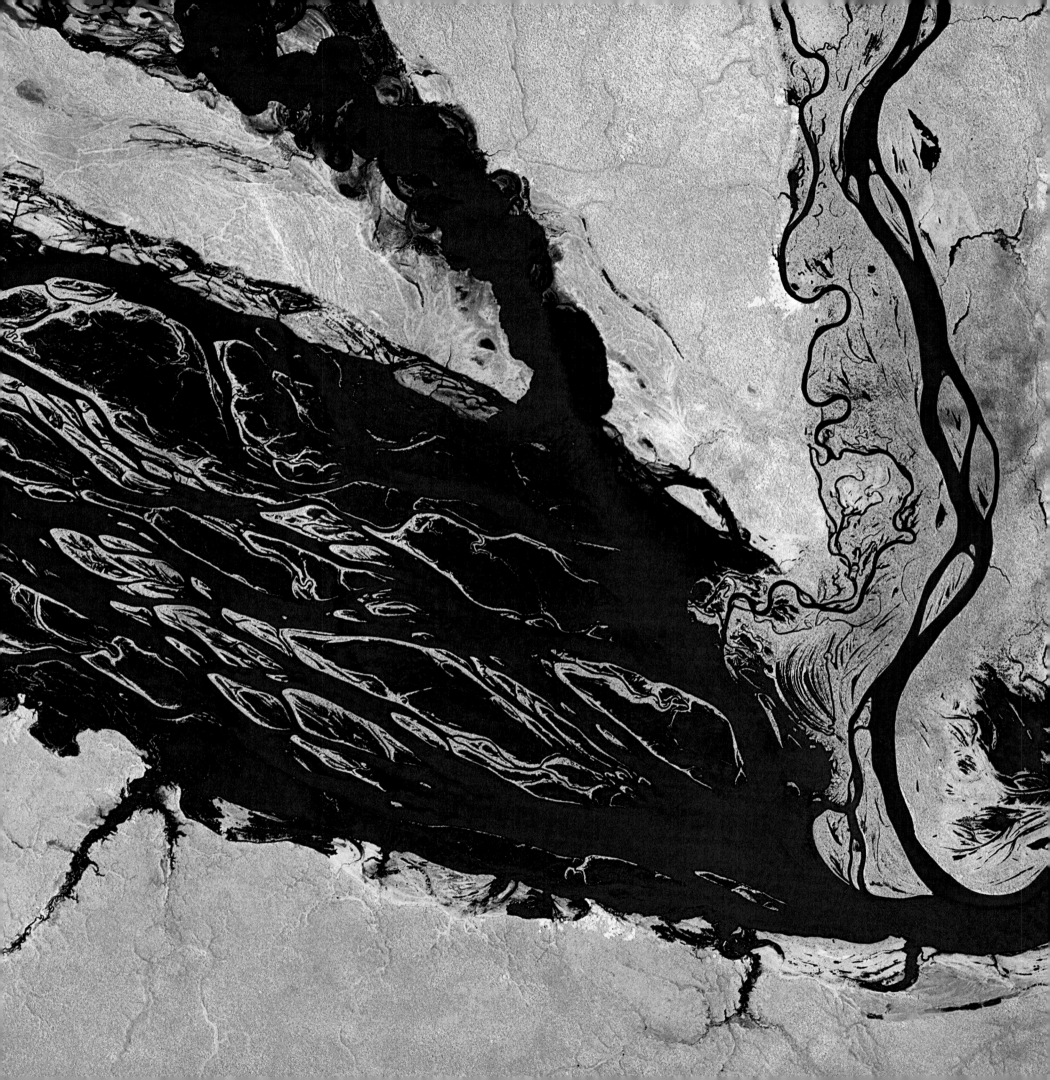

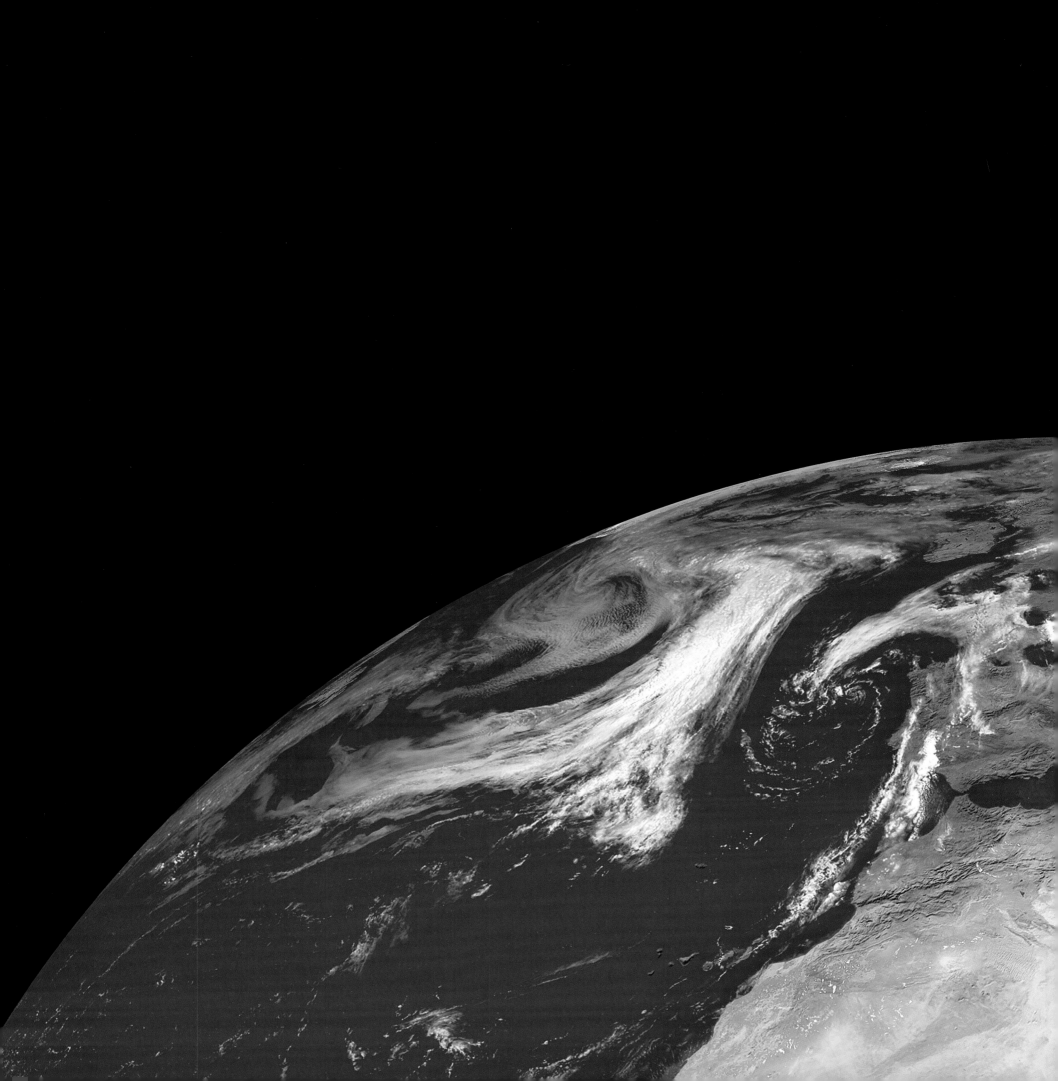

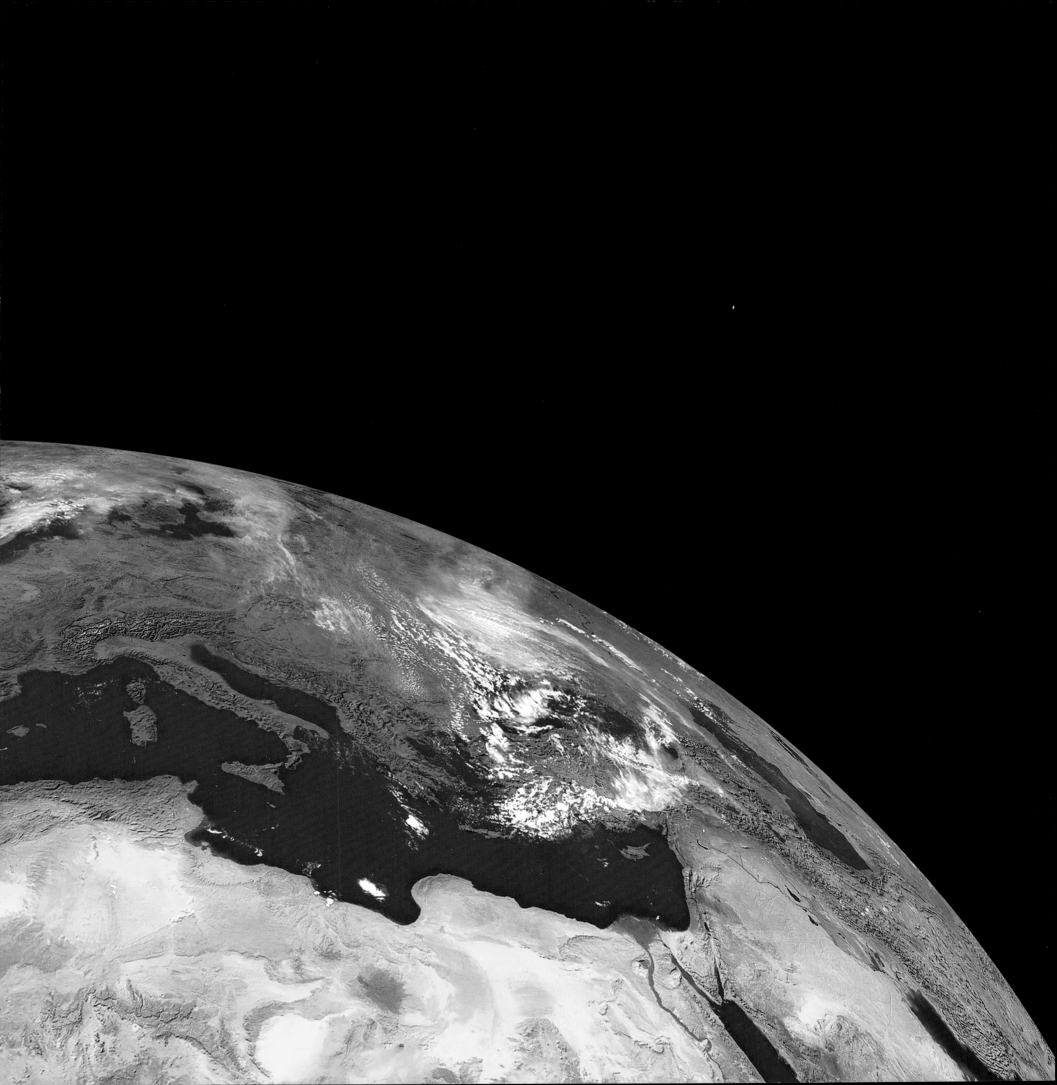

DESCRIPTION OF THE IMAGES

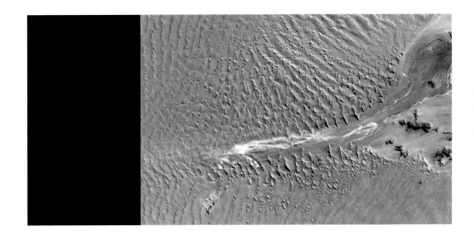

Namib Desert, Namibia

A dry valley breaks through the sand dunes of the Namib. The sporadic rains dissolve salts from the bedrock which are then deposited at the edges of the watercourses and can be seen as strongly reflecting bright regions.

The intriguing structure of this image is the result of the diverse shapes of the dunes, which can be distinguished in sharp detail.

Source: USGS/EROS Data Center; Landsat-7 ETM+

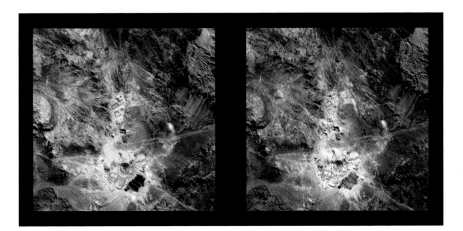

Escondida mine, Chile

The Escondida mine in Chile is the world's largest copper, gold and silver mine. It yields 127,000 tons of ore daily, which is processed locally and then transported to the coast via a pipeline.

The picture on the left shows a short-wave infrared image of the region, which highlights its geological features. The one on the right shows the same scene in the visible part of the spectrum. Images of this kind are of great value for mineral prospecting.

Source: NASA; Terra ASTER, 23.4.2000

Bangladesh

The deltaic forest region of the Sundarbans in Bangladesh lies only slightly above sea level and changes its shape as a result of frequent floods during the monsoon period. Data of this kind is also used to produce topographical maps.

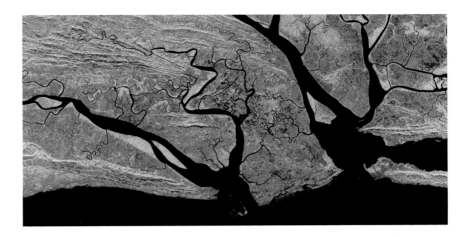

Source: DLR; SIR-C/X-SAR

A day as seen from a satellite

The sequence of images shows the course of the day as seen by the European weather satellite Meteosat. In the morning, the sun illuminates only the eastern part of the globe. The illuminated area then moves ever further westwards during the day to disappear again from the satellite's field of vision in the evening. These images represent an important source of information for weather forecasts and storm warnings.

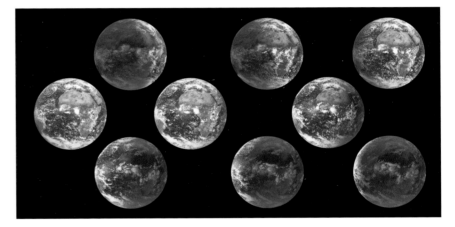

Source: DLR; Meteosat-7 (© EUMETSAT), June 2001

Antarctica, the source of icebergs

Radar satellites allow the ice shelf to be observed under any weather conditions and give early warning of icebergs.
The gigantic iceberg A38 (150 km long, 35 km wide) calved from the Ronne Ice Shelf (*left*) in October 1998. Shortly afterwards, it broke up into several pieces (A38A, B etc). Giant icebergs also calve from the Crosson Ice Shelf (*right*) and drift out into the South Pacific. The ice shelf is fed by the Thwaites Glacier.

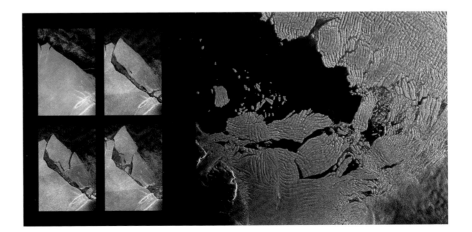

Source: Radarsat Int'l., DLR/ESA; RADARSAT-1, ERS-2, 23.2.2000

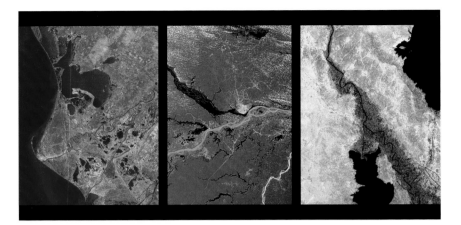

Rivers

Regions which are difficult to access, such as the strictly protected wetlands of the Danube delta nature reserve (*left*), the rainforest where the Rio Negro meets the Amazon (*middle*), and the Tigris valley near the Iraqi town of 'Ali al Gharbi (*right*), inaccessible for political reasons, can be observed with the aid of satellite data. Ecologically relevant changes can then be detected and suitable countermeasures taken.

Source: DLR (2), NASA; MOMS (2), Terra MISR

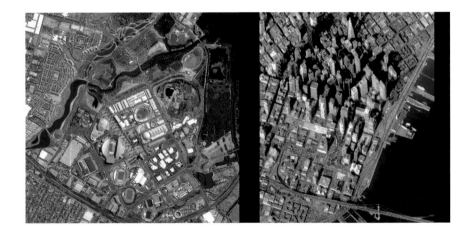

World cities seen from space

The Olympic site 2000 (*left*) is located on Homebush Bay about 14 kilometres west of Sydney. The picture shows the Olympic stadium, the Superdome and the facilities for the athletics, swimming and baseball competitions.
The striking shape of the Transamerica Pyramid skyscraper dominates downtown San Francisco (*right*). At the bottom left of the picture is the Bay Bridge which links the city with Oakland.

Source: Space Imaging; IKONOS, 1m Auflösung

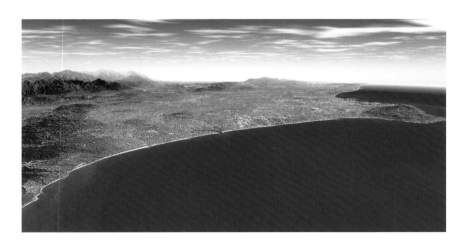

Los Angeles

A true-colour image has been computer-enhanced and combined with a digital elevation model to generate an almost realistic picture of the greater Los Angeles area. The view extends from the Pacific coast at Santa Monica to the San Gabriel mountains in the background. The yacht harbour in Marina del Rey and the international airport can be seen at the centre of the picture; the Palos Verdes peninsula juts out on the right.

Source: DLR; Daten: NASA, Landsat TM

Agriculture in Kansas

The state of Kansas is intensively farmed, and this picture is characterized by a circular pattern of irrigated fields. The various hues of the fields in this false-colour image indicate the type and condition of the crops and the amount of moisture in the ground. Seen from a satellite, the pattern formed by the fields resembles an abstract painting.

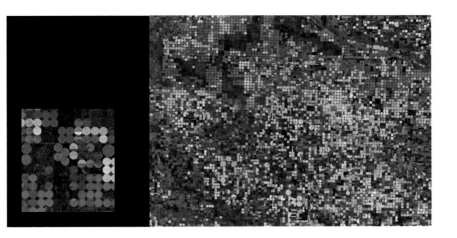

Source: USGS/EROS Data Center; Landsat-7 ETM+

Cartography

Satellite images are of great value to cartographers as they give a large-scale overview with high resolution even of inaccessible regions. The images on the left show a region near the Croatian coast (*above*), a scene from Slovakia (*below*) and, on the right, Mount Everest (*above*) and one of the Irrawaddy's mouths near Yangon (Myanmar).

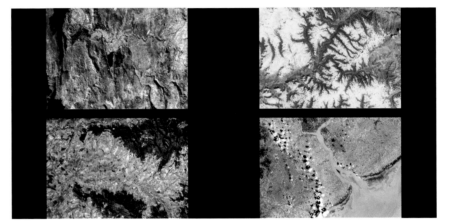

Source: DLR (3), ACRoRS; MOMS (3), Landsat TM

Eyes of the Earth?

An asteroid strike produced the Aorounga crater (*left*) in northern Chad. Scientists believe that other craters still remain undiscovered, suggesting a multiple strike. In the Mauritanian desert, sediments of a primeval ocean have been pushed up to the Earth's surface. Layers of varying hardness of the intrusion have eroded to become concentric rock rings and depressions. The striking 'ox eye' (*right*) is a landmark for astronauts.

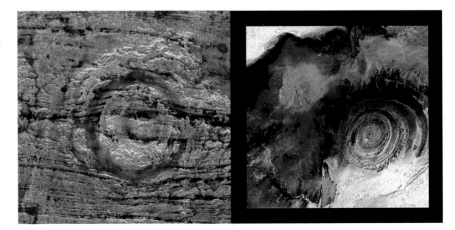

Source: NASA, USGS/EROS Data Center; SIR-C/X-SAR, Landsat-7 ETM+

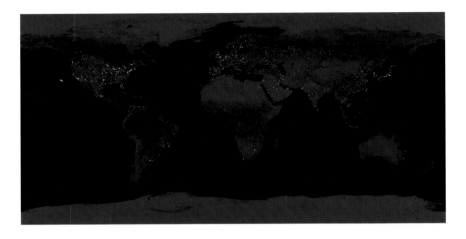

Our Earth at night

The urban areas of the Earth seen from space with special high-sensitivity cameras are revealed clearly by their lights. However, such areas are not always the regions of highest population density, as a glance at India shows. The edges of the continents are clearly demarcated from the sea by numerous coastal towns. These images allow the energy consumption of various regions to be calculated.

Source: DLR, NASA; DMSP OLS

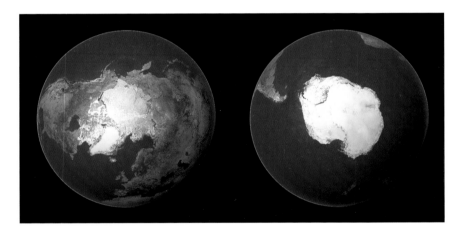

The Earth's poles

It is quite impossible to photograph the Earth's poles without an interfering layer of cloud. These exceptional views looking down vertically onto the Earth's poles could be obtained only with the aid of an artificial perspective generated on a computer. They are based on cloud-free mosaics of satellite images enhanced by computer animation techniques.

Source: Planetary Visions

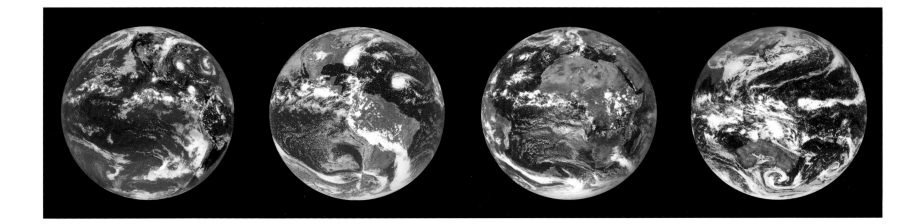

The Earth from a geo-stationary perspective

Several meteorological satellites are positioned in geo-stationary orbit at a height of 36,000 kilometres above the equator from where they continuously monitor weather conditions on Earth.

The images shown from left to right were taken by US satellites GOES-10 (positioned at 135° W) and GOES-8 (75° W), Europe's Meteosat-4 (0°) and Japan's GMS-5 (140° E).

Source: DLR (3), NASA; GOES-10, -8, Meteosat-4 (© EUMETSAT), GMS-5

Pearls in the sea

Drawn out like a string of pearls, the atolls of the Maldives form a pattern of rings. These images allow the locations of reefs, shallows and other danger zones for shipping to be detected. The spread of coral bleaching represents both an ecological and an economic threat to the Maldives, one of the world's premier diving regions. The full extent of the problem can be determined with the aid of satellites.

Source: USGS/EROS Data Center; Landsat-7 ETM+

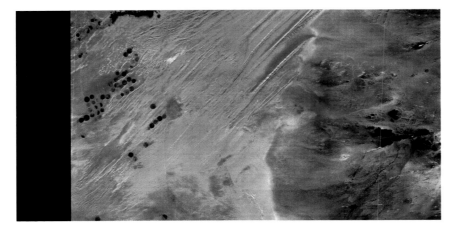

Farming on the edge of the desert

In arid regions, like this one at the edge of the Saudi Arabian desert, farming is possible only with the aid of intensive irrigation. The irrigated areas can be seen as circles to the left of the image. Mountain and dune features lend the picture an intriguing appearance.

Source: DLR; MOMS

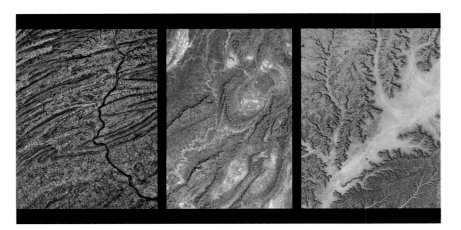

Geology

The acquisition of geological information as an aid to prospecting for oil and other mineral deposits is an important task for remote satellite sensing.
The images show, from left to right, the Appalachian mountains near Harrisburg with the Susquehanna River, geological structures in Afghanistan and the Wadi Hadhramaut in Yemen.

Source: USGS/EROS Data Center, NRSA, DLR; Landsat TM, IRS, MOMS

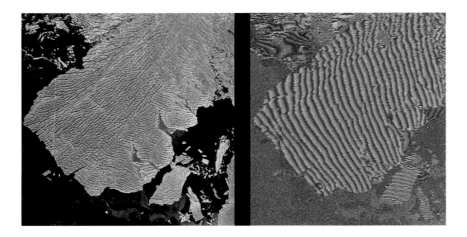

Thwaites Glacier, Antarctica

The Thwaites Glacier in western Antarctica feeds the Crosson Ice Shelf with its ice streams. The enhanced radar image on the left shows the many fractures and fissures of the glacier and several icebergs which have already calved. The associated fringe image provides information about topography, changes in ice thickness and direction of movement in the various parts of the glacier.

Source: ESA/DLR; ERS-2, 23.2.2000

Lone beauty

The Macdonnell Ranges in central Australia are formed from folded sedimentary rocks. They contain large gas deposits. The Finke River breaks through the mountains in a deep gorge in which flourish rare palms of a species some 50 million years old. The Rub 'al Khali is the world's largest homogeneous sandy desert. The dunes appear with a yellowish tinge, denoting the presence of iron oxide, whereas the clays and drift sand in the valleys between them produce a bluish reflection.

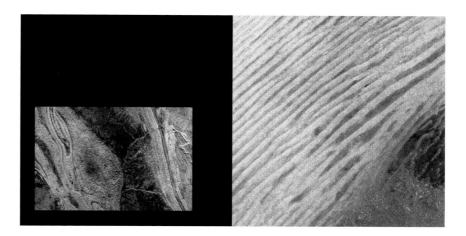

Source: NASA; SIR-C/X-SAR, Terra ASTER

Pack ice in the Weddell Sea

The diverse patterns of the pack ice (new and old ice, compressed floes) can only be seen from radar images. The thickness of the floes varies between a few centimetres (red) to more than two metres (blue-green). The dark lines indicate areas of open water.

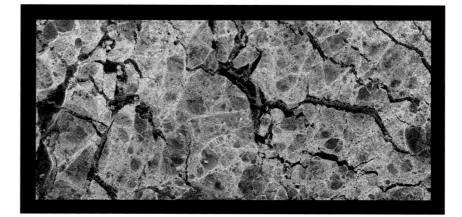

Source: NASA; SIR-C/X-SAR

Colourful world

Thailand's capital Bangkok (left) lies north of the estuary of the Chao Phraya River in the Gulf of Thailand. This satellite data was used for urban planning of the metropolis and its surroundings.
Huge areas are being cleared of forest in the Canadian province of British Columbia. Regular satellite images like these are indispensable for monitoring deforestation and the pattern of vegetation.

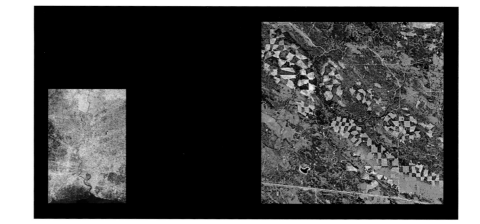

Source: ACRoRS, CCRS; Landsat TM

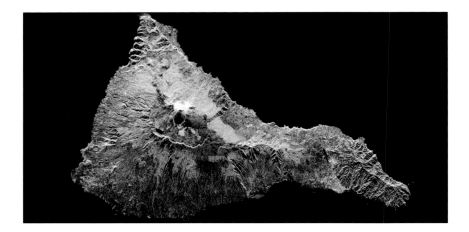

Tenerife

The island of Tenerife is dominated by the volcano of Pico de Teide, whose large crater (caldera) can be seen in the middle of the image. Streams of lava of varying ages and degrees of roughness flow into and out of it: they appear in hues of green and brown. The densely populated areas around the tourist centres of Los Christianos and Playa de Las Americas can be seen on the coast.

Source NASA; SIR-C/X-SAR

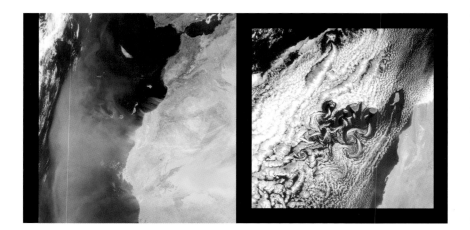

The Canary Isles in the wind

Storms transport huge quantities of sand from the Sahara far out to the Atlantic. This is how the dunes found on the Canary Isles were formed. Mountains present obstacles to wind currents. The mountain peaks of the Canaries produce Karman vortices whose full extent can only be mapped from space.

Source: NASA, ORBIMAGE; SeaWiFS

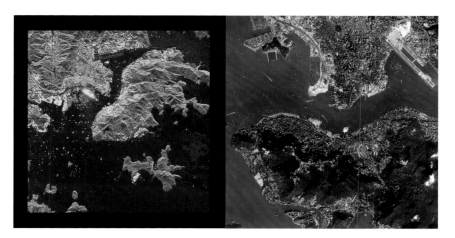

Hong Kong

Hong Kong is one of the most important harbours in the Far East. To the left, ships sailing the South China Sea can be seen as bright points. The city's skyscrapers act as mirrors and strongly reflect the radar signals, whereas the airport runways and streets appear as dark lines. The picture on the right shows the centre of the city, home to millions of people, and its ferry piers as an optical image with a resolution of four metres.

Source: NASA, Space Imaging; SIR-C/X-SAR, IKONOS

Saudi Arabia

The images show geological formations east of Mecca in Saudi Arabia. The circles in the middle picture are irrigated fields in the otherwise arid semi-desert. The search for groundwater – for instance in wadis buried under the sand – is an important task for geologists. Images of this kind help them in their work and are also useful for determining land use.

Source: DLR; MOMS

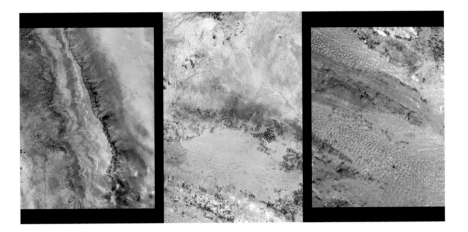

The Mississippi Delta

When the Mississippi reaches the Gulf of Mexico after flowing almost 4,000 kilometres right across the USA, it slows down and discharges its load of sediment. This process pushes the delta ever further out into the sea. The various types of alluvial land can be distinctly seen. The bright points in the Gulf of Mexico are oil platforms.

Source: NASA; SIR-C/X-SAR

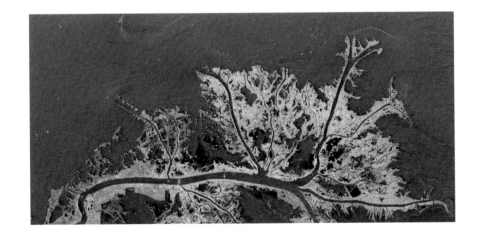

Land use

Satellite images make it easier to determine various types of land use. The images acquired by the German MOMS camera show examples from Australia (*top left*), Romania (*bottom left*) and Hungary (*bottom right*). The smooth texture of the tilled fields around the Dnieper in Ukraine shortly after winter make them appear in darker hues on the radar image (*top right*). The hedgerows between the fields and the woods on the riverbanks can be clearly seen.

Source: DLR (3), NASA; MOMS (3), SIR-C/X-SAR

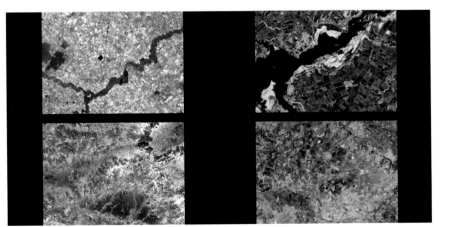

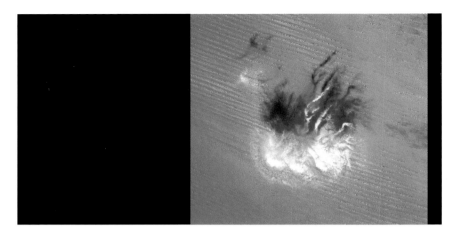

The Sahara

The first Spacelab, launched in November 1983, carried a special payload: a new kind of camera optimized for cartographical purposes. It was an advanced version of the Zeiss RMKA 30/23 with a film format of 23 x 23 cm and a ground resolution of 12 x 12 m.

The image shows one of the infrequent clouds over the Sahara west of El Djouf in Mauritania.

Source: DLR; Metrische Kamera, 2.12.1983

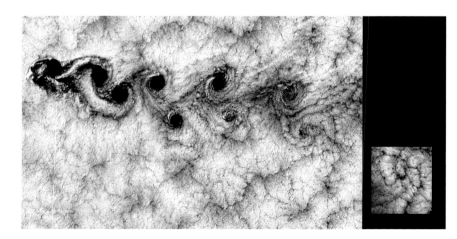

The lights of Asia and Europe

The urban areas of Asia (*left*) and Europe (*right*) show up clearly from space thanks to their illumination.

The urban areas of Europe and Japan shine much more brightly than the more densely populated cities of India. This tells us something about the energy consumption in these regions.

Source: NASA/DLR; DMSP OLS

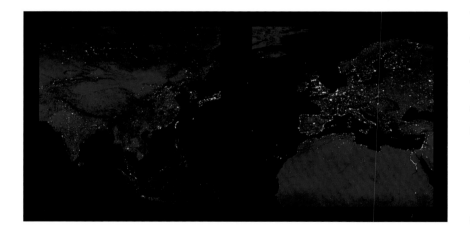

Vortices around Robinson's island

An impressive Karman vortex street is generated by the mountain peak on Alexander Selkirk Island (Chile). Only a satellite can record the true size of its wake. It was on this island that the character who inspired the story of Robinson Crusoe spent many years.

Right: A strong region of low pressure is brewing somewhere on the Earth. The typical cloud spiral has already formed.

Source: USGS/EROS Data Center, NASA; Landsat-7 ETM+, Terra MISR

Panorama of the North Atlantic seabed

The continents of Europe and America separated between 120 and 40 million years ago. The fracture initially ran between Greenland (*top left edge of the model*) and Canada, until rising magma broke up the land mass between Greenland and Scandinavia (*top right*). New satellite data reveals this process in all its drama.

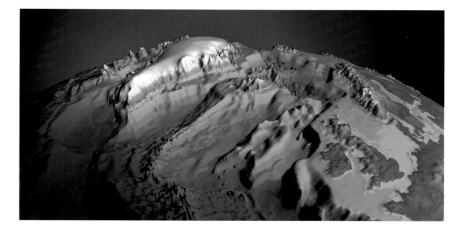

Source: DLR; ETOPO-5

Historical cities

Istanbul (*left*) has formed the bridge between Europe and Asia since classical times. The city lies on the Golden Horn, a narrow inlet of the Bosporus which links the Black Sea to the north with the Sea of Marmara to the south.

Madrid (*right*), the capital of Spain since 1561, was built on the walls of the Moorish fortress of Majrit dating from the ninth century. The core of the old city lies between the Royal Palace and the Parque del Retiro.

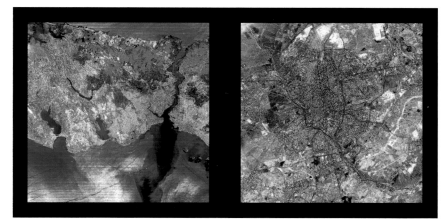

Source: NASA; Terra ASTER, 2000

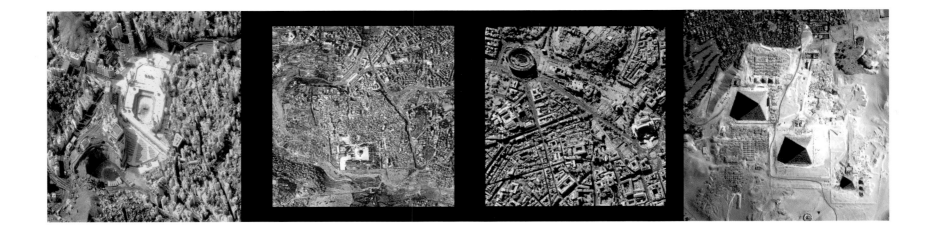

Sacred sites of humanity

Mecca (Al-Haram Mosque with the Kabah), Jerusalem (walled Old City with Temple Mount, Dome of the Rock and the al-Aqsa Mosque) and Rome (the Colosseum) are the most important places of the three great monotheistic religions. The great pyramids of Giza were built 4,500 years ago as symbols of divine worship for the pharaohs Khufu, Khafre and Menkaure.

Source: Space Imaging; IKONOS, 2001, 1m und 4m Auflösung

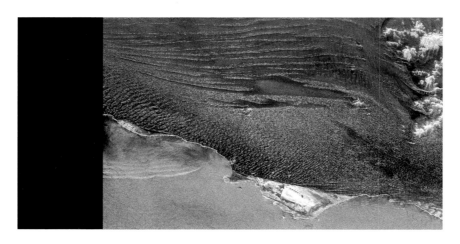

Namib Desert, Namibia

This radar image shows the Namib Desert at Diaz Point north of the town of Lüderitz. This region receives no more than a few centimetres of rain a year. The reddish areas are sand dunes which extend as far as the Atlantic (orange colour). The rocky outcrops breaking through the surface of the sand stand out on the right of the picture.

Source: NASA; SIR-C/X-SAR

Broad expanses

Barstow lies in the Mojave Desert (*left*). The orange-coloured round and rect-angular shapes are irrigated fields. Areas of scree appear in blue in this false-colour image, rocky areas in brown hues, and the dried-up lake Coyote is dark. Samara (*right*), the former Kuibyshev, on the Volga, is a busy industrial city. Small lakes and blind arms mark the earlier course of the meandering river. Samarskaya Luka National Park can be seen on the left of the image.

Source: NASA; SIR-C/X-SAR

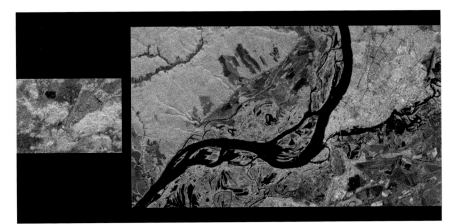

Morocco

The fold mountains of the High Atlas dominate the geography of Morocco. Over long periods of time, earthquakes and tectonic processes have shifted the fault lines. Wind and erosion then acted on layers of varying degrees of hardness to form the valleys and ridges on the eastern slopes of the mountains near the town of Rissani and the Algerian border.

Source: NASA; SIR-C/X-SAR

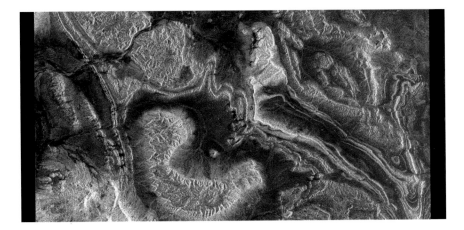

Natural and artificial structures

The area around Sunbury, USA (*left*), was created during the folding of the Appalachians. Erosion left only the harder sandstone in place. Oil pollutes the Arabian Sea around an offshore oilfield (*middle*). Wafer-thin oil films are dispersed over the water by wind and heaving seas. Formations buried under the sand (*right*) were discovered by radar scans in northern Sudan (Keraf Suture). They answer the age-old question as to what really determines the course of the Nile (yellow-green line).

Source: NASA; SIR-C/X-SAR

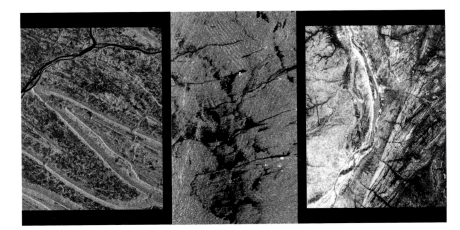

213

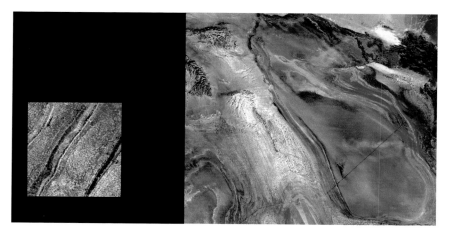

China

Forested mountain chains traverse the north of the Chinese province of Fujian (*left*). Small rivers meander through the areas used for farming. The image on the right shows geological structures at the southern edge of China's Altun Shan mountains. The black line crossing the picture from bottom left to top right is a road. This data was used for the geological mapping of China and for determining land use.

Source: USGS/EROS Data Center, China RSGS; Landsat TM

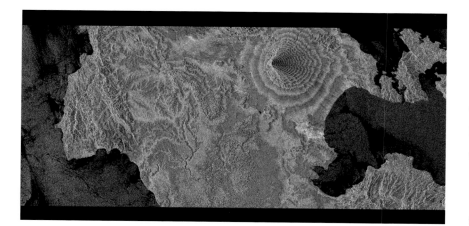

Fringes

Radar satellites clearly bring out the structures of the Earth's surface. Like the contours of a map, these lines of equal phase difference, known as fringes, represent layers of varying elevation. After further processing, they yield digital terrain models or three-dimensional images of the region. The image shows Mount Mayon on the island of Luzon (Philippines), a volcano whose most recent eruption was in June 2001.

Source: ACRoRS, ESA; ERS-1

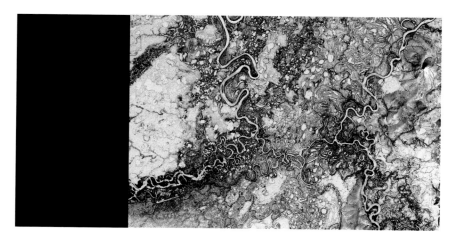

Siberian tundra

In the extreme east of Siberia near the Bering Strait, the Maynopil'gyn River wends its way through the permafrost region. The river is ice-free only a few months of the year, and the ground thaws down to no more than a few centimetres. Although this winter scene resembles a black-and-white photograph, colours can be seen along the right edge of the image.

Source: USGS/EROS Data Center; Landsat-7 ETM+

Glaciers

Seen from space, the Petermann Glacier in Greenland (*left*, in the upper third of the image) looks like a giant white shark.

The right-hand false-colour image of a large glacier in the Patagonian Ice Sheet shows the vegetation in reddish hues. Deep fissures can be seen in the ice.

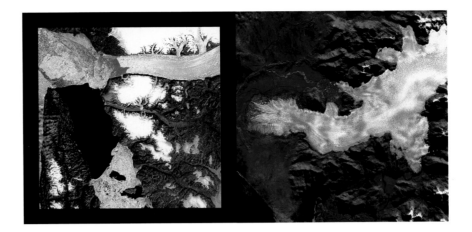

Source: USGS/EROS Data Center, NASA; Landsat-7 ETM+, Terra Aster

Geographical structures

Satellites allow geographical data to be collected with high precision from all regions of the Earth. Examples include scenes from Tibet (*left*), a salt lake in the Afghan Desert (*centre*) and the strongly contoured Croatian coast (*right*). Data of this kind are used increasingly in cartography.

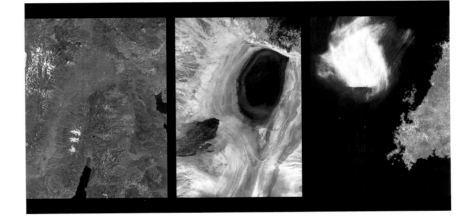

Source: DLR (2), GAF; MOMS (2), IRS

Low-pressure vortices

Having spent most of their destructive force, hurricanes reach as far as Europe in the form of low-pressure storm regions. Before reaching our latitudes from the tropical Caribbean, they have covered over 20,000 kilometres within two weeks. The left vortex, the residue of a tropical storm, struck central Europe with great force in February 1994. Storm Lothar (*right*) struck the German coast at Christmas 1999 and caused a tidal wave there.

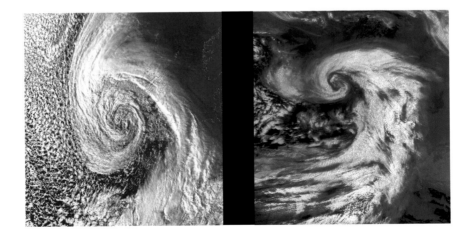

Source: DLR; NOAA-12 AVHRR (3.2.1994) und NOAA-14 AVHRR (25.12.1999)

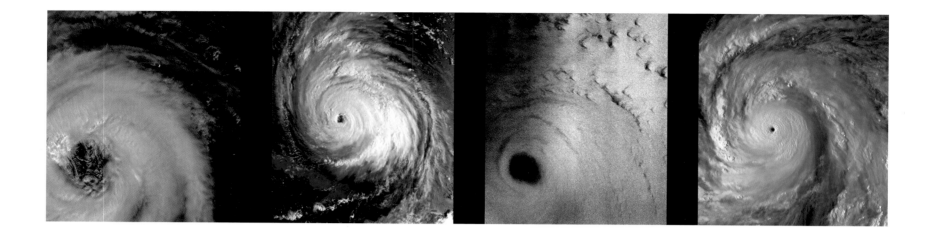

Hurricanes

Hurricanes are among the most violent storms on Earth. They arise in equatorial regions of the Atlantic, reach wind speeds of up to 300 kilometres per hour and develop into highly destructive forces. Their outliers can extend to Greenland and Scandinavia as stormy zones of low pressure. This sequence of images shows the hurricanes Alberto (image 1, 2000), Floyd (1999) seen from a weather satellite (image 2) and as a radar image (image 3), as well as Gilbert (image 4, 1988).

Source: NOAA (2), NASA, Radarsat Int'l.; NOAA AVHRR (2), Terra MISR, Radarsat –1

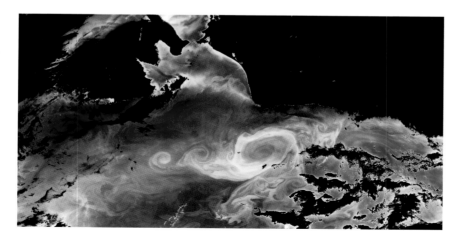

Currents

The vortices and currents forming in the water of the oceans are often invisible to the naked eye. A combination of thermal and colour data is needed to identify bodies of water with diverse temperatures and chlorophyll concentrations. Data of this kind is exceptionally useful to the fishing industry as well as for oceanographic studies.

Source: NASDA; OCTS

Mount Everest

Soaring to a height of 8,846 metres, Mount Everest is the world's highest mountain. It looms over the frontier region between Nepal and Tibet/China. This artificial 3D-view, generated from the data obtained from MOMS, shows the mountain without its famous cloud cover. Mountaineers from all over the world use representations of this kind to plan their expeditions.

Source: DLR; MOMS

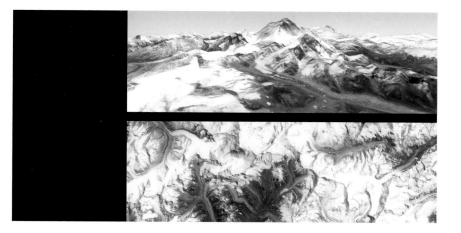

The Marree Man

During a routine investigation, Australian police found the largest rock carvings in the world on 15 July 1998. A figure four kilometres in length had been gouged out of the thin soil of the Simpson Desert to the south of Lake Eyre. The underlying bedrock peeps through to reveal the outline of an Aborigine hunter. To create the figure of the Marree man, the artists, who remain unknown, must have used heavy equipment controlled by computers and global positioning systems.

Source: ACRES; Landsat-5 TM on 28 June 1998

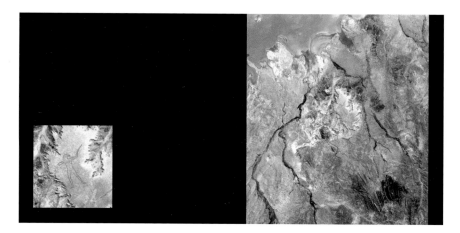

The dragon lake in Siberia

The artificial lake of Bratsk, fed by the waters of the Angara (coming from Lake Baikal at bottom right), Oka and Iya rivers, curves around the south Siberian mountains like a dragon. The dam and the city of Bratsk can be seen in the upper-left corner of the image.

Source: USGS/EROS Data Center; Landsat-7 ETM+

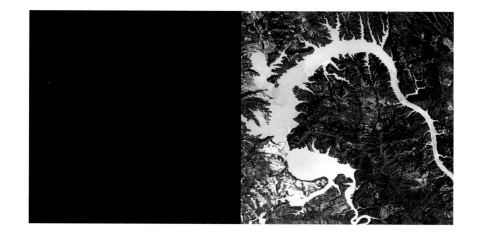

Ice on the ground and in the air

The giant icecap of Vatnajökull in Iceland also feeds the glaciers of the Skaftafell National Park, which move southwards towards the sea. The volcanoes of the Mid-Atlantic Ridge are still active under the ice.

A typical cloud formation over the Aleutians (Alaska) can be seen on the right. These structures are formed as cold polar air collides with significantly warmer air masses from the Pacific region.

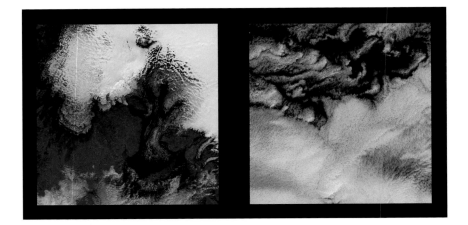

Source: USGS/EROS Data Center; Landsat-7 ETM+

Scenes from Bolivia

An image of a small town in Bolivia shows how the land used for growing crops encroaches into the rainforest of the upper Amazon. This data allows land-use maps to be produced and thereby logging, some of it illegal, in the primeval forest to be monitored.

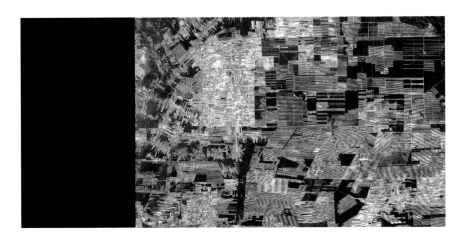

Source: USGS/EROS Data Center; Landsat-7 ETM+

The water of Lake Garda, Italy

Lake Garda in northern Italy is the country's largest lake. It was scooped out by glaciers during the last Ice Age. The Sirmione peninsula at its southern end is the site of Roman ruins and the famous Scaliger fortress. The picture, created by masking the land areas and subsequently enhancing the contrast, shows various substances suspended in the water as well as the tracks of numerous boats criss-crossing the lake.

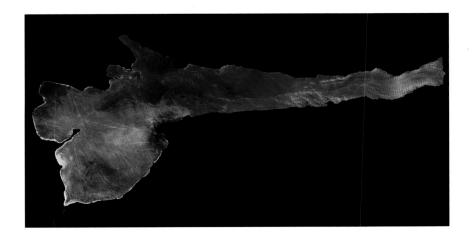

Source: NASA; Terra ASTER

Coastal landscape near Darwin, northern Australia

Regions of the world which are difficult to access can be more easily observed and classified from space. Use of the infrared channel shows the extensive mangrove forests on the coast of Arnhem Land and along the banks of the rivers in bright red.

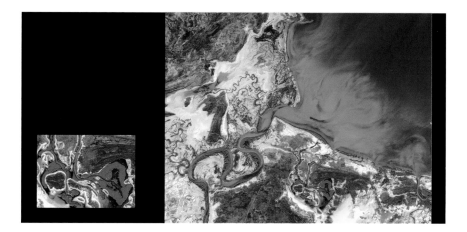

Source: DLR; MOMS

Lambert Glacier in Antarctica

Lambert Glacier is one of the world's largest glaciers as well as one of the longest, extending over 400 kilometres. Its catchment area covers over a million square kilometres and its ice feeds the Amery Ice Shelf. The radar image shows the glacier's arc-shaped tongues and the surrounding mountain peaks of MacRobertson Land. The large picture to the right is an optical view of the glacier. The rocks projecting from the glacier can be clearly seen in reddish hues.

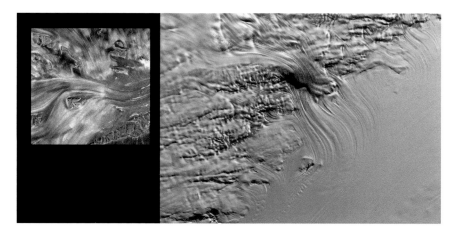

Source: Radarsat Int'l., USGS/EROS Data Center; Radarsat-1, Landsat-7 ETM+

High and low

Ngorongoro Crater (*left*) is the caldera of an ancient volcano. It is home to the world-famous wildlife reserve which forms part of the Serengeti National Park in Tanzania.

The image on the right shows Banks Peninsula near Christchurch, New Zealand. The striking Little River (or Akaroa) harbour cuts deep into the mountain, and a narrow tongue of land separates shallow Lake Ellesmere from the Pacific (bottom left of picture).

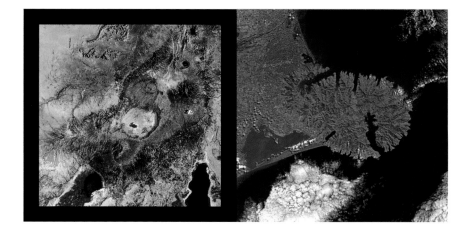

Source: GAF, NRSA; Landsat TM, IRS

A radar image of Los Angeles

This radar image shows the densely populated region of greater Los Angeles extending from Santa Monica Bay, top left, to the San Gabriel mountains. Highways and the grid pattern of the city's streets can be clearly seen. The black marks on the right edge of the image are the traces of the Altadena bush fire of 1993. One of the largest NASA research centres is located close to the site of the fire.

Source: NASA; SIR-C/X-SAR

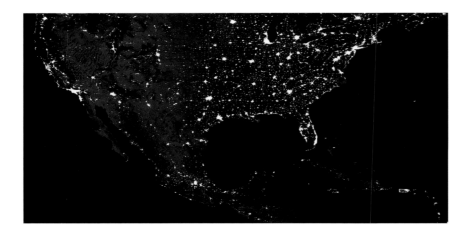

The lights of North America

The large urban agglomerations and cities of North America are clearly visible from space. The regular pattern of the highways in the otherwise sparsely populated Middle West dominates the centre of the picture.

Source: NASA/DLR; DMSP OLS

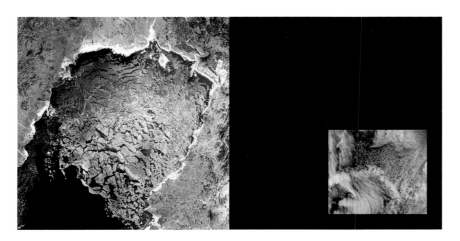

Ice

Spring comes to China. The ice in the Gulf of Bo Hai (*left*) east of the Chinese capital of Beijing already begins to break up in February.
The air masses cool down strongly over the pack ice of the Barents Sea (*right*). The moisture they contain condenses and is pushed in geometrical patterns to the warmer sea by air movements.

Source: China RSGS, DLR; Landsat TM, NOAA-14 AVHRR

Dasht-e-Kavir Desert, Iran

The incessant wind has blown the sand away to reveal the underlying rock of the Dasht-e-Kavir in Iran. The various layers of rock interspersed with clay and salt deposits have a polished appearance. The splash of colour makes this scene resemble a palette discarded by a heavenly artist.

Source: USGS/EROS Data Center; Landsat-7 ETM+

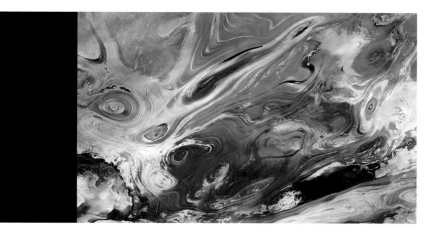

The ozone hole over the Antarctic

The ozone layer over the Antarctic reacts strongly to the rising concentration of trace gases in the atmosphere. As long as the sun warms the atmosphere in the Antarctic spring, the ozone is dissociated by catalysis: an ozone hole is formed (violet). The layer regenerates again in the Antarctic summer. Although this map is issued daily, it shows only time segments of about ten days each.

Source: DLR / ESA; ERS-2 GOME, 2000

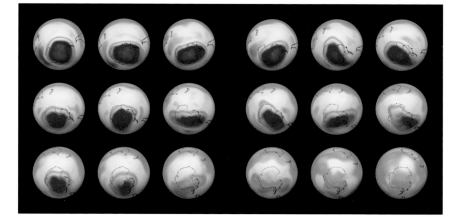

Rub 'al Khali, Saudi Arabia

The mountains skirting the arid Rub 'al Khali (Arabic for 'the empty quarter') in the border region between Saudi Arabia and the Arab Emirates stack the sand up into high dunes.

Source: GAF; Landsat TM

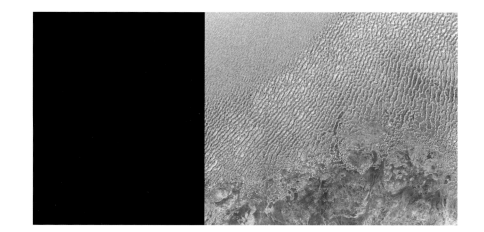

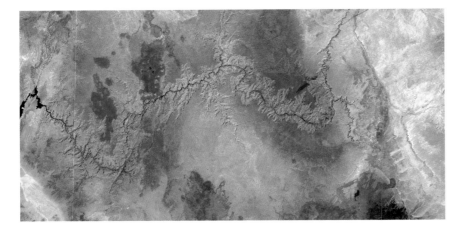

Grand Canyon, USA

Over the last five to six million years, the Colorado River has dug its way into the Colorado plateau, some 2,500 metres in height. The Grand Canyon, up to 1,600 meters deep, first became accessible to tourists via the Bright Angel Fault (lower centre of image). The width of the image covers two complete swaths recorded by the Landsat -7 ETM+ satellite.

Source: USGS/EROS Data Center; Landsat-7 ETM+, 2001

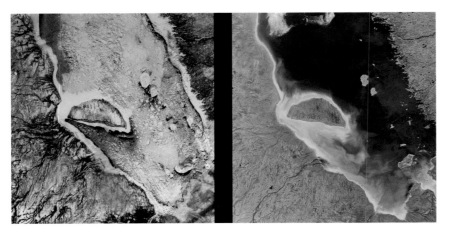

James Bay, Canada

The images show James Bay in Canada, named after British explorer Thomas James, in winter (*left*) and in summer (*right*). The bay forms the southern part of Hudson Bay and freezes up almost completely in winter.

Source: NASA; Terra MISR, 9.8.2000 und 16.1.2001

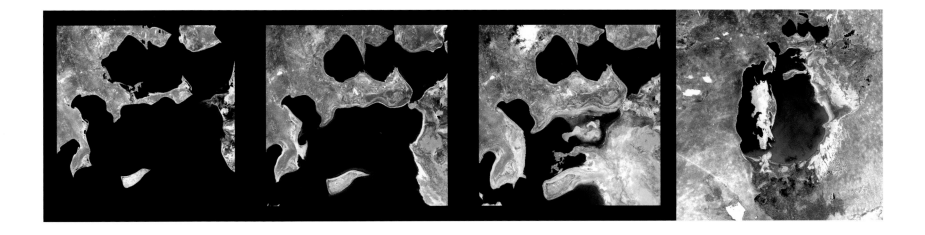

Aral Sea, Kazakhstan/Uzbekistan

The Aral Sea has been shrinking dramatically since the early 1960s, its surface declining by 50 per cent between 1960 and 1995, and its volume by as much as 75 per cent. Large quantities of water are diverted from its tributary river, the Amu Darya, to irrigate the cotton fields in the arid region to its south. Fishing villages which existed as recently as twenty years ago on the shore of this inland sea are now remote from its waters. The image on the right shows the complete sea in 1998. The three sections show the part known as the Small Aral Sea to the north-east in the years 1972, 1987 and 2000. The former bay has now completely dried up and separates the smaller northern sea from the large southern sea. Whereas the Large Aral Sea continues to shrink, the water level of its northern extension remains stable at present.

Source: USGS/EROS Data Center (3), DLR; Landsat-1 (1972), -5 TM (1987), -7 ETM+ (2000), RESURS-01 (1998)

Dasht-e-Lut, Iran

The desert wind has exposed the layers of an old seabed, pushed up by tectonic forces. Salt-bearing layers reflect the sunlight more strongly. The wadis (as seen below left) are a source of groundwater, allowing sparse vegetation to exist.

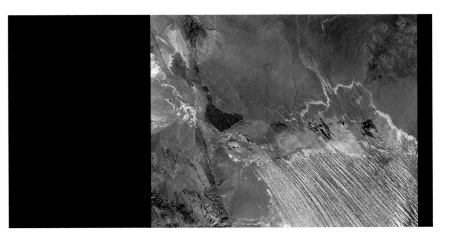

Source: NRSA; IRS

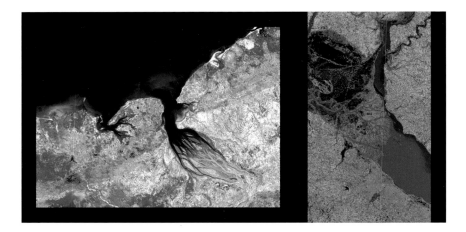

Urbanization

Deforestation has exposed the land to heavy monsoon rains. Within a very short time, alluvium has deposited around the estuary of the Betsiboka River (Madagascar) and numerous sandbanks have been formed. The weight of sediment seriously silts up the harbour of Mahajanga.

Buenos Aires (*right*), the capital of Argentina, lies on the Río de la Plata. The Río Uruguay has been dammed to create large artificial lakes before flowing into the estuary. The area to its right is already Uruguayan territory.

Source: USGS/EROS Data Center; Landsat-7 ETM+

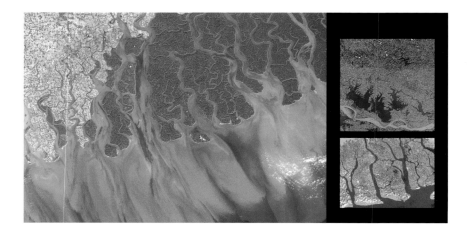

Major rivers

Changes in the course of rivers can be clearly tracked from space. The images from left to right show the mouths of the Ganges in Bangladesh (the Sundarbans), the lower course of the Yangtze between Wuhan and Nanjing (*above*) and the delta of the Niger near Port Harcourt (Nigeria).

Source: NRSA, DLR, Hugin; IRS, MOMS, Landsat-7 ETM+

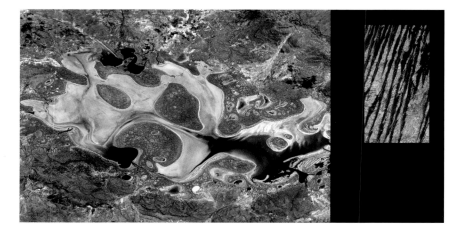

Deserts

After a sporadic shower, the otherwise dry Lake Carnegie (*left*) on the edge of Australia's Gibson Desert has filled with water again. The sparse vegetation (in greenish hues) flourishes after the rain.

Eroded sediment formations (*right*) break through the sand dunes in the Sahara. The wide darker bands are longitudinal dunes, which may extend over several hundreds of kilometres. The narrow red strips are reflections from the sharp ridges of the dunes.

Source: USGS/EROS Data Center, NASA; Landsat-7 ETM+, SIR-C/X-SAR

Rann of Kutch, India

The border region between the Indian province of Gujarat and Pakistan forms part of the Thar Desert and has been the scene of repeated skirmishes between the armies of the two countries. Large salt lakes, dry most of the year round (*left*), and thinly populated dusty plains (*right*) characterize the landscape.

Source: NRSA; IRS

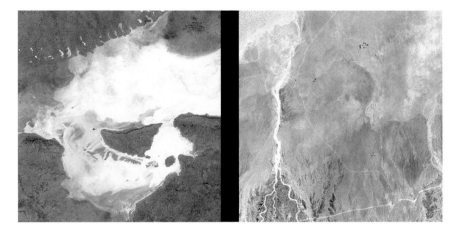

Central Thailand

The tablelands in the centre of the image and on its right edge are remnants of a much larger plateau which has been worn away by erosion. The left plateau is home to the Phu Kradung National Park in north central Thailand.

Source: NASA; SIR-C/X-SAR

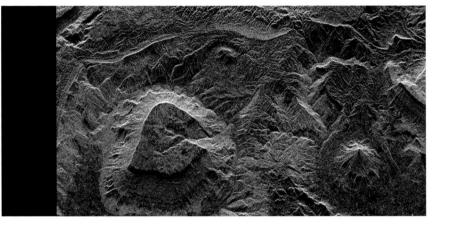

Development planning in China

Satellites provide optimal support for the planning and monitoring of government development schemes.

Data acquisition from the coastal areas of northern Jiangsu province (*left*) is greatly facilitated with their aid. After heavy rainfall in June 1996, Lake Dongting (*right*) overflowed its banks. In some places, only the raised field ridges remained visible. The image allows the damage suffered by local agriculture to be estimated.

Source: China RSGS; Landsat TM

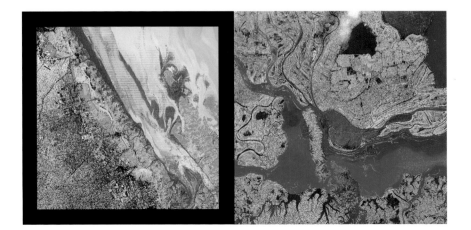

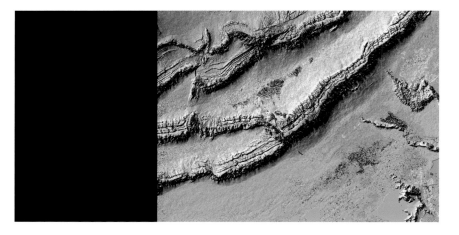

Tien Shan, China

During a special mission in which the two satellites ERS-1 and ERS-2 flew in tandem formation, their radar sensors recorded data from the Tien Shan mountains in northern China. It was further processed to yield this digital elevation model.

Source: DLR/ESA; ERS-1/2 Tandem, 1999

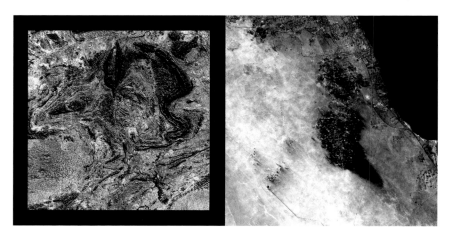

Deposits

Like a fossil of a bird from the primeval past, the rocks of the Macdonnell Ranges (*left*) in Australia stand out in bold relief against the uninhabited wilderness. The search for mineral deposits is greatly aided by highly detailed images of this kind. Burning oil wells pollute the desert near Kuwait City (*right*). The changes in the texture of the sandy areas clearly reveal the soot particles even on the radar picture.

Source: USGS/EROS Data Center, NASDA; Landsat-7 ETM+, JERS

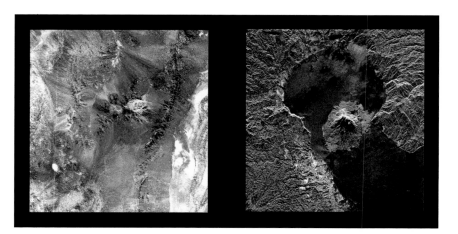

Volcanic activity

On the high plateau of northern Chile, tectonic plates meet at very different angles. Sedimentary layers are folded up steeply and eroded. Pyroclastic material on their surfaces makes the area appear flat in places.
The volcano of Sakurajima on the island of Kyushu (Japan), continuously active since 1955, forms a peninsula in the centre of Kagoshima Bay. Radar satellites detect significant indicators of its activity, including elevation changes in the centimetre range.

Source: NASA; Terra ASTER, SIR-C/X-SAR

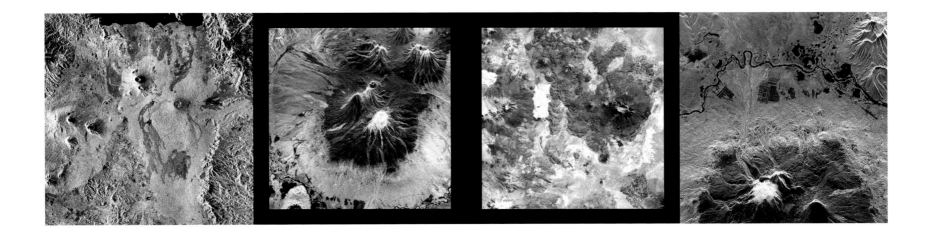

Volcanoes

The chain of the Virunga volcanoes (3,000–4,500 metres, *left*) on the border between Rwanda, the Democratic Republic of the Congo and Uganda is home to the last mountain gorillas of our planet.

Klyuchevskaya Sopka (4,750 metres, *centre left*) on the Kamchatka Peninsula is one of the most active volcanoes on Earth. Its last great eruption took place in the year 2000. Kamchatka (*right*) forms part of the Ring of Fire, a chain of active volcanoes encircling the Pacific Ocean.

The world's highest volcanoes are found in the Andes of South America. The centre of the image is dominated by Cerro Luxsar and the dark-coloured lava outcrops of Pampa Luxsar. The stratovolcanoes of Olca and Paruma (*centre right*) can also be clearly seen.

Source: NASA; SIR-C / X-SAR, Terra ASTER

Geological fireworks in central Iran

The system of the Neh fault with its numerous subsidiary faults extends across the centre of the picture in the border region of the Arabian-Asian continental collision. The wealth of colour of this desert scene reflects the diversity of rock types pushed to the surface by tremendous seismic forces.

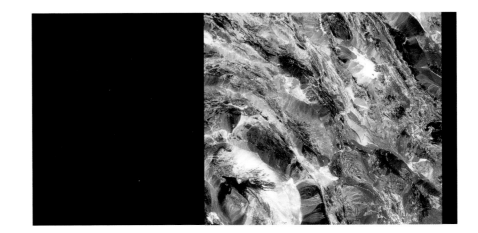

Source: GAF; Landsat TM

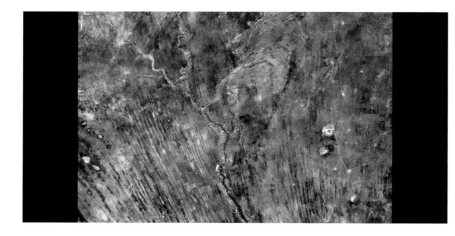

The optimist

An intrepid lone farmer – known as 'the optimist' – wrests his harvest from the inhospitable Kalahari Desert in eastern Namibia. His irrigated field can be seen as a small red circle at the fork of two dry valleys in the centre of the picture.

Source: USGS/EROS Data Center; Landsat-7 ETM+

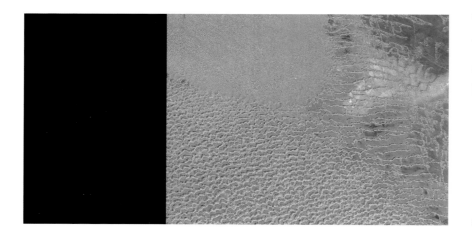

The empty quarter

The Rub 'al Khali Desert in Saudi Arabia is one of the driest and most barren regions of the Earth. It is traversed by only a few Bedouin tribes. Their language has many special names for different types of dune.

Source: NRSA; IRS

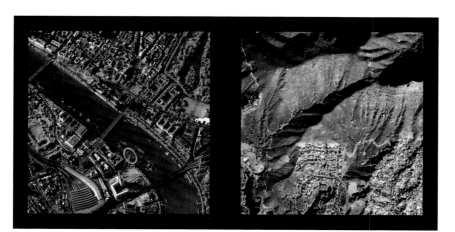

Signs of the times

A glimpse from a satellite's vantage point reveals unsuspected details: the world-famous letters in the hills above Hollywood (*right*) welcome not only visitors to the city but astronauts as well.

The Millennium Dome and the giant wheel of British Airways, known as the London Eye, on the banks of the Thames in London (*left*) can also be clearly distinguished from a height of 700 kilometres.

Source: Space Imaging; IKONOS, 1m resolution

Water temperatures

The infrared channels of weather satellites are sensitive to the temperatures of water surfaces. The image on the left shows the temperatures on North America's Great Lakes. Their waters are mixed by currents and inflows from rivers. The sequence of images on the right shows changes in the surface temperatures of the Mediterranean Sea caused by cold water flowing in from the Atlantic through the Strait of Gibraltar and by the mistral wind blowing down from southern France.

Source: DLR; NOAA-14 AVHRR (2), NOAA-12 AVHRR

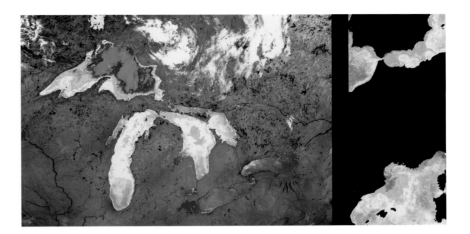

Wilderness in northern China

Over thousands of years, rainfall and melt water have produced these characteristic fan-shaped structures in the northern foothills of the Altun Shan mountains. Images of this kind also help prospectors search for mineral deposits.

Source: China RSGS; Landsat TM

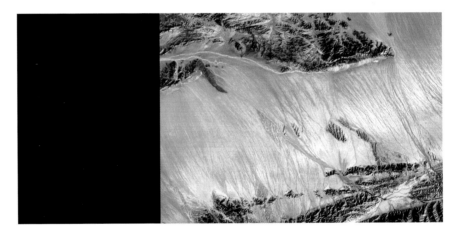

Traces

Even traces of military conflicts can be detected from space: defensive earthworks and embankments extend along the border between Iraq and Iran, dating from the war between these two countries.
The satellite image on the right shows traces of bush fires in the Tanami Desert – an outlier of the Great Sandy Desert – in Australia's Northern Territory.

Source: USGS/EROS Data Center; Landsat-7 ETM+

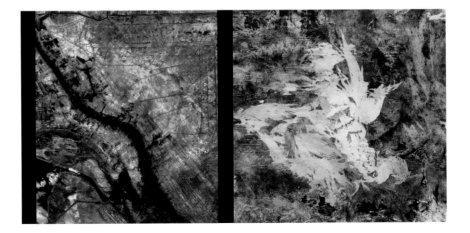

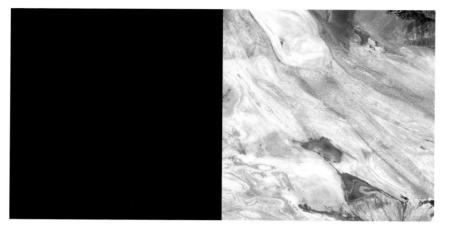

Altun Shan, China

Like an island, a prominence rises from a large salt plain to the south of the Altun Shan mountains in northern China. When it rains in the mountains, the plain may be flooded and a salt lake can form.

Source: NRSA; IRS

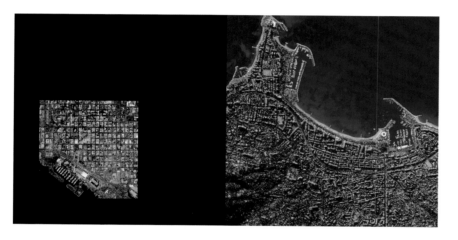

Cities by the sea

The chessboard pattern of the city of San Diego (USA) dominates the picture. The yacht harbour can be seen on the lower left.
The fashionable seaside resort of Cannes (France) enjoys a picturesque location on the Côte d'Azur. Its beaches and yacht harbour are world-famous.

Source: Space Imaging; IKONOS, 1 m Auflösung

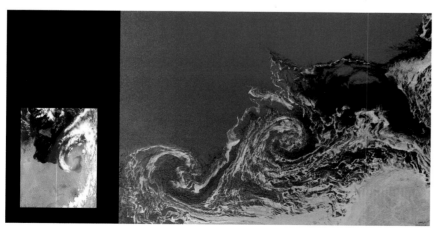

Eddies

Regions of low pressure are formed over the Mediterranean Sea in spring as a result of inflows of cold air: the desert wind known as the sirocco also blows across their front. Two large eddies (*right*) with diameters of 40 and 60 kilometres, rotate in the Weddell Sea. The colours are arbitrary and result from the varied polarization and strength of the backscattered radar signals. They tell us about the thickness and age of the ice floes.

Source: DLR, NASA; Terra MODIS, SIR-C/X-SAR

Amazon jungle, Brazil

North of Manaus, the Rio Jaú flows into the Rio Negro, the largest tributary of the Amazon. In the dense tropical forest, the rivers are constantly seeking new beds after the rainy season. Continuously shifting sandbanks and river islands characterize the picture.

Source: USGS/EROS Data Center; Landsat-7 ETM+

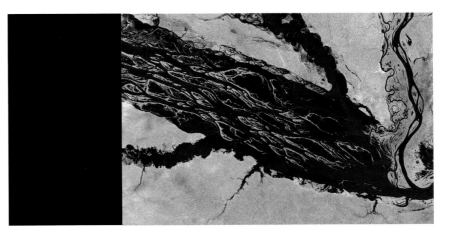

A fine day in Europe

Central Europe is cloud-free, but a new area of low pressure is brewing over the Atlantic. Only geo-stationary weather satellites permit such a broad overview of weather conditions.

Source: DLR, Planetary Visions; Meteosat-6 (© EUMETSAT)

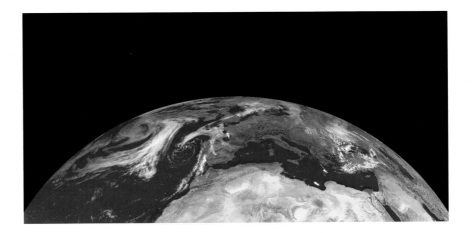

ABBREVIATIONS

Sensors

ASTER	Advanced Spaceborne Thermal Emission and Reflection Radiometer (Terra)
AVHRR	Advanced Very-High Resolution Radiometer (NOAA)
ETM	Enhanced Thematic Mapper (Landsat)
GOME	Global Ozone Monitoring Experiment (ERS, ENVISAT)
MISR	Multi-angle Imaging Spectrometer (Terra)
MODIS	Moderate-resolution Imaging Spectroradiometer (Terra)
MOMS	Modular Optoelectronic Multispectral Scanner (Shuttle)
OCTS	Ocean Color and Temperature Scanner (ADEOS)
OLS	Optical Linear Scanner (DMSP)
SAR	Synthetic Aperture Radar (ERS, JERS)
SeaWiFS	Sea Wide Field Sensor (OrbView-2)
SIR	Synthetic Imaging Radar
TM	Thematic Mapper (Landsat)

Satellites

DMSP	Defense Meteorological Satellite Program (USA)
ENVISAT	Environmental Satellite (Europe)
ERS	European Remote Sensing Satellite (Europe)
GOES	Geostationary Operational Environmental Satellite (USA)
GMS	Geostationary Meteorological Satellite (Japan)
IRS	Indian Remote Sensing Satellite (India)
JERS	Japanese Earth Resources Satellite (Japan)
Resurs	Russian Earth Observation Satellite
Terra	Earth Observation Satellite (USA)

Various

ESA	European Space Agency
ETOPO-5	Elevation model of the Earth (USGS)